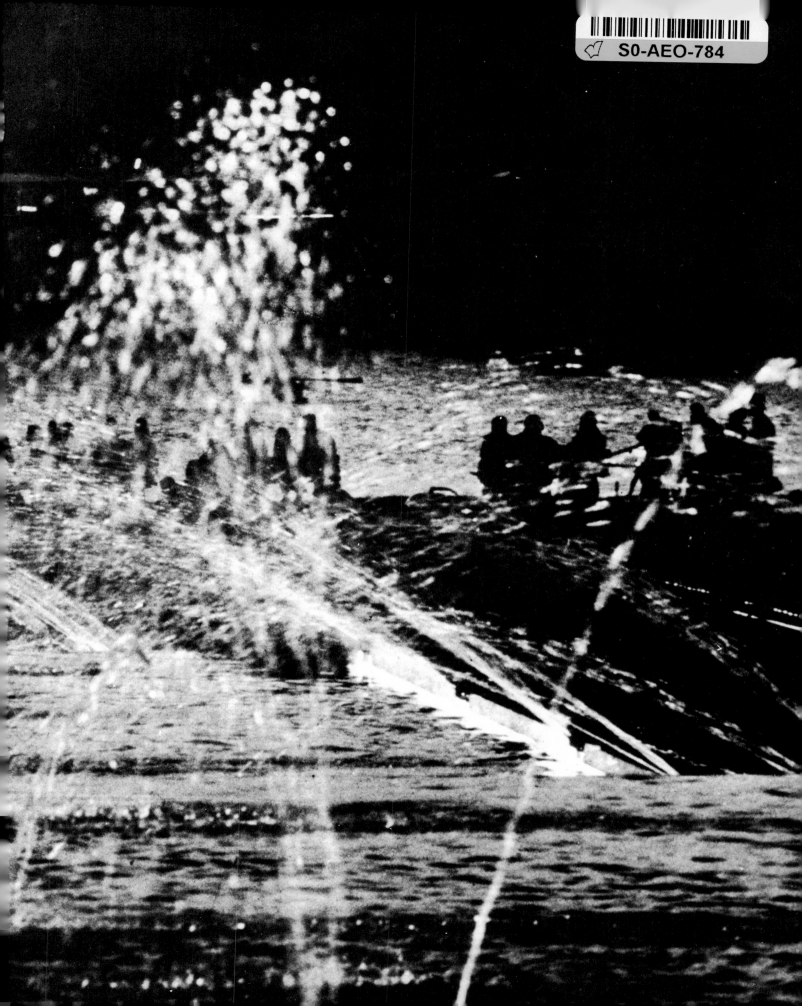

PHOTOGRAPHY YEAR BOOK
1979

INTERNATIONALES
JAHRBUCH DER FOTOGRAFIE
1979

Photography Year Book 1979

Edited by John Sanders

**INTERNATIONALES
JAHRBUCH DER FOTOGRAFIE
1979**

FOUNTAIN PRESS

Deutsche Ausgabe: Wilhelm Knapp Verlag, Düsseldorf

Fountain Press,
Argus Books Ltd,
14 St James Road,
Watford, Herts,
England

ISBN 0 85242 625 9

Deutsche Ausgabe:
Wilhelm Knapp Verlag,
Niederlassung der Droste Verlag GmbH
4000 Düsseldorf I

ISBN 3 87420 106 6

© Argus Books Ltd, 1978
Published October 1978

Printed in England by
G. A. Pindar & Son Ltd,
Scarborough, N. Yorkshire

THE CONTENTS

INHALT

THE PHOTOGRAPHERS

DIE FOTOGRAFEN

Editorial
By John Sanders

One critic of the last *Photography Year Book* loftily pronounced that it contained 'fairly professional pictures by amateurs and fairly amateur pictures by professionals' and, although this may never make the Dictionary of Quotations (and was meant to be unkind) I decided on reflection that he had really paid my contributors a compliment since it has been my experience that the most stimulating professional photographers I meet are usually those who still retain the amateur enthusiasm which made them turn professional in the first place, and the most interesting amateurs are those who – while perfectly happy with their amateur status – are determined to acquire professional skills in order to extend the range of pictures they wish to take for their own satisfaction.

Having disposed of the Year Book, my reviewer then went on to talk about what he felt was more 'serious' photography in other publications. I too admire much of what he listed, but it was the word 'serious' that intrigued me, just as I was intrigued by the word 'concerned' with which some photographers liked to label themselves a few years ago as though this somehow conferred the membership of an exclusive club.

The whole history of painting is, of course, littered with clubs, societies, groups, movements and secessionist movements which artists have always yearned to join for one reason or another, the predominating motive nearly always being real or imaginary status and a desire for self advancement. That great art can result from all too human motivation can be seen at any major art gallery, but while pursuit of the fashionable can produce work of lasting merit if the artist is talented enough to begin with, fashions can change as rapidly as received opinion and the unlucky opportunist can sometimes find himself back out again in the cold just as he feels secure in the conviction that he has managed to come in from it.

For the political adventurer, finding himself with the wrong opinions at the wrong place and at the wrong time can prove a fatal miscalculation, but while it would be foolishly unjust to suggest that all artists who receive fashionable acclaim are untalented opportunists, some are deceived by over praise – which can be as ruinous as unwarrented neglect.

Photographically, this can be observed in major picture exhibitions and in picture books, including some sponsored by large industrial concerns. Among these is often a contribution which holds up two fingers to everything the sponsor stands for and which, not too long ago, would never have got past the preliminary selectors. The fact that it may have merit is not the point at issue. I may be over cynical but I rarely believe the protestations by the sponsors, overt or implied, that inclusion of such work proves that they are enlightened and broadminded. Rather the reverse. I think it simply proves that they are chicken hearted and should have demonstrated the courage of their real convictions by raising two fingers of their own at the intruder and telling him to go hold a show of his own down the road. This is what happened in the past and art was the better for it in that rejection so

infuriated the *refusées* that they did hold their own salons in which work totally at variance with the philosophy – or lack of it – of the established order successfully communicated unorthodox ideas and fresh ways of looking at the world. There are, of course, mainly traditional or wholly radical offerings still around, but while it is right to seek co-operation rather than conflict in most areas of human activity, the conflict of ideas – wholeheartedly pursued on both sides – is an essential dynamic if progress rather than stagnation is to result.

The portrait of an ignorant provincial, thumbs hooked in his braces as he proclaims 'I don't know much about art but I do know what I like', may not commend itself to the sophisticated but there is a self confidence in the remark sadly lacking among many of those today otherwise unconvinced that change for change's sake is necessarily a good thing. They must know that their opponents have no doubts about what has to be done, but instead of boldly stating their real opinions, they prevaricate – rather like the curate who, asked by his Bishop if he liked the smelly egg he had been given, timidly replied 'Oh yes my lord. Parts of it are excellent'.

Photography Year Book must inevitably be like the curate's egg. Good in parts. Unless every copy happened to be acquired by an army of clones who shared my tastes and prejudices in every respect. It could, and probably will, be pointed out to me that, by putting such a disparae collection of images between the covers of this book, I betray the same lack of a positive philosophy but this would be to misunderstand my motives as an editor. While I regard it as essential that my contributors should have firm opinions and the technical ability to express them, I tend to suspect those to whom their eyes are clearly less important to them that their nose – ever raised to sniff out the first signs of some new trend to be eagerly embraced as proof of intellectual awareness or possession of a social conscience.

Writing in *Australian Photography*, Laurence Le Guay expressed, in one very succinct paragraph, what I have always considered to be my own approach to putting together a collection such as this. 'I believe photography needs to be broad in its outlook and should resist all attempts to force it into narrow or elite fields of aesthetic evaluation. There should be room for the curious as well as the creative. The descriptive as well as the revealing'. After commenting that much photographic education in Australia was still overshadowed by the 'old developing and printing rites', he added the further illuminating remark that attempts to evaluate a photograph should be more in line with literature than painting in that it really matters little how a photograph is produced. 'Only the end result counts. It is a new way of seeing. A new way of understanding'.

I remember reading an article some years ago which mentioned a school of novelists in France who believed that the whole notion of fiction as something to actually *interest* the reader was not only old fashioned but in some ways anti-social. A famous French film maker was quoted – as an indication that this anti-story-line campaign had also spread to the visual media – as saying that 'any film which tells a story is putting itself at the disposal of the ruling class' and this, if accurately reported, is a statement I personally still find very curious.

Explanations given for such arguments ranged from changes in the environment, our inability to understand or control our human condition, a new sense of the relativity of time; erosion by instantaneous electronic communication of the linear or serial narrative; the fact that novels and short stories were 'bourgeois' inventions created for the amusement of a no longer dominant middle class; that bizarre happenings in actual life have overtaken the power of surprise generated by fiction; that an anti-heroic age has no place for a hero and that strongly plotted stories have outlived their natural life span and are part of an exhausted art form.

Einführung des Herausgebers von John Sanders

Ein Kritiker des letzten *Jahrbuchs der Fotografie* erklärte etwas verächtlich, daß es "recht professionelle Aufnahmen von Amateuren und recht amateurhafte Aufnahmen von Professionellen" enthalte. Diese Feststellung wird zwar niemals in einer Sammlung berühmter Zitate erscheinen, und sie war bestimmt nicht als Kompliment gedacht. Nach reiflicher Überlegung gelangte ich jedoch zu dem Schluß, daß dieser Ausspruch doch positiv zu werten sei, da unter den mir persönlich bekannten Berufsfotografen diejenigen besonders interessant sind, die nach wie vor den amateurhaften Enthusiasmus besitzen, der sie ursprünglich dazu veranlaßt hat, Berufsfotografen zu werden. Andererseits sind die interessantesten Amateure diejenigen, die zwar mit dem Amateurstatus durchaus zufrieden, aber entschlossen sind, den Berufsfotografen in technischer Hinsicht auf keine Weise nachzustehen, so daß sie die Vielfalt der Effekte erzielen können, die sie für die Erfüllung ihrer fotografischen Bestrebungen benötigen.

Nachdem unser Kritiker das Jahrbuch "abgetan" hatte, wandte er sich der seiner Ansicht nach mehr "seriösen" Fotografie in anderen Veröffentlichungen zu. Auch ich bewundere viele der von ihm angeführten Leistungen, doch schuf mir das Wort "seriös" gewisse Bedenken. Ähnliche Bedenken hatte ich im Zusammenhang mit dem Wort "engagiert", durch das sich gewisse Fotografen vor einigen Jahren zu charakterisieren pflegten, als ob es sie auf geheimnisvolle Weise zu Mitgliedern eines exklusiven Klubs machte.

Natürlich strotzt die gesamte Geschichte der Malerei nur so von Klubs, Gesellschaften, Gruppen, Bewegungen und Sezessionsbewegungen, denen Künstler stets aus dem einen oder anderen Grunde anzugehören wünschten. Dabei bestand das vorherrschende Motiv in nahezu allen Fällen in dem Streben nach echtem oder fiktivem Status und einem Wunsch zur Selbstförderung. Daß diese nur zu menschlichen Beweggründe zu großer Kunst führen können, erkennen wir in jeder größeren Kunstgalerie, doch obgleich Werke von dauerndem Wert aus dem Streben nach Modernität erwachsen können, wenn der Künstler an und für sich genügend talentiert ist, können sich Moden ebenso schnell wie konventionelle Standpunkte ändern, und wenn er Pech hat, kann sich der Opportunist wieder in der "Wildnis" befinden, gerade wenn er meint, ihr endgültig entronnen zu sein.

Für den politischen Abenteurer kann es tragisch sein, wenn seine Ansichten nicht ort- und zeitgemäß sind. Selbstverständlich wäre es unsinnig und ungerecht zu behaupten, daß jeder Künstler, dessen Erfolg darauf beruht, daß er der vorherrschenden Mode gerecht wird, ein talentloser Opportunist sei, doch steht fest, daß schon so mancher Künstler übermäßigem Lob zum Opfer gefallen ist, dessen Folgen ebenso vernichtend sein können wie die ungerechter Vernachlässigung.

In der Welt der Fotografie zeigt sich dies in führenden Fotoausstellungen und Fotoanthologien, u.a. einigen von großen Industriekonzernen geförderten Sammlungen. Diese enthalten oft Beiträge, die alle Grundsätze des Förderers verneinen und vor nicht allzu langer Zeit niemals über die Vorwahl hinweggekommen wären. Der Umstand, daß eine solche Aufnahme in künstlerischer oder anderer Hinsicht von Wert sein mag, ist unerheblich. Vielleicht bin ich zu zynisch, aber ich glaube den Förderern nur selten, wenn sie erklären oder andeuten, die Annahme eines solchen Werkes beweise, daß sie aufgeklärt und großzügig seien. Das Gegenteil dürfte eher der Fall sein. Meiner Ansicht nach beweist dies einfach, daß sie feige sind und nicht den Mut besitzen, ihre wirklichen Ansichten zu vertreten, indem sie den Eindringling zurückweisen und ihm sagen, er möge seine Werke doch an anderer Stelle zeigen. So war es in der Vergangenheit, und der Kunst nützte eine derartige Einstellung nur, denn sie spornte die Außenseiter dazu an, eigene Ausstellungen zu veranstalten, in denen der vorherrschenden Philosophie — oder deren Mangel — vollkommen widersprechende Werke mit Erfolg unorthodoxe Ideen vermittelten und völlig neue Anschauungsweisen vorstellten. Selbstverständlich gibt es auch heute noch vorwiegend traditionelle bzw. völlig radikale Veröffentlichungen und Ausstellungen. Während jedoch auf den meisten Sektoren menschlicher Tätigkeit Zusammenarbeit besser ist als Konflikt, ist der Konflikt von Ideen, wenn er beiderseits mit aufrichtiger Überzeugung ausgetragen wird, unerläßlich, da die Kunst sonst, anstatt sich zu entwickeln, stagniert.

Das Bild eines unwissenden Provinzlers, der mit dem Brustton der Überzeugung erklärt "ich verstehe nicht viel von der Kunst, aber ich weiß, was mir gefällt", mag Kunstkenner nicht sehr ansprechen, doch bringt diese Bemerkung ein Selbstvertrauen zum Ausdruck, an dem es heute leider vielen fehlt, die an und für sich nicht davon überzeugt sind, daß Neuerung als Selbstzweck unbedingt zu begrüßen sei. Es muß ihnen doch bewußt sein, daß ihre Gegner ganz klare Richtlinien verfolgen, doch anstatt ihre wirklichen Ansichten mutig zu vertreten, versuchen sie jedem Problem aus dem Wege zu gehen. Man denkt in diesem Zusammenhang an die englische Anekdote von dem Hilfspfarrer, der, als ihn der Bischof fragte, ob ihm das ihm vorgesetzte übelriechende Ei schmecke, zaghaft die Antwort gab: "Doch, doch, hochwürdigste Exzellenz, Teile davon sind hervorragend."

Es läßt sich nicht vermeiden, daß das *Jahrbuch der Fotografie* ein wenig wie das Ei des Hilfspfarrers ausfällt, also zum Teil gut ist. Es ist unmöglich, den Wünschen jedes Lesers voll und ganz zu entsprechen, denn dies würde

voraussetzen, daß mein Geschmack und meine Vorurteile mit denen aller Leser identisch sind. Man könnte mir vorwerfen — und das wird mir kaum erspart bleiben — daß ich durch das Vereinigen so unterschiedlicher Bilder in diesem Werke einen ähnlichen Mangel an positiver Philosophie an den Tag gelegt habe, doch würde dies bedeuten, daß meine Beweggründe als Herausgeber nicht verstanden wurden. Zwar halte ich es für unerläßlich, daß diejenigen, die Beiträge zu dem Jahrbuch liefern, feste Überzeugungen und die technische Fähigkeit haben, um ihnen Ausdruck zu verleihen, doch traue ich in der Regel denjenigen nicht, für die das, was sie sehen, anscheinend weniger wichtig ist als die ewige Jagd nach den ersten Anzeichen irgendeiner neuen Strömung, mit der sie sich als Beweis für ihre intellektuelle Einsicht oder den Besitz eines Sozialgewissens eifrig identifizieren.

In einem in *Australian Photography* veröffentlichten Artikel formulierte Laurence Le Guay auf außerordentlich verständliche Weise, was ich immer als meinen eigenen Grundsatz für das Zusammenstellen einer Sammlung wie des Jahrbuchs erachtet habe. Er erklärte: "Meiner Ansicht nach sollte die Fotografie großzügig sein und jedem Versuch widerstehen, sie in enge oder elitistische Bereiche ästhetischer Beurteilung zu zwängen. Nicht nur das Schöpferische sollte annehmbar sein, sondern auch das Merkwürdige, nicht nur das Seherische, sondern auch das Beschreibende." Er stellte fest, daß ein Großteil der fotografischen Ausbildung in Australien noch immer unter dem Schatten der alten Riten des "Entwickelns und Kopierens" stehe, und bemerkte dann, was ebenfalls sehr interessant ist, daß eine Fotografie mehr wie ein literarisches Werk und nicht so sehr wie ein Gemälde beurteilt werden sollte, da es wirklich kaum eine Rolle spiele, wie eine Fotografie entstanden sei. "Nur das Endergebnis zählt. Es handelt sich dabei um eine neue Art des Sehens, eine neue Art des Verstehens."

In einem Artikel, den ich vor einigen Jahren las, war die Rede von einer Gruppe französischer Romanschriftsteller, deren Ansicht nach die ganze Idee, daß ein literarisches Werk die Leser tatsächlich *interessieren* sollte, nicht nur altmodisch, sondern in gewisser Hinsicht antisozial war. Um zu beweisen, daß diese Einstellung auch in den visuell darstellenden Künsten vertreten werde, wurde von einem berühmten französischen Filmregisseur berichtet, der angeblich gesagt hat: "Jeder Film mit Story stellt sich in den Dienst der herrschenden Klasse." Wenn er richtig zitiert wurde, so vertritt er meiner Ansicht nach eine recht merkwürdige Einstellung.

Zur Begründung dieser Argumente wurden von den Vertretern der Gruppe die verschiedensten Erklärungen geboten. Sie verwiesen auf Änderungen in der Umwelt, unsere Unfähigkeit die menschliche Verfassung zu verstehen oder zu beherrschen, und auf ein neues Gefühl für die Relativität der Zeit; auf die Erosion der fortschreitenden oder seriellen Erzählung durch augenblickliche elektronische Verständigung; und den Umstand, daß Romane und Kurzgeschichten "spießbürgerliche" Erfindungen zur Belustigung einer nicht mehr vorherrschenden Mittelklasse gewesen seien. Sie behaupteten, daß bizarre Ereignisse im wirklichen Leben die Literatur ihrer Fähigkeit zu überraschen beraubt hätten; daß es in einem antiheroischen Zeitalter keinen Raum für Helden gäbe und daß gründlich geplante Handlungen heute nicht mehr von Nutzen seien und einer erschöpften Kunstform angehörten.

Der Verfasser des Artikels gelangte zu dem Schluß, daß Versuche und Neuerungen zwar wertvoll seien und Bestseller in der Regel weder bahnbrechende Entwicklungen noch den Geschmack der am meisten gebildeten Leser widerspiegeln, aber andererseits in acht der zehn führenden amerikanischen Bestseller die Handlungen gründlich ausgearbeitet seien und die traditionelle erzählende Form keineswegs tot sei und es keine Schande sei sie zu genießen.

Ich glaube, daß dies auch für die Fotografie gilt, denn obgleich diese Kunstform ohne Zweifel die Erfassung des Unvorhersehbaren, von Stimmungen und psychologischen Effekten gestattet, kann und sollte sie mehr oder weniger komplizierte "Storys" erzählen — selbst wenn dies bedeutet, daß der Realität eine einfachere Form verliehen wird, als dem tatsächlichen Erlebnis entspricht. Dies bedeutet nicht, daß intelligente Fotografen die Empfindungen ihrer Zeit außer Acht lassen oder ausschließlich visuelle Klischees bringen sollten. Andererseits sollten sie sich nicht ausschließlich auf das Informative konzentrieren und vor dem Unterhaltenden zurückschrecken.

Bei der Auswahl der Bilder für dieses Buch war ich bestrebt sowohl das Neue als auch das Traditionelle zu berücksichtigen, und im Verlaufe dieser Tätigkeit unterhielt ich mich mit vielen hochinteressanten Fotografen wie Penny Slinger, in deren Atelier ich eine wirklich außergewöhnliche Sammlung von Collagen sah, in denen das Endergebnis weit von dem entfernt war, was sich mit einer Kamera allein erzielen läßt, und Leo Mason, dem Sportfotografen, dessen Werk den Aspekt des "entscheidenden Moments" auf die Spitze treibt, da das Endergebnis nahezu völlig von der instinktiven Fähigkeit abhängt, gerade im richtigen Augenblick auf den Knopf zu drücken. Die Kamera mit Motorantrieb hat die Erzielung denkwürdiger Aktionsaufnahmen natürlich sehr erleichtert, und die neuesten Verfahren automatischer Einstellung werden weitere Fortschritte in dieser Hinsicht ermöglichen. Keine Kamera wird jedoch je in der Lage sein, die künstlerische Komposition — die Zusammenstellung der wesentlichen Bildelemente auf eine Weise, die der Stimmung und dem Ziel erfolgreichen Ausdruck verleigt — zu bestimmen.

Gewisse Kritiker haben im Zusammenhang mit früheren Ausgaben des Jahrbuchs erklärt, so große Sammlungen von Aufnahmen seien "unverdaulich", daß gegensätzliche Wirkungen einander aufheben, wenn viele verschiedene Künstler nur durch ein oder zwei Bilder vertreten sind, und daß sich das Werk eines Fotografen nur richtig beurteilen läßt, wenn es durch eine umfassendere Sammlung vertreten ist. Zwar stimme ich mit diesen Argumenten bis zu einem gewissen Grad überein, bitte aber zu bedenken, daß dieses Buch als Anthologie der Werke möglichst vieler Fotografen gedacht ist. Jeder kann Bilder zur Beurteilung unterbreiten, und bei dieser Gelegenheit möchte ich diejenigen, die in der nächsten Ausgabe vertreten sein möchten, darauf aufmerksam machen, daß die Teilnahme keinen Einschränkungen unterliegt. Um Beispiele *Ihrer* besten Bilder zu unterbreiten, brauchen Sie diese nur an die Verlags-Auschrift zu senden, doch müssen sie uns bis spätestens 1. Februar

nach Veröffentlichung der gegenwärtigen Ausgabe erreichen. Vergessen Sie aber nicht, Ihren Namen und Ihre Anschrift auf jedes Bild zu schreiben und genügend Informationen über dessen Ausführung für den technischen Teil zu liefern. Die Bildtexte sollten kurz gefaßt und sachlich — nicht deskriptiv — und vor allem genau sein. Wir müssen annehmen, daß die Bildtexte wahrheitsgetreu sind, da es uns nicht möglich wäre, in so viele verschiedene Länder zu reisen, um persönlich sicherzustellen, daß alle Einzelheiten hinsichtlich der von uns zur Veröffentlichung ausgewählten Bilder wirklich stimmen. Ich danke allen Fotografen in allen Teilen der Welt, die die Zusammenstellung dieses Werkes ermöglicht haben, und wünsche denjenigen, die hoffen, *ihre* Bilder nächstes Jahr in Druck zu sehen, Erfolg.

Focus Elsevier Fotojaarboek 1979
Voorwoord

Reeds vele jaren bestaat voor de internationale uitgave van het *Photography Yearbook* ook in ons land een ongemeen grote belangstelling. Deze constatering en de kwaliteit van het boek hebben ons doen besluiten de uitgave van een Nederlandse vertaling te laten verschijnen en wel met de voor de hand liggende titel: *Focus Elsevier Fotojaarboek.* Als kijkboek geeft het daarnaast het nodige inzicht in een aantal technieken en stromingen in de fotografie weer.

In het *Focus Elsevier Fotojaarboek* is geen scheidingslijn te trekken tussen amateur-en vakfotografie. Het is in feite een mengeling van beiden, namelijk de beroepsfotografen met een amateur-creativiteit en amateur-fotografen met een professionele technische instelling.

Immers, de meest stimulerende beroepsfotografen die ik tegenkom zijn naar mijn ervaring meestal diegenen die nog steeds dat amateur-enthousiasme kunnen ophrengen, dat hen er in feite toe deed besluiten beroeps te worden — en de meest belangwekkende amateurs zijn diegenen die — hoewel volmaakt tevreden met hun amateur-status — vastbesloten zijn zich de vaardigheden van de beroeps eigen te maken teneinde tot hun eigen tevredenheid het terrein van de opnamen die ze wensen te maken uit te breiden. Vaak word ik geïntrigeerd door het woord 'serieus', zoals ik eveneens word geïntrigeerd door het woord 'betrokkenheid' dat enkele jaren geleden door een aantal fotografen werd gebezigd om een beschrijving van zichzelf te geven, alsof het hen op de een of andere manier lid maakte van een exclusieve club.

Uiteraard is de hele geschiedenis van de schilderkunst bezaaid met clubs, verenigingen, groepen, bewegingen en afscheidingsbewegingen, waarvan kunstenaars om de een of andere reden altijd reuzegraag lid wilden worden; waarbij de belangrijkste reden bijna altijd het bereiken van een echte of een vermeende status was, alsmede de wens zichzelf naar voren te schuiven. Dat kunst met een grote K uit zeer menselijke beweegredenen kan ontstaan, kan in elk museum van enige naam worden vastgesteld, maar hoewel het najagen van modegrillen werk van blijvende waarde kan opleveren, mits de kunstenaar om te beginnen voldoende talent heeft, verandert de mode al even snel als de publieke opinie en de onfortuinlijke opportunist vindt zichzelf buitengesloten juist op het moment dat hij zich veilig waant in de overtuiging dat hij binnen is.

Voor de politieke avonturier kan het een fatale misrekening blijken zich op het verkeerde tijdstip met de verkeerde mening op de verkeerde plaats te bevinden, maar hoewel het zowel dwaas als onrechtvaardig zou zijn om te suggereren, dat alle kunstenaars die op een gegeven ogenblik 'in' zijn opportunisten zonder enig talent zijn, is het wel zo dat een enkeling zich door een teveel aan lof om de tuin laat leiden — hetgeen even afbrekend kan zijn als te worden miskend zonder dat daarvoor aanleiding bestaat.

Vanuit een fotografisch standpunt bezien is dat op belangrijke fototentoonstellingen en in galeries ook wel te merken, waarbij ik de enkele die door bedrijven worden gesponsored niet wil uitsluiten. Onder de laatstgenoemde is vaak wel een foto te vinden, die al datgene waarvan de sponsor een symbool is met opzet belachelijk maakt, een inzending die in het nabije verleden trouwens zelfs niet door de voorselectie zou zijn gekomen. Het feit dat een dergelijke inzending wel degelijk verdiensten kan hebben doet hier niet ter zake. Ik mag dan misschien *te* cynisch zijn, maar het valt mij moeilijk te geloven in de openlijke of bedekte toespelingen van de sponsors als zou het accepteren van dergelijk werk aantonen, dat zij verlichte geesten met ruime opvattingen zijn. Eerder het tegendeel. Ik vind dat het alleen maar hun zwakheid toont en dat ze uit hun werkelijke overtuiging de moed hadden moeten putten om zelf de indringer te kijk te zetten en hem te laten weten dat hij er beter aan deed een eindje verder zelf een tentoonstelling op touw te zetten. Dat werd in het verleden ook gedaan en de kunst heeft er zelfs van geprofiteerd in die zin, dat de weigering van hun werk de *refusés* zo nijdig maakte dat ze inderdaad hun eigen salons gingen houden, waarin werk werd getoond, dat niet alleen volledig in strijd was met de heersende normen — respectievelijk gebrek aan normen — maar dat bovendien met succes ongebruikelijke ideeën en nieuwe wereldbeschouwingen naar voren bracht. Natuurlijk is er nog steeds in hoofdzaak traditioneel, dan wel uiterst radicaal werk te vinden, maar hoewel het op de meeste terreinen van menselijke activiteit op zijn plaats is naar samenwerking te streven, vormen tegenstrijdige ideeën — aan beide kanten vurig nagestreefd — een noodzakelijk dynamisme wanneer naar vooruitgang in plaats van stilstand wordt gestreefd.

Het beeld van het domme 'boertje van buten', zijn handen diep in de zakken van zijn overall, terwijl hij verkondigt: 'Ik heb geen verstand van kunst, maar ik weet drommels goed wat ik mooi vind' mag de gecultiveerde mens dan belachelijk voorkomen, maar er schuilt in die opmerking een zelfbewustheid die men tevergeefs zal zoeken bij diegenen die er verre van overtuigd zijn, dat verandering zelf noodzakelijkerwijze prijzenswaardig is. Ze zouden moeten weten, dat er bij hun tegenstanders geen enkele twijfel bestaat over wat er moet worden gedaan, maar in plaats van ronduit voor hun werkelijke mening uit te komen draaien ze eromheen — ongeveer zoals de kapelaan die op een vraag van de bisschop of het minder verse

ei, dat men hem had voorgezet, in de smaak viel, beschroomd antwoordde: 'O ja, Monseigneur. Bepaalde stukken smaken uitstekend.' Het *Focus Elsevier Fotojaarboek* zal onvermijdelijk gelijkenis vertonen met het ei van de kapelaan. Bepaalde stukken zullen in de smaak vallen. Tenzij elk exemplaar zou worden aangeschaft door een leger van identieke in een reageerbuis gekweekte schepselen, wier smaak en vooroordelen in ieder opzicht met de mijne overeenkomen. Men zou erop kunnen wijzen — en dat waarschijnlijk ook niet nalaten — dat ik, door zulk een allegaartje van afbeeldingen in één boek samen te brengen, hetzelfde gebrek aan positieve instelling verraad, maar dan zouden mijn beweegredenen als redacteur worden misverstaan. Hoewel ik het zonder meer noodzakelijk vind dat mijn medewerkers niet alleen een duidelijke mening hebben maar eveneens het technisch vermogen om die mening gestalte te geven, neig ik ertoe die mensen te wantrouwen voor wie de ogen kennelijk van minder belang zijn dan de neus — die steeds paraat is om de eerste tekenen van een nieuwe rage te ruiken en die dan gretig aan te grijpen als bewijs van intellectueel bewustzijn, dan wel het bezit van een maatschappijk geweten. In een artikel in *Australian Photography* drukt Laurence Le Guay in een zeer bondige alinea precies datgene uit wat ik met betrekking tot het samenstellen van een collectie altijd als mijn eigen aanpak heb beschouwd. 'Ik vind dat fotografie ruim van opvatting moet zijn en alle pogingen dient te weerstaan om haar in een nauwbegensd of elite-keurslijf van esthetische waardebepalingen te dwingen. Er dient ruimte te zijn voor zowel het bizarre als het creatieve. Voor zowel het beschrijvende als het onthullende.' Na verder te hebben opgemerkt dat de fotografische opleiding in Australië nog te veel in de schaduw staat van het oude 'ontwikkelen en afdrukken'-ritueel, voegt hij daaraan nog de verhelderende opmerking toe dat pogingen een foto op de juiste waarde te schatten meer literair dan schildertechnisch zouden moeten zijn, omdat het in feite weinig uitmaakt op welke manier een foto is vervaardigd. 'Alleen het eindresultaat is van belang. Het is een nieuwe wijze van zien. Een nieuwe manier van begrijpen.'

Ik herinner me dat ik een aantal jaren geleden een artikel las, waarin romanschrijvers van een bepaalde letterkundige richting in Frankrijk werden genoemd, die het idee aanhingen dat de hele instelling dat een roman de lezer zou moeten aanspreken niet alleen ouderwets, maar in sommige opzichten zelfs asociaal zou zijn. Als indicatie dat deze campagne voor het verhaal zonder lijn zich ook tot de visuele media had uitgestrekt, werd een beroemde Franse filmregisseur aangehaald die zou hebben gezegd 'dat iedere film die een verhaal vertelt een concessie is aan de heersende klasse' en als die opmerking inderdaad juist is weergegeven, vind ik die persoonlijk nog steeds bijzonder vreemd.

De verklaringen die voor dergelijke argumenten werden gegeven varieerden van maatschappijveranderingen, ons onvermogen om ons menszijn te doorgronden en te beheersen, tot een nieuw begrip voor het betrekkelijke van de tijd; van erosie door ogenblikkelijke elektronische communicatie van het lineaire of serieverhaal; van het feit dat romans en korte verhalen 'bourgeois'- uitvindingen waren, geschreven tot vermaak van een gegoede klasse die niet langer een overheersende positie innam; dat bizarre gebeurtenissen uit het werkelijke leven de verbazing die door de romanliteratuur werd opgeroepen zouden hebben overtroffen; dat een tijdperk van anti-heldendom geen plaats heeft voor de held en dat verhalen met een sterke intrige zichzelf hebben overleefd en deel uitmaken van een uitgeputte kunstvorm. Hoewel het zich er rekenschap van gaf dat proefnemingen en vernieuwingen wel bepaalde verdiensten hebben en dat 'best-sellers' over het algemeen niet noodzakelijkerwijs de voorlopers van nieuwe ontwikkelingen zijn, dan wel een weerspiegeling van de smaak van de intelligente lezer, besloot het artikel met een kanttekening bij het feit dat acht van de tien titels op de toenmalige Amerikaanse lijst van meest verkochte boeken bijzonder levendige intriges bleken te hebben en dat, verre van dood te zijn, de traditionele verhalende vorm nog steeds springlevend was, zodat niemand zich voor een dergelijke voorkeur hoefde te schamen.

Ik geloof dat dit evenzeer opgaat voor de fotografie die — hoewel zeker in staat om het onvoorspelbare de baas te kunnen en stemming en psychologische diepgang weer te geven — verhalen met een variërende moeilijkheidsfactor kan en moet kunnen vertellen, zelfs wanneer dat inhoudt dat de werkelijkheid in een minder chaotische vorm moet worden gegoten dan die waarin zij eigenlijk ervaren is. Dit houdt uiteraard niet in dat de intelligente fotograaf dan maar blind moet zijn voor gevoeligheden van zijn eigen tijd, of dat hij zich *uitsluitend* van visuele clichés zou moeten bedienen, maar evenzeer dat ze er niet voor moeten terugdeinzen om behalve informatief ook onderhoudend te zijn.

Editorial
por John Sanders

En una de las reseñas críticas dedicadas al último *Photography Year Book*, leí textualmente que contenía "fotografías de caracter medianamente profesional, obra de aficionados, y fotografías de carácter casi aficionado, realizadas por profesionales". Pese a que no creo que esta frase llegue nunca a ser incluída en un "Diccionario de Citas" (ya que resulta evidente la intención de molestar por parte de su autor) me pareció, al meditarla con más tiempo, que en realidad se trataba de un verdadero "piropo" para los fotógrafos cuyas producciones figuran en el libro, ya que la experiencia me ha demostrado que los fotógrafos profesionales más interesantes son precisamente aquellos que conservan todavía el entusiasmo básico que les indujo a convertir su afición en trabajo, mientras que los fotógrafos aficionados más prometedores son aquellos que – a pesar de estar totalmente satisfechos con su "status" –, muestran una evidente determinación en dominar las técnicas profesionales que les permitirán extender notablemente su campo de acción.

A continuación, dejando de lado el *Year Book*, el autor de la reseña que acabo de mencionar se refiere a otras publicaciones, cuyo carácter no duda en calificar como más "serio". Debo decir que yo también siento una pro-

funda admiración por la mayor parte de esas publicaciones pero, de todos modos, la palabra "serio" me dejó sumido en un mar de confusiones: me hizo pensar en lo que ocurrió años atrás en relación con el calificativo "comprometido" con el que algunos fotógrafos gustaban de etiquetarse por entonces, utilizándolo como el santo y seña de sus obras para poder formar parte de una especie de club de entrada restringida.

Nadie ignora que a lo largo de la historia de la pintura se han multiplicado desaforadamente los clubs, asociaciones, grupos, movimientos y actitudes secesionistas, en los que los artistas han deseado reunirse por una gran variedad de razones, entre las que ha predominado normalmente, sin embargo, la prisa en conseguir un mejor "status" o el deseo de ver reconocidos sus méritos individuales. Sin lugar a dudas, una simple visita a cualquier museo o galería nos convencerá inmediatamente de que en la gestación de las más extraordinarias obras artísticas ha intervenido fundamentalmente el ansia del autor por ser reconocido, pero hay que decir que, a pesar de que los artistas de talento son indudablemente capaces de producir obras de mérito aviniéndose a trabajar sobre temas de moda, las variaciones sufridas por la opinión general son tan súbitas e imprevisibles que los simples oportunistas se ven a menudo desenmascarados precisamente cuando más felices se las prometían.

Opinar por opinar, sustentando una opinión "incorrecta", en un momento y lugar determinados, puede costarle a uno muy caro. Desde luego sería estúpidamente injusto decir que todos los artistas apreciados por el público son, en realidad, oportunistas sin talento, pero también es cierto que la carrera de algunos se ve arruinada por un exceso de alabanzas a la postre tan fatales como el olvido inmerecido.

En el campo de la fotografía, es posible observar un símil de lo que acabo de decir tanto en las más importantes exposiciones como en las recopilaciones de trabajos editadas, (incluso en las patrocinadas por los grupos industriales más conocidos). A veces es fácil encontrar alguna obra que no responde a la imagen que tenemos del editor y que anteriormente no hubiera pasado ni tan siquiera la selección previa. No se trata en este caso de dilucidar si posee o no algún mérito. Puede que mis palabras parezcan cínicas pero debo confesar que no me convencen los editores que afirman haber incluído la obra para demostrar hasta donde llega su tolerancia. Creo que de hecho dan pruebas de lo contrario. Se nos presentan, en todo caso, como personas extrañamente temerosas, que habrían quedado mejor si se hubieran enfrentado abiertamente con el "intruso" y le hubieran enviado a exponer sus obras en la calle. Esto es precisamente lo que sucedía en el pasado y no hay duda de que el arte ha obtenido de ello enormes beneficios, puesto que el furor causado en los *refusées* por el rechazo de sus producciones les llevó a abrir sus propias salas de exposición, en las que, separados completamente de las convicciones artísticas – o de la falta de las mismas – reinantes en su tiempo, pudieron difundir con mayor efectividad su nueva manera de "ver" el mundo. Estoy convencido de que, incluso en la actualidad, el eterno conflicto entre las posiciones artísticas conservadoras y avanzadas continua siendo – a pesar de que no se me oculta la importancia de buscar compromisos en muchos de los campos de la actividad humana –, un motor esencial del progreso de las artes.

La imagen del provinciano ignorante, con los pulgares tensando los tirantes, que tranquilamente proclama. "No entiendo mucho de arte, pero sé apreciar lo que me gusta", puede resultar poco atractiva para las personas de gustos sofisticados, pero hay que reconocer que revela una seguridad de la que desgraciadamente carecen muchas personas (que no están en absoluto convencidas, por otra parte, de que los cambios sean buenos en sí mismos). Deberían darse cuenta de que sus oponentes no tienen ninguna duda acerca de lo que es necesario hacer; sin embargo, en lugar de dar a conocer valientemente sus opiniones, prefieren salir con evasivas. Están actuando como el cura al que su obispo preguntó si estaba bueno el huevo nauseabundo que le acababa de ofrecer, y respondió diciendo: "Oh, sí, Eminencia. Algunas partes son excelentes".

El *Photography Year Book* ha de resultar inevitablemente como el huevo del cura. Bueno en parte. A menos que los ejemplares fueran adquiridos en su totalidad por un grupo de mellizos intelectuales que se identificaran totalmente con todos o cada uno de mis gustos y prejuicios. Se me podría acusar, y seguramente se me acusará, de que, al reunir en este libro un conjunto de imágenes tan enormemente variadas, estoy haciendo gala de la misma falta de firmes convicciones a la que me he referido en líneas anteriores. Creo, sin embargo, que ello sería no entender en absoluto los motivos que me guían. Mientras que, por una parte, considero esencial que los fotógrafos seleccionados trabajen con criterios firmes y cuenten con la habilidad técnica adecuada para traducir a éstos en imágenes, me parecen siempre sospechosos aquellos que tienden a fiarse menos de lo que ven sus ojos que de lo que husmea su nariz (que tienen siempre alerta para captar las primeras señales de cualquier nueva moda, a la cual están dispuestos a doblegarse inmediatamente para probar su inquietud intelectual o la posesión de una extremada conciencia social).

En un artículo publicado en *Australian Photography,* Laurence Le Guay expresa en un brevísimo párrafo las mismas ideas que me han llevado a reunir una colección de este tipo. "Creo que la fotografía debe abarcar un campo lo más extenso posible y debe resistirse contra todos los intentos de forzarla a introducirse en ámbitos estrechos o elitistas de evaluación artística. En ella deben tener cabida tanto los aspectos curiosos como los genuinamente creativos, los descriptivos y los reveladores." Después de mencionar el hecho de que la enseñanza de la fotografía en Australia todavía se halla distorsionada por la importancia concedida a los antiguos "ritos" de revelado e impresión, añade una observación enormemente esclarecedora: los intentos de valorar estéticamente una fotografía deben regirse por criterios literarios antes que pictóricos, en el sentido de que hay que conceder muy poca importancia al modo en que se obtiene la misma. "Lo que realmente importa es el resultado final. Este debe corresponder a una nueva forma de *ver*, a una nueva forma de *entender*".

Recuerdo haber leído hace años en cierto articulo que había aparecido en Francia una nueva escuela de novelistas, convencidos de que el concepto de ficción entendido como una forma de despertar el *interés* del lector

era, además de completamente pasado de moda, decididamente antisocial. También se recogía en él – como una prueba de que esta campaña antiargumental había llegado asimismo a difundirse entre los artistas dedicados a los medios visuales –, la siguiente afirmación de un famoso director cinematográfico francés: "Toda película en que se desarrolle una historia se halla de por sí al servicio de las clases dominantes". Si no se cometió en ella ningún error de transcripción, se trata a mi parecer de una frase realmente curiosa.

Las razones que se daban como explicación de estas afirmaciones eran las que siguen: las modificaciones experimentadas por el medio ambiente, la manifiesta incapacidad para controlar o comprender nuestra propia condición, la aprehensión moderna de la relatividad temporal, la erosión provocada por la comunicación electrónica instantánea en la narración lineal o serial; el hecho de que las novelas y cuentos eran en realidad invenciones "burguesas" pensadas como medio de esparcimiento de una clase media que había perdido su hegemonia; el hecho de que los extraños sucesos ocurridos últimamente en la vida real habían acabado con la capacidad sorpresiva propia de la ficción, de que nuestra época antiheróica no admitía ya la existencia de héroes novelescos y de que las historias dotadas de un argumento definido habían llegado al final de su vida natural y empezaban a formar parte de una tradición artística agotada. El articulista concluía su trabajo, sin embargo, afirmando que, a pesar de que era preciso reconocer que las innovaciones y experimentos poseían un mérito indiscutible y que los *best-seller* no solían reflejar las inquietudes vanguardistas o los gustos de los lectores más cultos, no podía echarse en olvido que ocho de los diez títulos más vendidos entonces en América estaban construidos sobre una vigorosa línea argumental y que la narrativa tradicional, lejos de estar muerta, gozaba de una excelente salud, y que nadie debía avergonzarse si sus preferencias se decantaban hacia la misma.

Creo que estos argumentos se pueden aplicar también perfectamente a la fotografía, la cual, aunque es plenamente capaz de explorar con tacto y fuerza psicológica las regiones ocupadas por lo imprevisible, puede y debe darnos a conocer historias de variada complejidad, incluso en los casos en que sea necesario reorganizar la realidad en una forma menos caótica que la que nos brinda la propia experiencia. Lo cual no quiere decir que los fotógrafos inteligentes deban permanecer ciegos frente a las inquietudes más sentidas en su época o que deban trabajar basándose en clichés puramente visuales, ni tampoco que deban sacrificar su función lúdica en aras de ofrecer una más pura información.

En este libro he tratado de incluir diversas muestras de fotografías realizadas según esquemas tanto innovadores como tradicionales. El proceso de reunión del material me

ha proporcionado la oportunidad de conversar con algunos fotógrafos de personalidad especialmente atractiva. Los nombres de dos de ellos se proyectan instantáneamente en mi memoria: Penny Salinger, en cuyo estudio tuve ocasión de contemplar una extraordinaria colección de collages, de estructura final situada lo más lejos posible de lo que un objetivo fotográfico "entendería" como realidad, y Leo Mason, el fotógrafo deportivo en cuya obra se halla ilustrada claramente la importancia del "momento decisivo" en determinados aspectos de la técnica fotográfica, en el sentido de que el resultado obtenido depende casi por completo de la habilidad instintiva capaz de juzgar con precisión cual es la exacta fracción de segundo en que el dedo debe presionar el disparador. No cabe duda de que las cámaras controladas automáticamente han simplificado enormemento el proceso de obtención de imágenes en movimiento, ni de que los últimos perfeccionamientos introducidos en los sistemas de enfoque automáticos constituyen un nuevo paso adelante. Sin embargo, nunca una máquina será capaz de producir por sí sola una composición creativa, entendiendo como tal la ordenación de los elementos esenciales, captándolos en la forma más adecuada para transmitir artísticamente el concepto y la estructura subyacentes.

En algunas reseñas críticas dedicadas a las ediciones de años anteriores he leído también la afirmación de que una colección de fotografías tan extraordinariamente amplia resulta poco menos que digerible, mientras que en otras se arguye que es imposible apreciar claramente la capacidad de los fotógrafos si sólo se ofrecen una o dos obras de cada uno. Aunque estoy completamente de acuerdo con estas críticas, déjenme descargar diciendo que ello constituye una exigencia de la propia concepción del libro, especie de "poupourri" en el que se trata de dar cabida a la mayor cantidad posible de artistas. Todo el mundo puede solicitar la inclusión de sus fotografías y, a propósito, creo que éste es un buen momento para recordar a aquellos que quisieran ver sus obras en la próxima edición, que en la selección no se aplica ningún criterio restrictivo. En caso de que deseen enviar algunas de las mejores muestras de su producción, todo lo que deben hacer es remitirlas por correo a la dirección indicada en la portada, de manera que lleguen a nuestras manos antes del día uno de Febrero inmediatamente posterior a la publicación de este libro. Y no se olviden incluir en cada fotografía su nombre y dirección así como proporcionarnos los datos técnicos necesarios para mencionarlos en la sección correspondiente. Es preferible que los pies sean más objetivos y breves que excesivamente descriptivos. Les rogamos también encarecidamente que sean fidedignos. Mis más efusivas gracias a los fotógrafos de todo el mundo que han hecho posible la concepción de este libro y mis mejores deseos de éxito para aquéllos que aspiran a ver editados sus trabajos el año próximpo.

Editorial
par John Sanders

Un critique du dernier *Photography Year Book* a sentencieusement déclaré que celui-ci contient "des clichés imputables à des professionnels réalisés par des amateurs et des clichés imputables à des amateurs réalisés par des professionnels". Même si cette déclaration (qui se voulait désagréable) n'entre jamais au Dictionnaire des citations, il m'a paru à la réflexion que c'était en fait un compliment à l'adresse de tous ceux qui ont contribué à constituer le présent album, car, si j'en juge d'après ma propre expérience, les photographes professionnels les

plus stimulants que je rencontre sont généralement ceux qui ont su conserver l'enthousiasme d'amateur qui a fait d'eux des professionnels, et les amateurs les plus attachants sont ceux qui – tout en étant pleinement satisfaits de leur état d'amateurs – sont déterminés à acquérir des qualifications professionnelles afin d'élargir la gamme des photographies qu'ils souhaitent prendre pour leur propre satisfaction.

Ayant fait litière du Year Book, mon critique aborde ensuite ce qu'il estime être de la photographie plus "sérieuse" dans d'autres publications. J'admire, moi aussi, nombre des photographies citées par lui, mais c'est le mot "sérieuse" qui m'a intrigué, de même que j'ai été intrigué par le mot "concerné" dont certains photographes aimaient à se qualifier il y a quelques années, comme si cet adjectif conférait en quelque sorte l'exclusivité de l'appartenance à un club.

Toute l'histoire de la peinture, nul ne le conteste, fourmille de clubs, de sociétés, de groupes, de mouvements et de mouvements sécessionnistes auxquels les artistes ont toujours aspiré à s'affilier pour une raison ou une autre, le mobile prédominant étant presque toujours la recherche d'une position, réelle ou imaginaire, et un désir d'auto-avancement. Que le grand art puisse résulter de motivations qui ne sont que trop humaines, voilà ce que l'on peut constater dans toute grande galerie d'art, mais si la recherche de la vogue peut engendrer des oeuvres d'un mérite durable et si l'artiste est assez talentueux au départ, les modes sont susceptibles de changer aussi rapidement que les idées reçues, et l'opportuniste malchanceux peut parfois se trouver rejeté dans les ténèbres extérieures à l'instant même où il a l'intime conviction d'avoir réussi à en sortir.

Pour l'aventurier politique, le fait de se trouver avec des opinions erronées à la mauvaise place et au mauvais moment peut se révéler fatal, mais tandis qu'il serait inconsidérément injuste de sous-entendre que tous les artistes qui reçoivent la consécration de la mode du jour sont des opportunistes sans talent, certains se laissent abuser par un excès de louange – qui peut avoir un effet tout aussi désastreux qu'une négligence injustifiée.

Photographiquement parlant, c'est là un phénomène que l'on peut observer dans les grandes expositions de photographie et dans les livres de photographie, y compris certains patronnés par de grandes sociétés industrielles. Parmi ces oeuvres, il s'en trouve toujours une qui fait fi de tout ce que représente le protecteur et qui, il n'y a pas si longtemps, n'aurait jamais dépassé le stade de la première sélection. Le fait que cette oeuvre puisse avoir certains mérites n'est pas le sujet du débat. On me trouvera peut-être par trop cynique, mais j'accorde rarement crédit aux protestations, déclarées ou implicites, des protecteurs selon lesquelles l'insertion de ces oeuvres prouve qu'ils sont éclairés et procèdent d'un esprit large. Ce serait plutôt l'inverse. Je pense que cela prouve tout simplement que ces gens sont veules et qu'ils auraient dû affirmer leurs convictions intimes en faisant obstacle à l'intrus et en l'invitant à aller organiser sa propre exposition ailleurs. C'est ce qui se faisait jadis, et l'art avait tout à y gagner en ce sens que les *refusées* en étaient si contrariées qu'elles tenaient leurs propres salons, dans lesquels les oeuvres totalement en opposition avec la philosophie – ou l'absence de philosophie – de l'ordre établi communiquaient avec succès des idées non orthodoxes et de nouveaux moyens de regarder le monde. On trouve ensuite, évidemment, surtout des offres traditionnelles ou totalement radicales, mais s'il est légitime de chercher la coopération plutôt que le conflit dans la plupart des secteurs de l'activité humaine, le conflit d'idées – activement poursuivi des deux côtés – est un élément dynamique essentiel pour parvenir au progrès et non à la stagnation.

Le portrait d'un provincial ignorant, pouces crochetés dans ses bretelles tandis qu'il proclame: "Je ne connais pas grand-chose à l'art, mais je sais ce que j'aime", n'est peut-être pas particulièrement de nature à plaire aux sophistiqués, mais il y a dans cette remarque une confiance en soi qui fait tristement défaut chez nombre de ceux qui aujourd'hui ne sont pas autrement convaincus que le changement pour le changement est nécessairement un bonne chose. Ils doivent savoir que leurs adversaires n'ont aucun doute sur ce qu'il convient de faire, mais, au lieu d'exposer hardiment leurs véritables opinions, ils tergiversent – un peu comme ce vicaire qui, alors que son évêque lui demandait s'il aimait l'oeuf malodorant qui lui avait été donné, repondit timidement: "Certainement, Monseigneur. Certaines parties en sont excellentes."

Le *Photography Year Book* est inévitablement voué à être comme l'oeuf du vicaire: bon en partie. A moins que chaque photographie n'ait pu être acquise par une armée d'adeptes qui partageaient mes goûts et mes préjugés à tous égards. Il se pourrait – il est même probable qu'on n'y manquera pas – que l'on souligne à mon adresse que, en plaçant une collection aussi disparate d'oeuvres entre les couvertures du présent album, je trahis le même manque de philosophie positive, mais ce serait là méconnaître mes mobiles en tant que rédacteur en chef. Tout en considérant comme fondamental que mes collaborateurs aient des opinions solidement affirmées et l'habileté technique nécessaire pour s'exprimer, j'ai tendance à suspecter ceux qui estiment que leurs yeux sont nettement moins importants pour eux que leur nez – toujours retroussé pour renifler les premiers signes de quelque tendance nouvelle qu'ils pourraient embrasser passionnément comme preuve de conscience intellectuelle ou de la possession d'une conscience sociale.

Dans *Australian Photography*, Laurence Le Guay a exprimé, en un paragraphe très succinct, ce que j'ai toujours considéré comme ma propre méthode pour créer une collection comme celle-ci. "Je pense que la photographie doit être large dans ses vues et résister à toute tentative visant à la confiner dans des cadres étroits ou dans des secteurs d'élite répondant à des considérations d'ordre esthétique. Il doit y avoir place pour le curieux aussi bien que pour le créateur, pour le descriptif aussi bien que pour le révélateur." Après avoir souligné que l'enseignement de la photographie en Australie est encore sous l'influence pesante des rites "du développement et de l'impression", il ajoute cette remarque saisissante, selon laquelle toute tentative visant à évaluer une photographie doit procéder davantage de la littérature que de la peinture, étant donné que la manière dont une photographie est obtenue importe finalement peu: "Seul le résultat final compte. C'est une nouvelle manière de voir, une nouvelle manière de comprendre".

Je me rappelle avoir lu, il y a quelques années, un article

mentionnant une école française de romanciers, qui considérait que toute la notion de fiction, en tant qu'elle représente quelque chose susceptible d'*intéresser* vraiment le lecteur, était non seulement désuète mais, par certains côtés, antisociale. Un metteur en scène français réputé était cité – pour souligner que cette campagne anti-fiction s'était étendue aussi aux moyens visuels – comme ayant déclaré que "tout film qui raconte une histoire se met à la disposition de la classe dirigeante", ce qui, si la citation est exacte, est une affirmation que je trouve personnellement encore très curieuse.

Les explications données à l'appui de ces arguments allaient des changements survenus dans l'environnement à notre incapacité de comprendre ou de commander à notre condition humaine, et à un nouveau sens de la relativité du temps; à l'érosion par la communication électronique instanée du narratif linéaire ou de série; au fait que les romans sont des inventions "bourgeoises" destinées à l'amusement d'une classe moyenne qui n'est plus dominante depuis longtemps; que les événements bizarres de la vie réelle ont dépassé le pouvoir de surprise engendré par la fiction; qu'un âge anti-héroïque n'a pas de place pour un héros et que les histoires à l'intrigue fortement nouée ont débordé leur durée de vie naturelle et constituent pour une part une forme épuisée de l'art.

Tout en reconnaissant que l'expérience et l'innovation ont des mérites et que les "best-sellers" ne reflètent généralement pas des développements d'avant-garde ou les goûts des lecteurs les plus cultivés, l'article conclut en commentant le fait que huit des dix livres figurant sur la liste actuelle des best-sellers aux Etats-Unis sont fondés sur des histoires solidement structurées et que, loin d'être morte, la forme narrative traditionnelle est toujours très vivante, et que personne ne devrait avoir honte d'y prendre plaisir.

Je pense que cela est également vrai de la photographie, qui, tout en étant assurément capable de traiter l'imprévisible, peut et doit, avec du sentiment et avec le sens de l'exploration psychologique, raconter des histoires d'une complexité variable – même si cela implique un remaniement de la réalité visant à la présenter sous une forme moins chaotique. Cela ne signifie pas que les photographes intelligents doivent être aveugles aux sensibilités de leur propre temps ou se limiter exclusivement à des clichés visuels, mais, tout au contraire, implique qu'ils ne doivent pas avoir peur de distraire aussi bien que d'informer.

Dans le présent album, je me suis efforcé de réunir des exemples tant de visions novatrices que de visions traditionnelles et, en rassemblant les éléments, j'ai eu le plaisir de parler à de nombreux photographes extrêmement attirants. Deux me viennent immédiatement à l'esprit: Penny Slinger, chez qui j'ai pu voir la plus extraor-

dinaire collection de collages, le résultat final étant très éloigné de ce que l'objectif de l'appareil considérerait comme la réalité, et le photographe de sports Leo Mason, dont le travail résume l'aspect "moment décisif" du moyen en ce sens que le résultat final dépend presque entièrement de la capacité instinctive de juger, à quelques fractions de seconde près, de la pression à exercer sur le déclencheur de l'obturateur. L'appareil photographique à moteur a évidemment grandement facilité l'obtention d'images de mouvement mémorables, et les toutes dernières techniques de la mise au point automatique ont encore accru cette facilité. Cependant, aucun appareil ne pourra jamais dicter la composition créatrice, l'arrangement des éléments essentiels dans les limites du cadre d'une manière permettant de communiquer avec succès le sentiment et le concept.

Certains critiques des éditions précédentes se sont également plaints de ce qu'une collection de photographies de cette ampleur est indigeste; que le sens annule le sens lorsque de nombreux collaborateurs sont représentés par une ou deux photographies seulement, et que des évaluations valables de l'oeuvre d'un photographe ne sont possibles que si celle-ci est présentée dans une collection plus large. Tout en étant pour l'essentiel d'accord sur cet argument, je répondrai seulement que le format du présent album est prévu pour recevoir un pot pourri d'oeuvres émanant d'un nombre de photographes aussi élevé que possible compte tenu de l'espace disponible. Tout personne peut soumettre des photographies, et c'est peut-être ici le lieu de rappeler à ceux qui souhaiteraient être représentés dans la prochaine édition qu'il n'y a aucune restriction à l'entrée. Si *vous* souhaitez envoyer des exemples de vos meilleures photographies, il vous suffit de les expédier à l'adresse figurant en tête de la page de titre, de telle sorte qu'ils y parviennent au plus tard le 1er février suivant la date de parution de la présente publication. Mais n'oubliez pas d'indiquer votre nom et votre adresse sur chacune des photographies et de fournir des renseignements à leur sujet pour la section technique. Les légendes doivent être concises plutôt que descriptives, et surtout exactes. Nous devons, en effet, admettre que les renseignements fournis par chaque légende sont conformes à la réalité et donnés en toute bonne foi, car il nous serait évidemment impossible, compte tenu des exigences de l'impression, de parcourir le monde pour vérifier personnellement chaque détail des photographies qui nous parviennent de nombreux pays différents pour être insérées dans notre album. Je remercie ici tous les photographes qui, de par le monde, ont permis la réalisation de cet album et j'adresse mes voeux de succès les plus sincères à tous ceux qui espèrent voir *leurs* oeuvres publiées l'année prochaine.

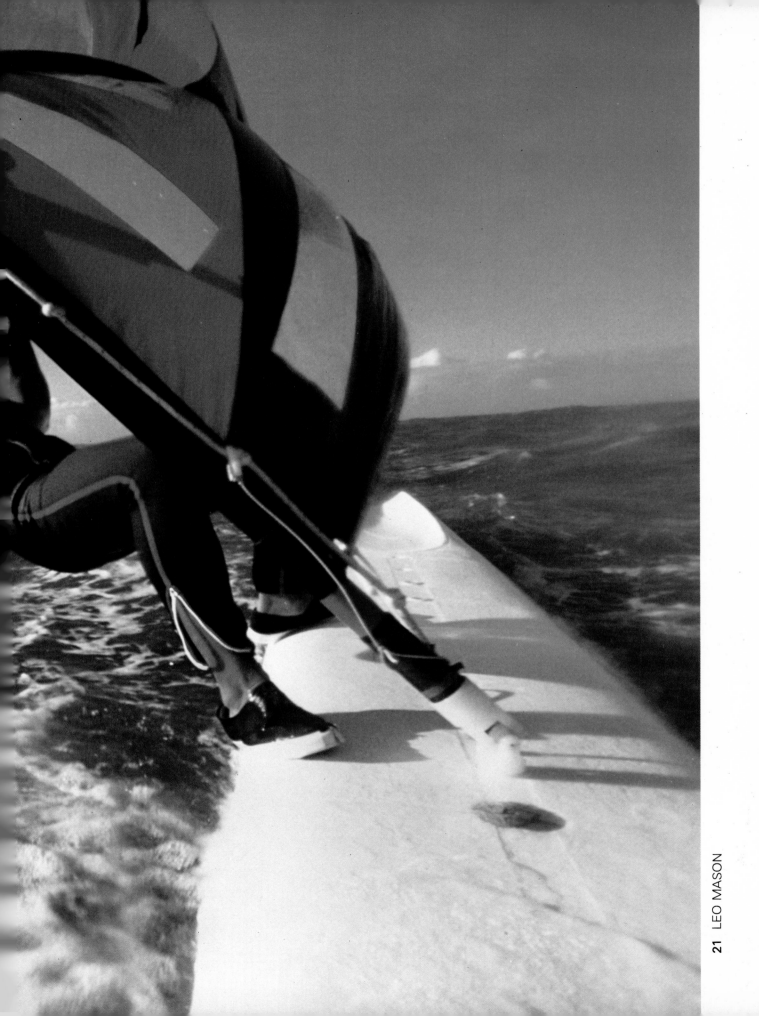

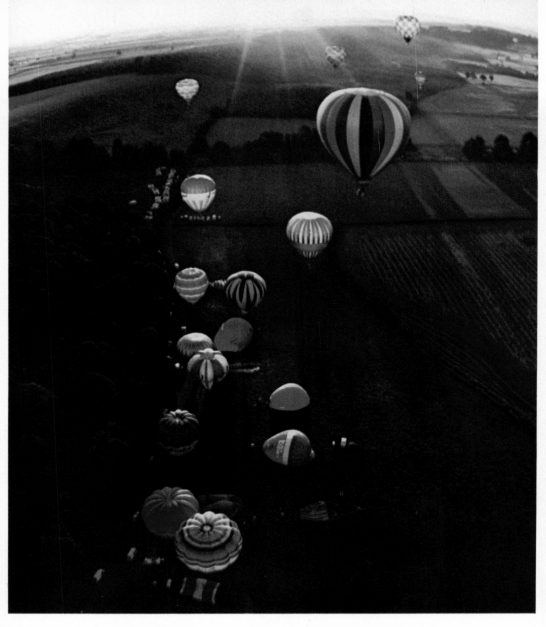

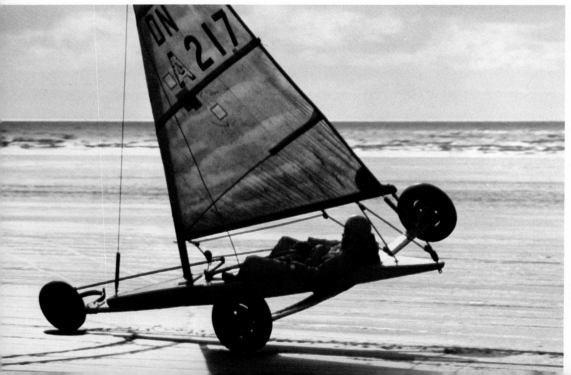

22/24 LEO MASON

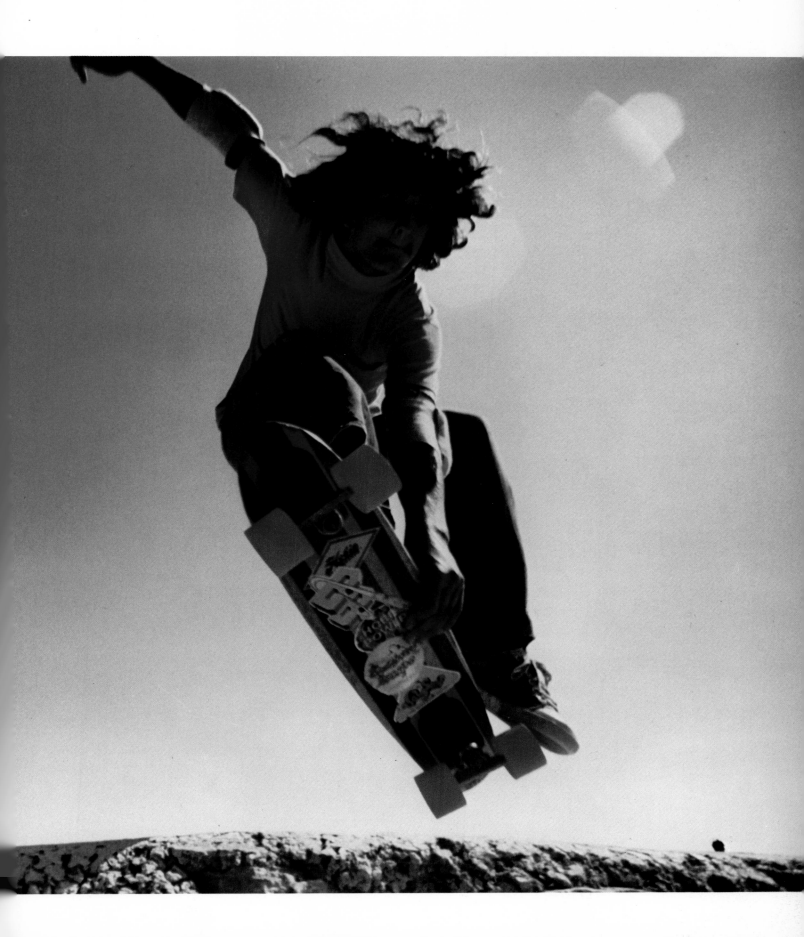

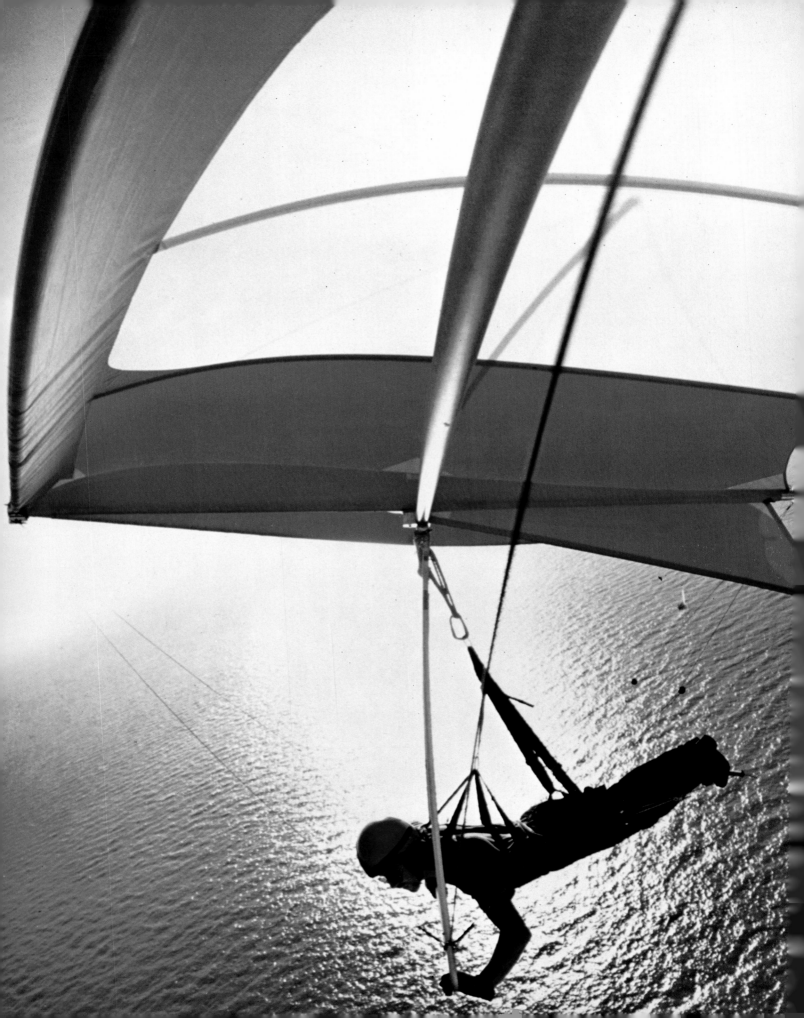

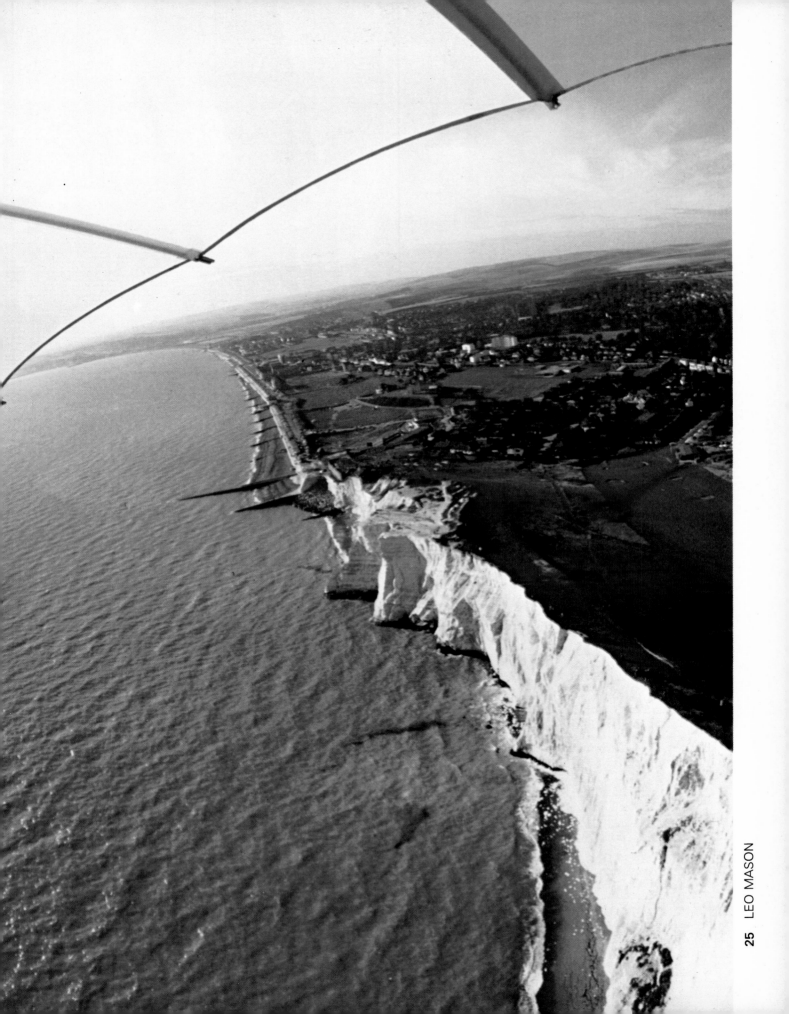

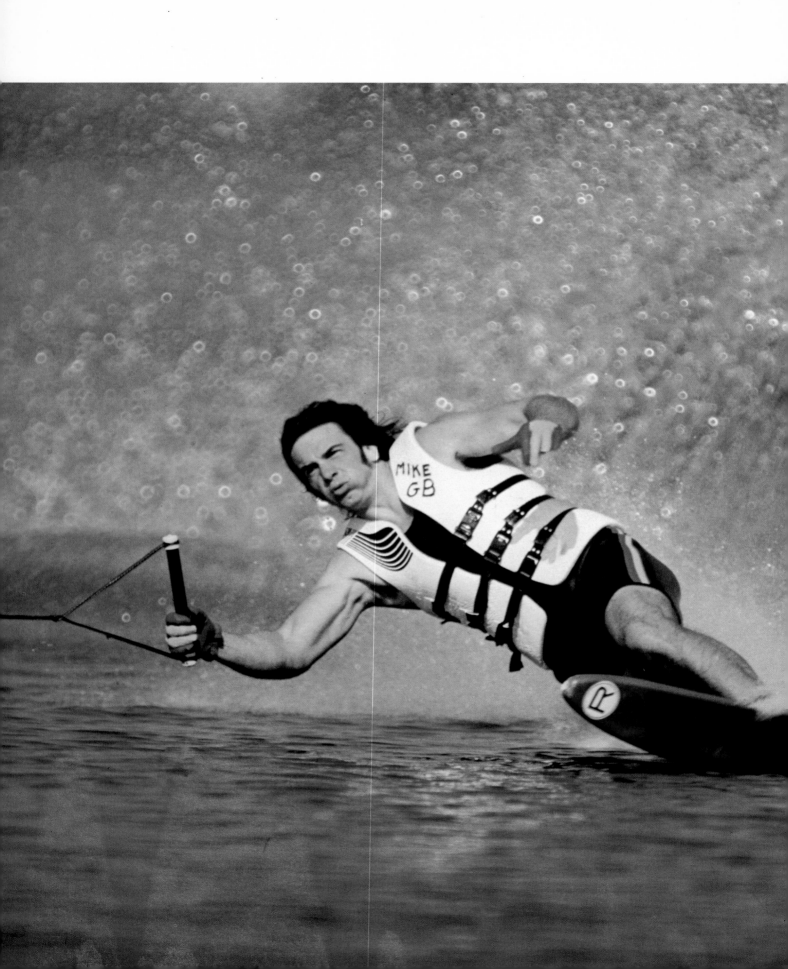

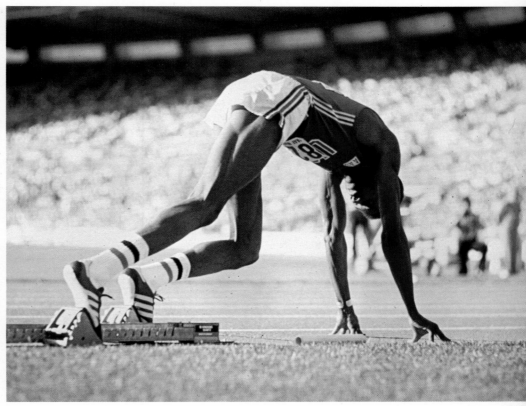

27 STEVE POWELL **28** TONY DUFFY

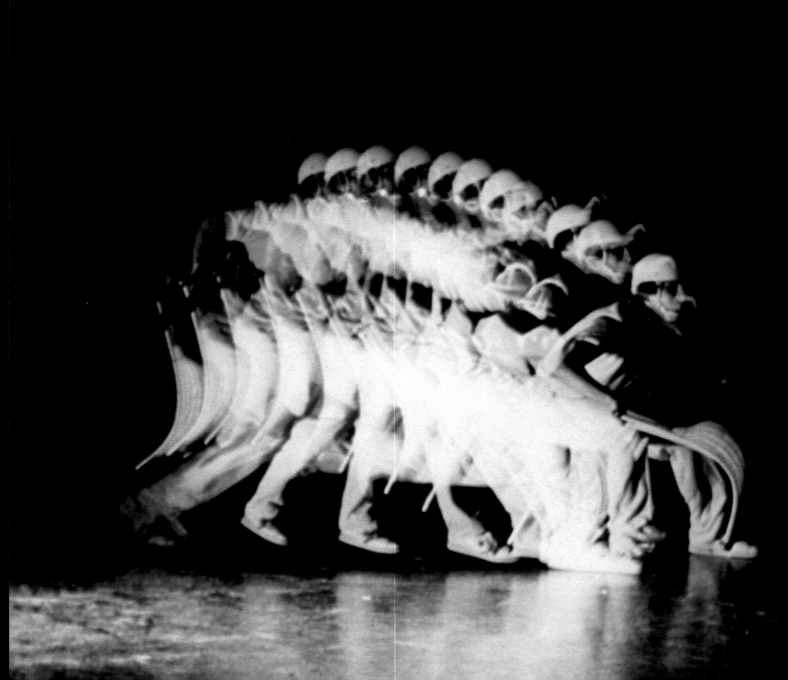

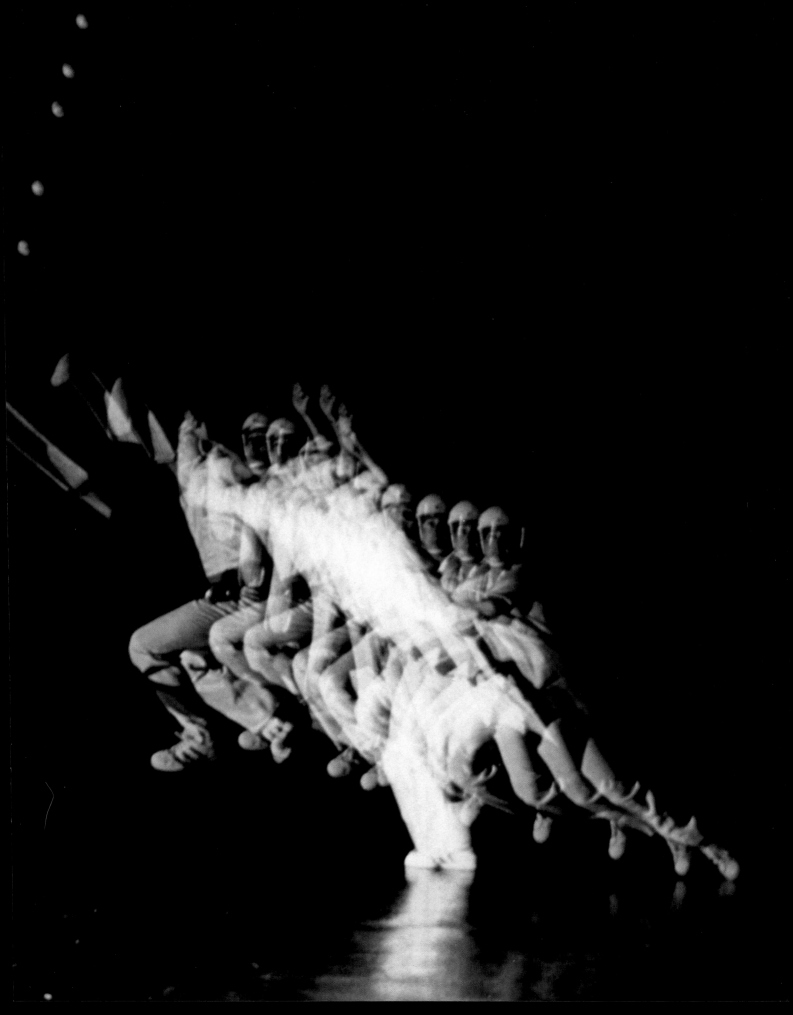

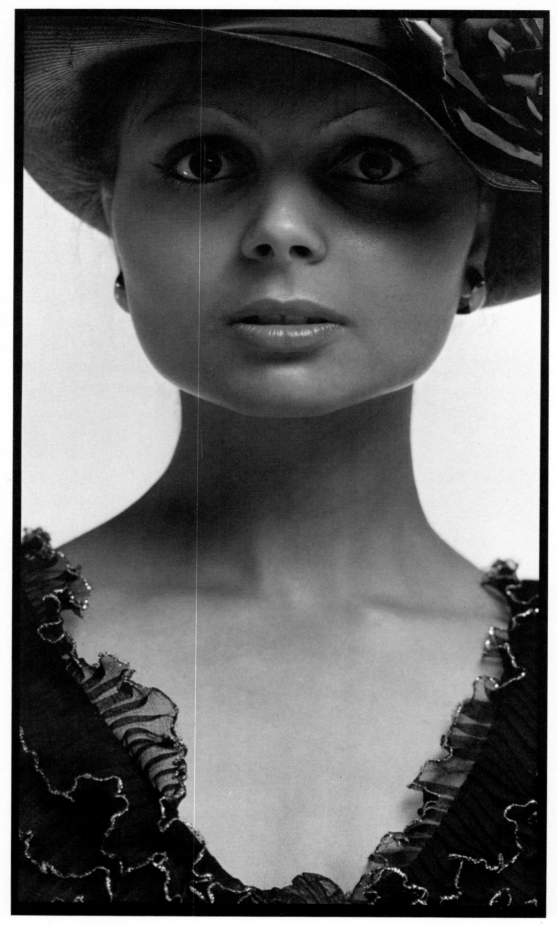

30/31 M. GERMANN

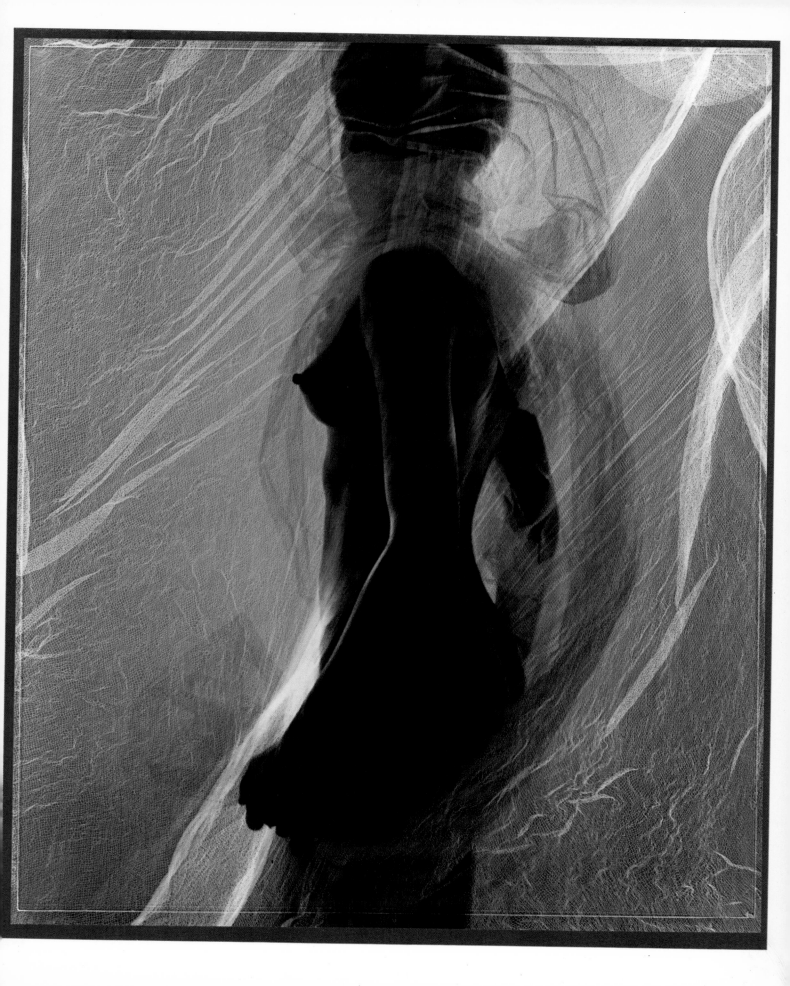

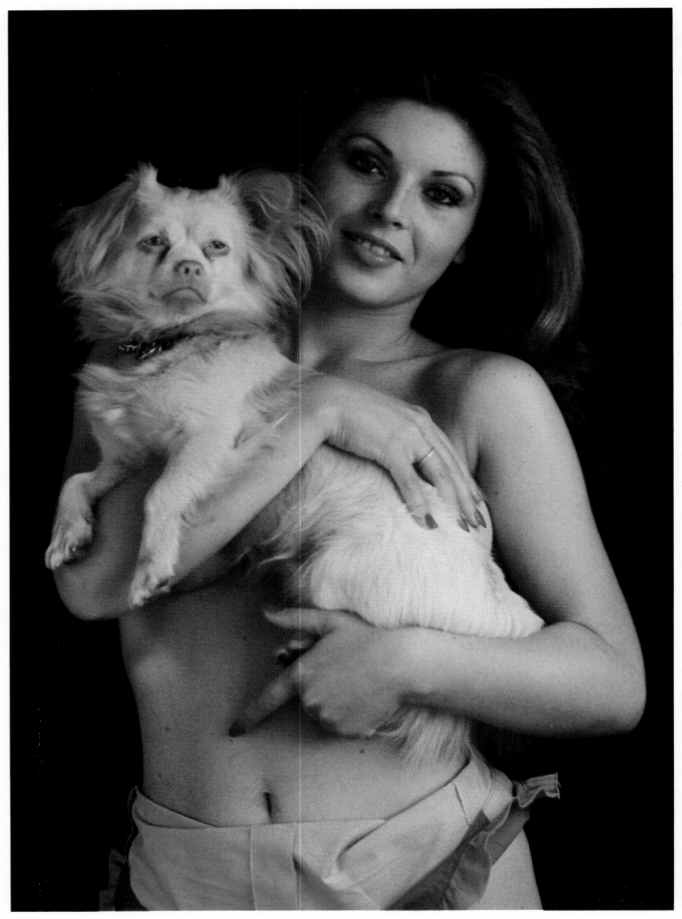

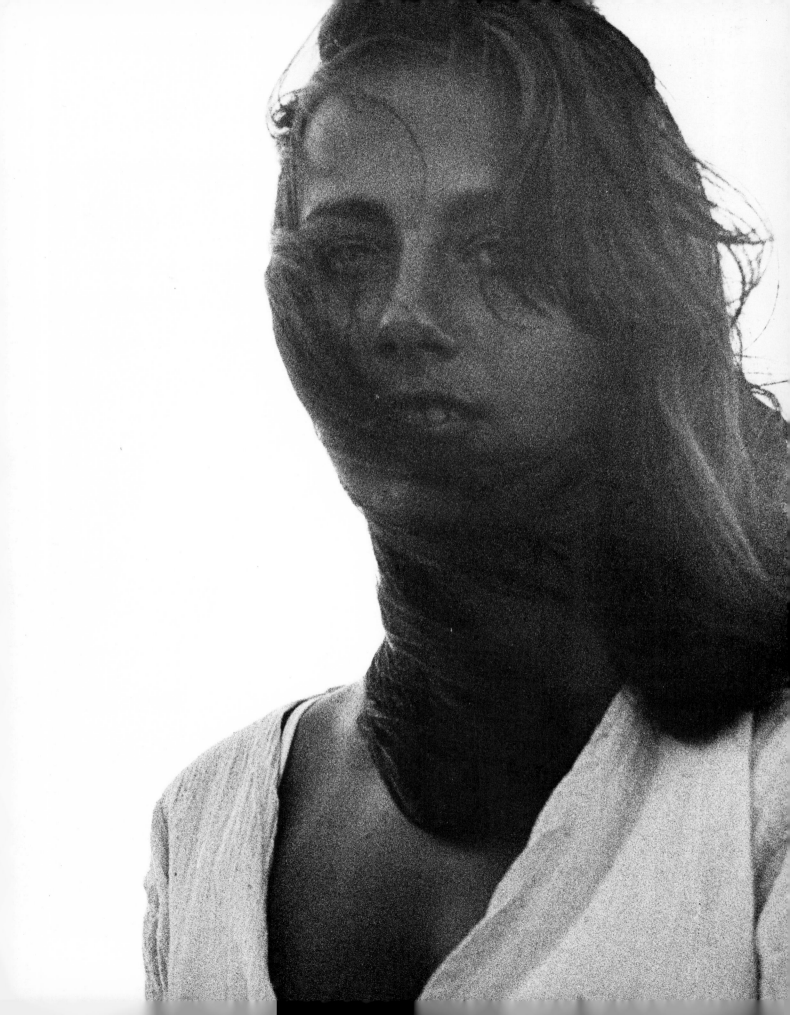

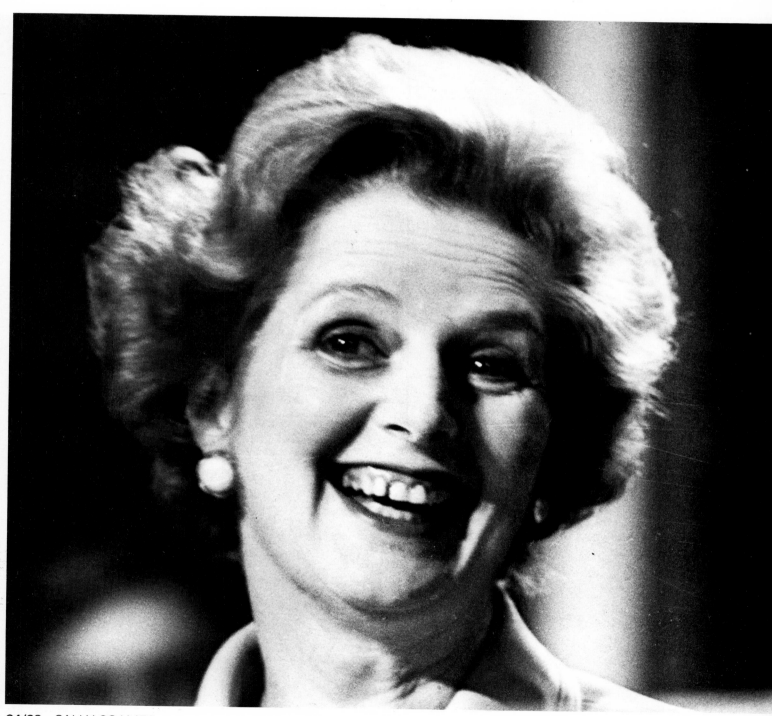

34/38　SALLY SOAMES

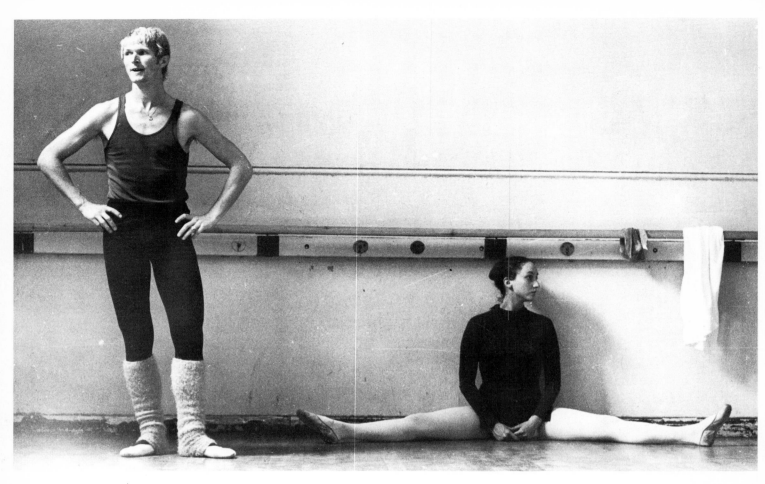

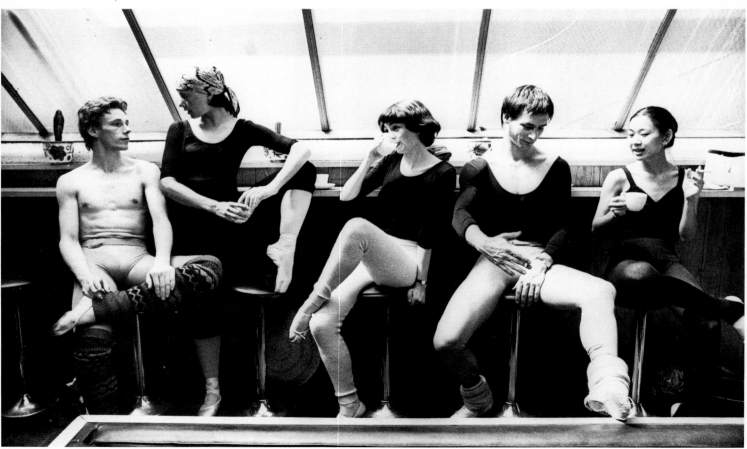

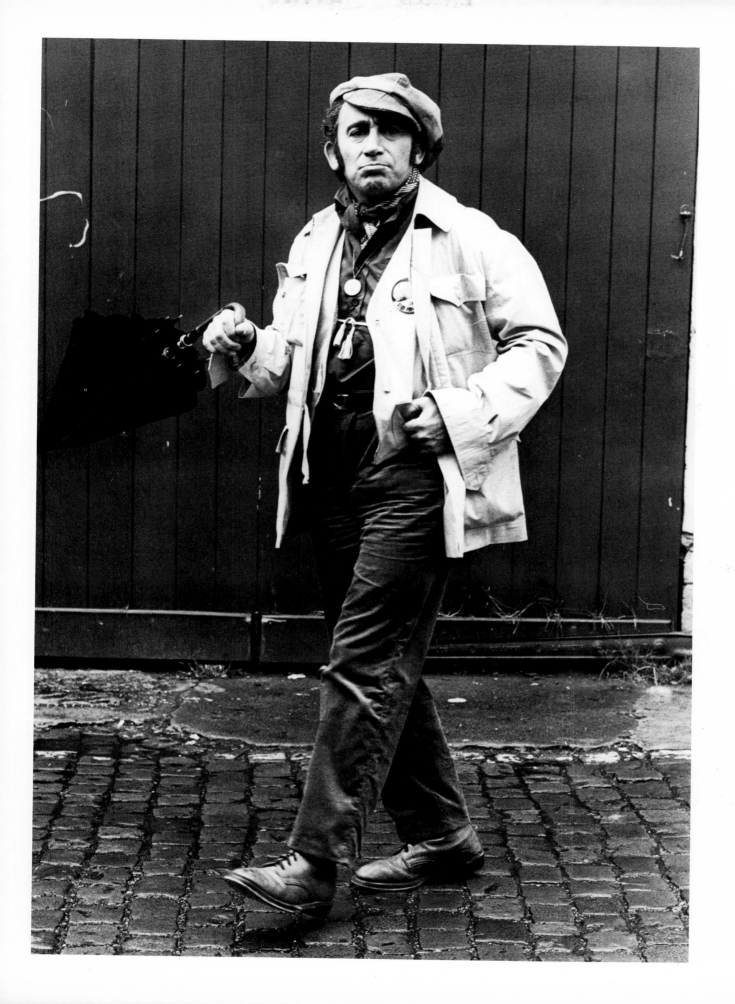

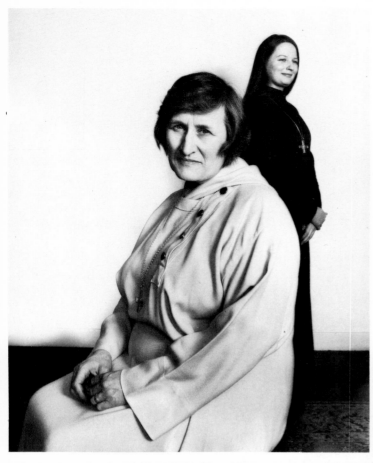

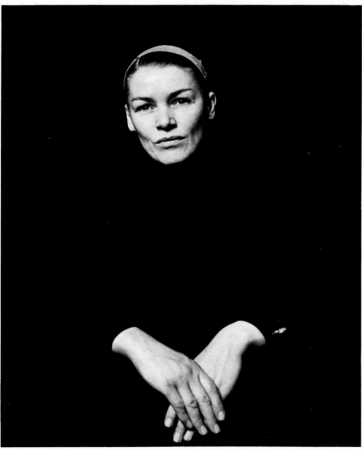

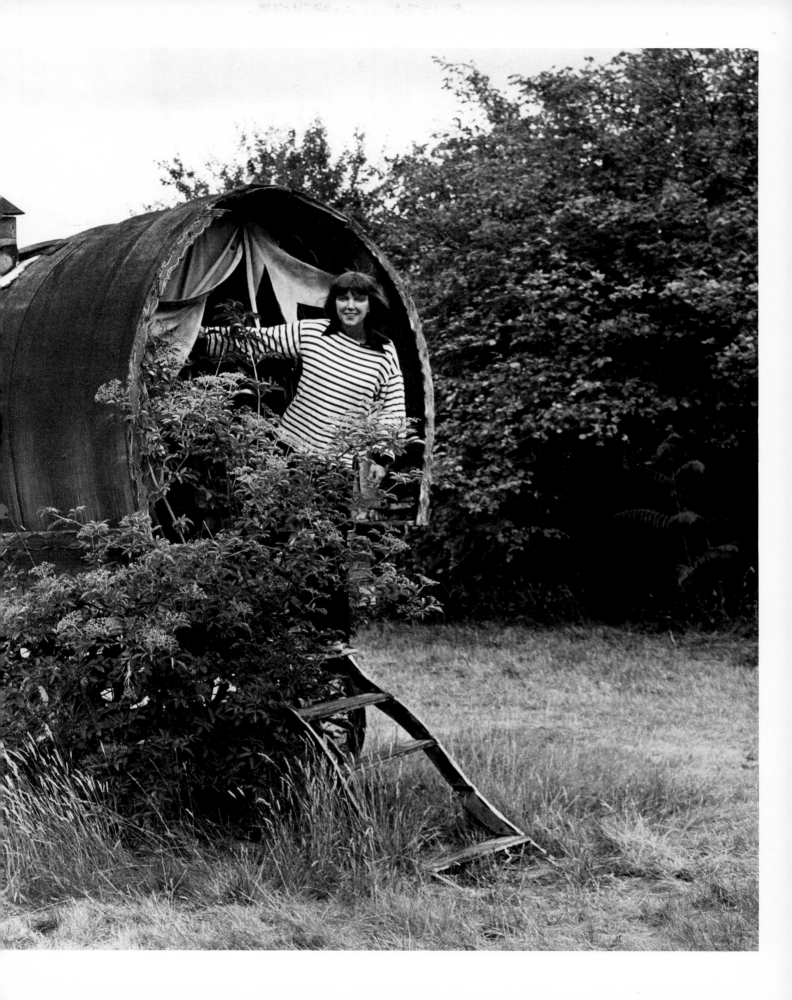

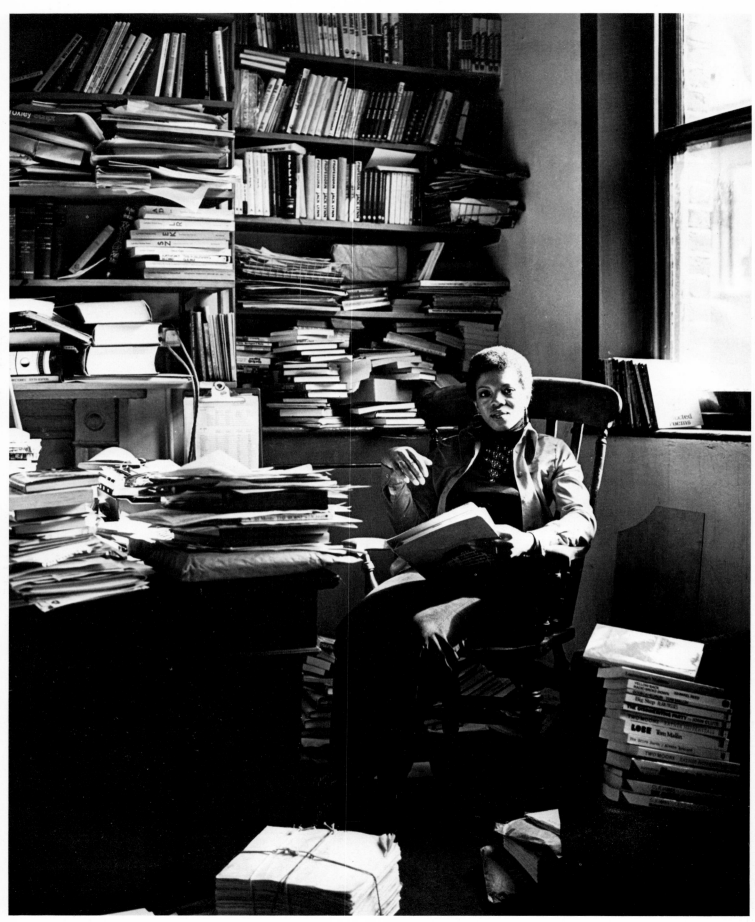

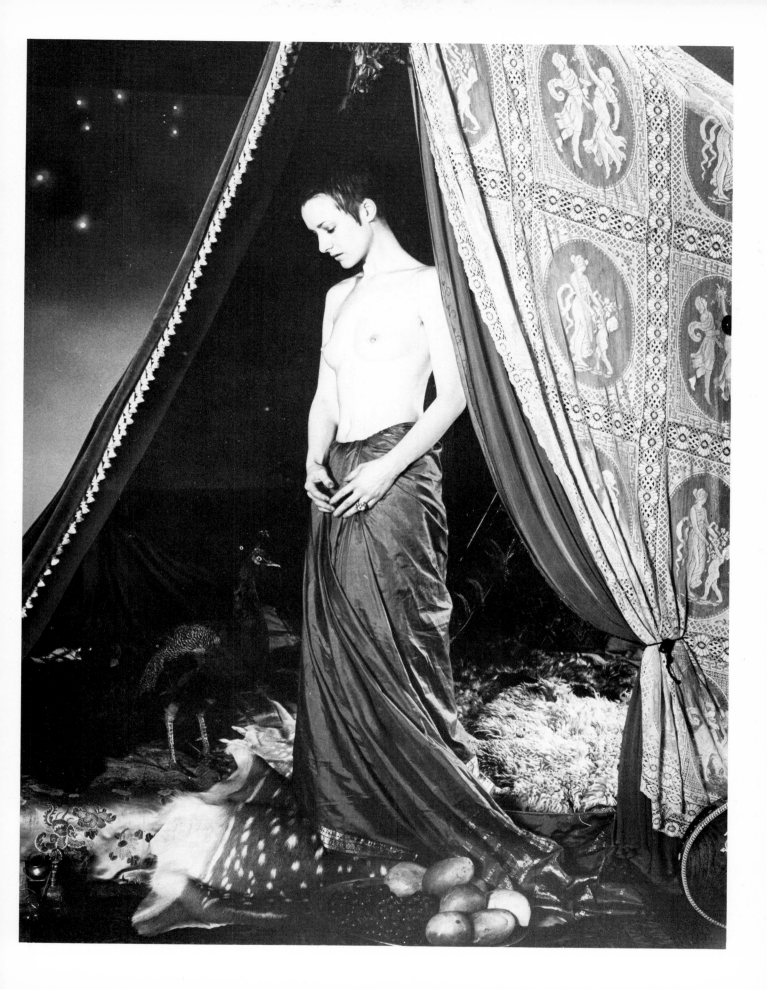

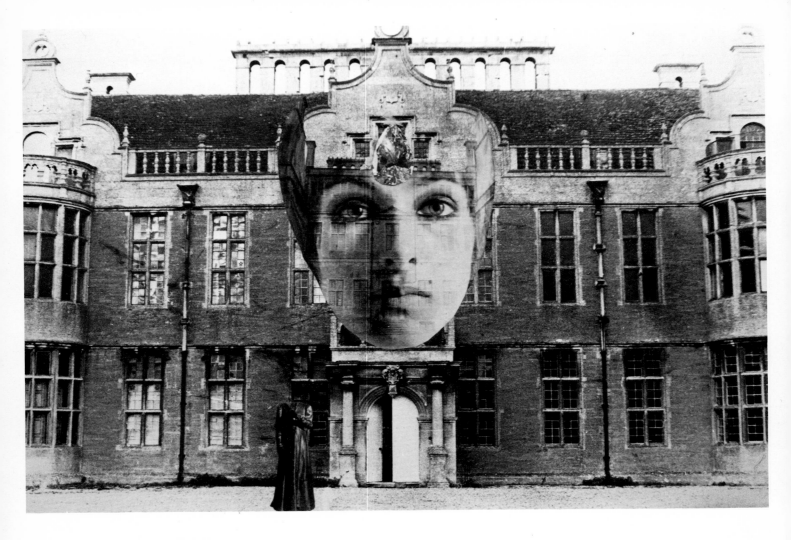

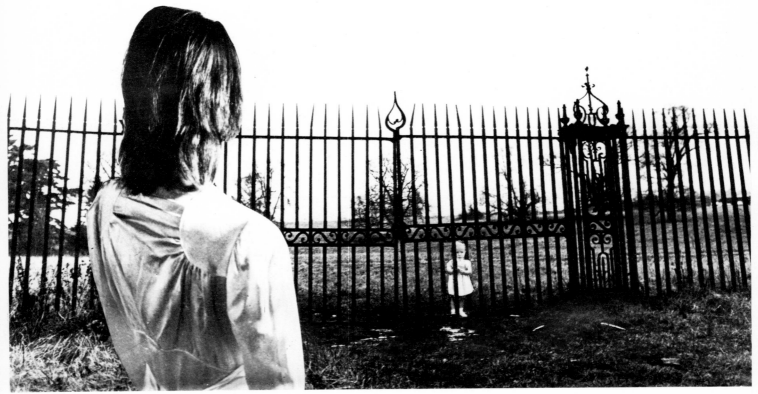

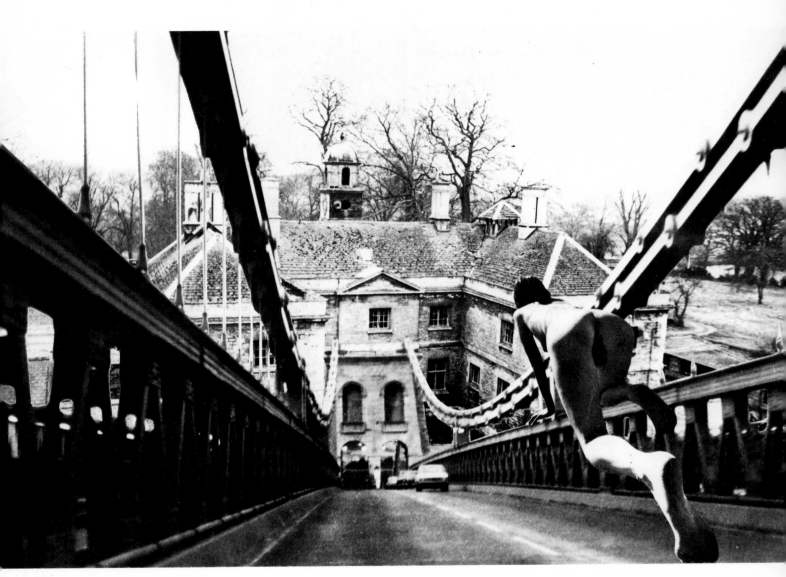

47/49 PENNY SLINGER

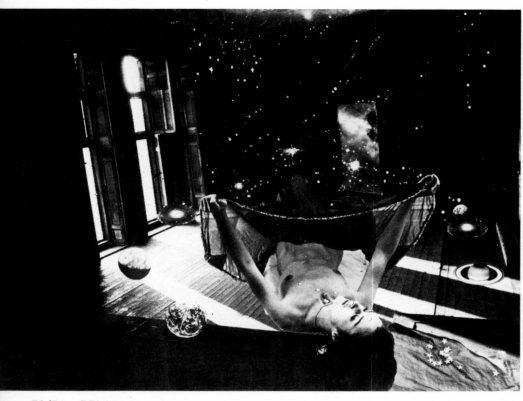

50/51 PENNY SLINGER

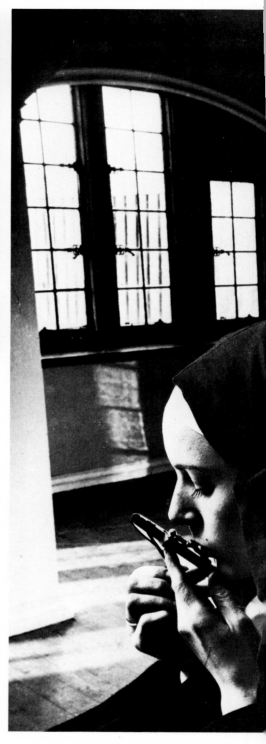

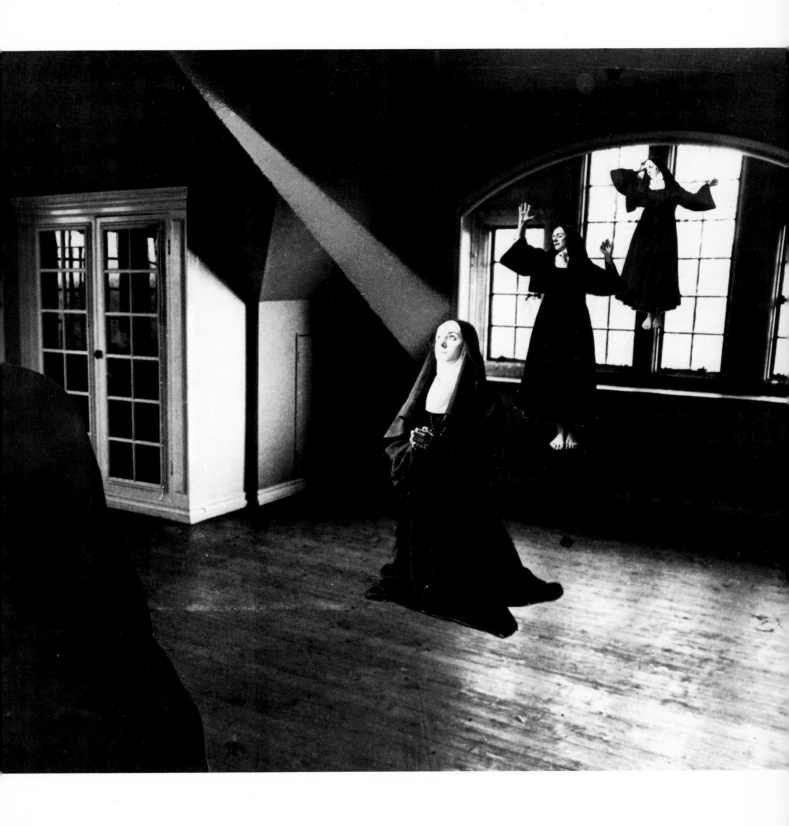

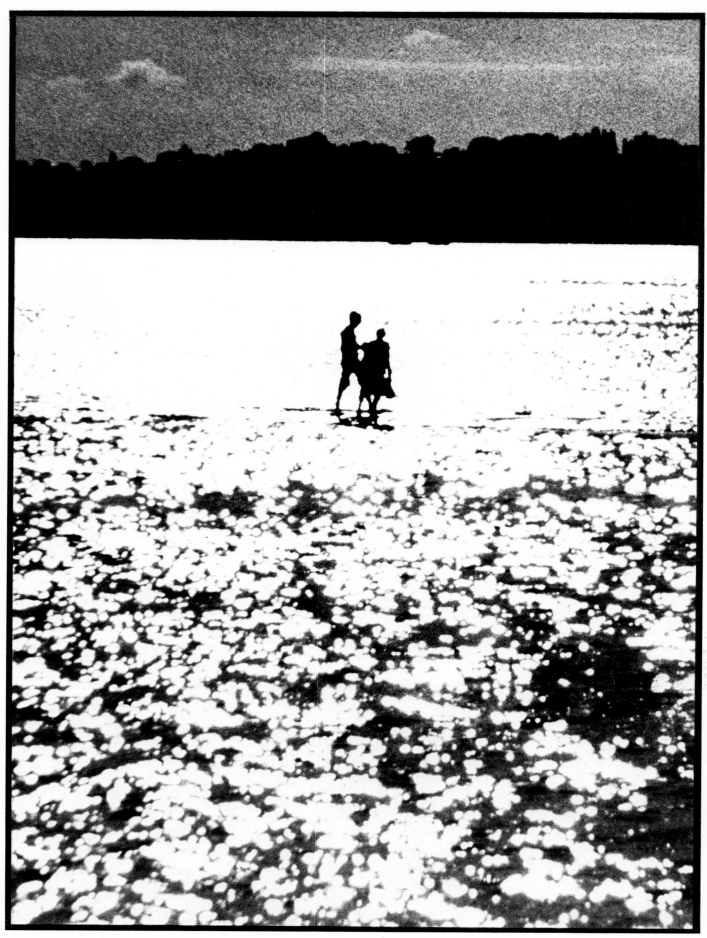

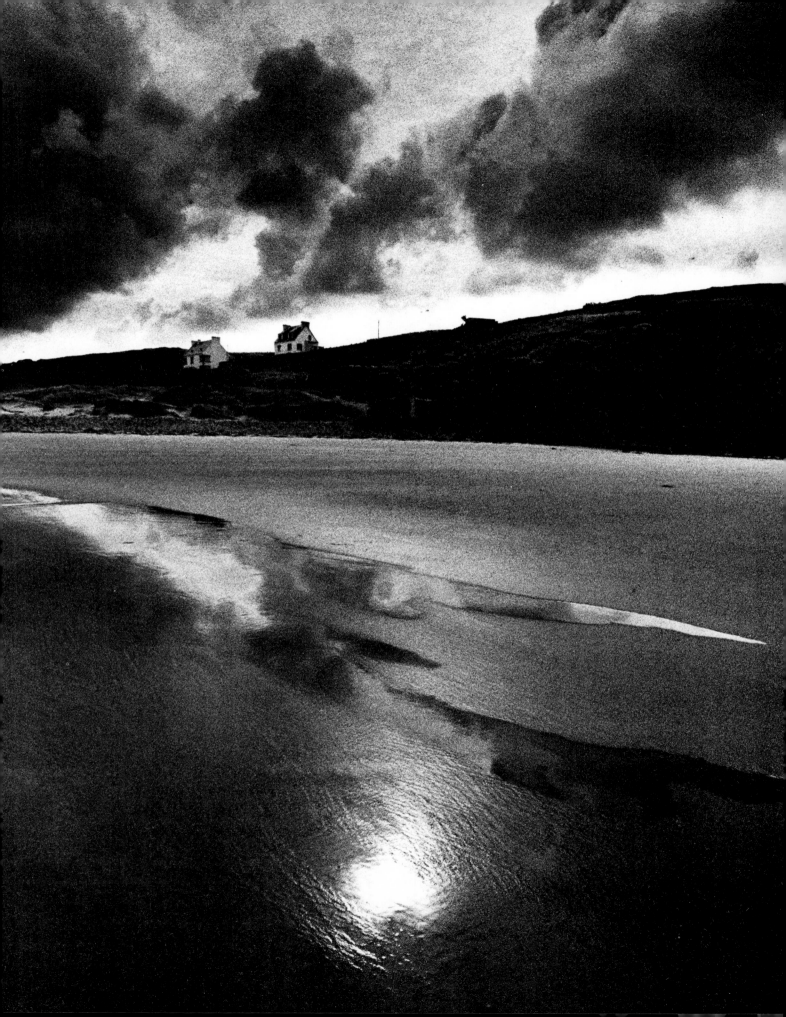

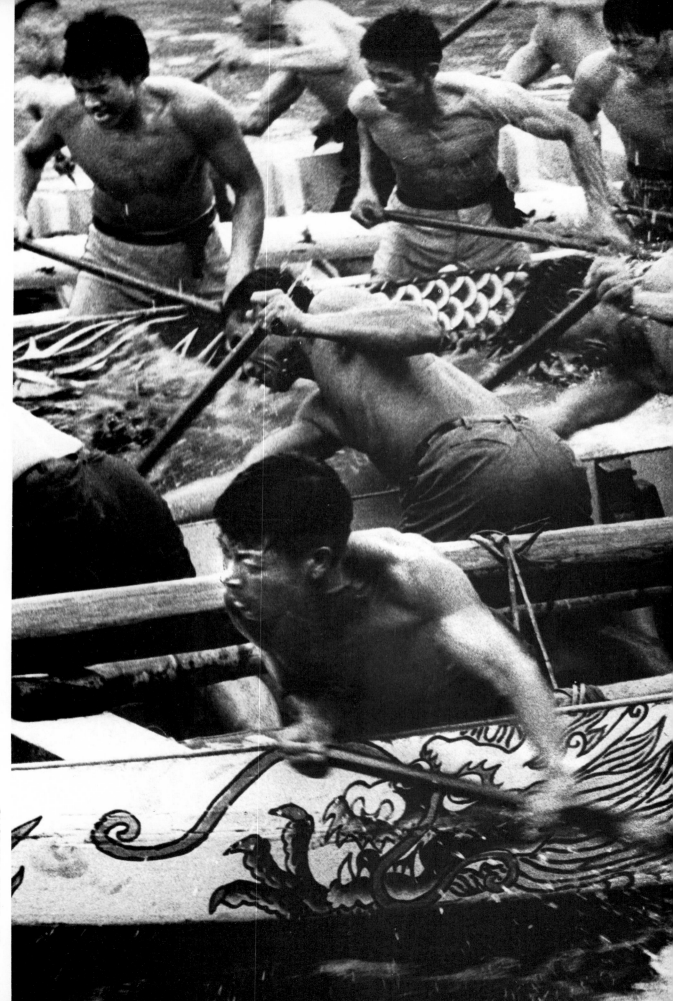

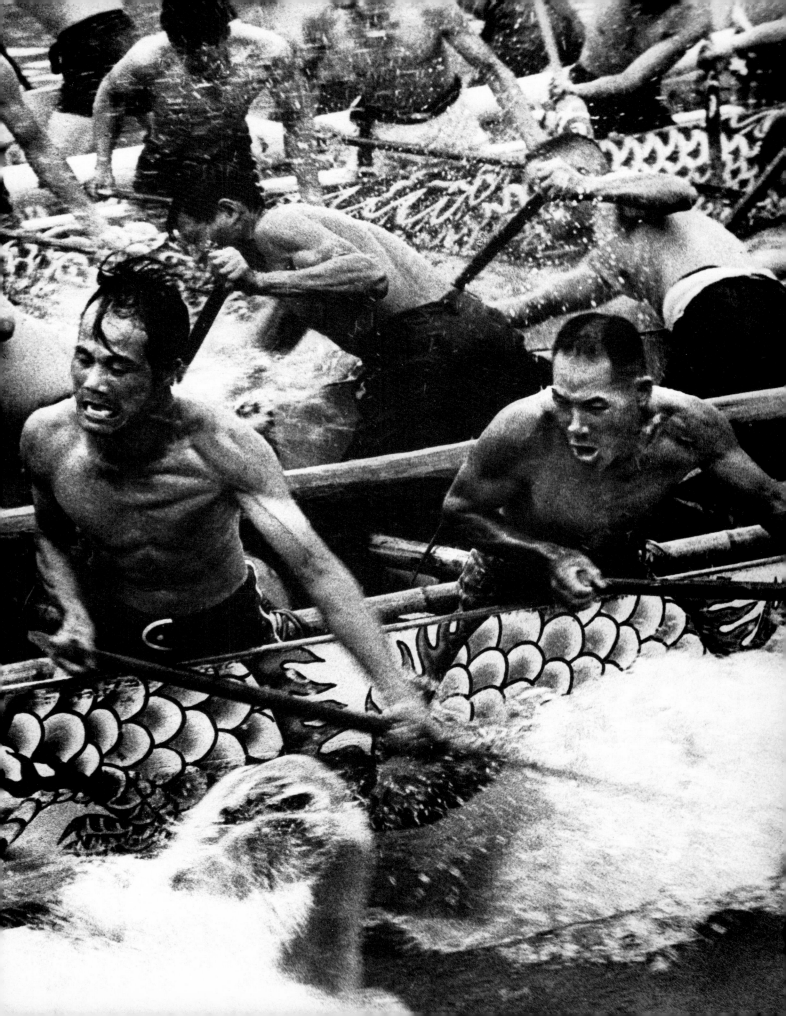

55/58 BRIAN DUFF

59/60 GEORG FISCHER

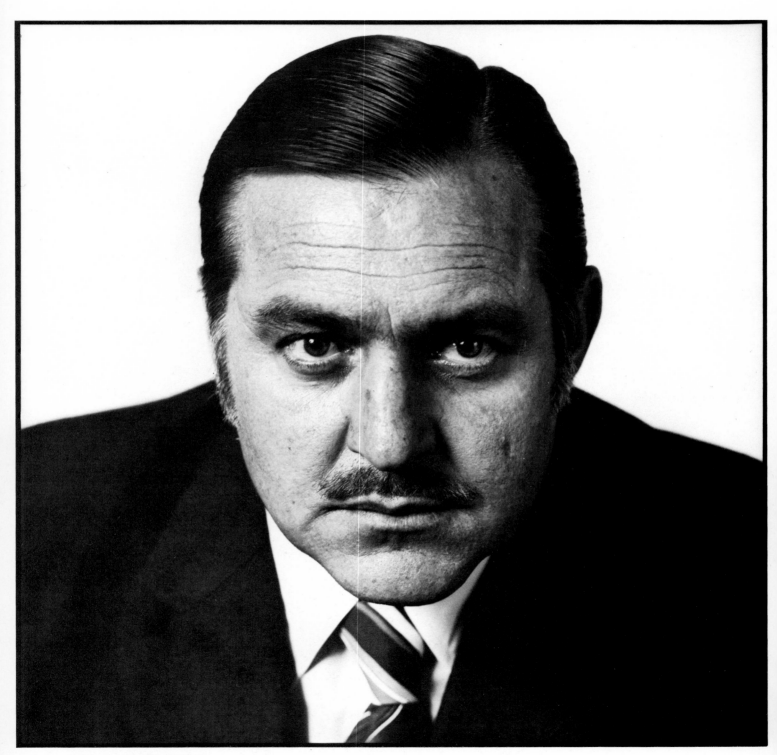

61/62 STRUAN ROBERTSON

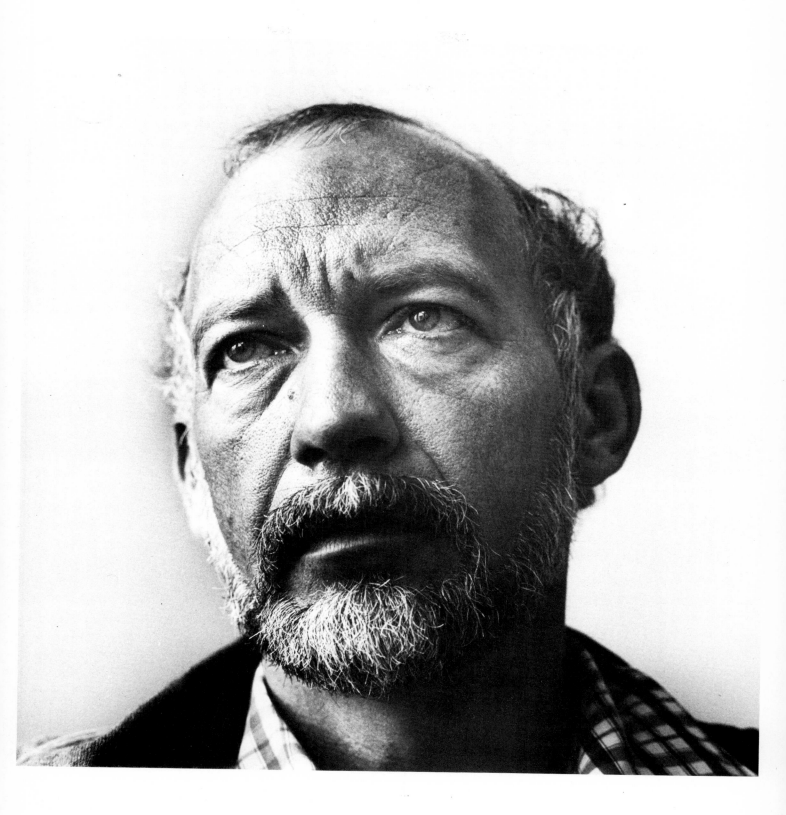

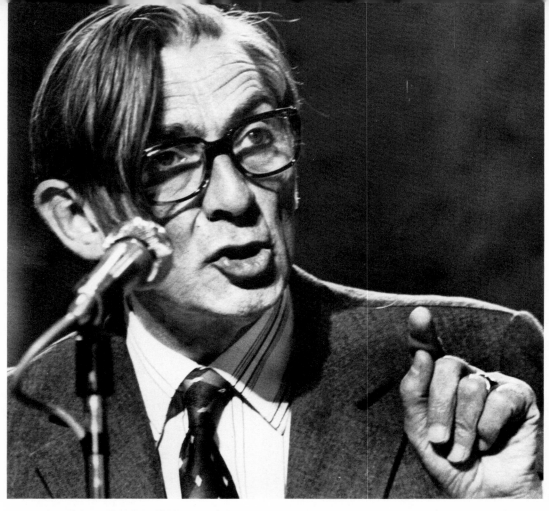

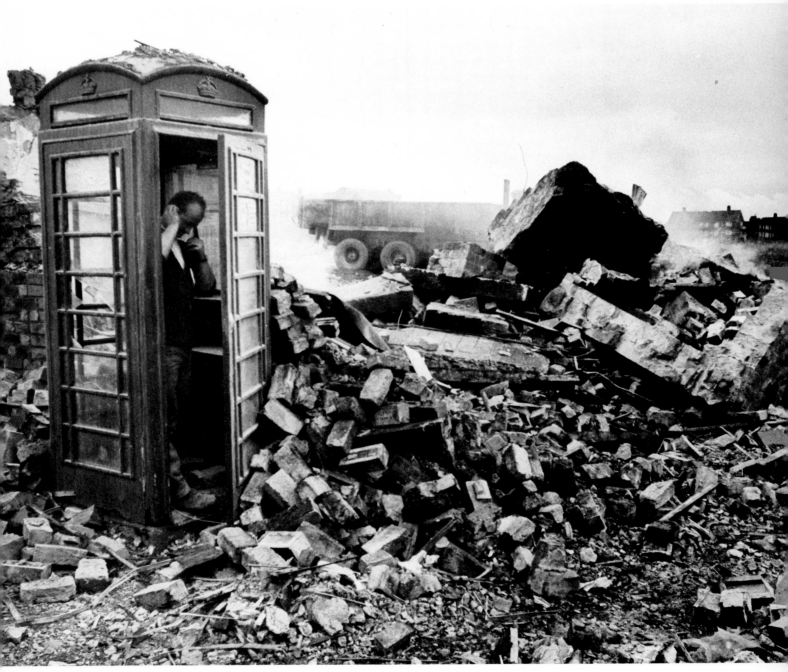

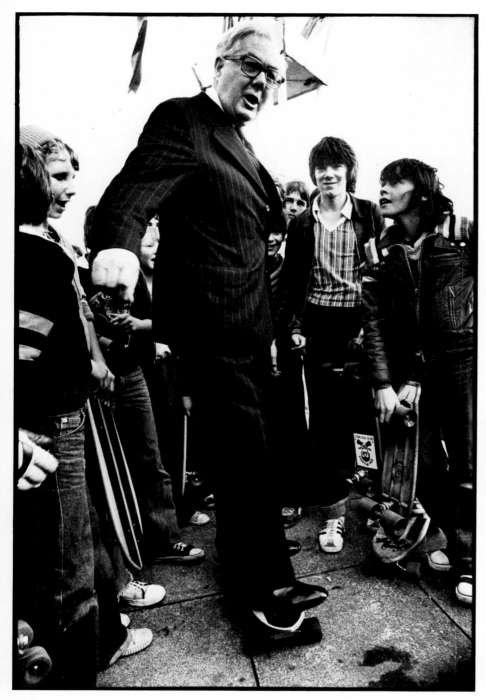

66/67 NICK ROGERS

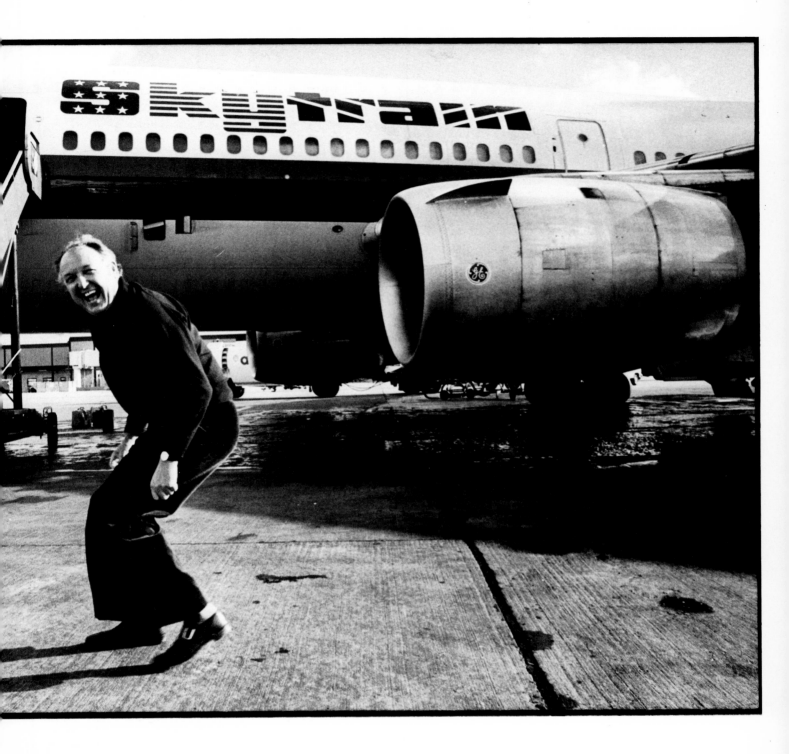

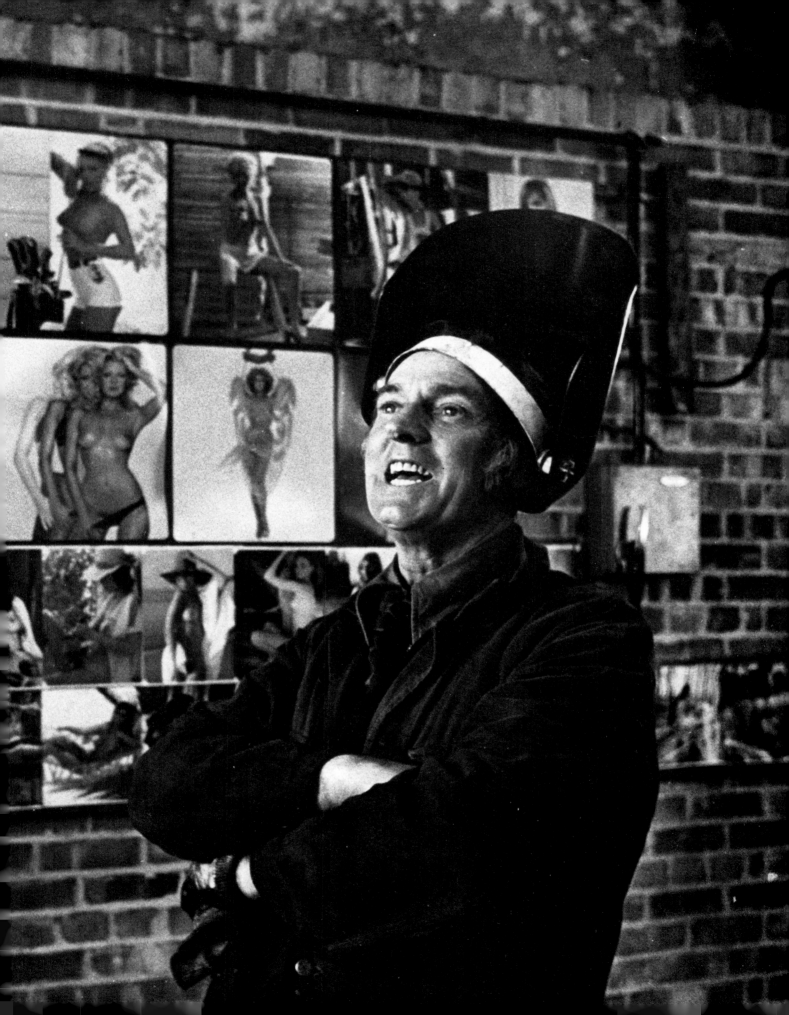

69 FRANK LOUGHLIN **70** JOSEP MARIA RIBAS PROUS

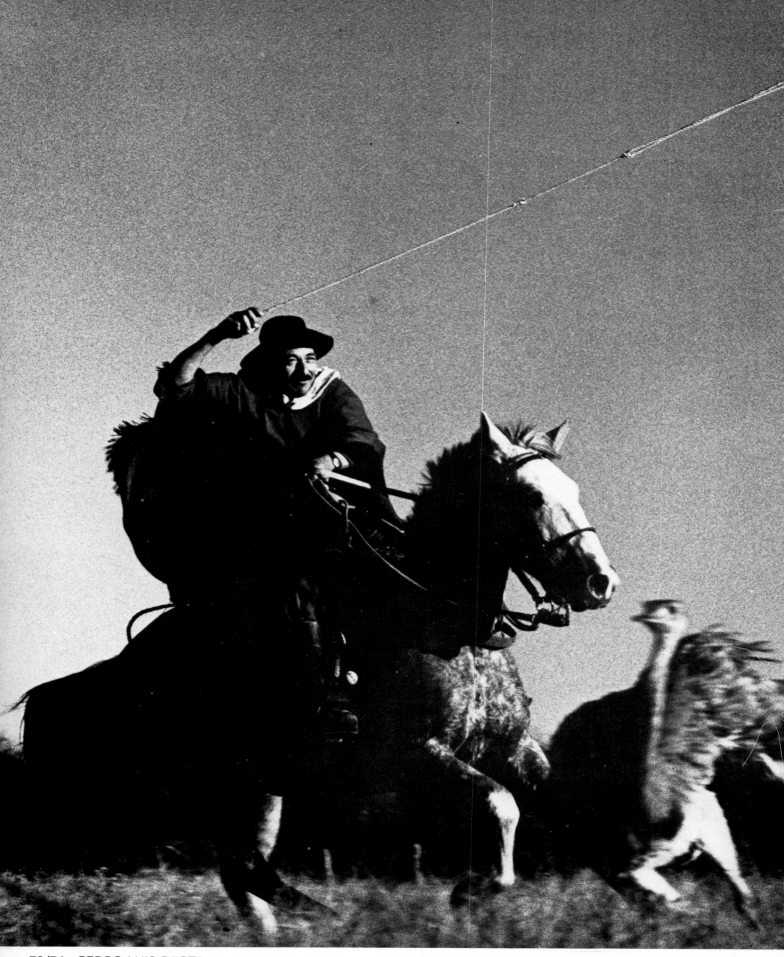

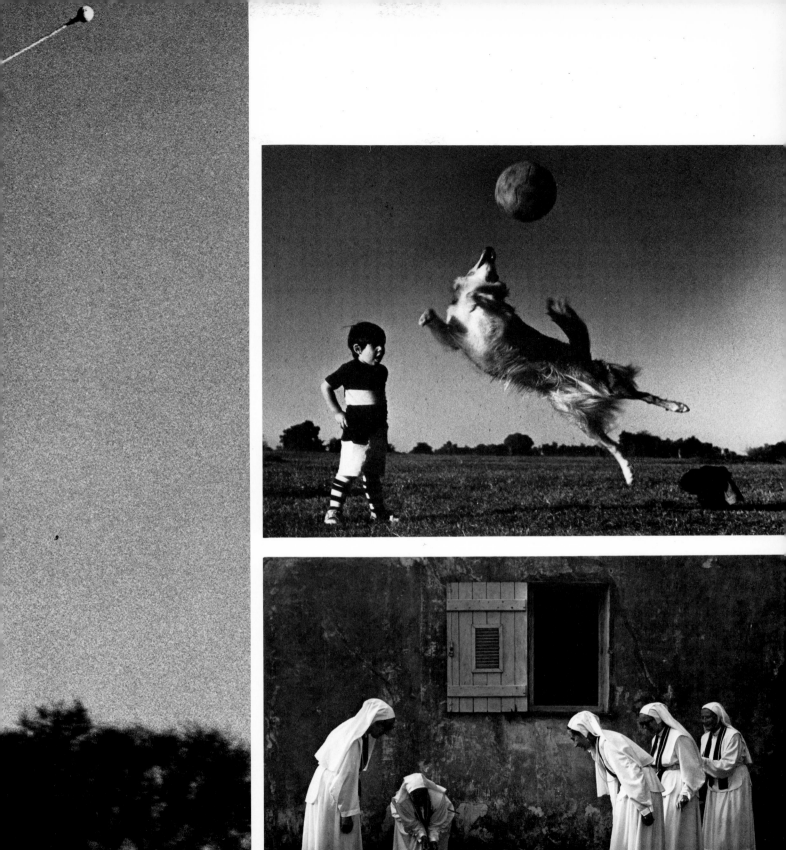

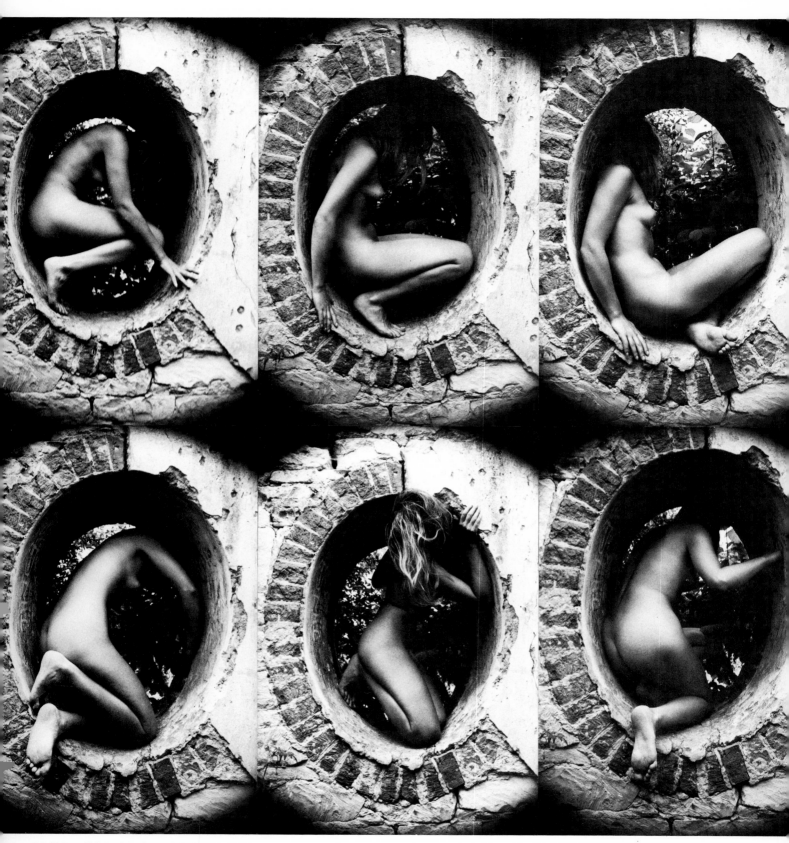

JULIUSZ GARZTECKI

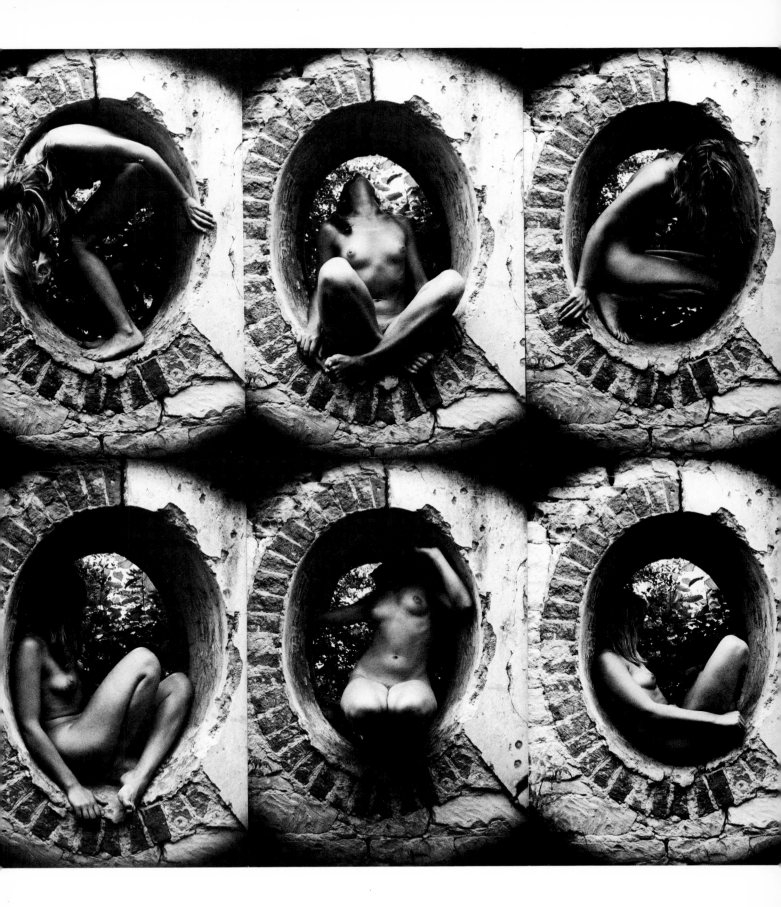

87/88 MARKUS JOKELA

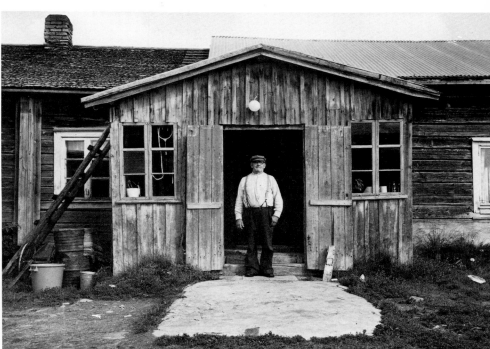

89/91 KALERVO OJUTKANGAS

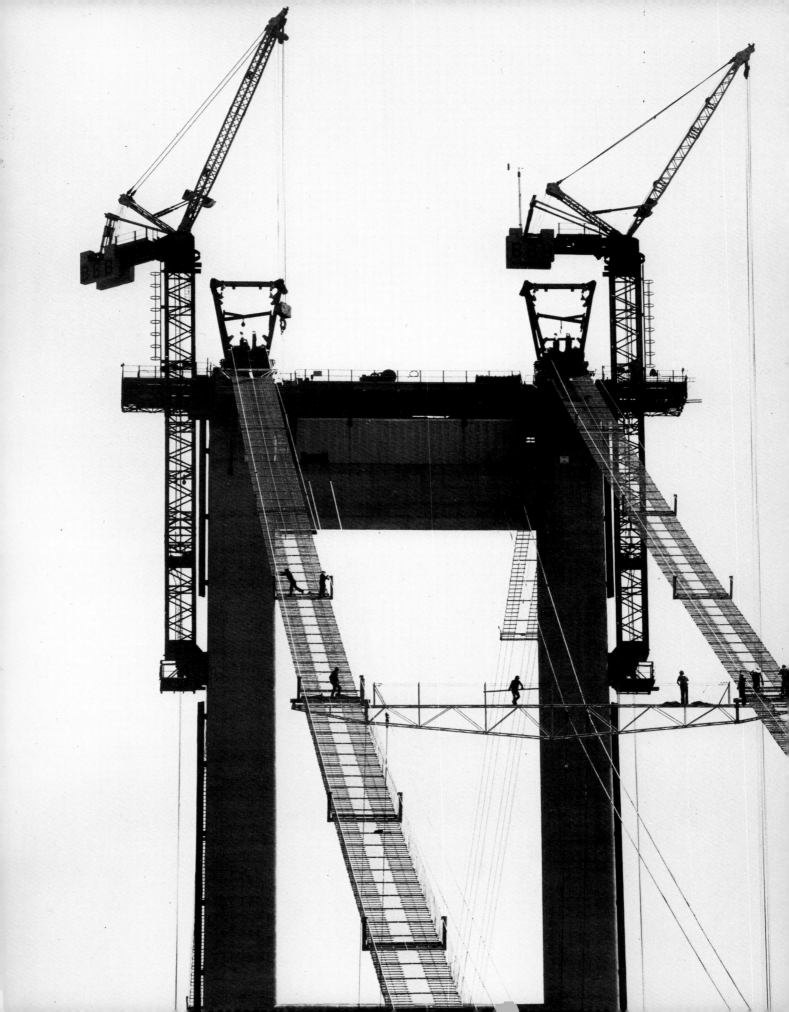

92/93 CLELAND RIMMER

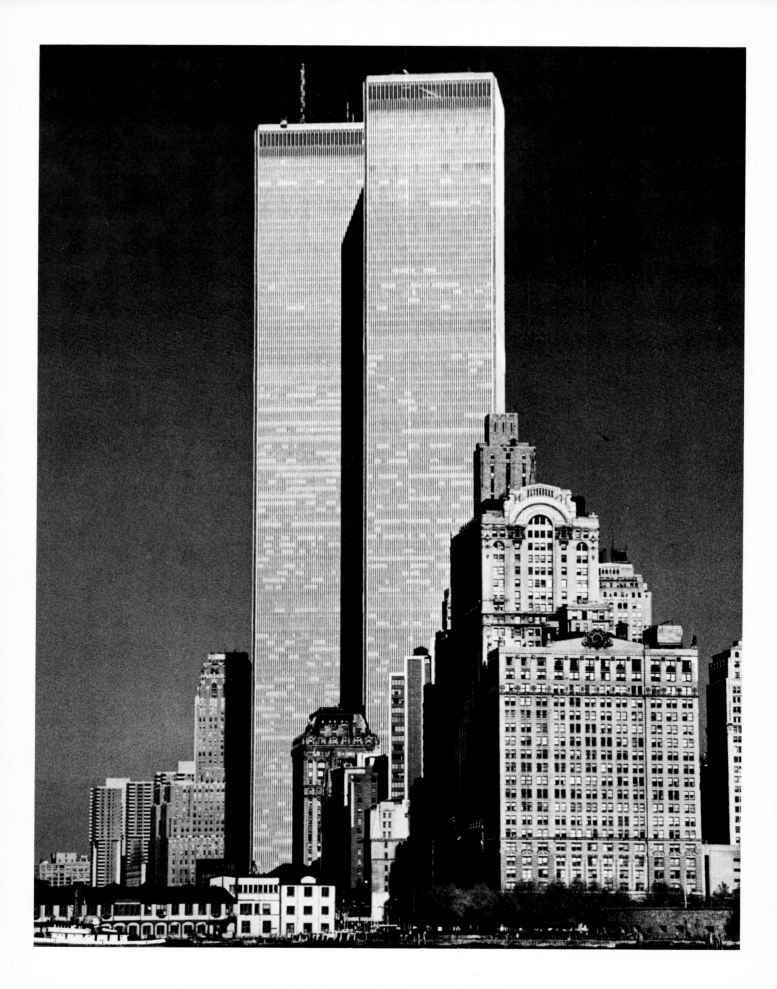

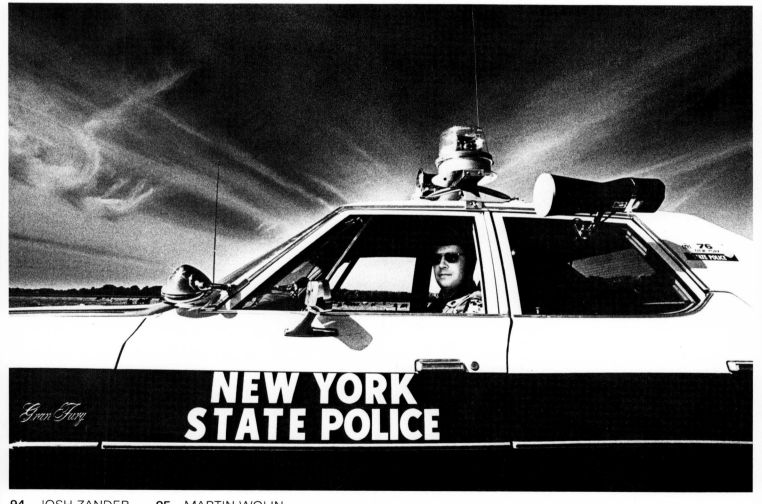

94 JOSH ZANDER 95 MARTIN WOLIN

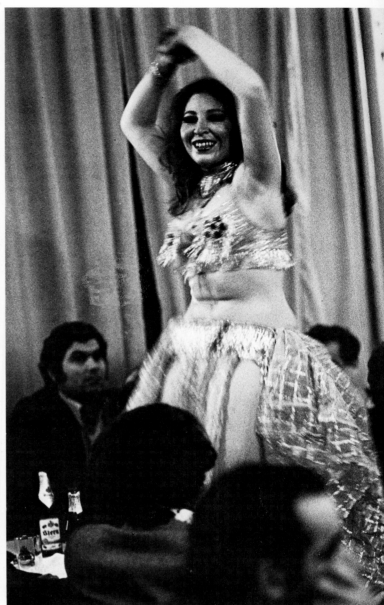

96/97 HENNING CHRISTOPH

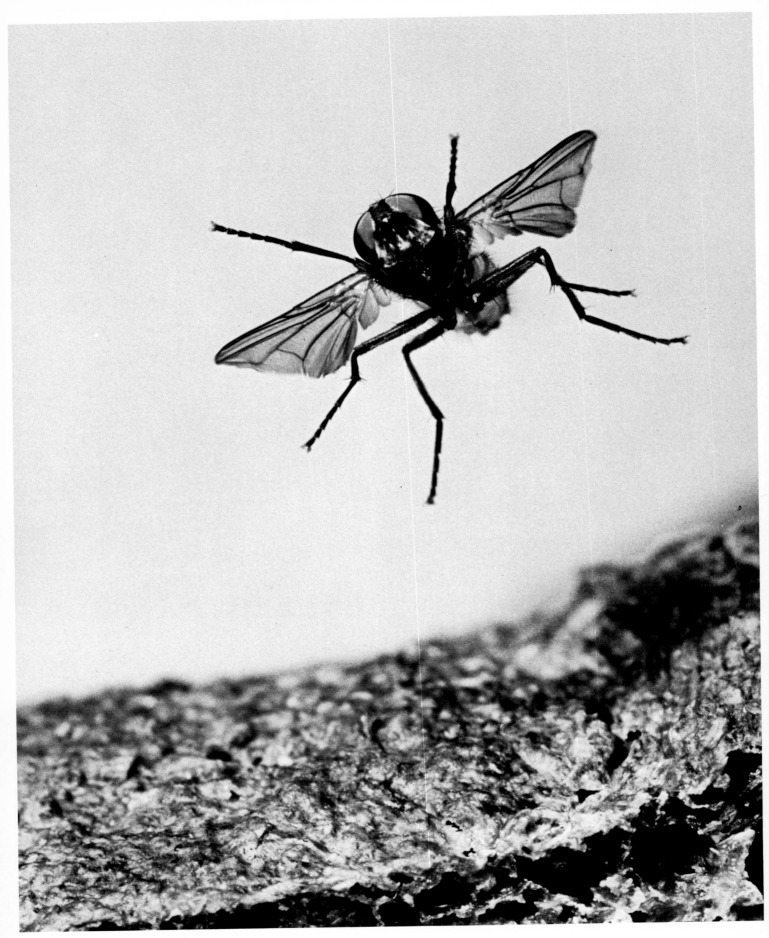

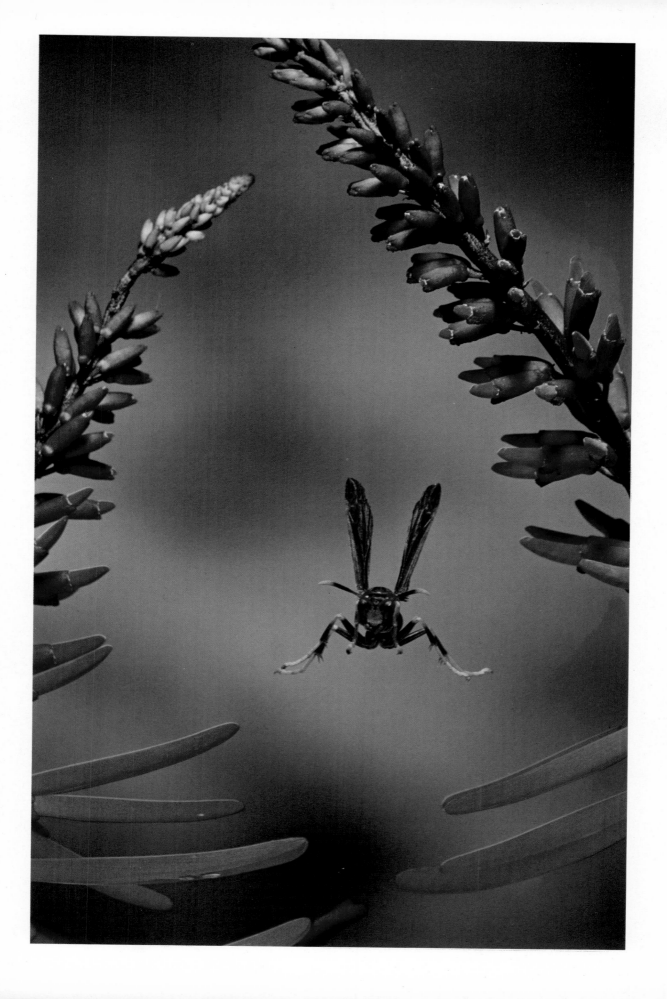

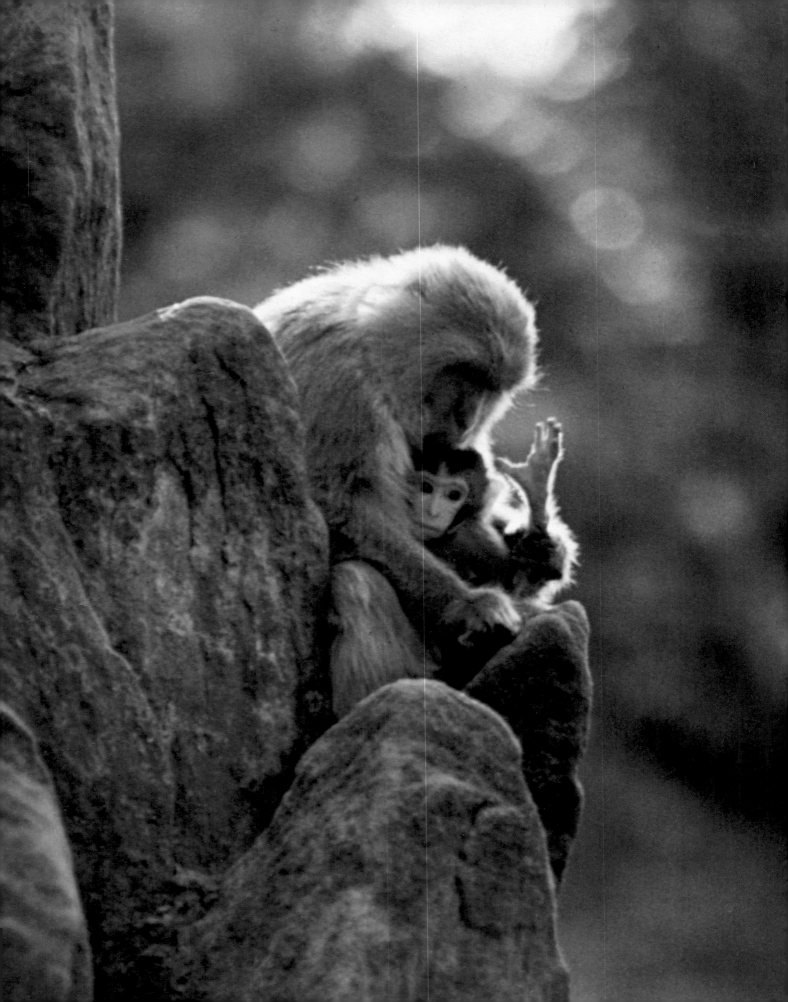

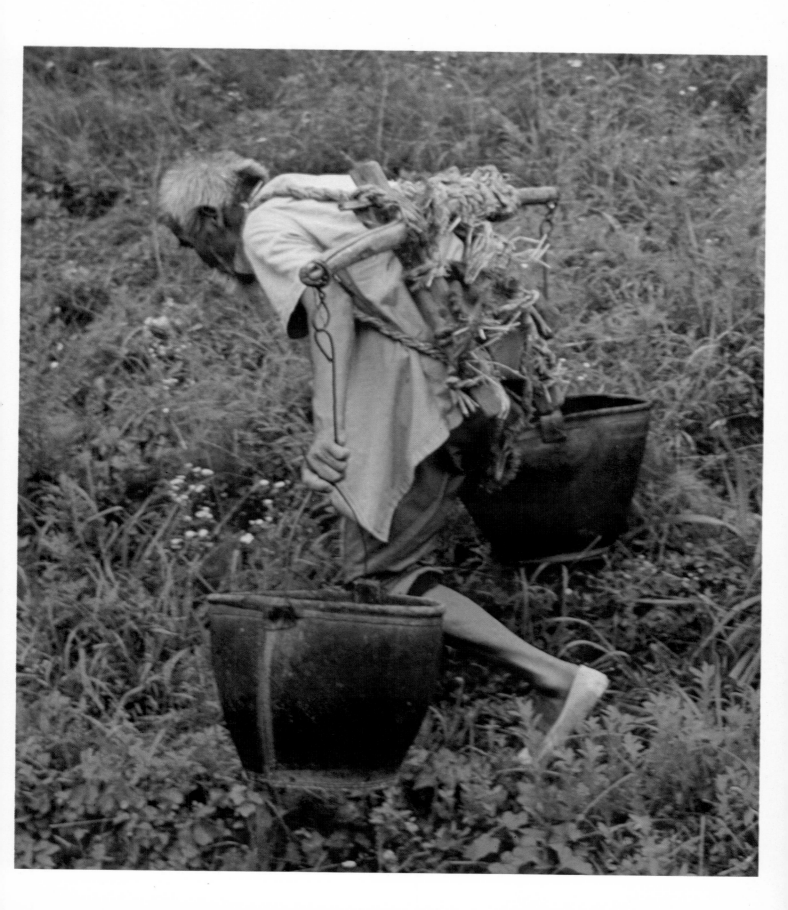

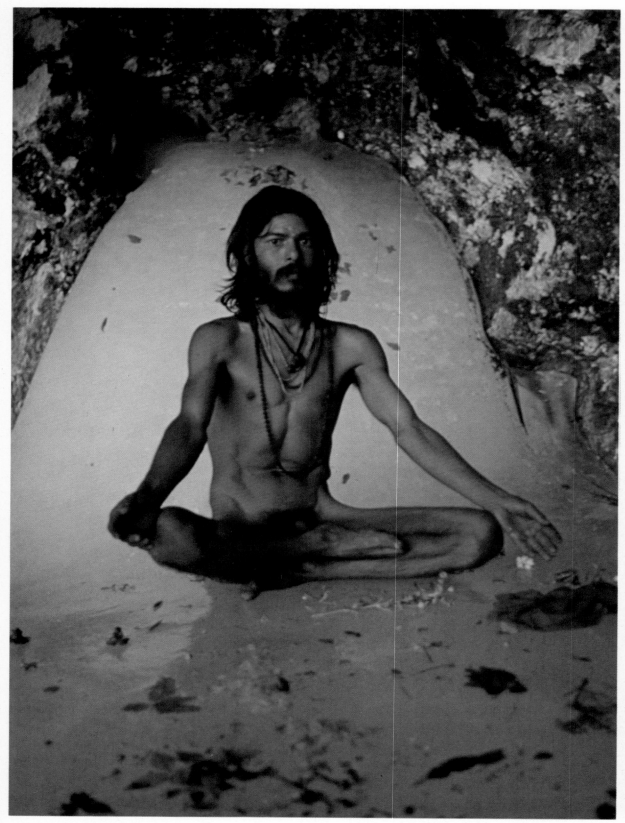

109/110 HEINZ STÜCKE

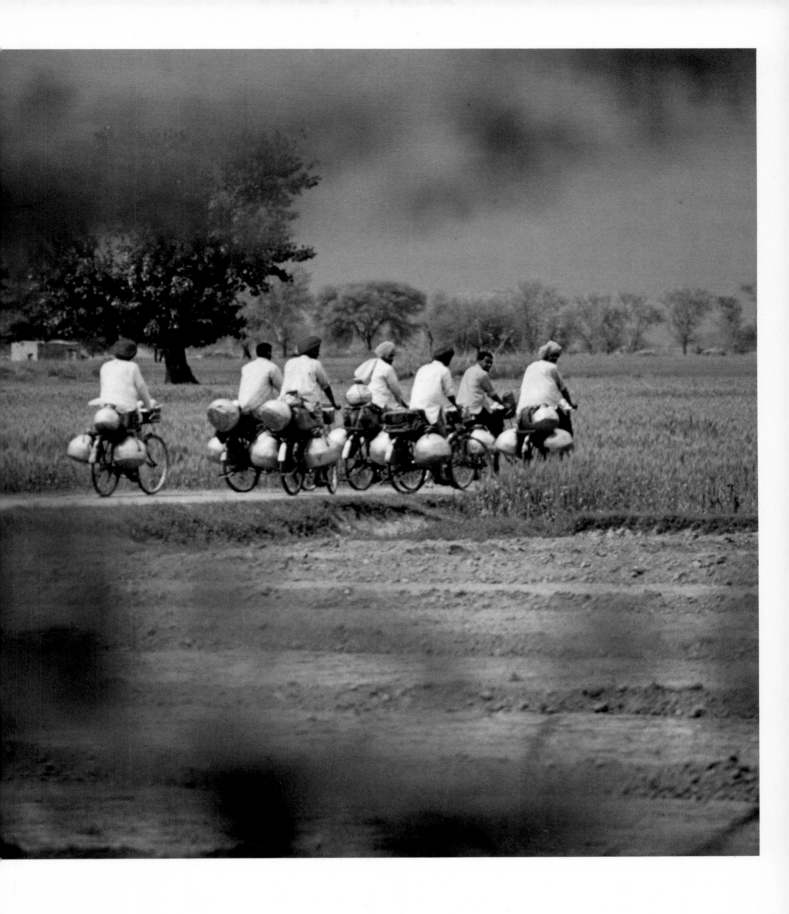

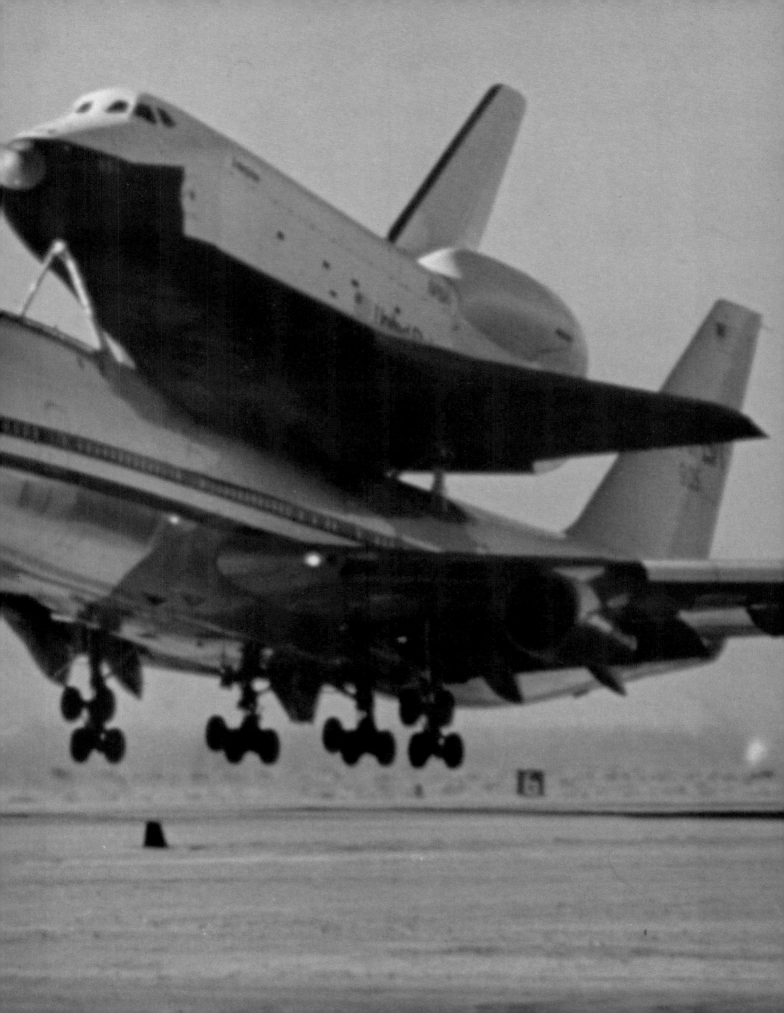

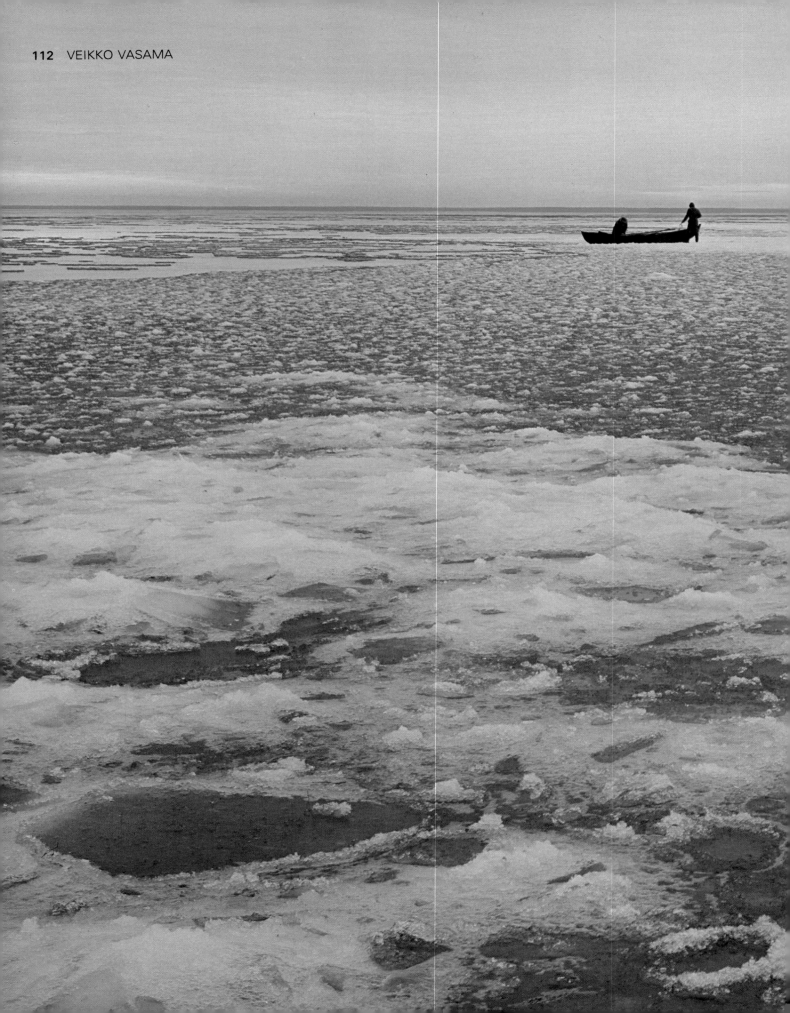

113/114 GUNNAR LARSEN

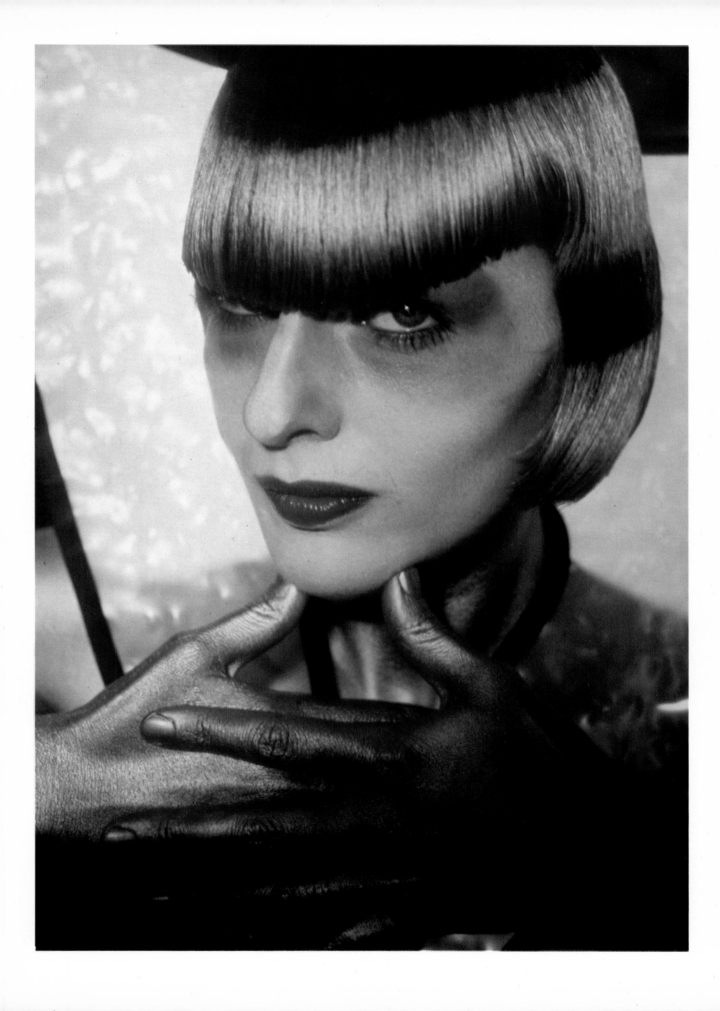

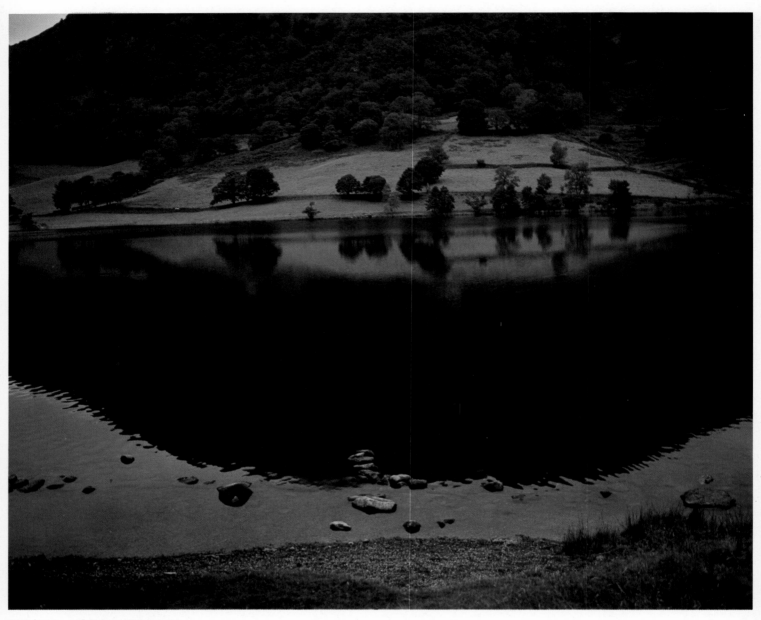

115/116 JORGE LEWINSKI

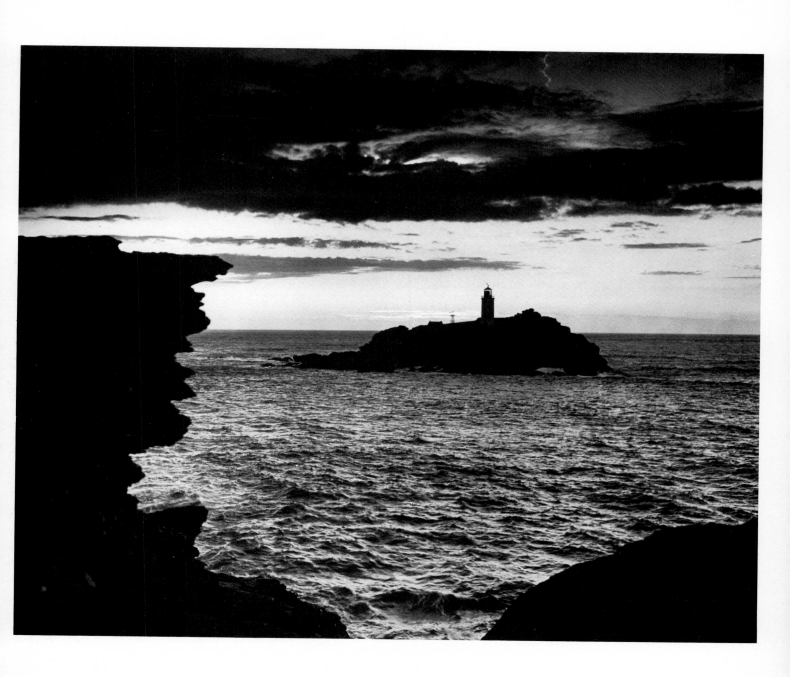

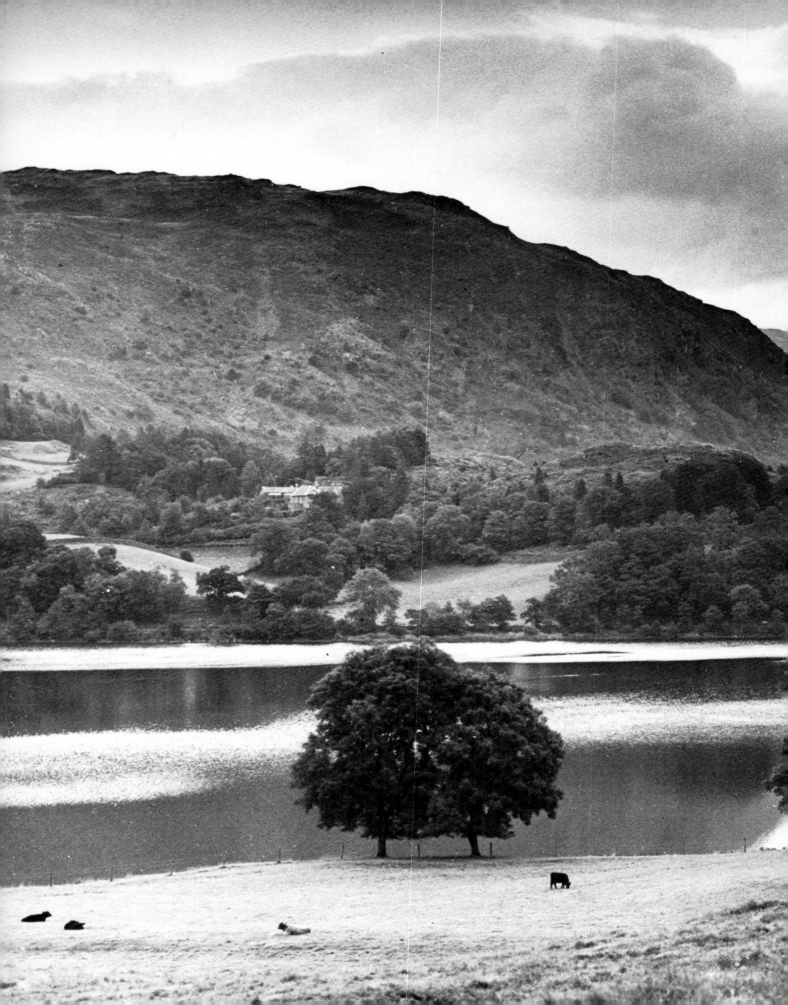

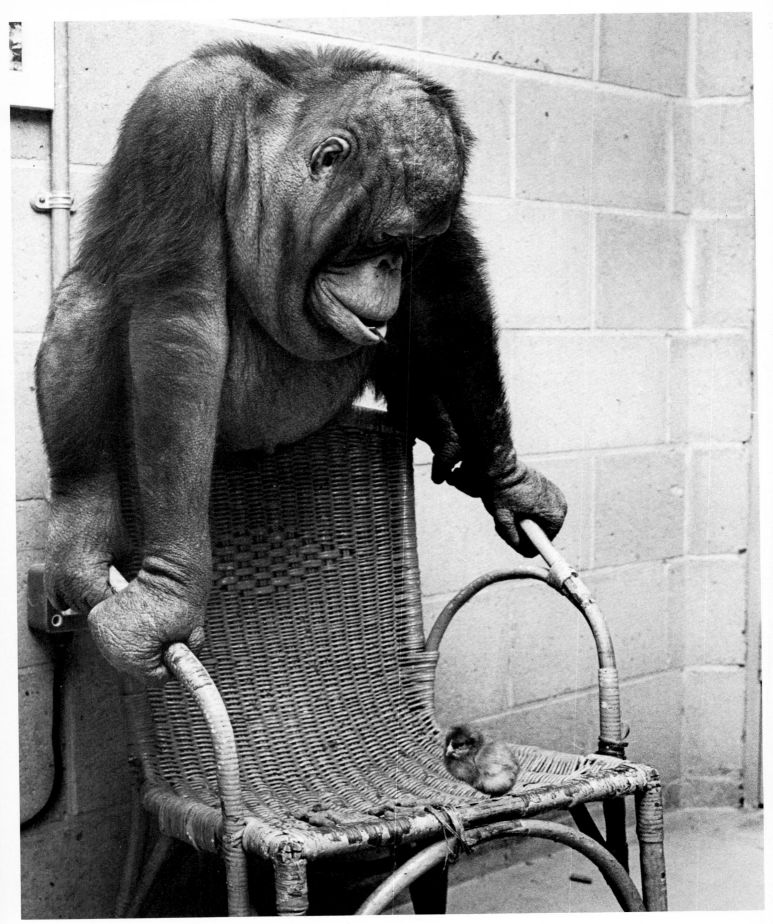

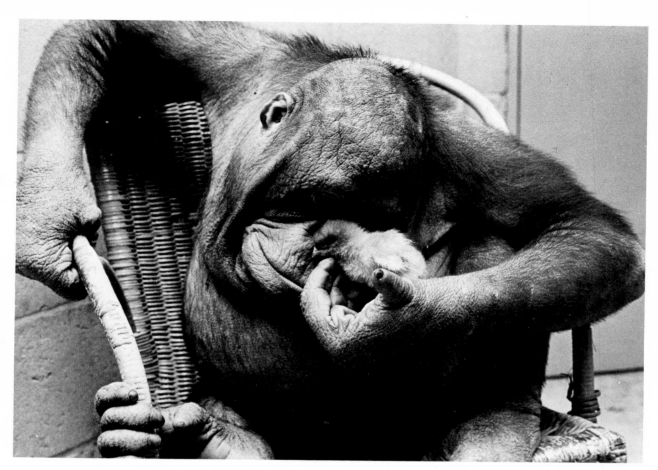

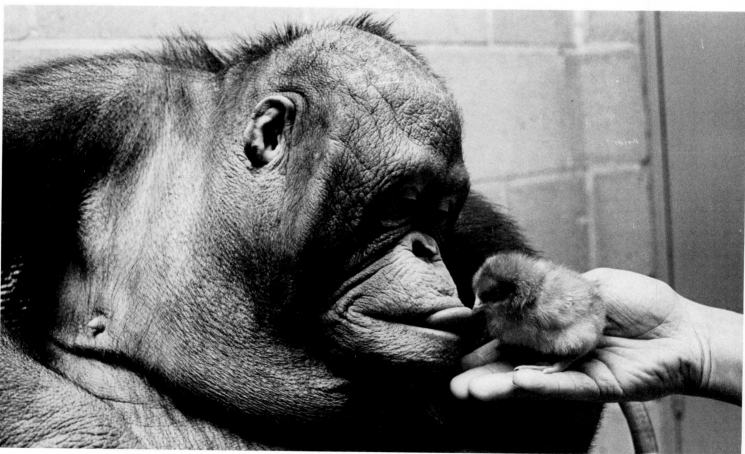

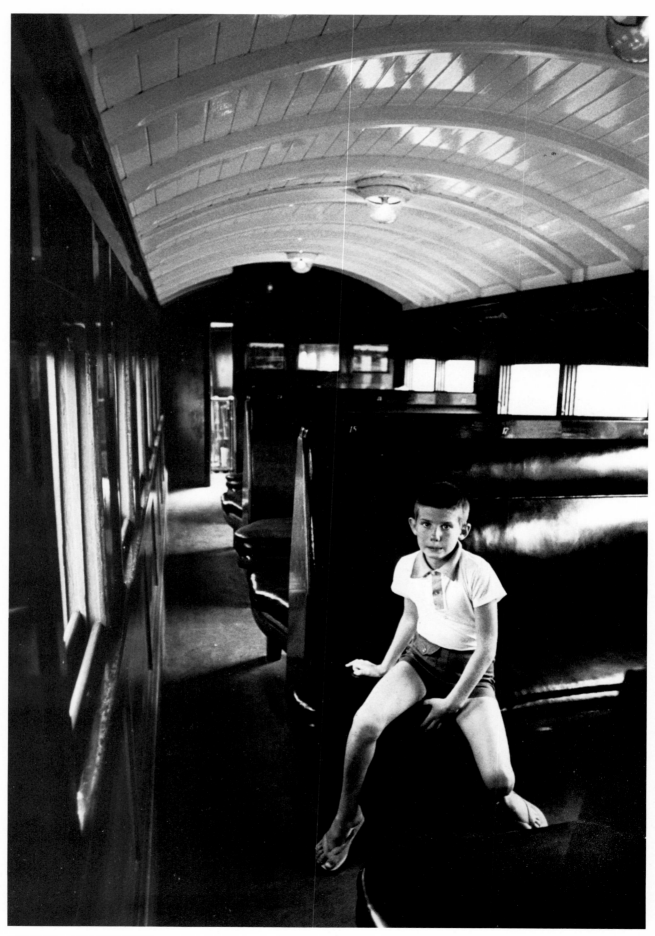

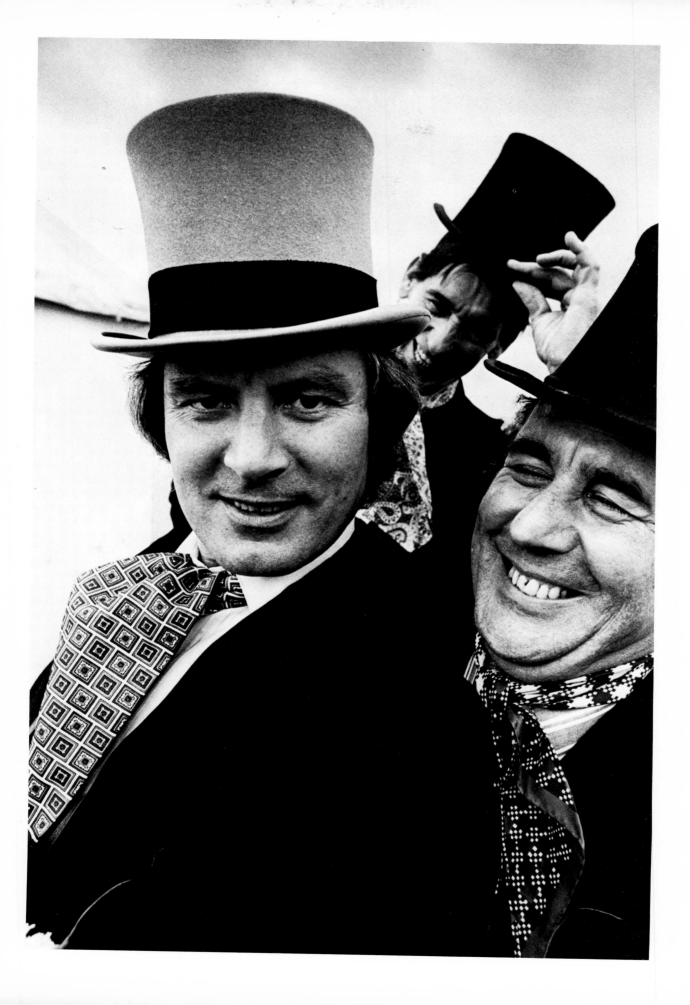

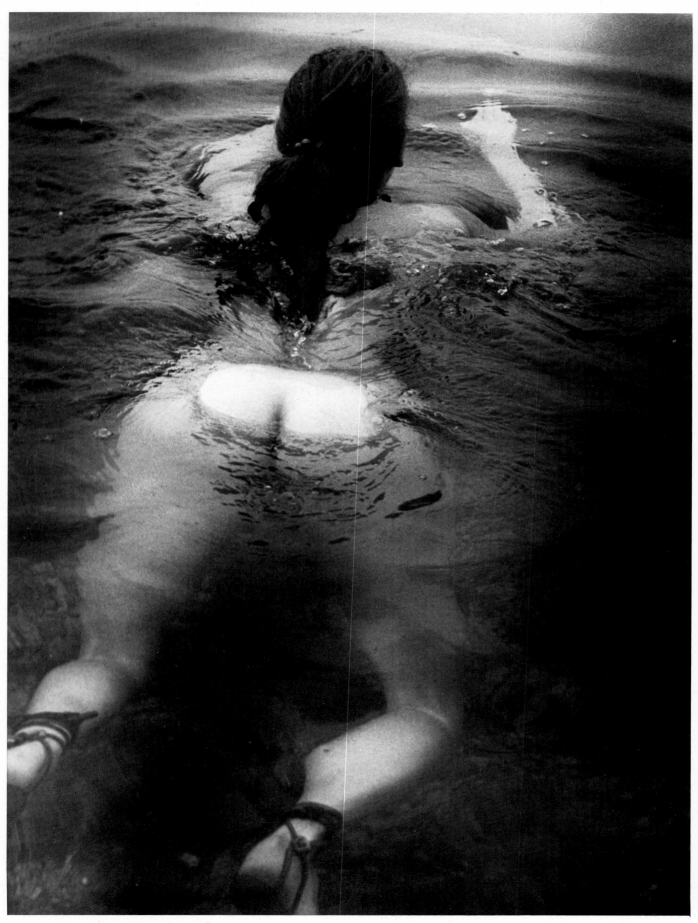

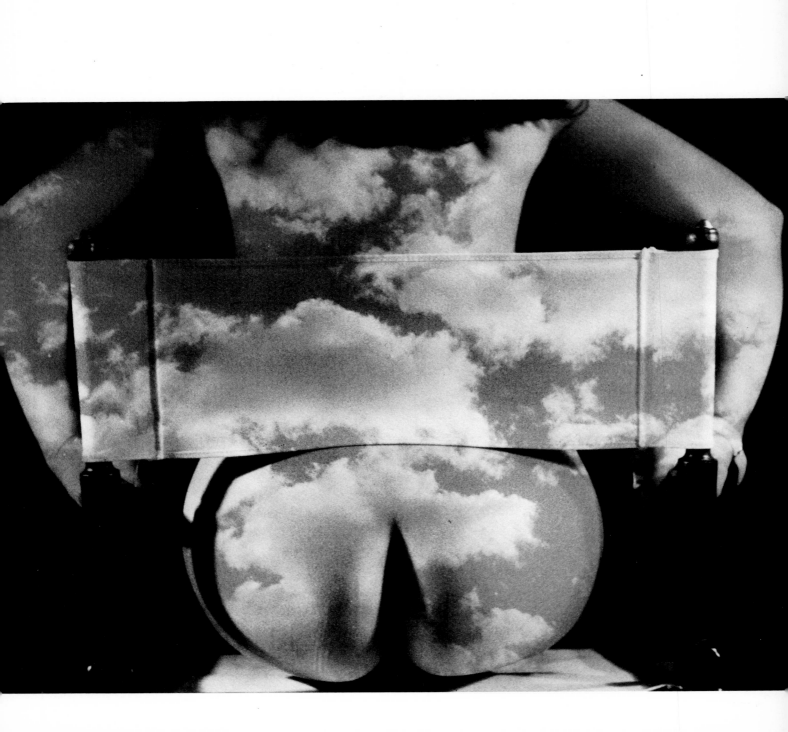

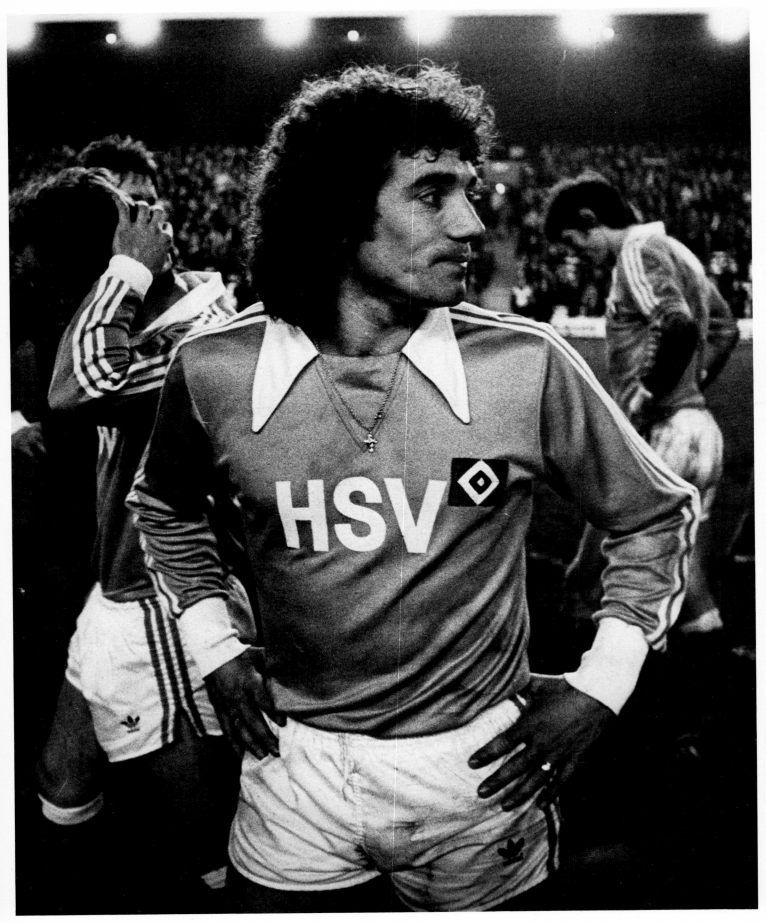

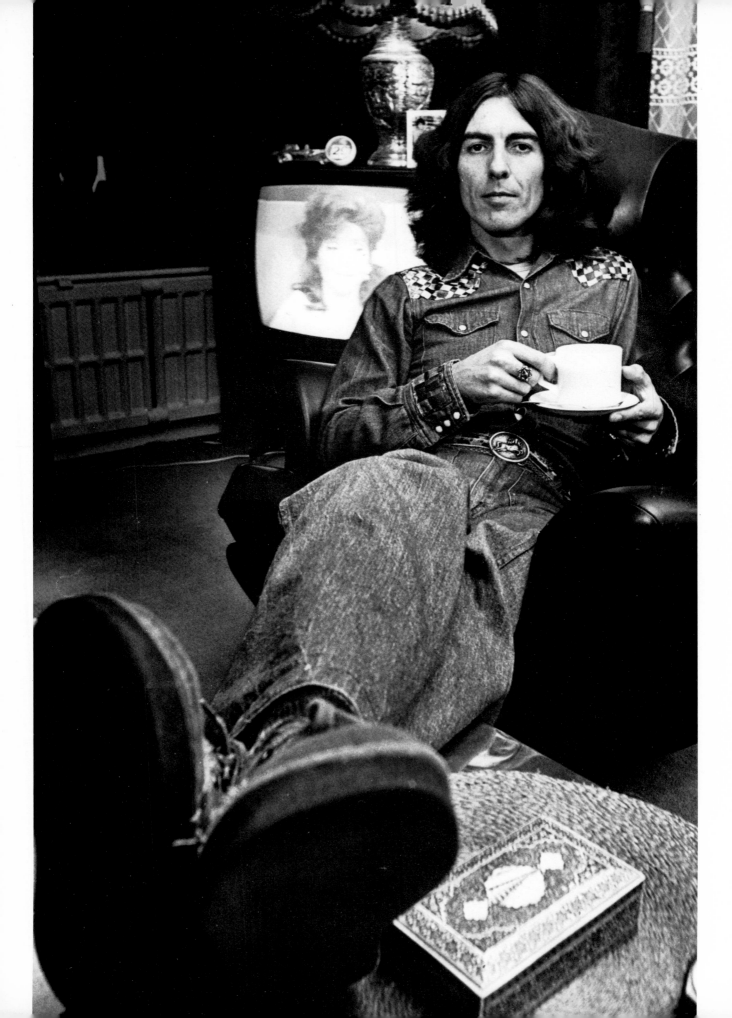

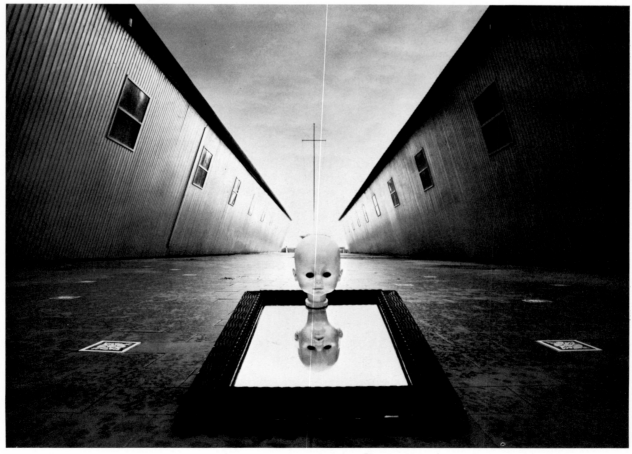

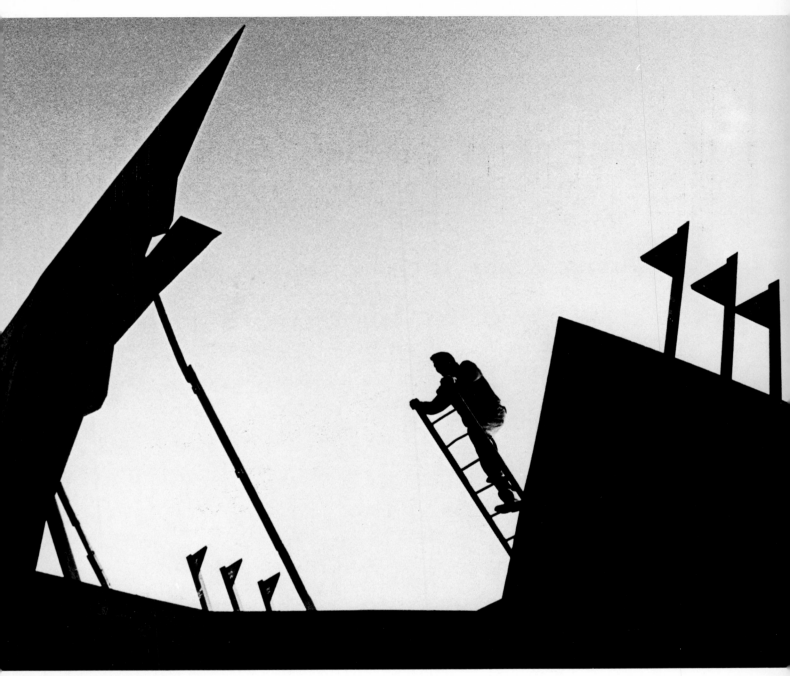

127/129 ENZO LOMBARDI

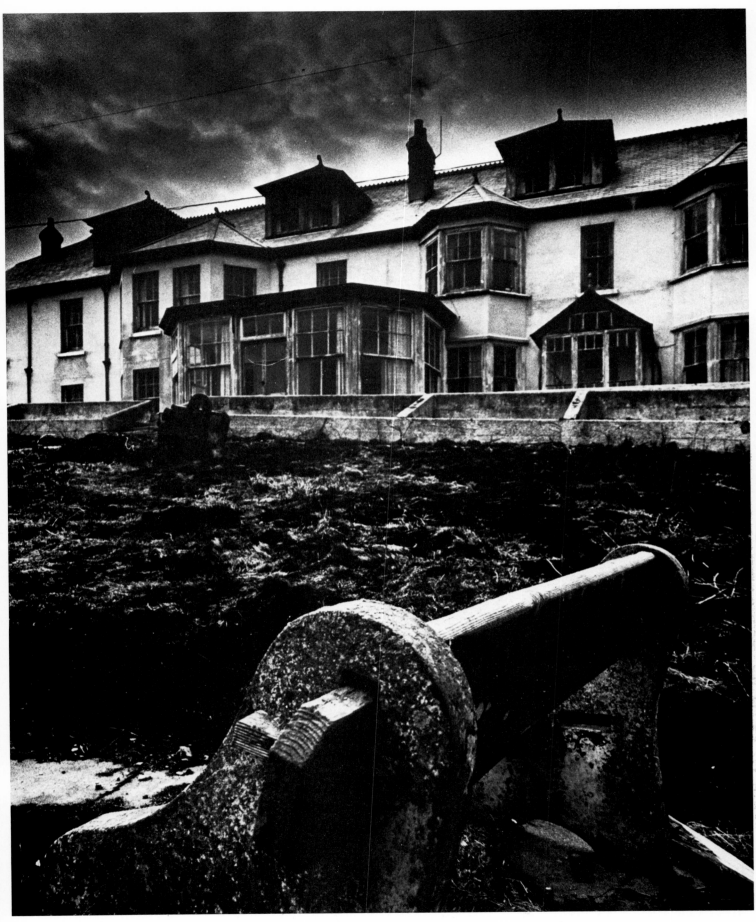

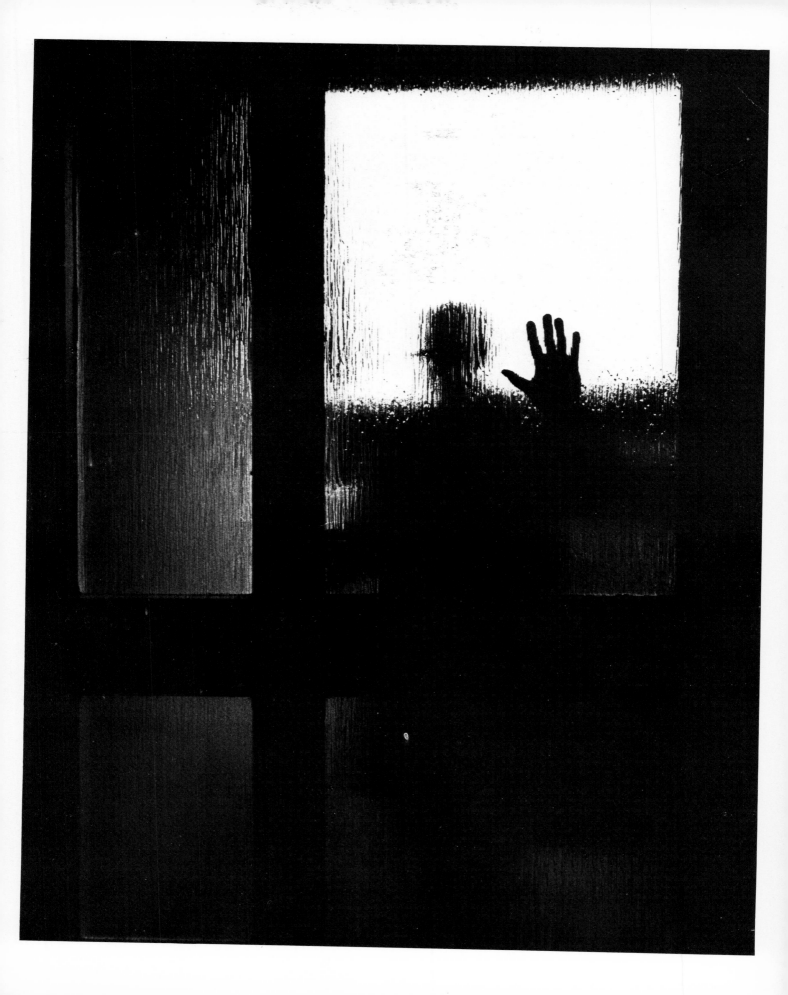

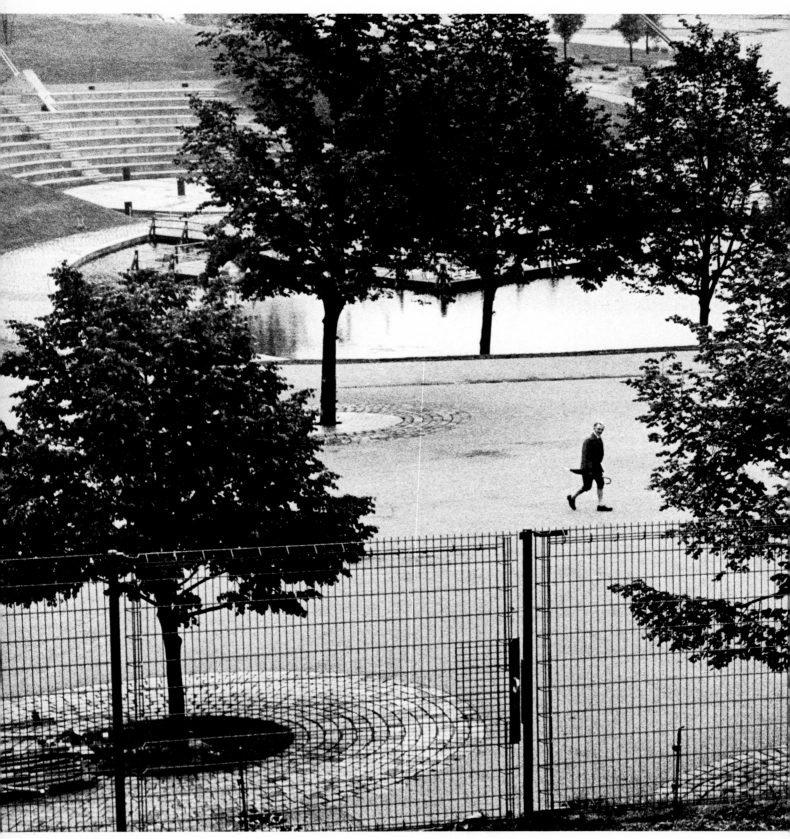

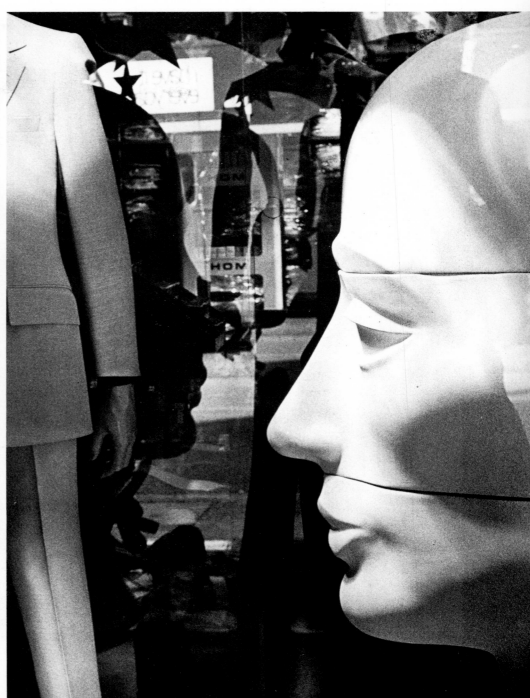

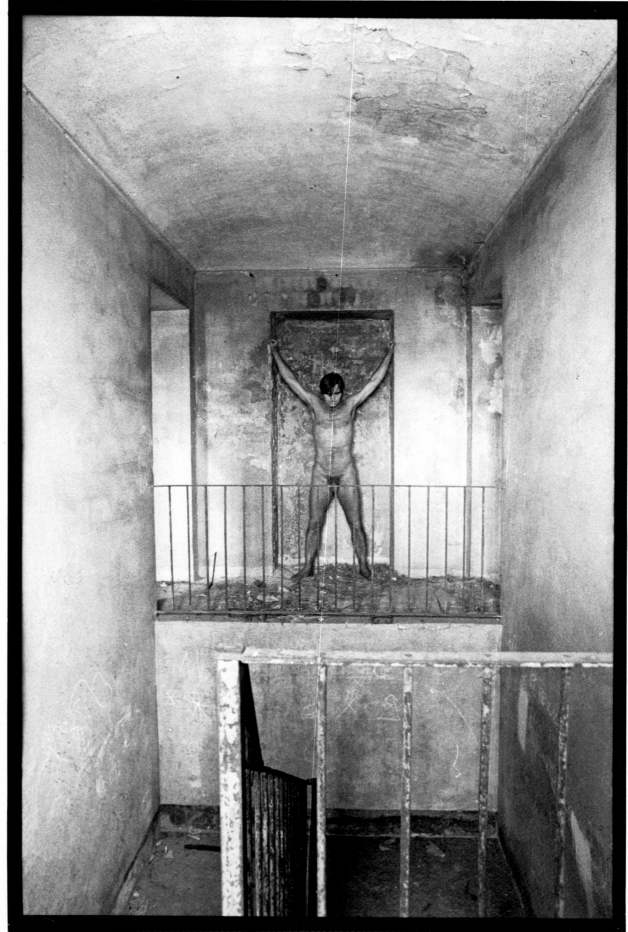

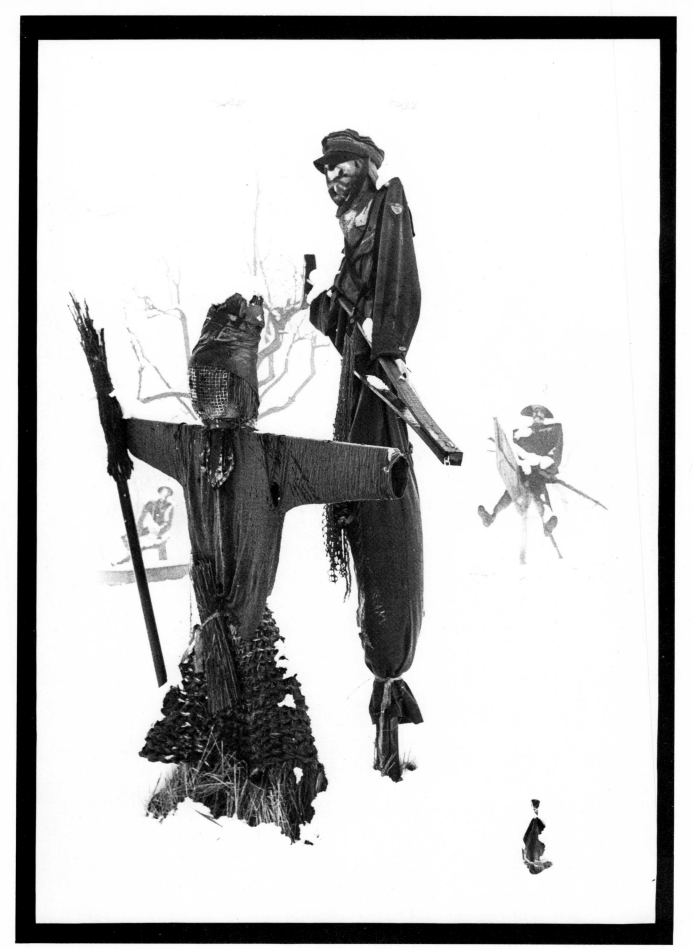

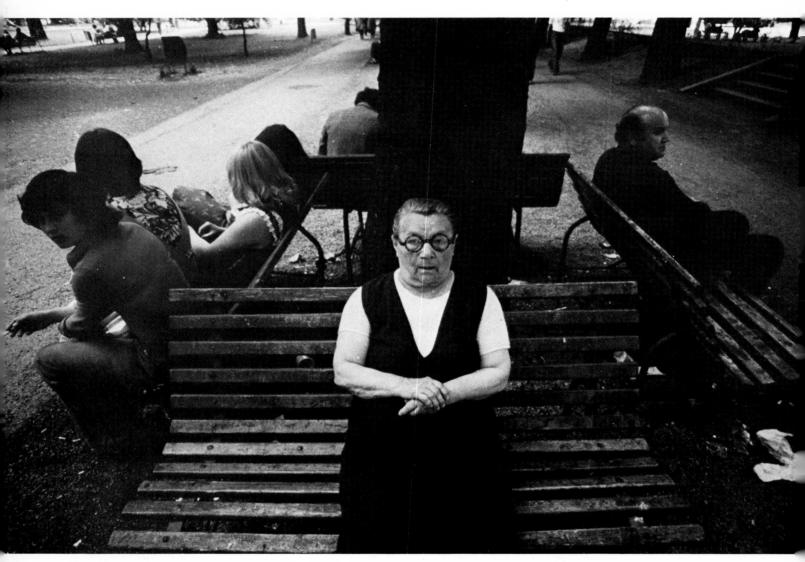

136/137 VLADO BACA

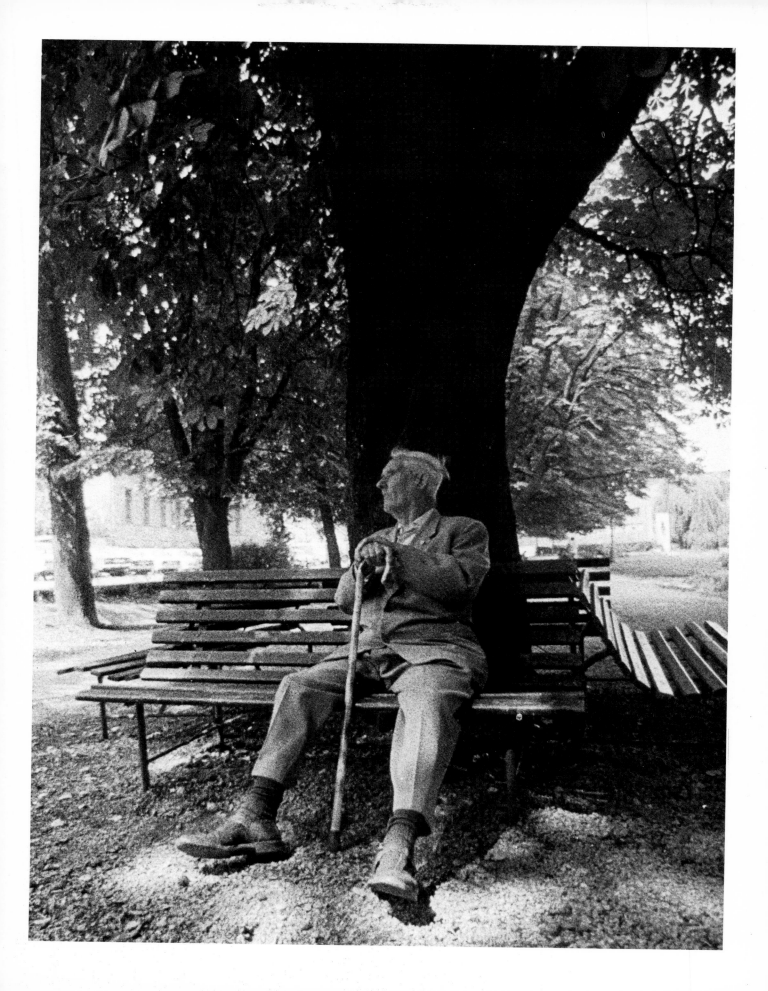

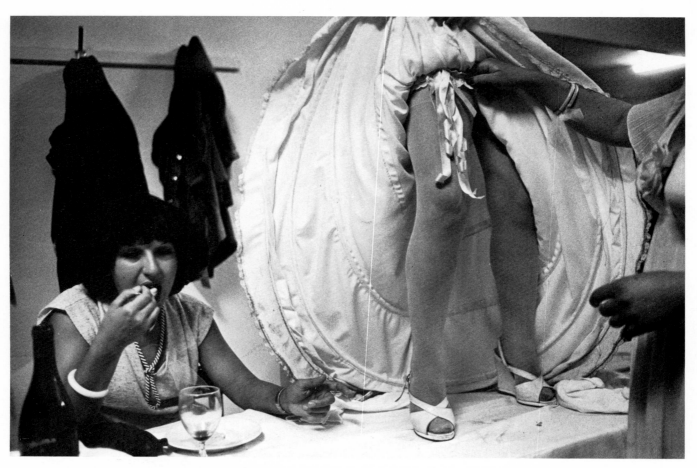

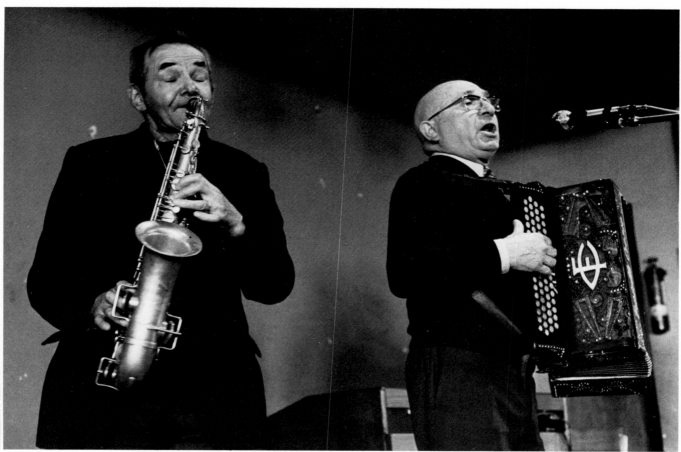

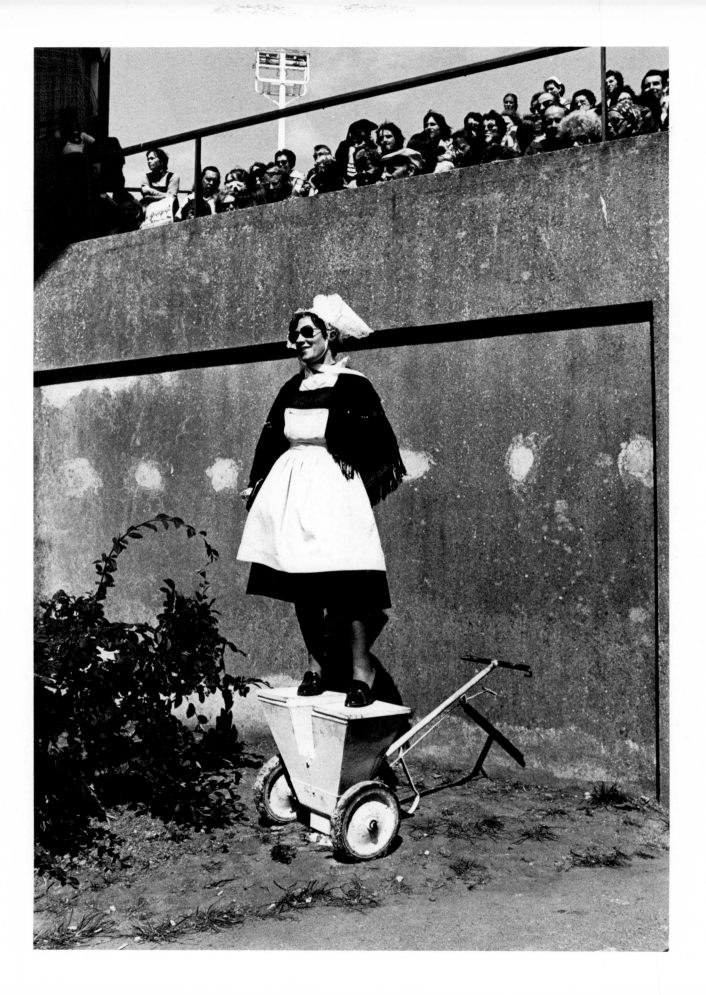

141/142 YORAM LEHMANN

143/144 YORAM LEHMANN

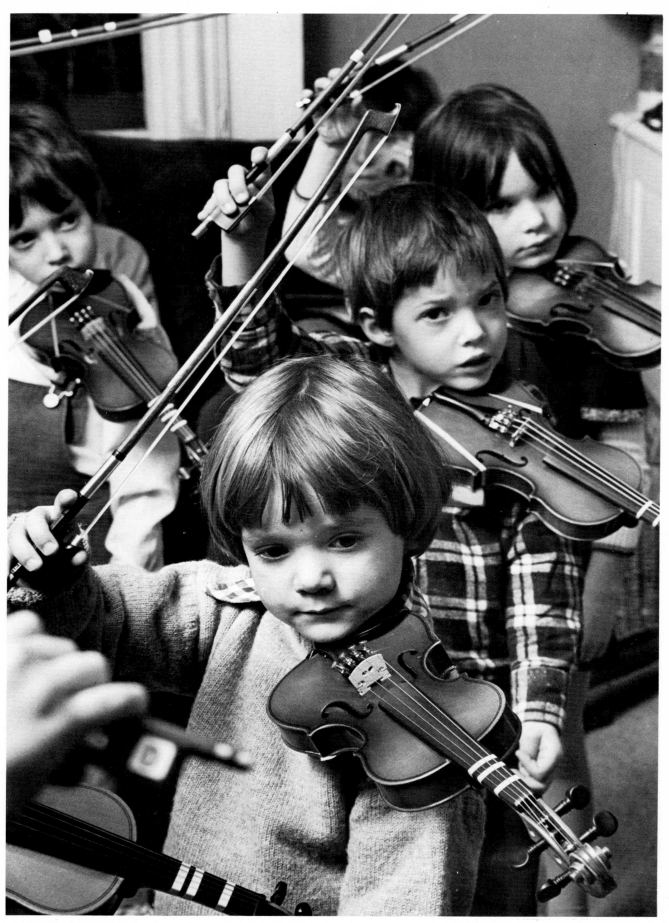

145/148 CHRIS CAPSTICK

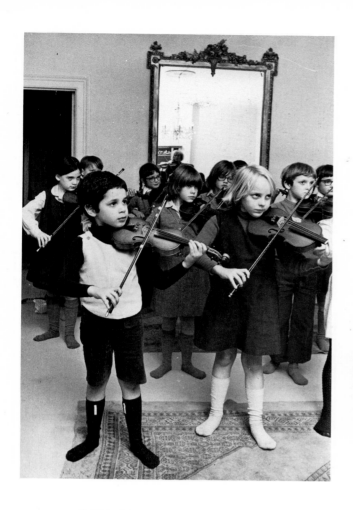
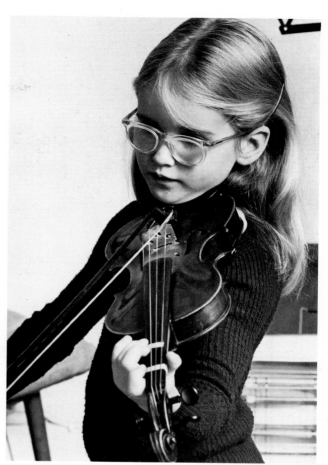
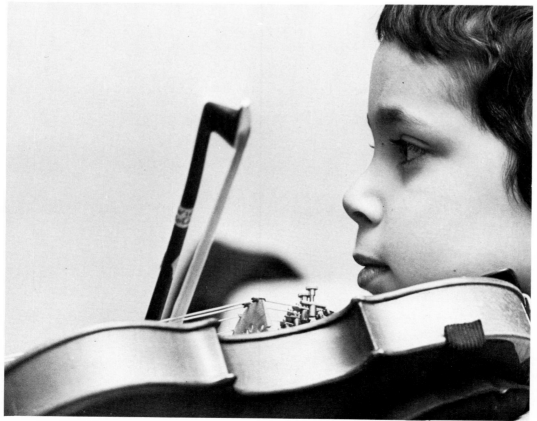

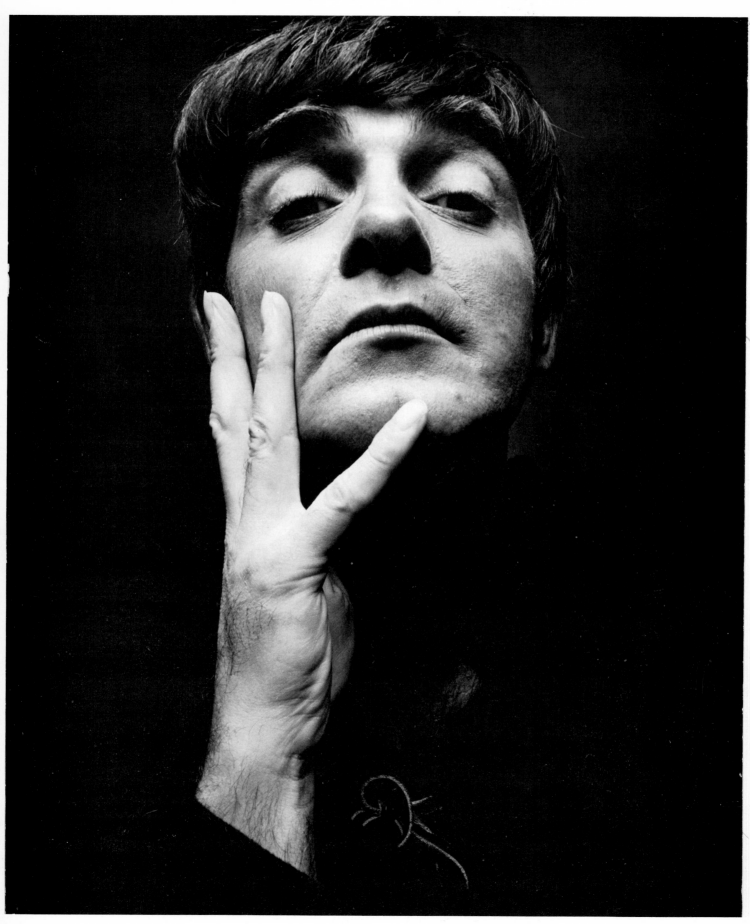

151/152 MICHAEL JOSEPH

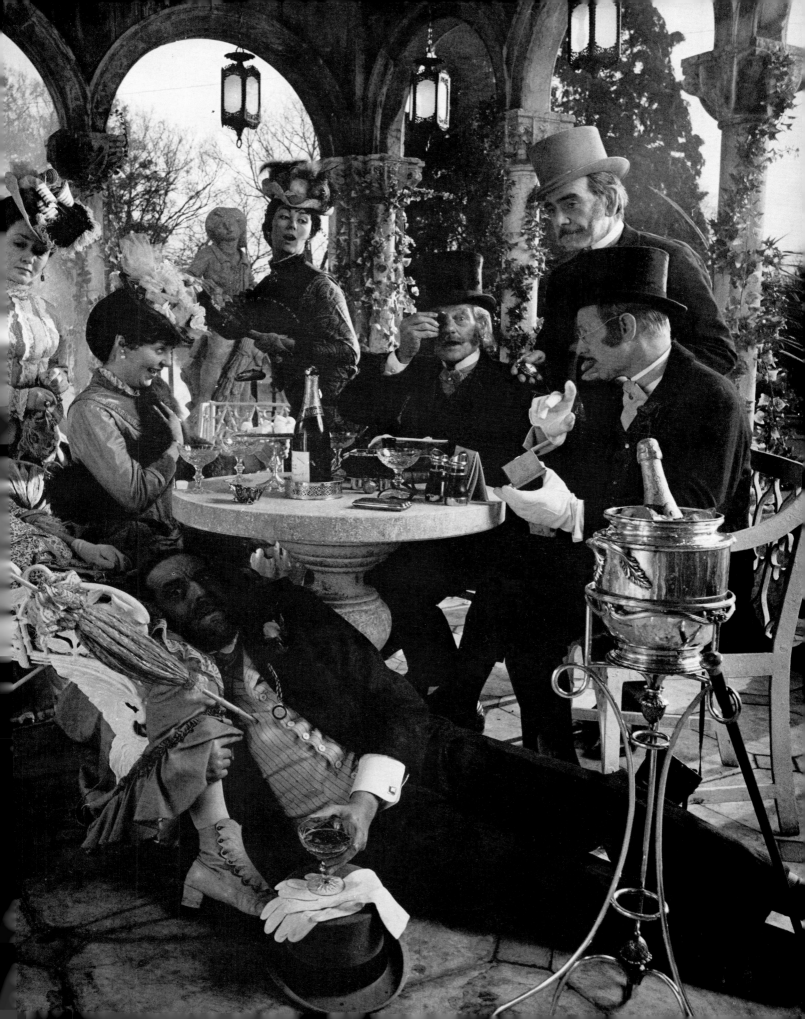

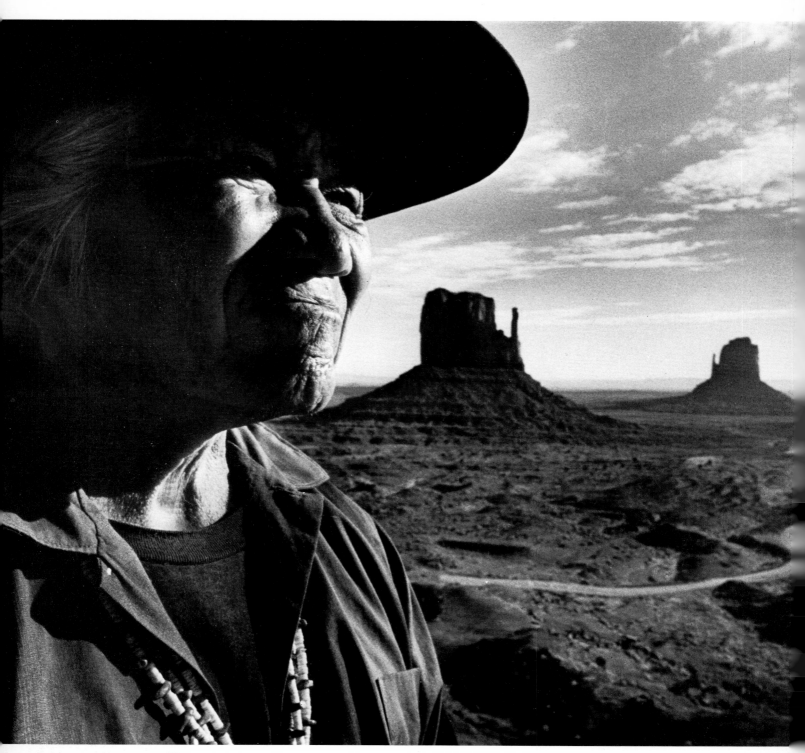

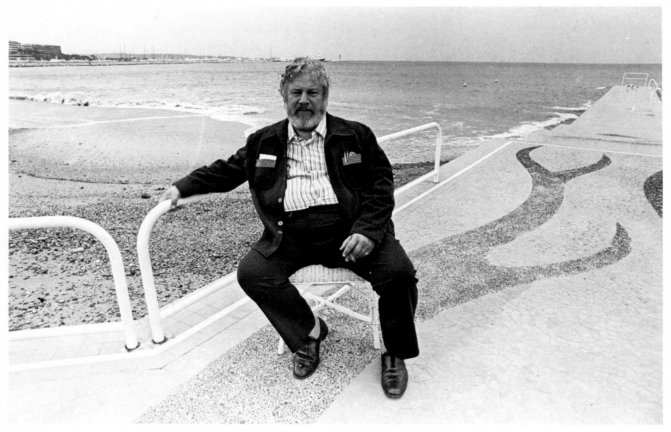

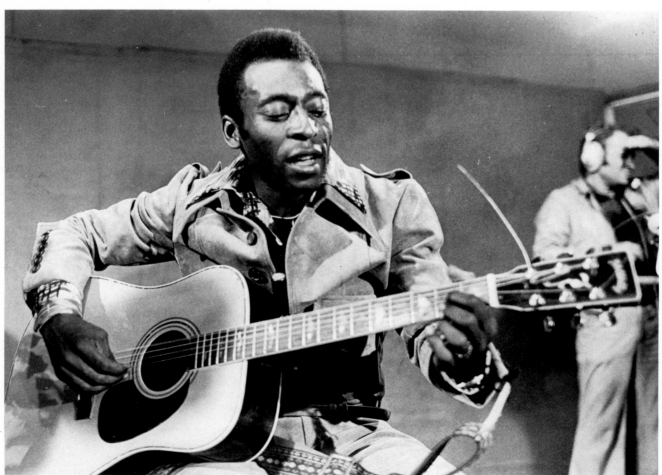

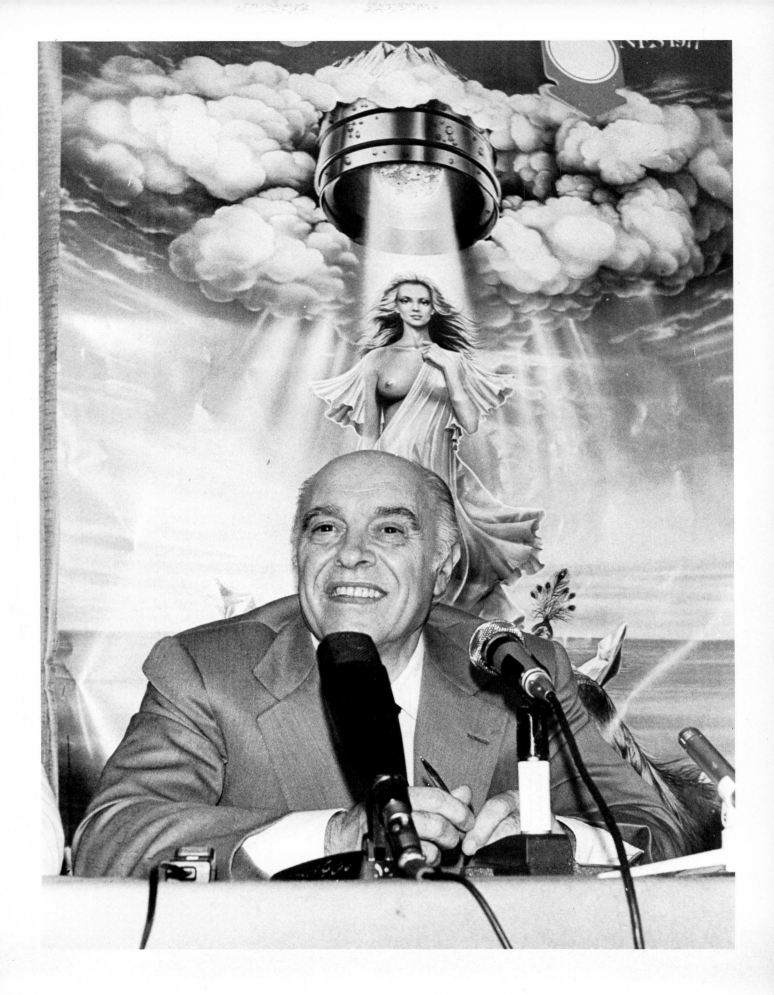

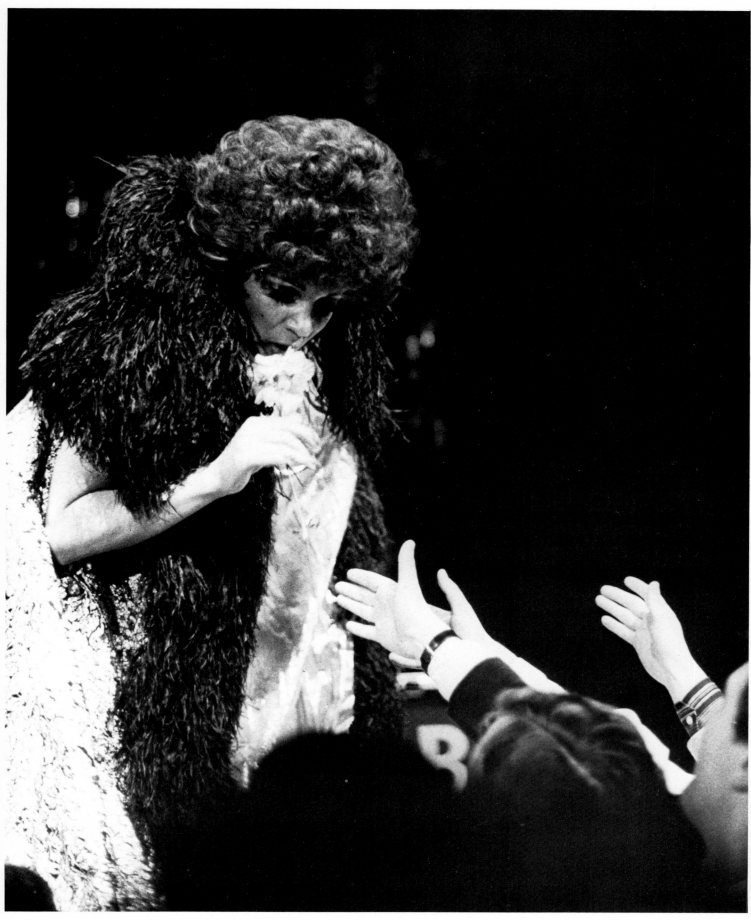

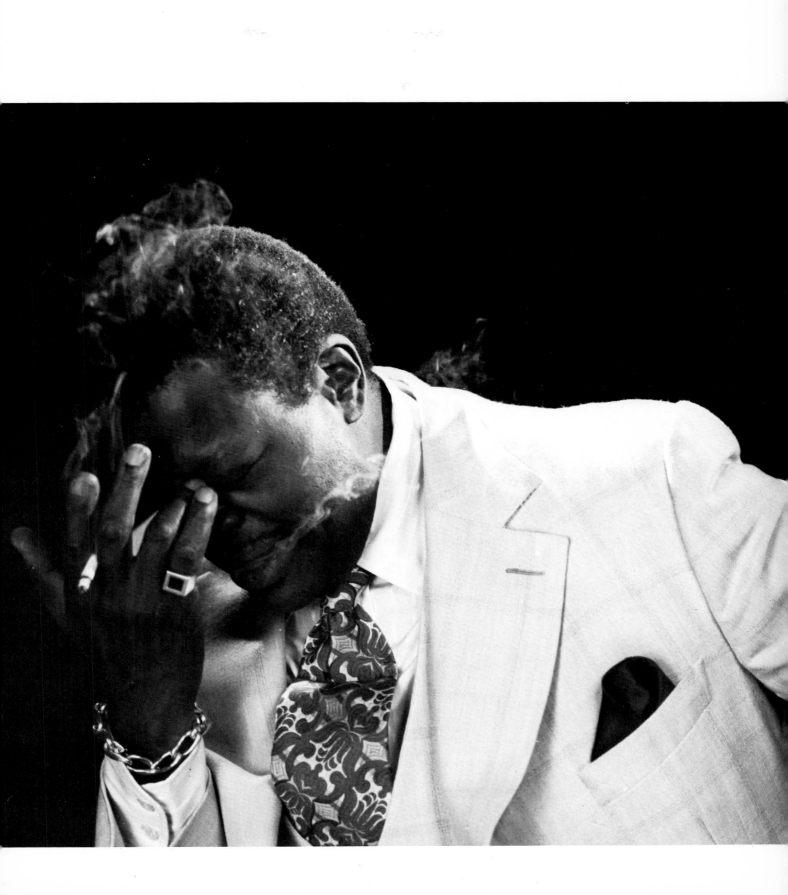

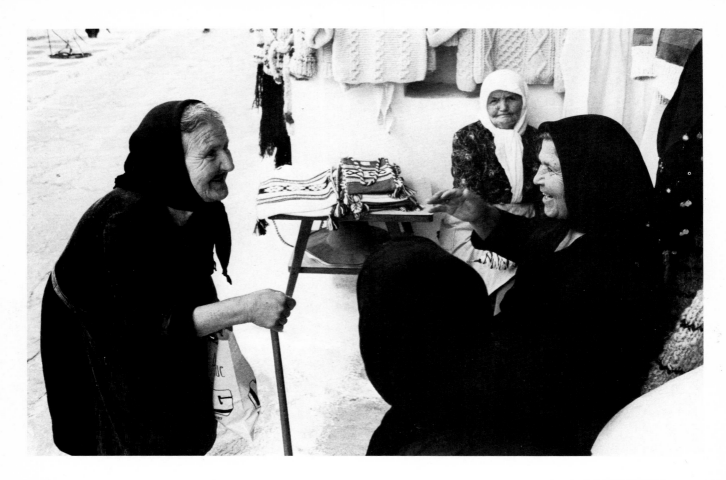

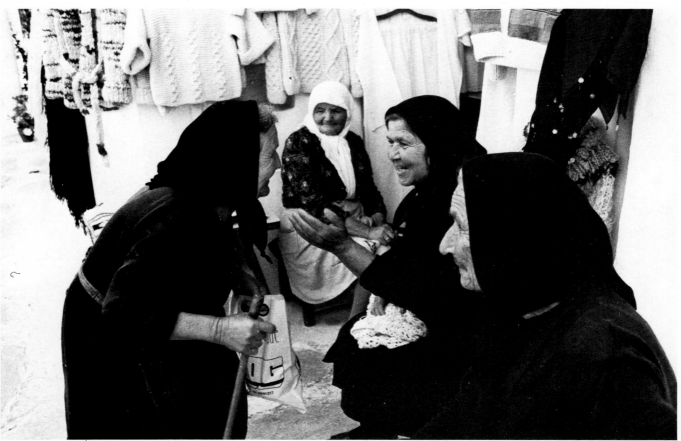

160/163 RAYMOND DE BERQUELLE

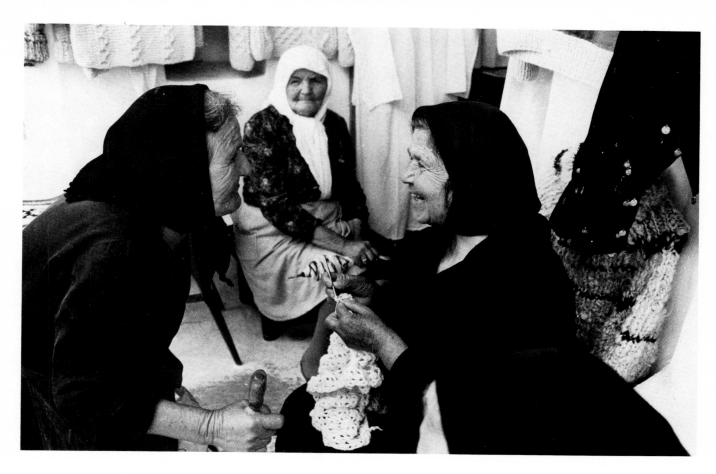

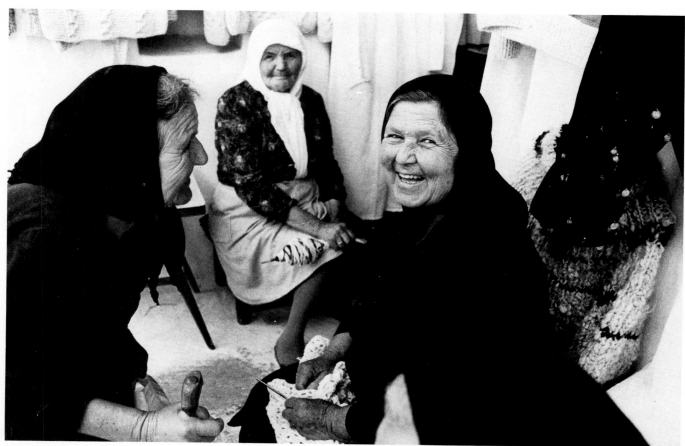

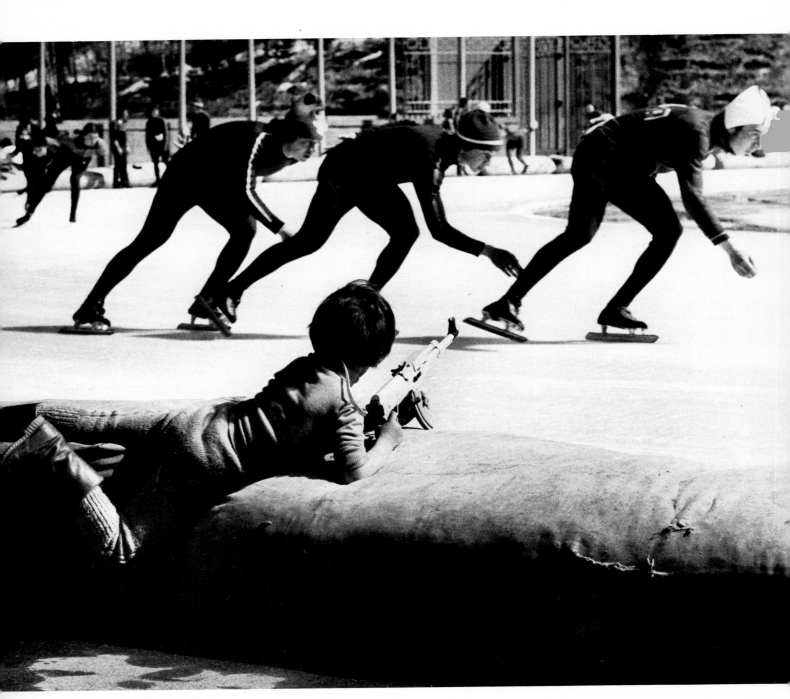

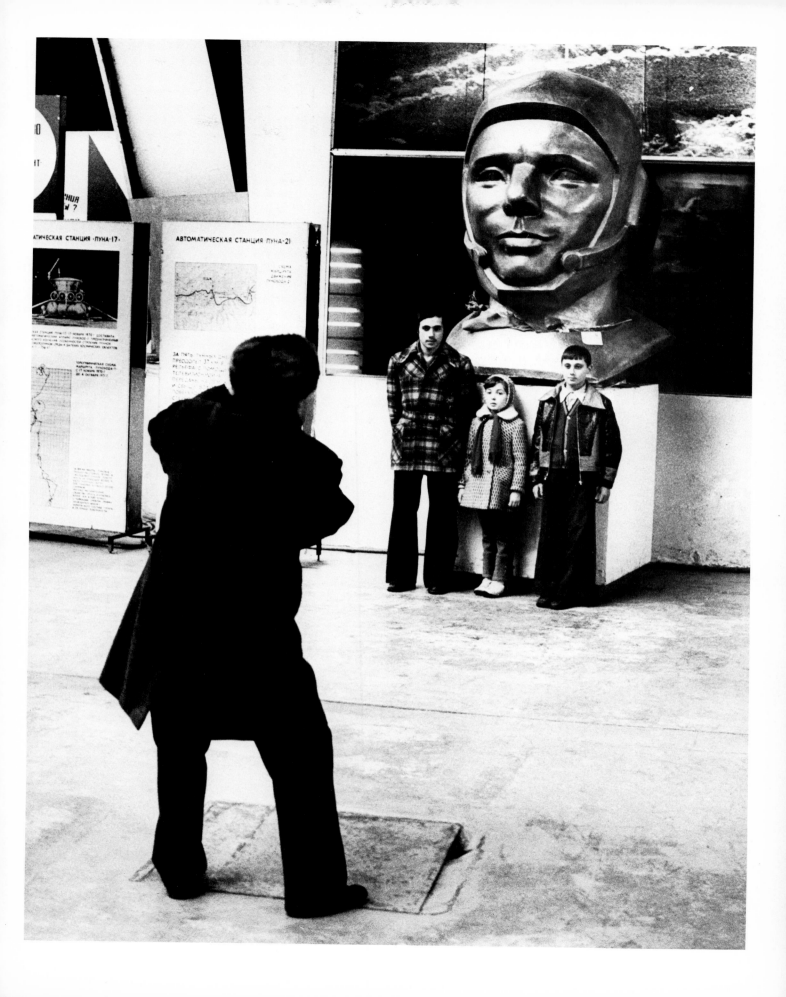

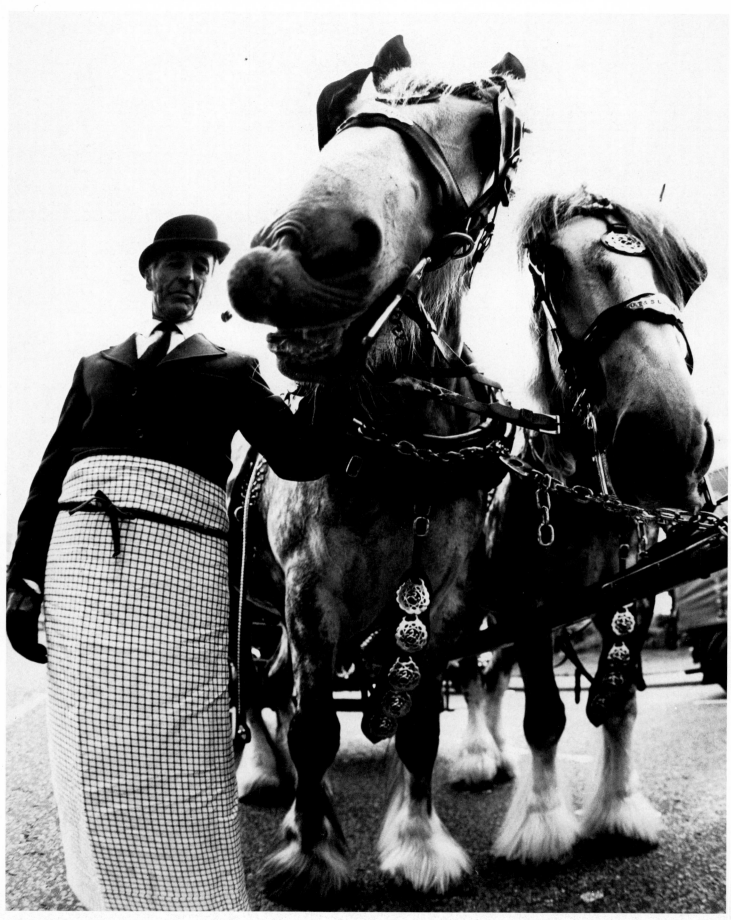

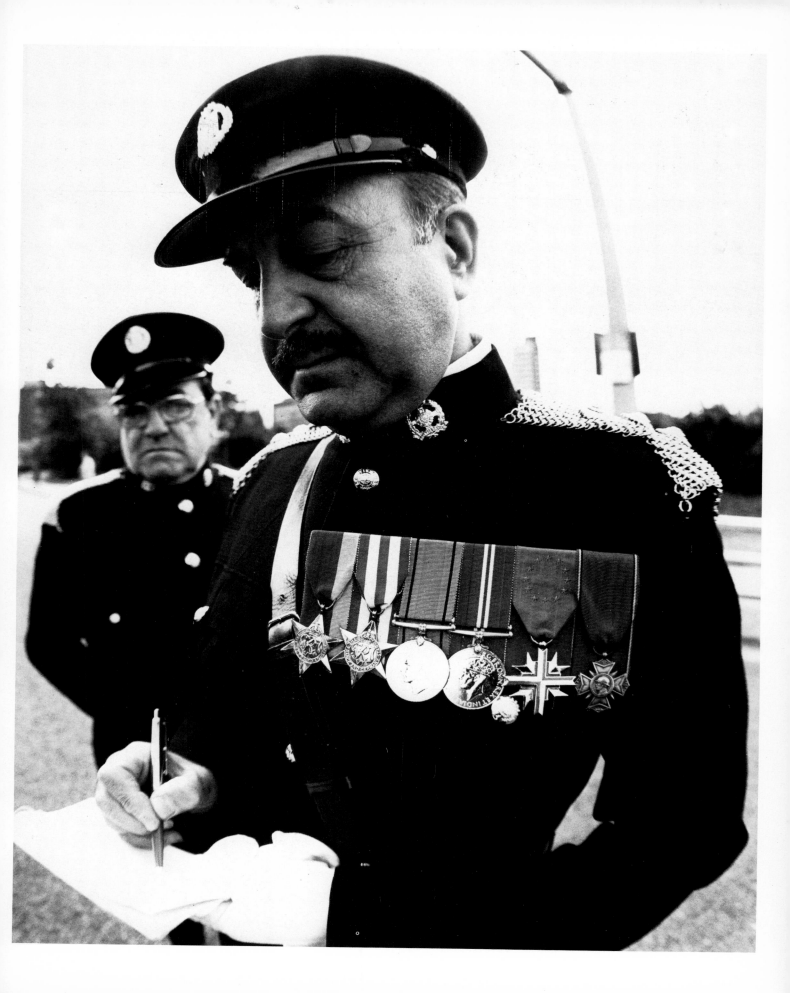

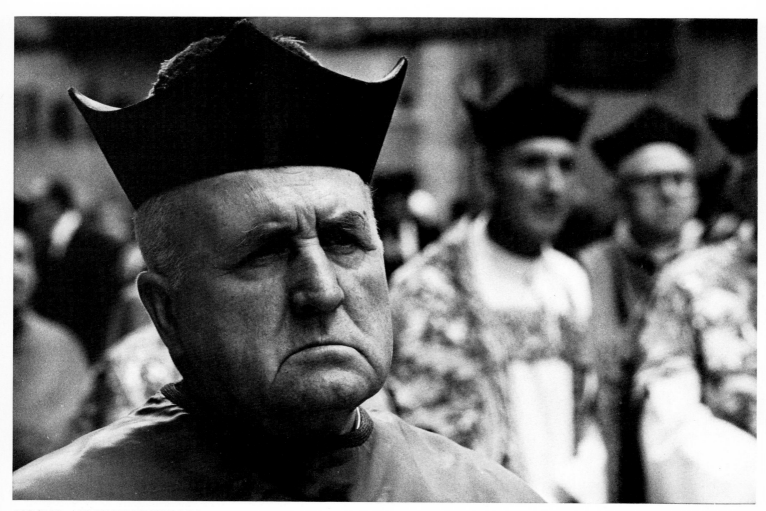

168/169 JOSE TORREGROSA

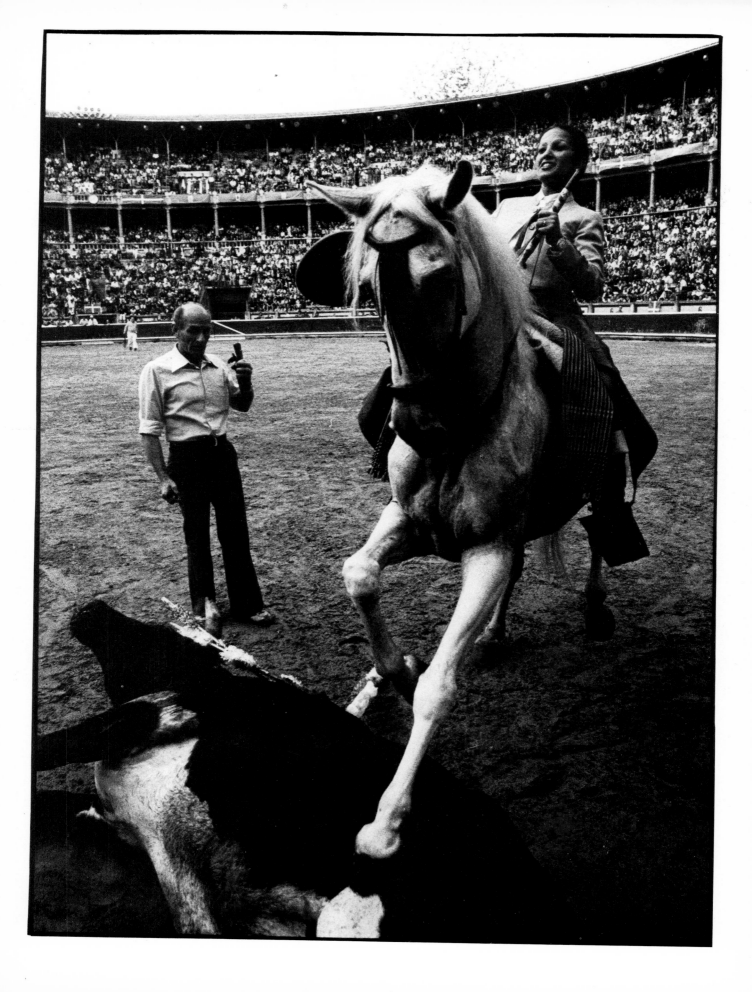

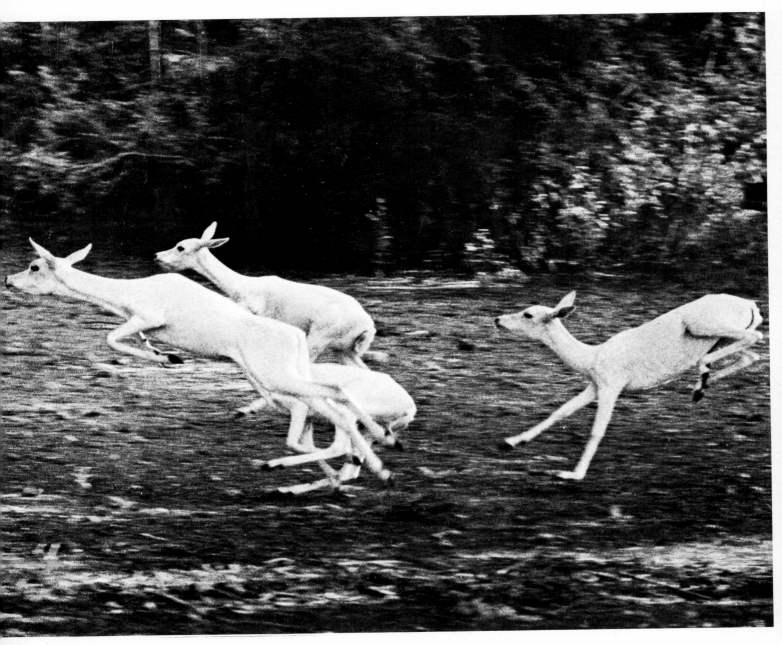

170/171 S. PAUL

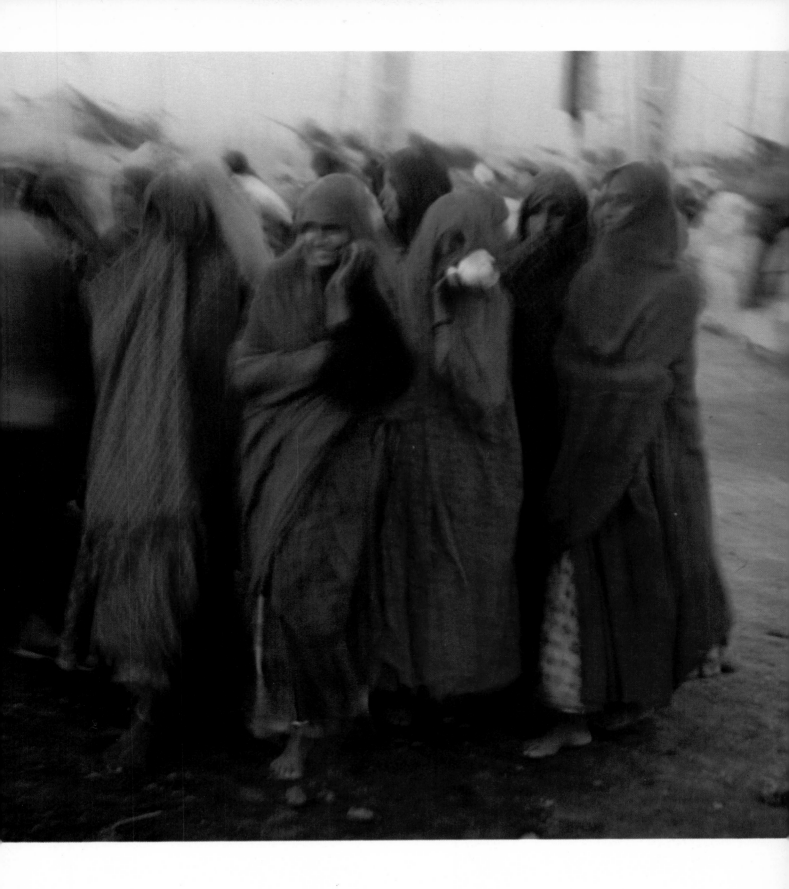

172/175 JOSE TORREGROSA

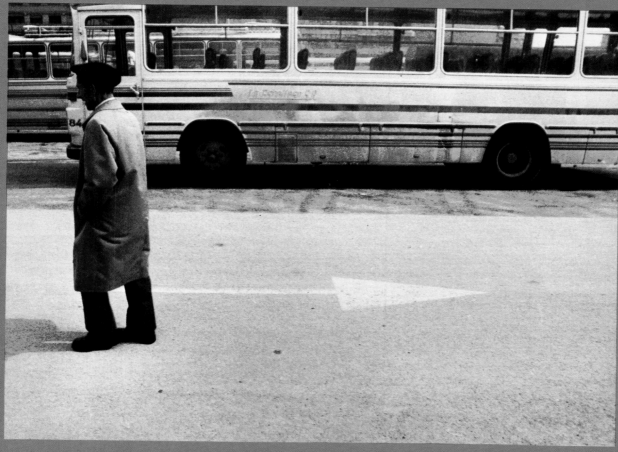

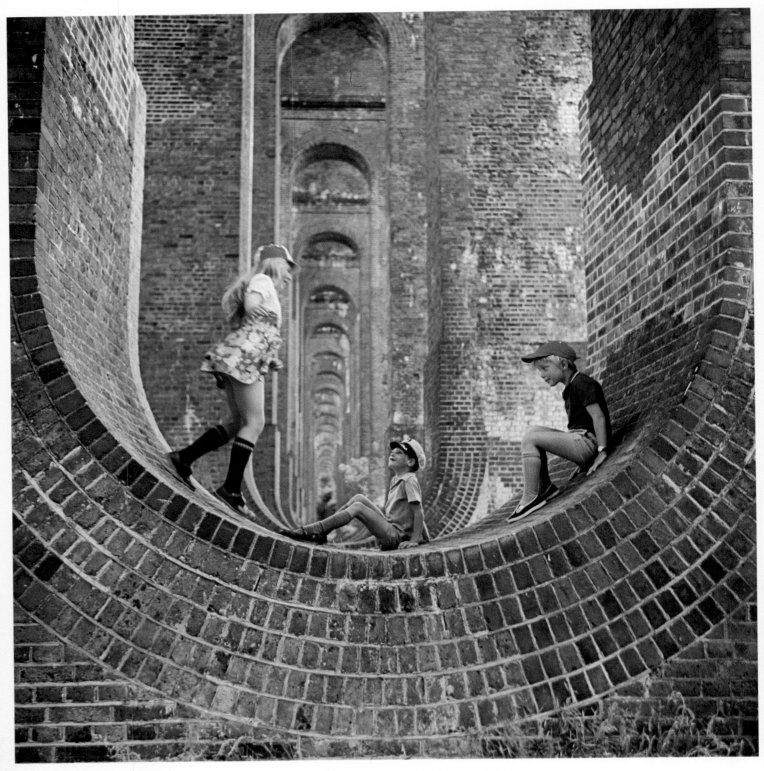

TONY BOXALL

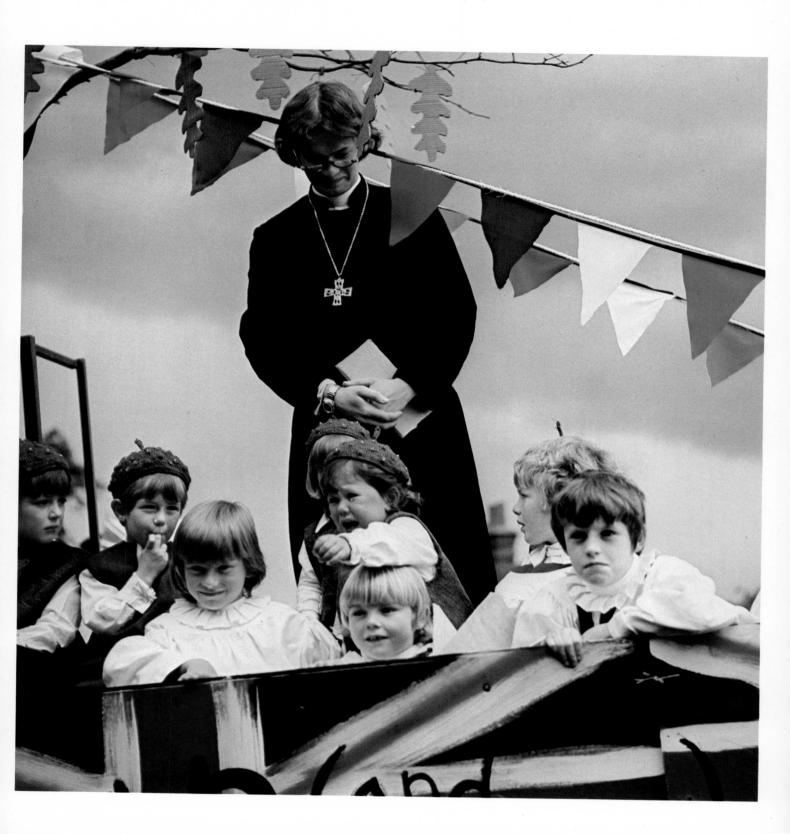

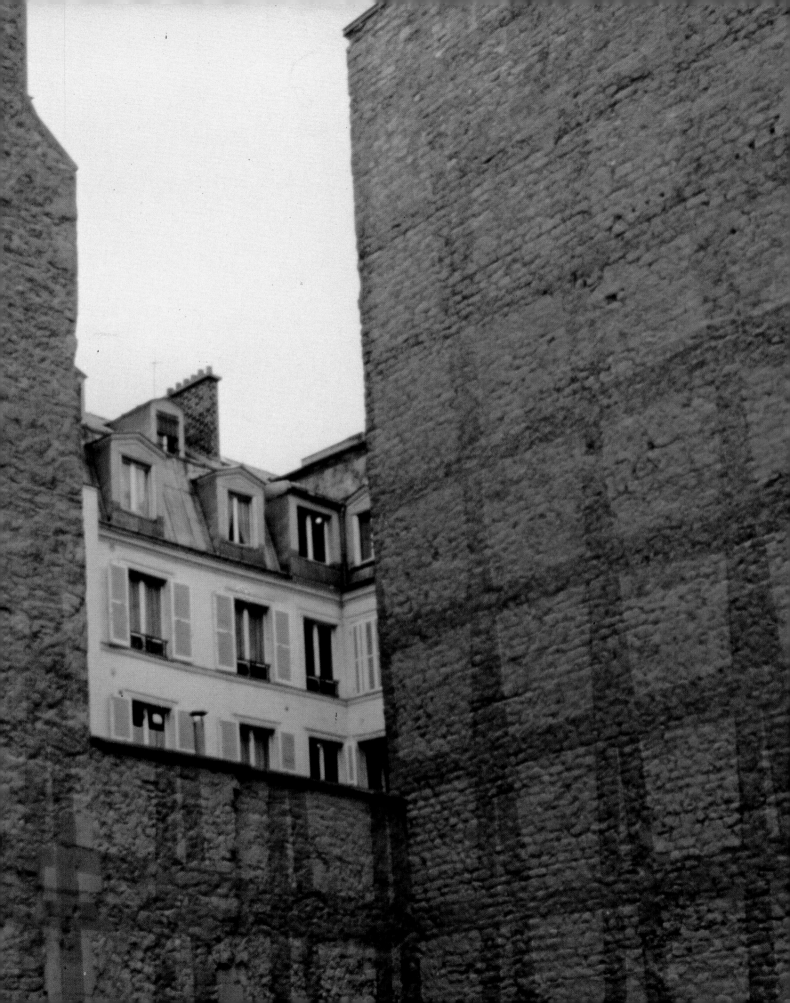

179 GERI DELLA ROCCA DE CANDAL **180** JAMES ELLIOTT

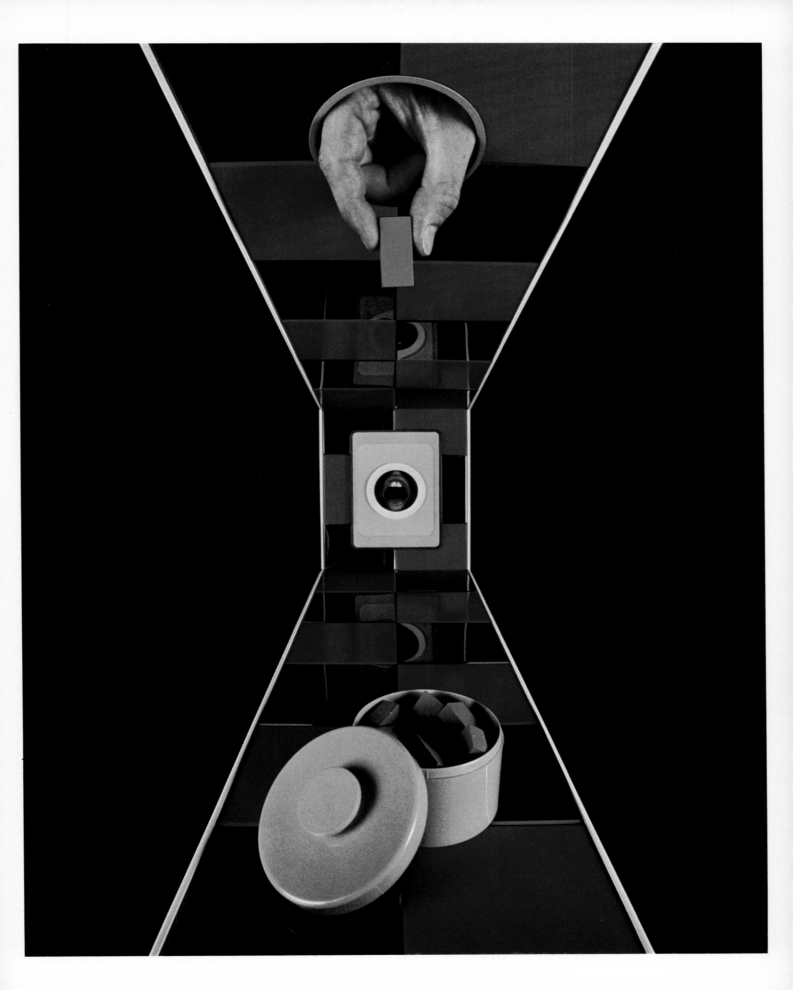

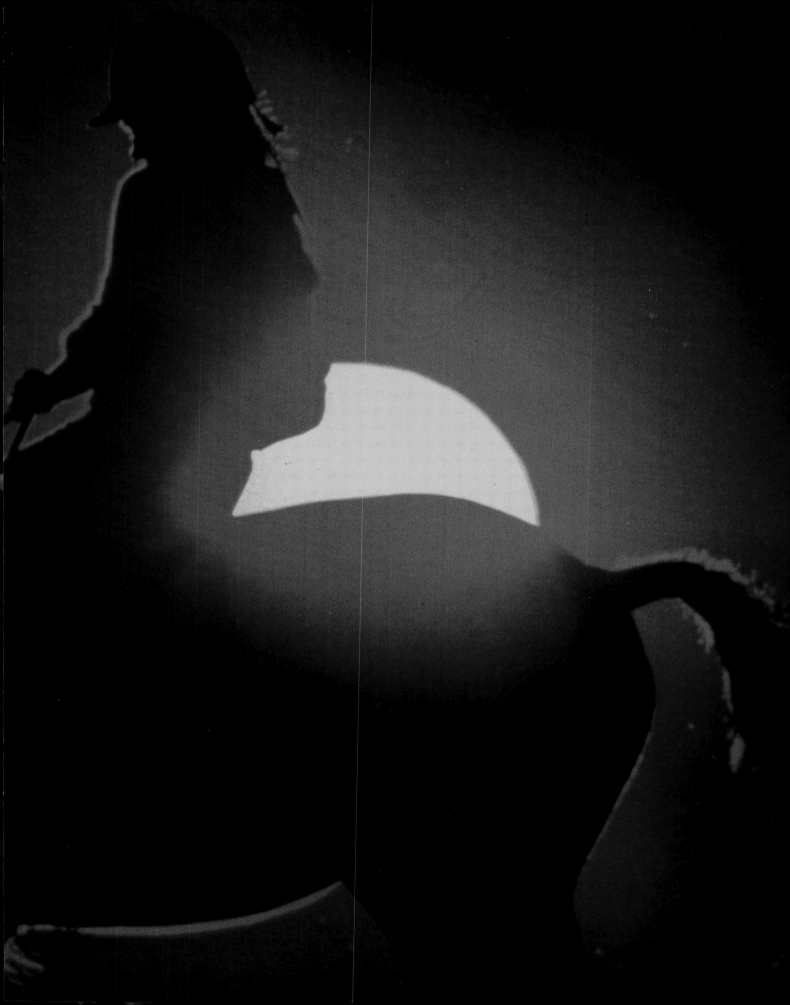

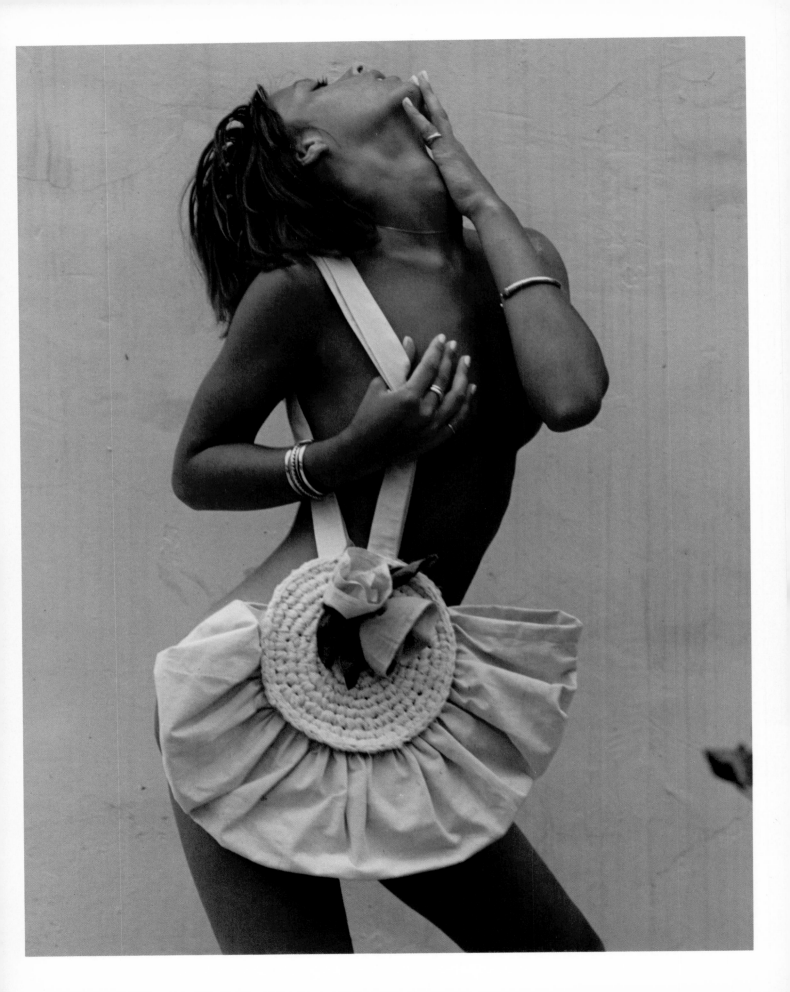

182/183 JACQUES BOURBOULON

185/186 TSANG CHI-YEN

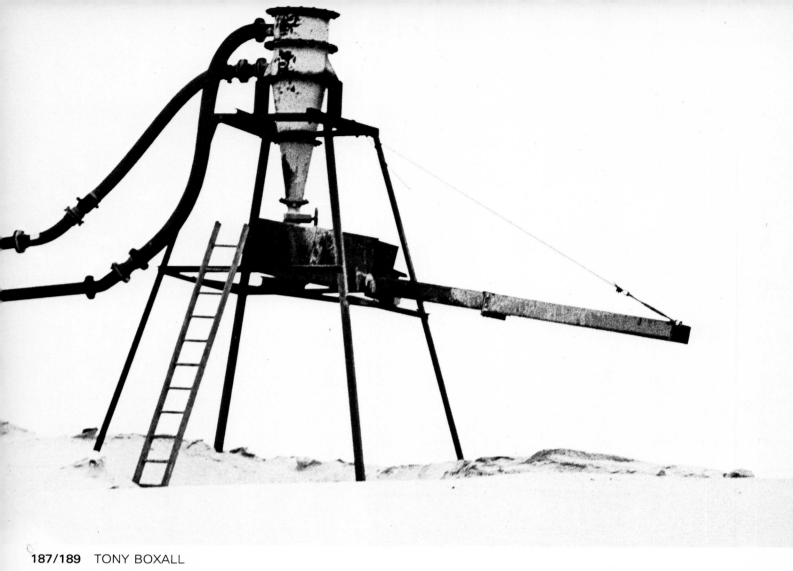

187/189 TONY BOXALL

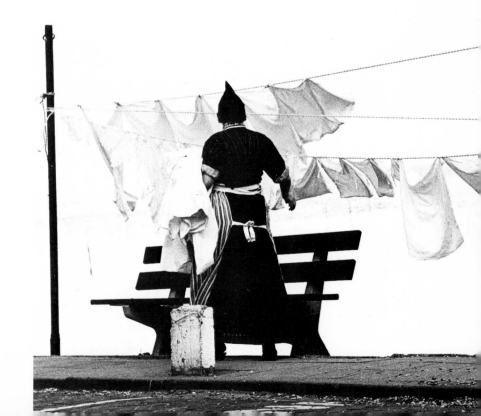

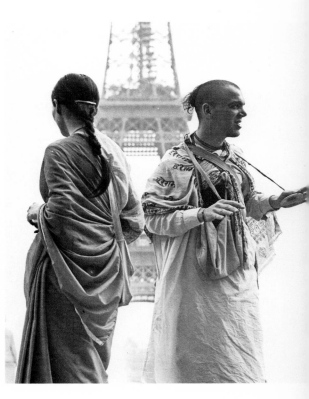

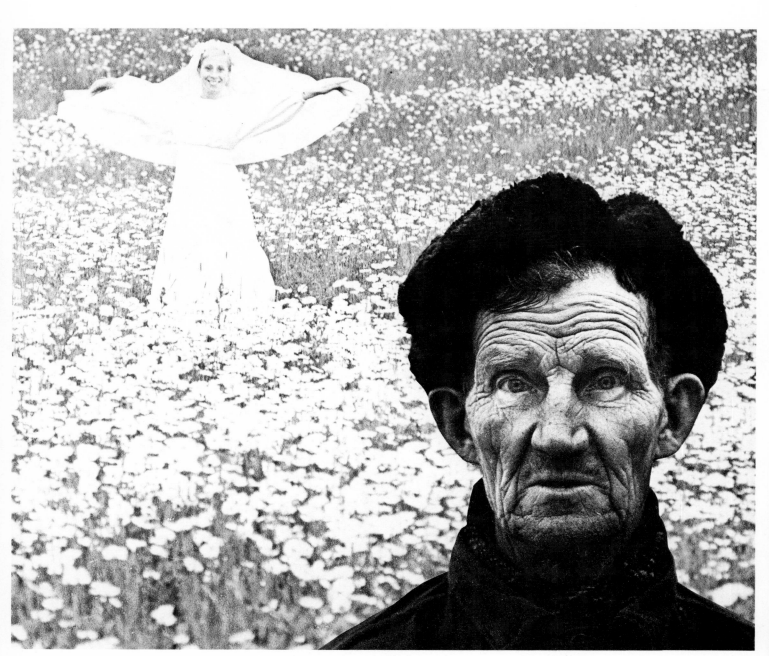

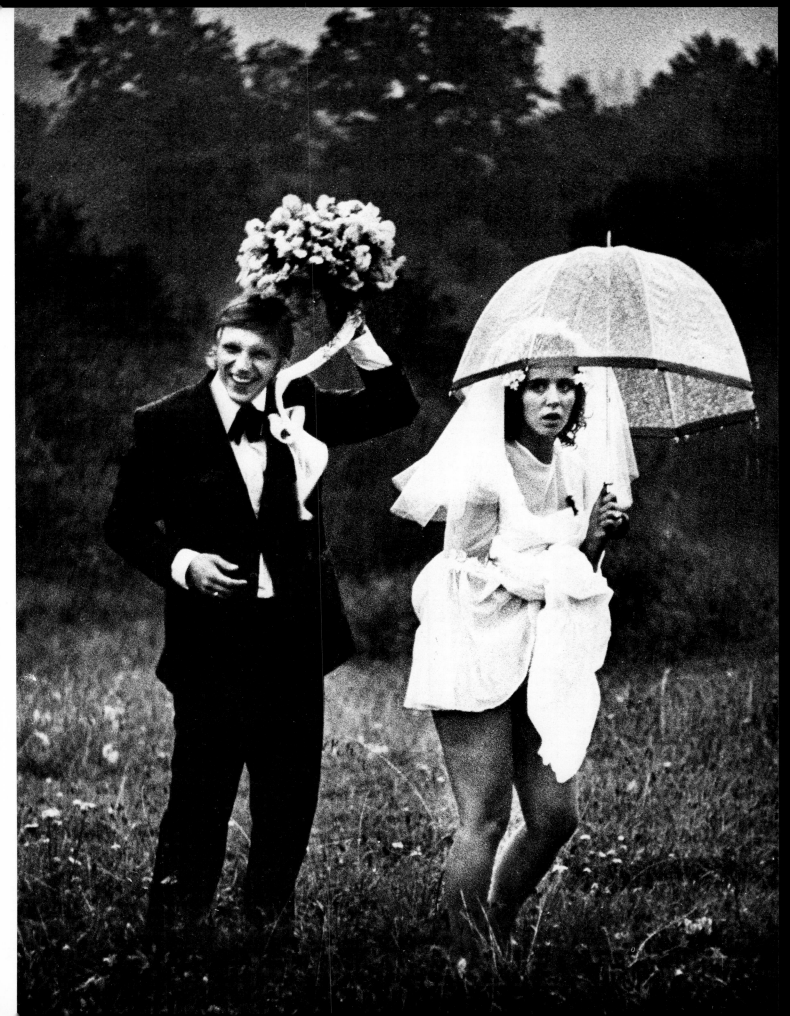

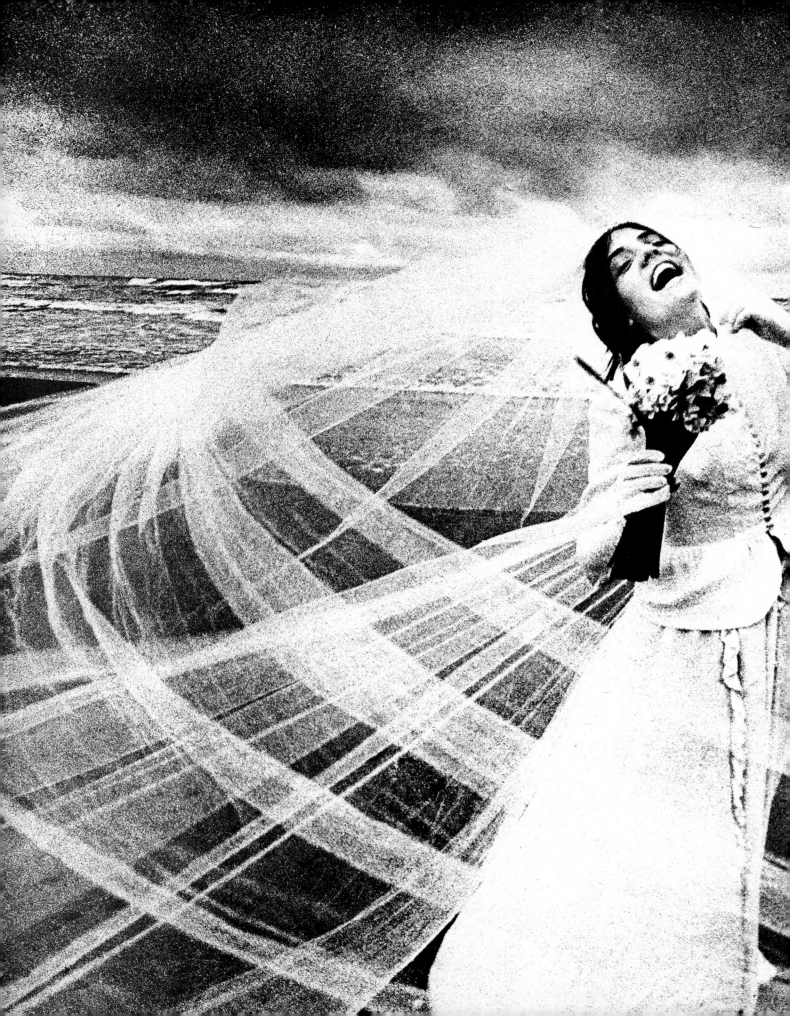

192 VALDIS BRAUNS

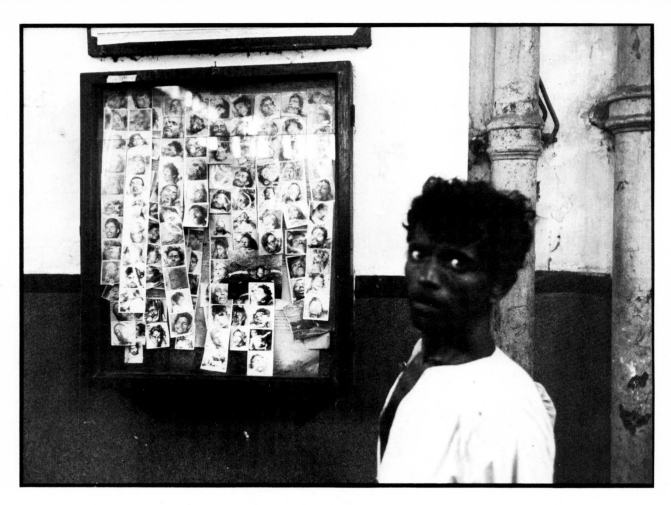

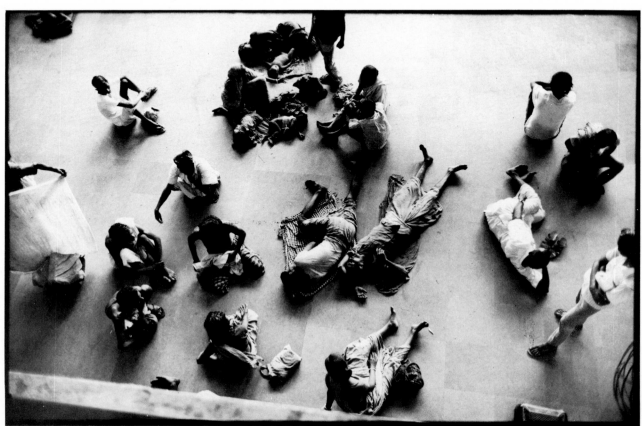

193/196 DENIS THORPE

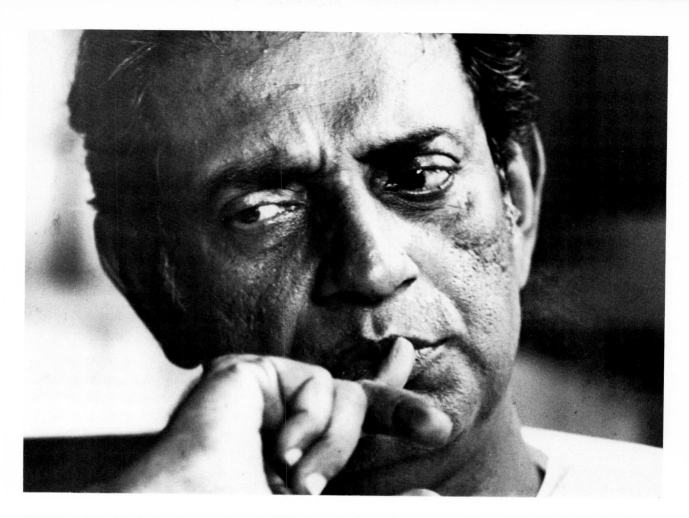

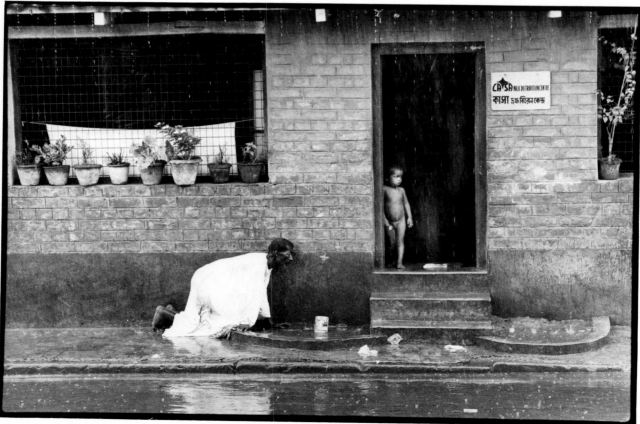

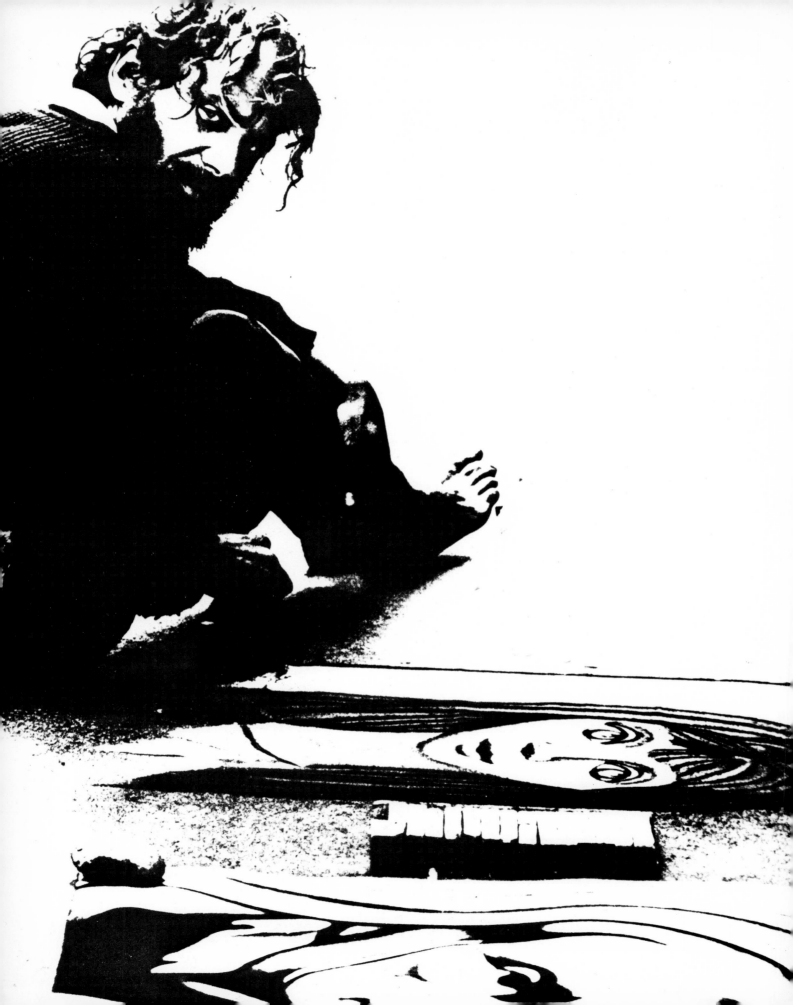

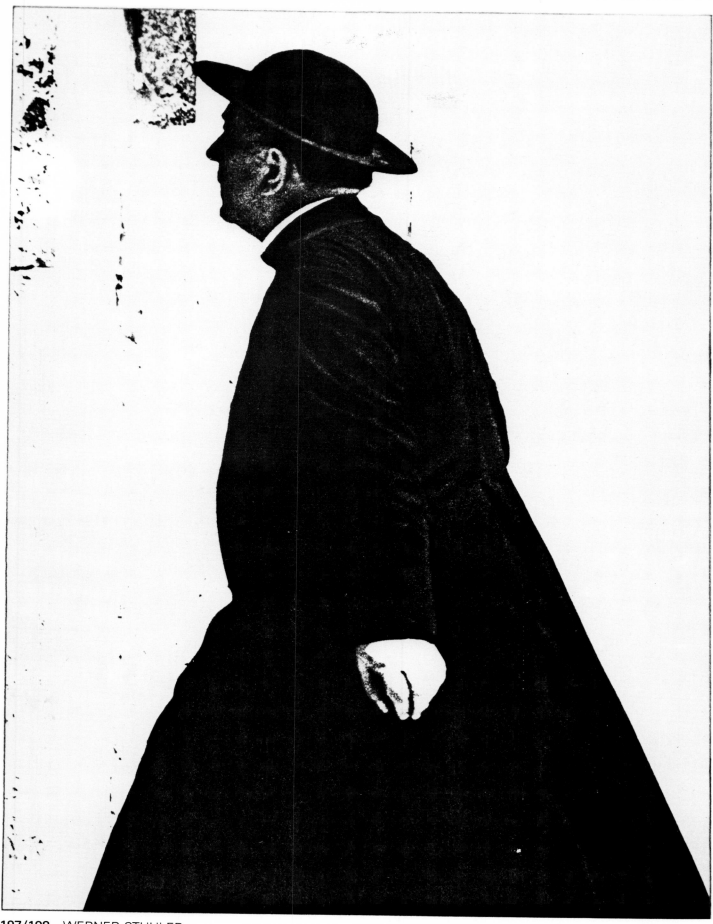

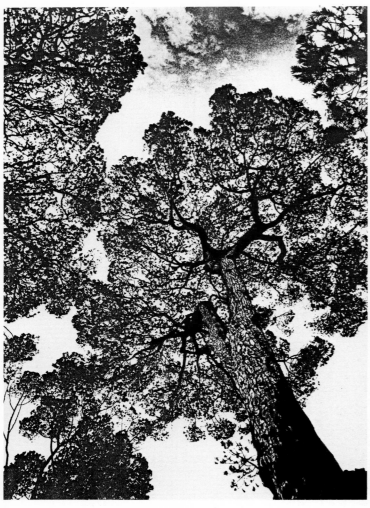

199/200 WERNER STUHLER

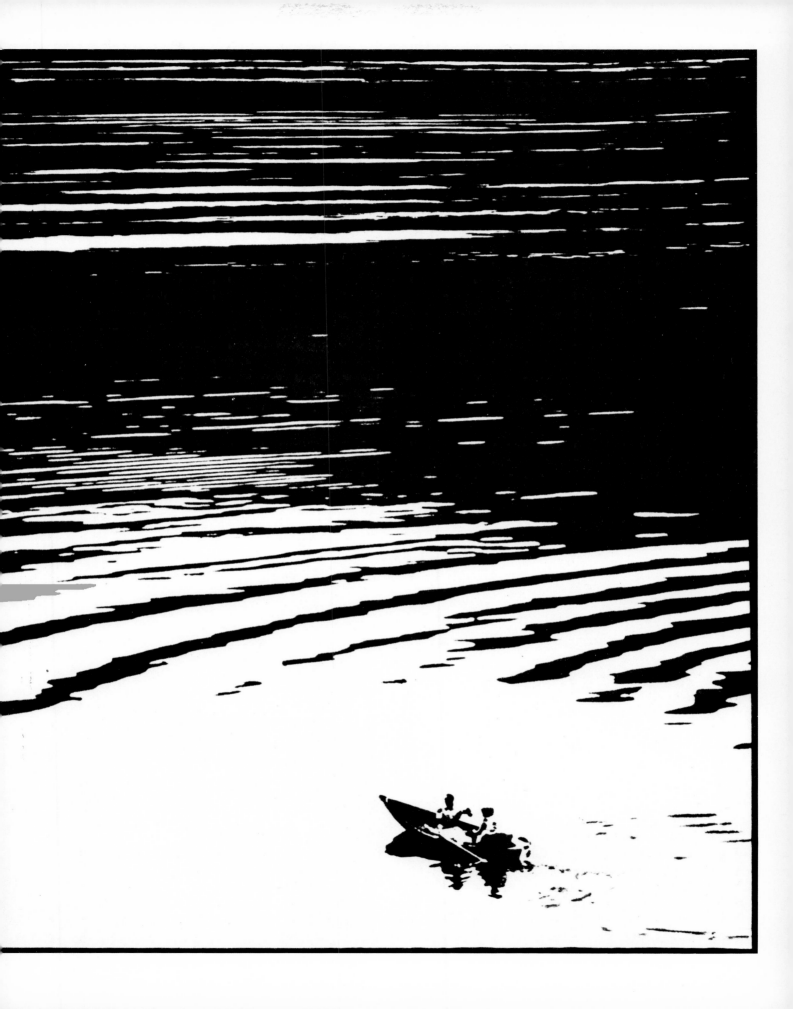

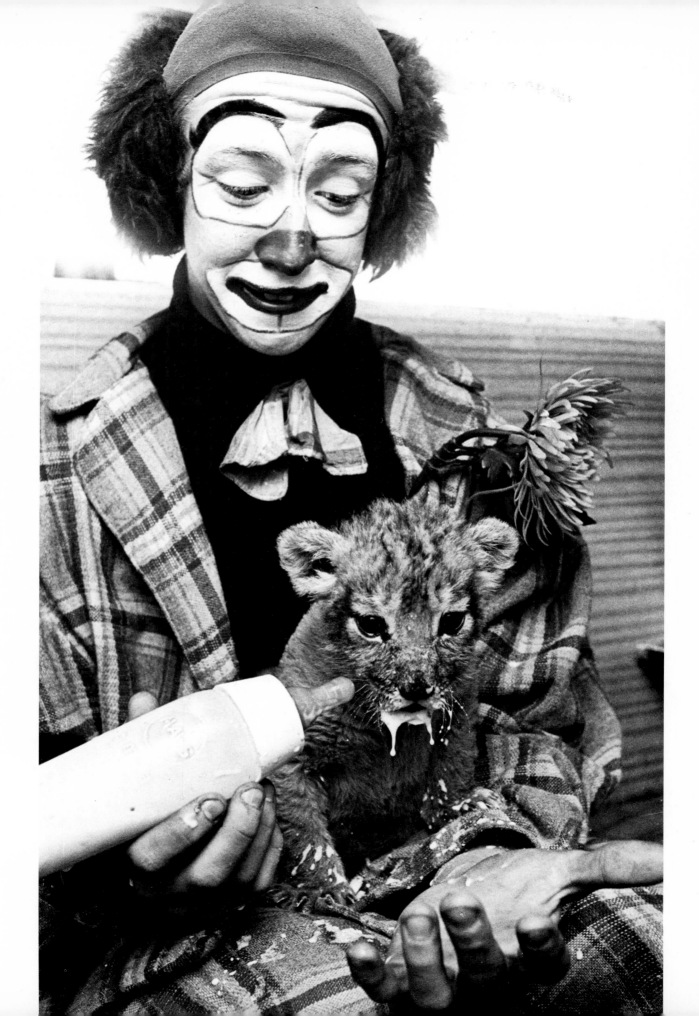

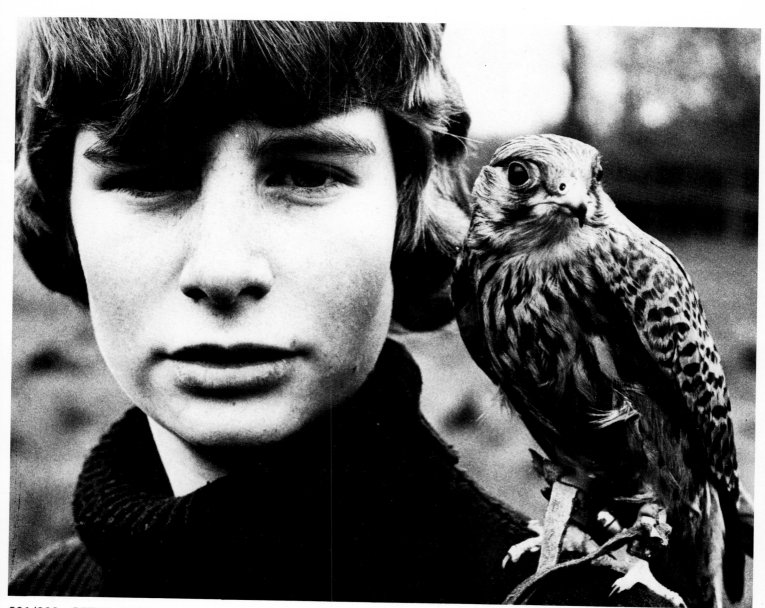

201/202 PETER J. HOARE

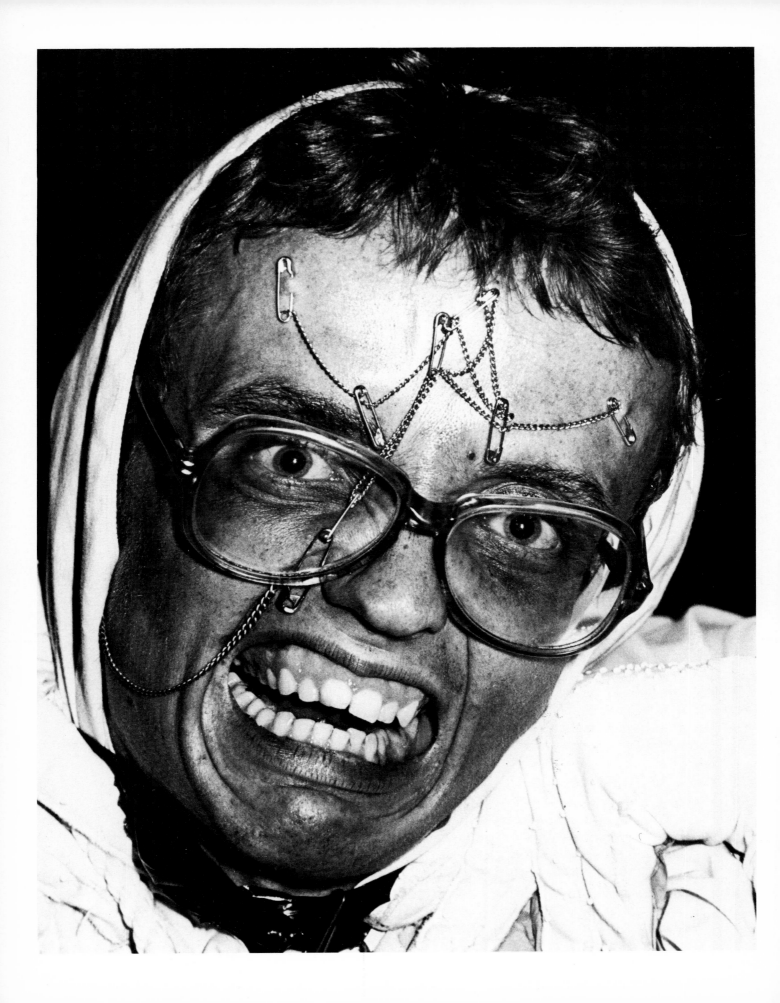

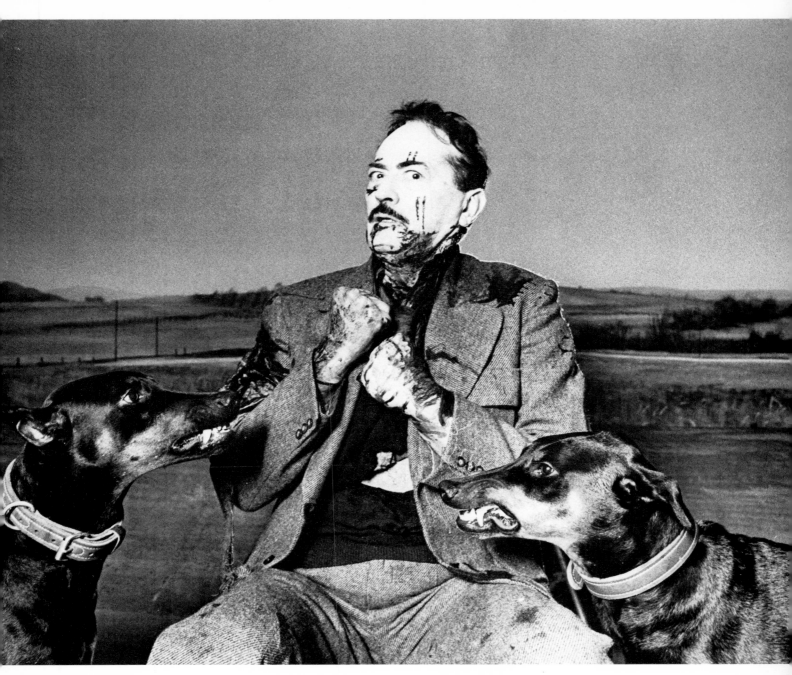

203 PAUL HARRIS **204** TERRY FINCHER

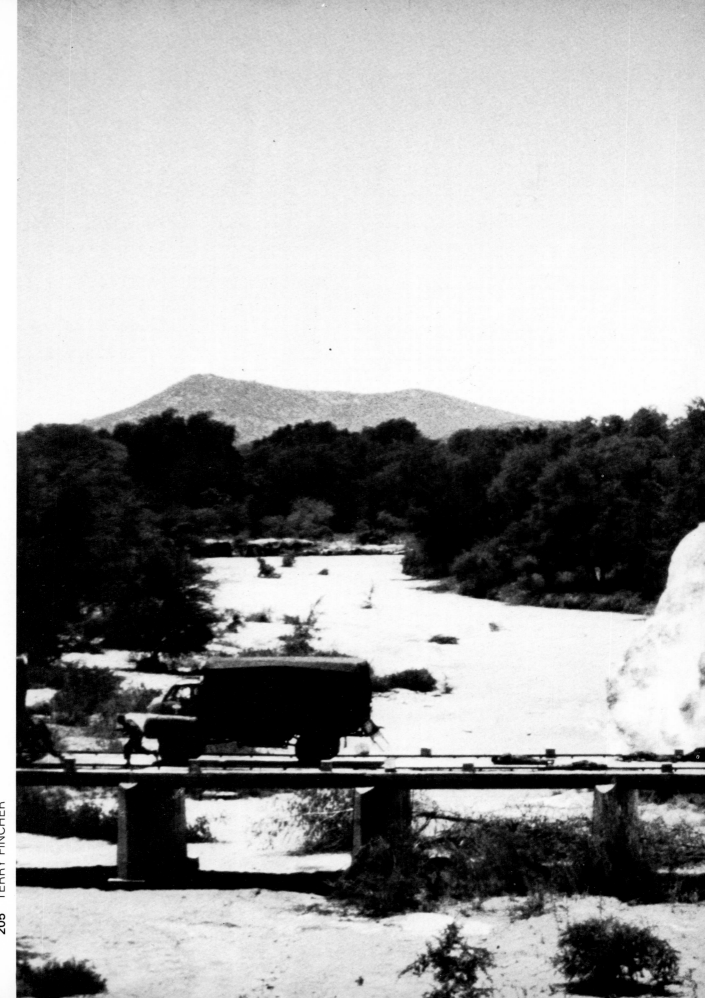

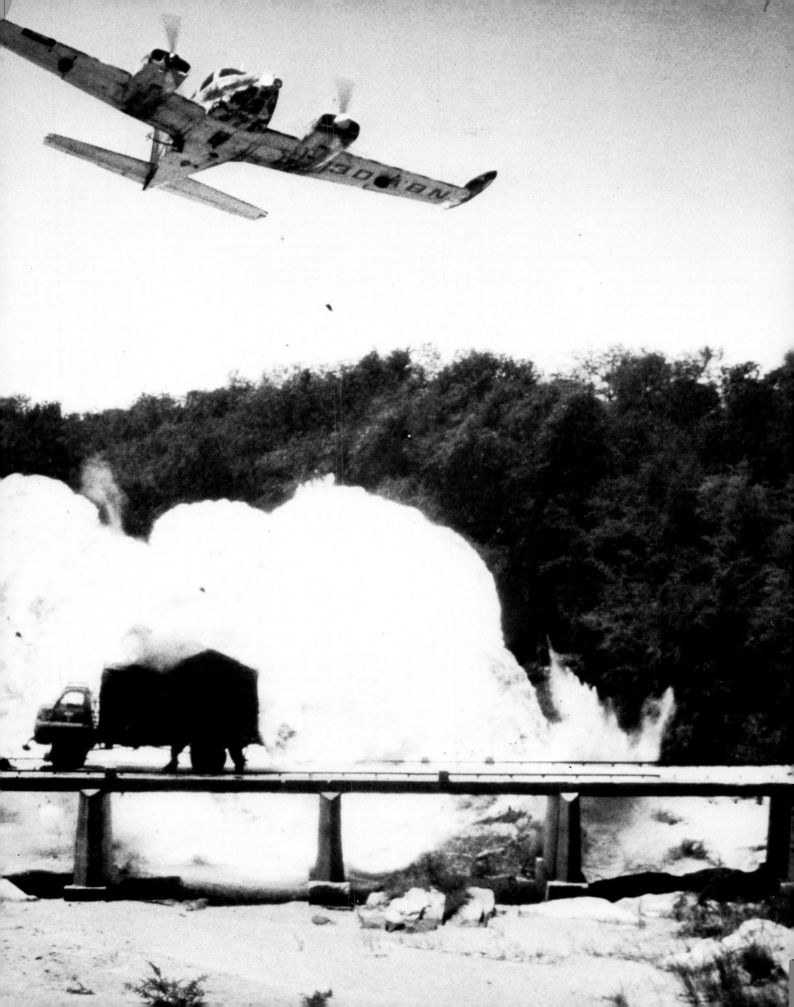

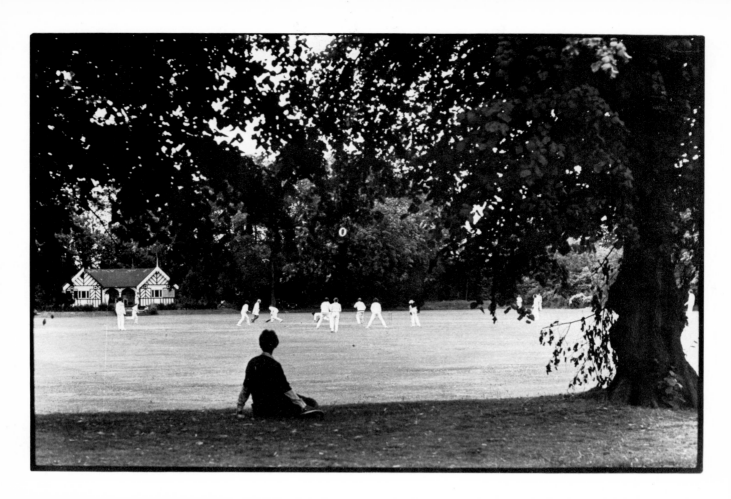

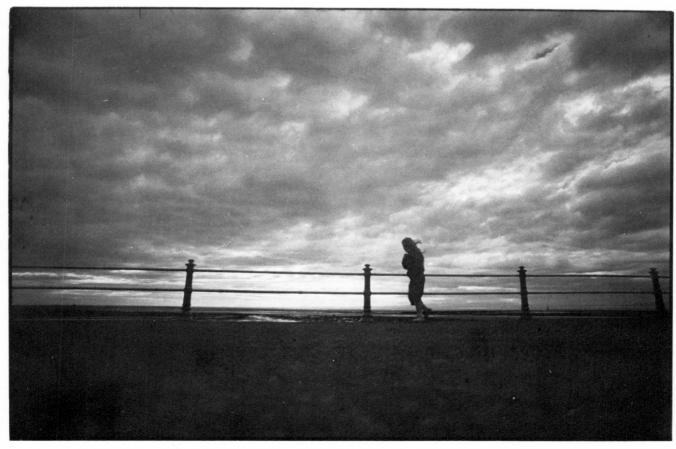

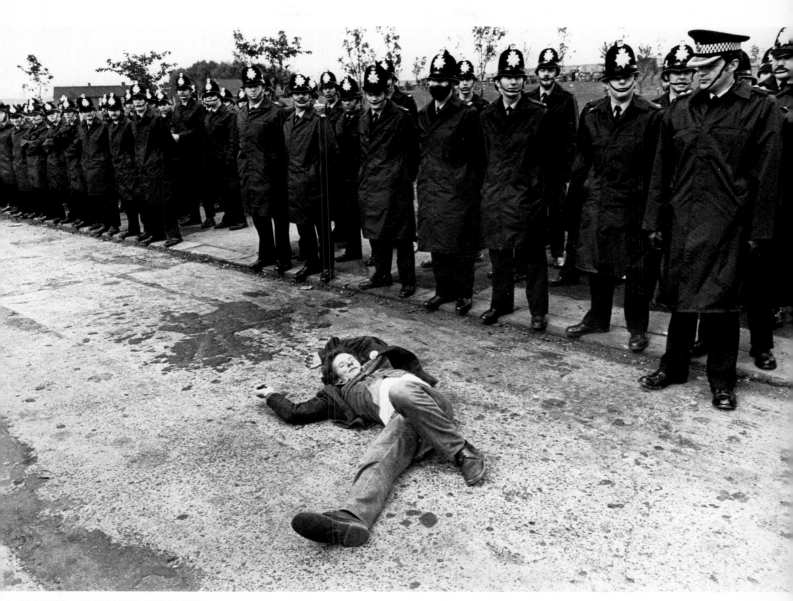

206/208 HOWARD WALKER

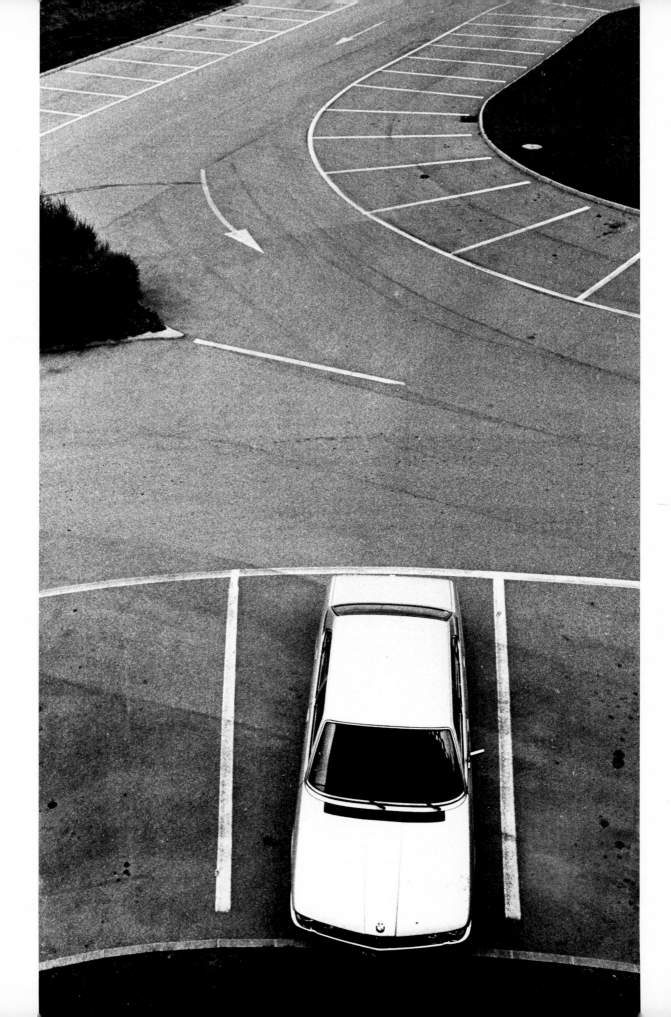

211/213 DON McPHEE

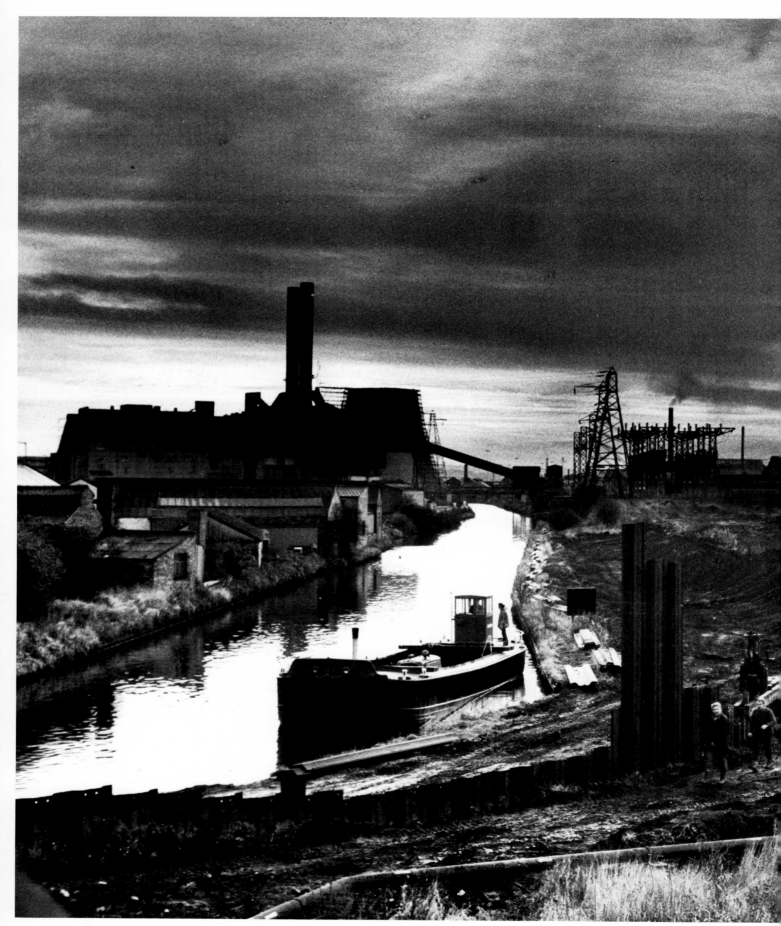

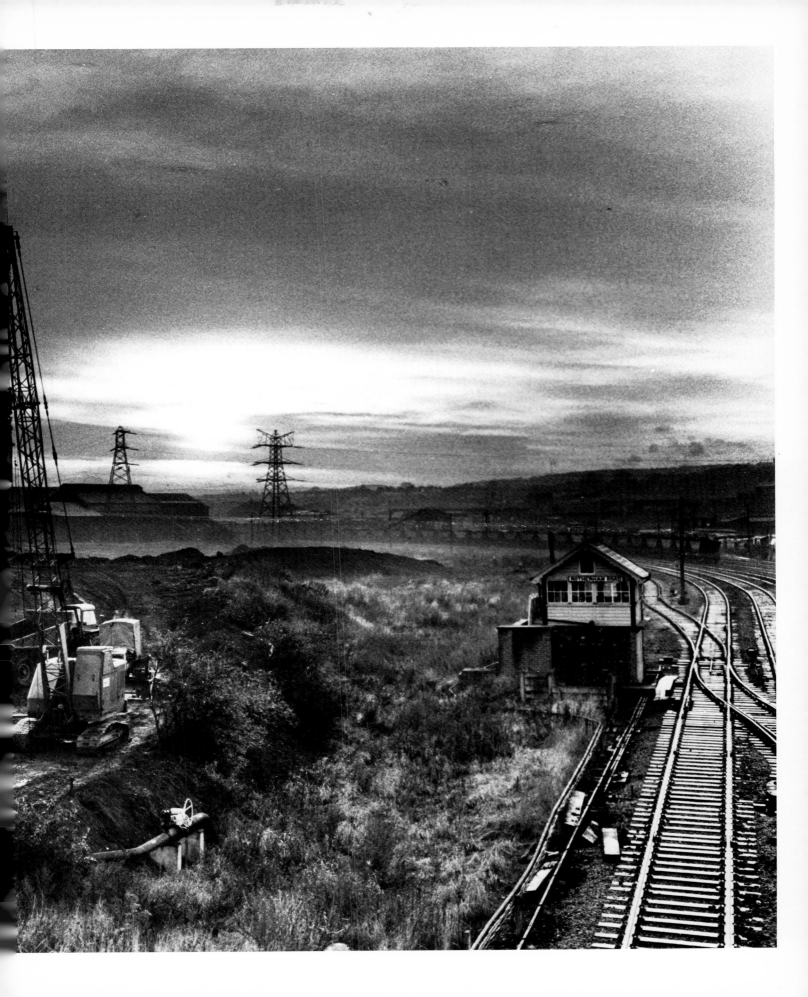

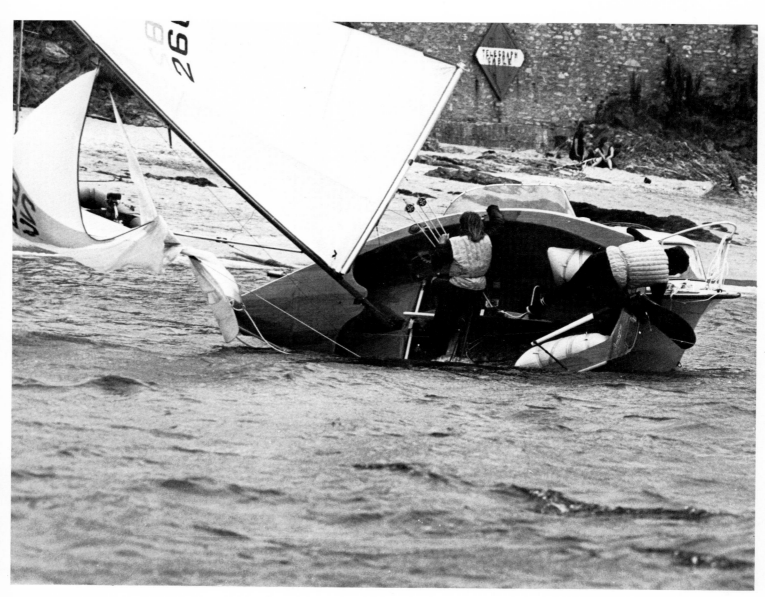

215/217 ROBERT K. O'NEILL

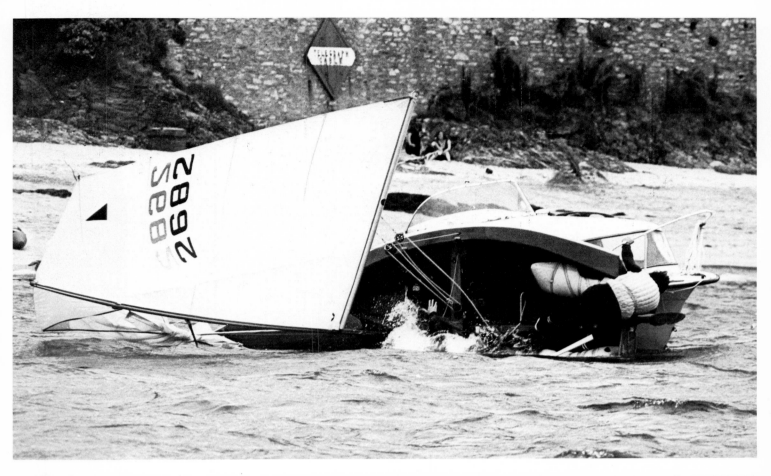

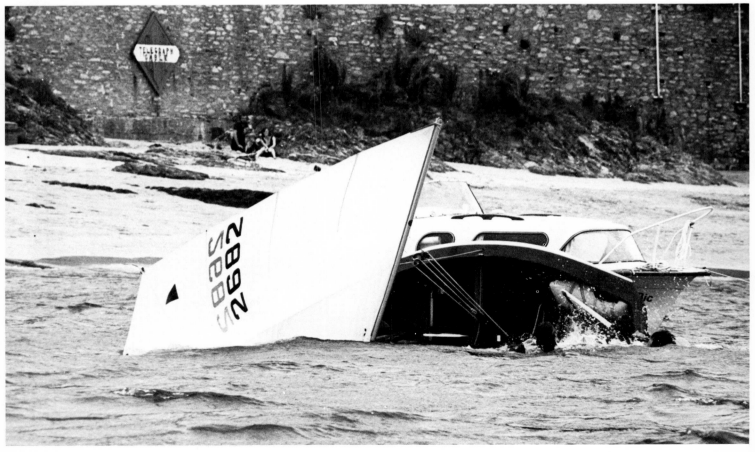

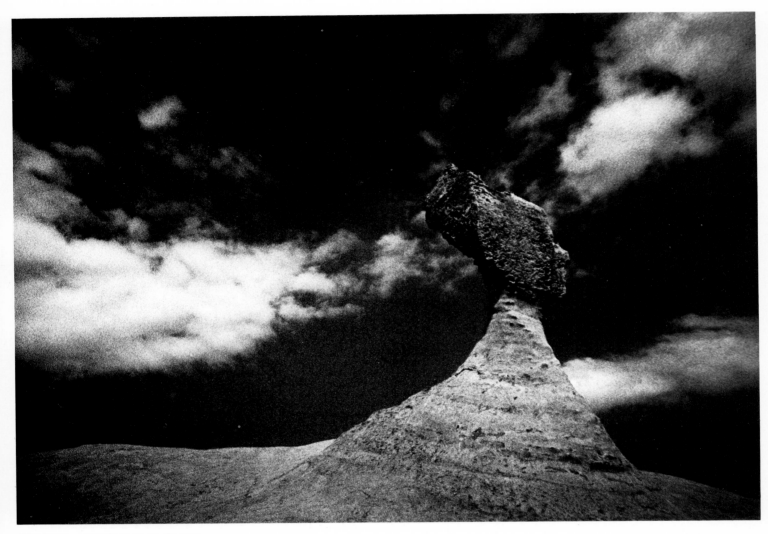

218/219 ATTOW T. T. CHEN

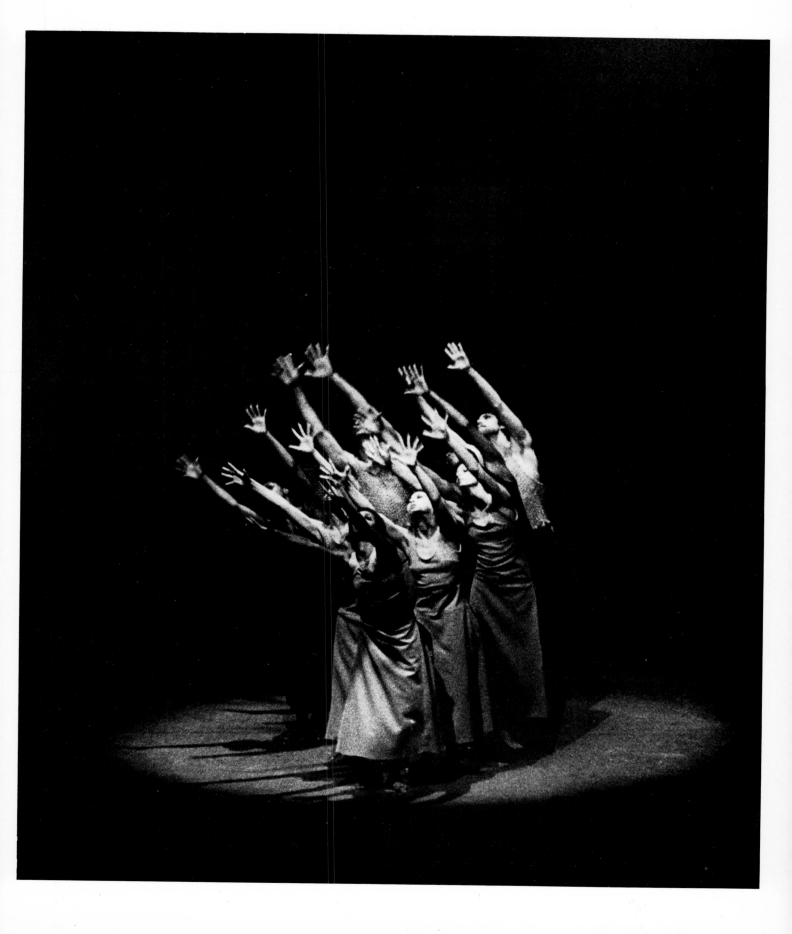

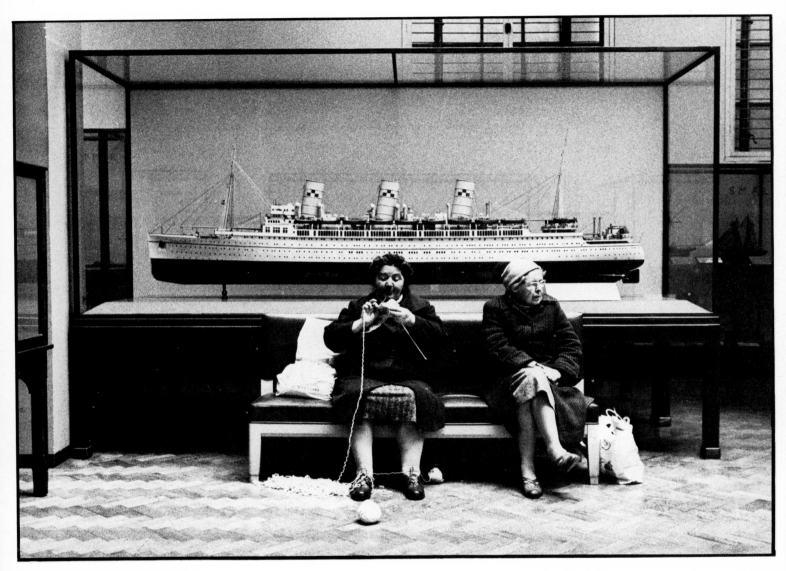

220/221 COLIN MONTEITH

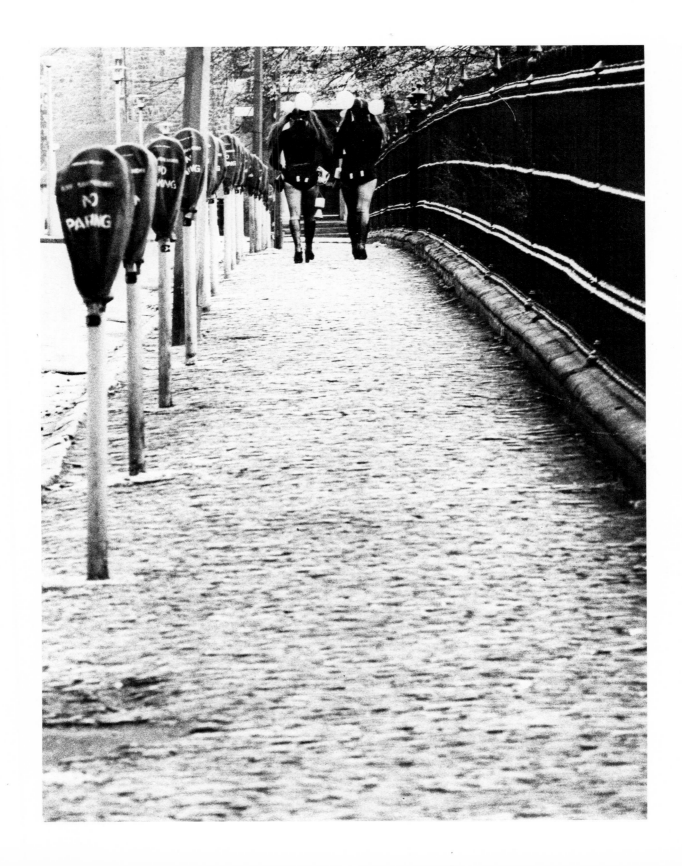

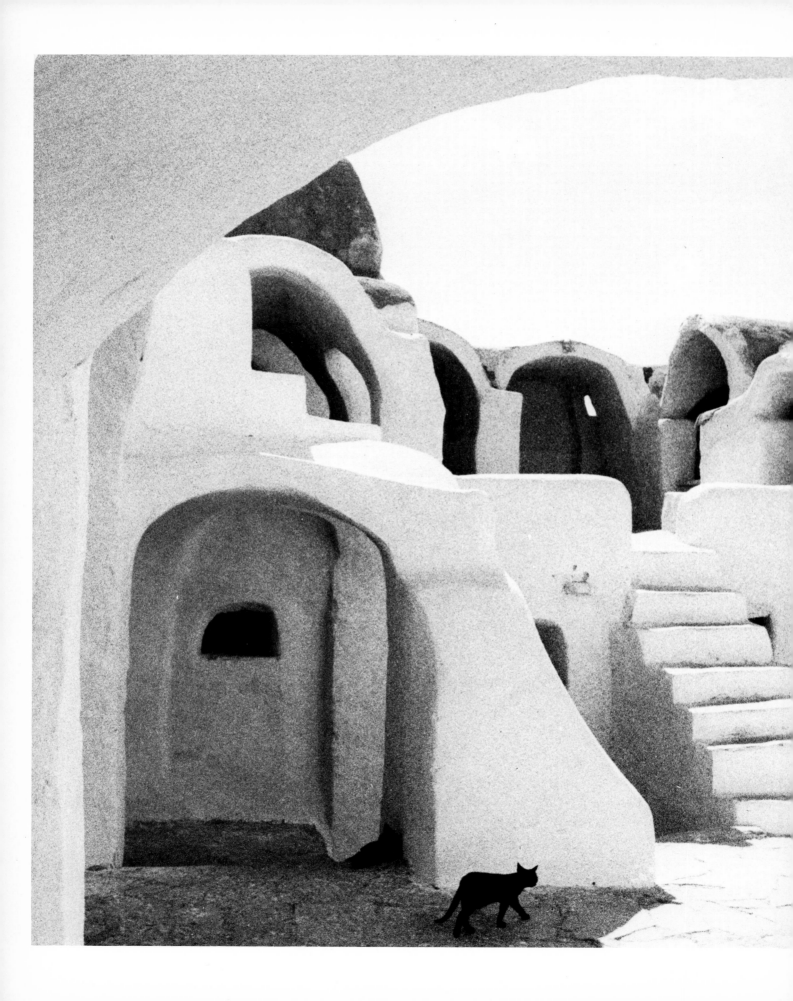

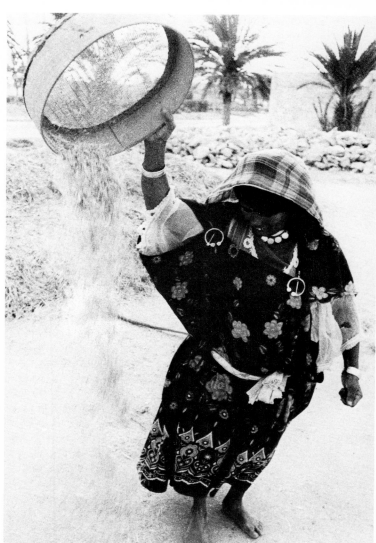

222/223 ERWIN KNEIDINGER

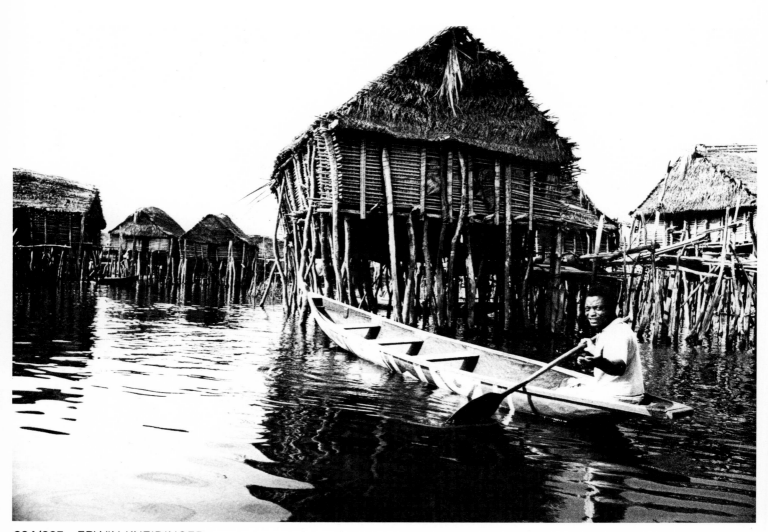

224/225 ERWIN KNEIDINGER

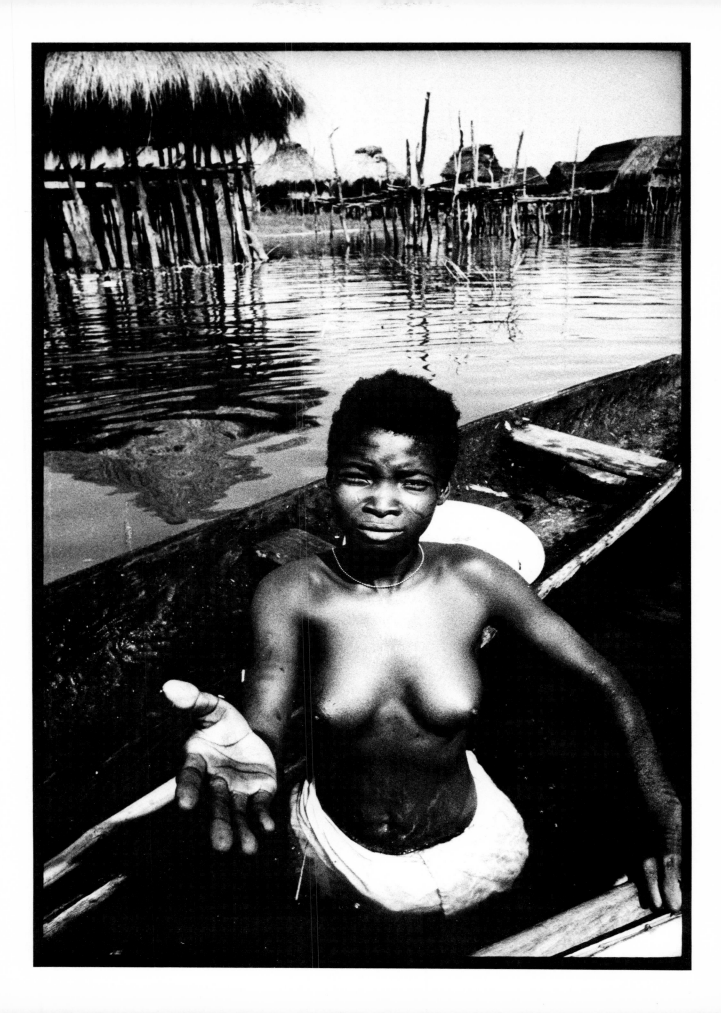

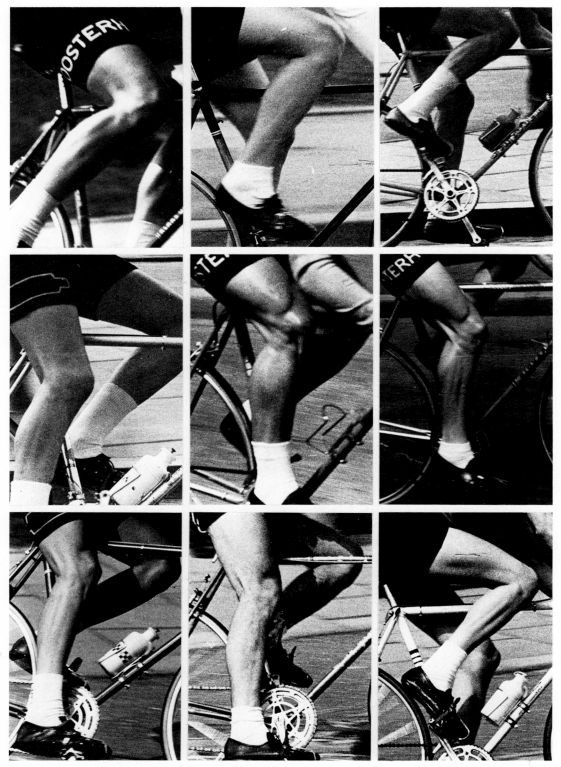

HANSJOCHEN HEINECKE

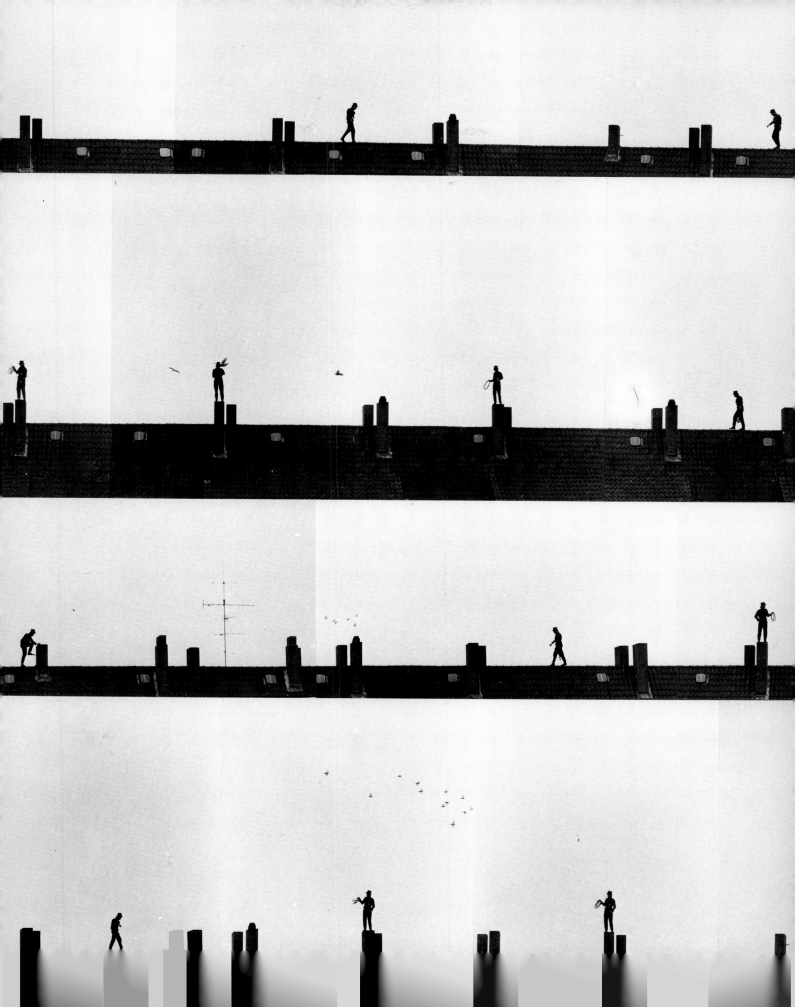

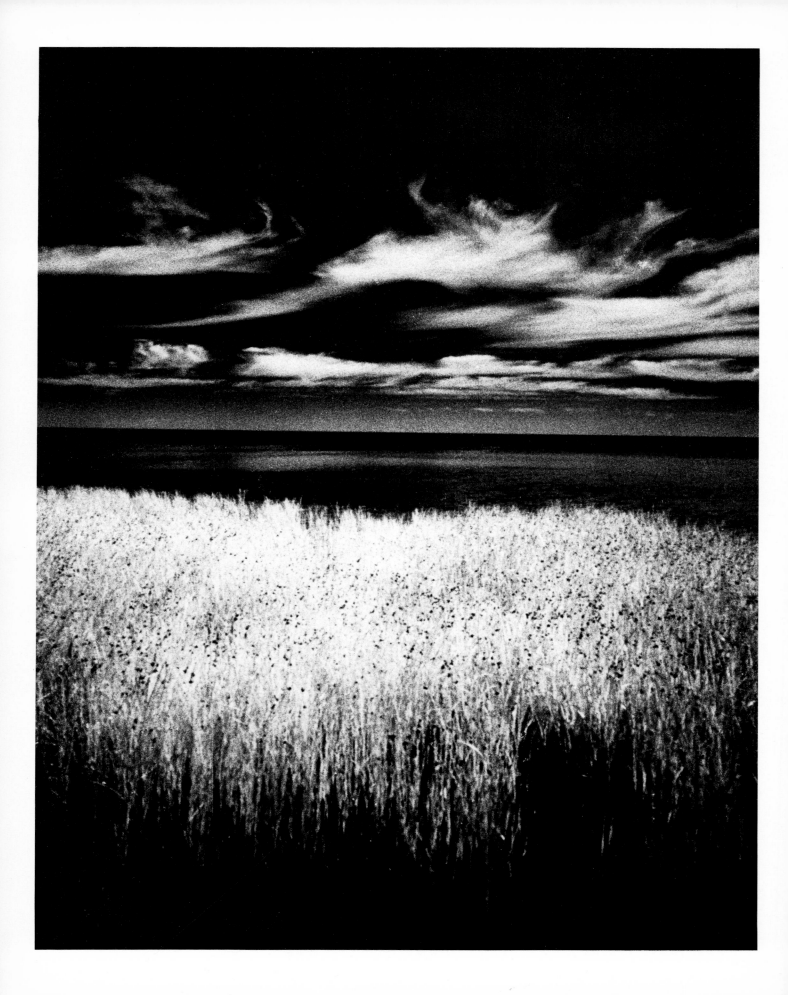

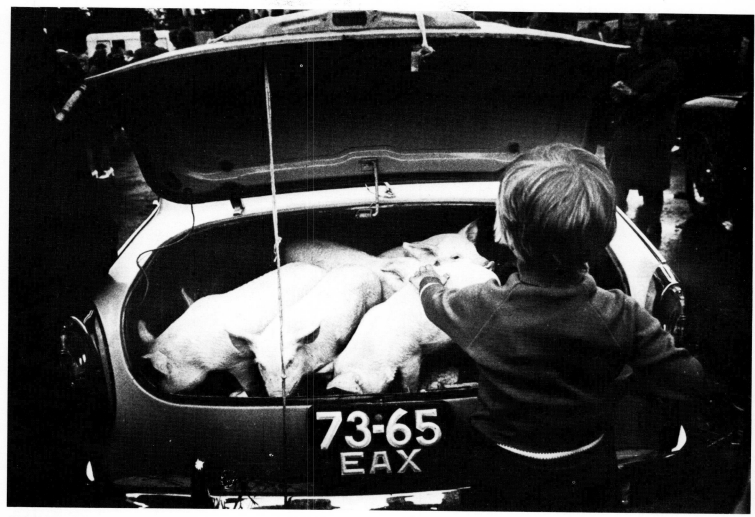

228/229 PEETER TOOMING

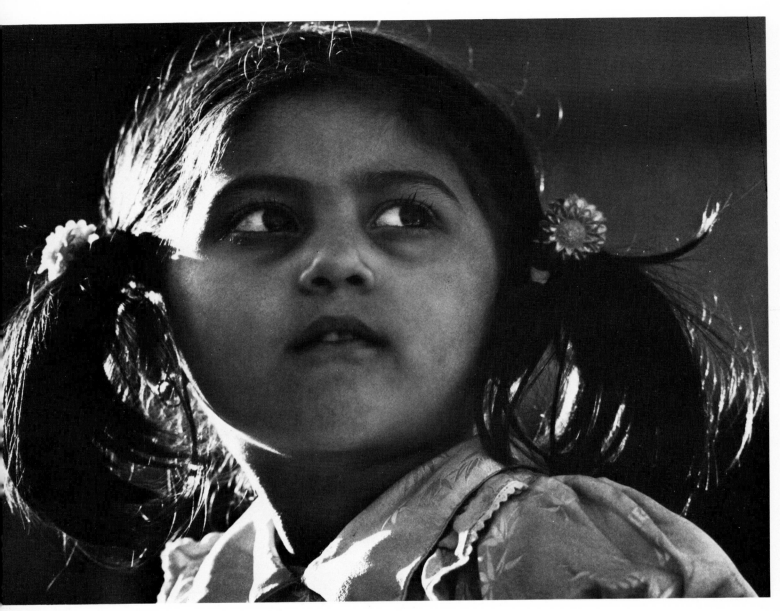

230/231 M. R. OWAISI

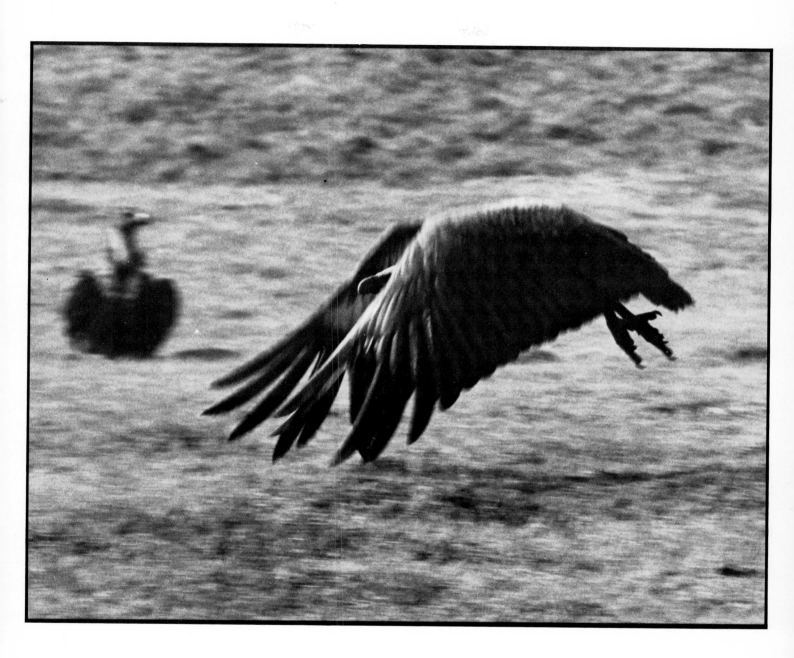

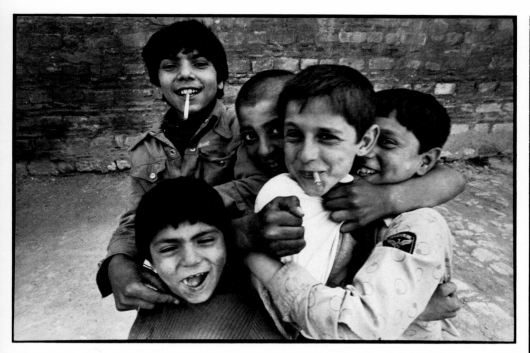

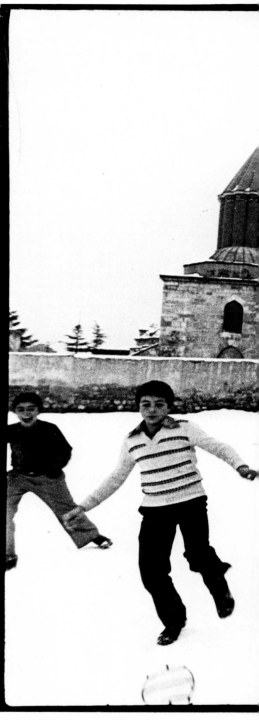

232/234 SEMSI GUNER

236 MIKE HOLLIST

Technical Data

Front Endpaper

Photographer	Semsi Güner
Camera	Nikon F
Lens	135 mm Nikkor
Film	Kodak Tri-X
Shutter Speed	1/250
Aperture	f/5.6
Developer	D76
Paper	Forte

Dusk in Ankara, where a combination of fountains, boats and people illuminated by the last rays of the sun provided the Turkish photographer with a subject ideally suited for his medium long focus lens.

Abenddämmerung in Ankara, wo eine von dem letzten Strahlen der Sonne beleuchtete Gruppe von Springbrunnen, Booten und Leuten dem türkischen Fotografen ein Thema bot, das für sein Objektiv mittlerer Brennweite ideal war.

Zonsondergang in Ankara, waar een combinatie van fonteinen, scheepjes en mensen, die door de laatste zonnestralen in het licht worden gezet, de Turkse fotograaf van een ideaal onderwerp voor zijn 135 mm objectief voorziet.

Crepúsculo en Ankara. La combinación de fuentes, embarcaciones y gente, iluminadas por los últimos rayos del sol, proporcionaron al fotógrafo turco un tema ideal para ser captado con su objetivo de longitud mediana.

Crépuscule à Ankara, où une combinaison de fontaines, de bateaux et de personnes, éclairés par les derniers rayons du soleil, a fourni au photographe turc un sujet idéal pour son téléobjectif.

1

Photographer	Paul Joyce
Camera	MPP Micro Press 5 × 4
Lens	135 mm Xenar
Film	Ilford FP4
Developer	Promicrol

It may be appropriate to commence a Year Book of Photography with a reminder that man has senses other than his eyes – a point beautifully made by Paul Joyce with this portrait of famed potter Bernard Leach.

Zu Beginn eines Jahrbuches der Fotografie sollten wir vielleicht daran ereinnern, dass der Mensch abgesehen von Augen auch noch andere Sinne besitzt. Paul Joyce ist dies mit diesem Porträt des berühmten Töpfers Bernard Leach hervorragend gelungen.

Wellicht is het passend om een fotojaarboek te beginnen met een herinnering aan het feit dat de ogen niet de enige zintuigen van de mens zijn – hier prachtig duidelijk gemaakt door Paul Joyce met zijn portret van de bekende pottenbakker Bernard Leach.

Una buena manera de dar comienzo al Photography Year Book puede consistir en recordar que el hombre cuenta con otros sentidos aparte del de la vista. Este es el mensaje que parece enviarnos Paul Jones a través de su retrato del famoso ceramista Bernard Leach.

Peut-être convient-il d'ouvrir un annuaire de photographie en rappelant que l'homme est doté de sens autres que celui de la vue – et c'est ce qu'a magnifiquement illustré Paul Joyce par ce portrait du potier réputé qu'est Bernard Leach.

2

Photographer	Paul Joyce
Camera	MPP Micro Press 5 × 4
Lens	135 mm Xenar
Film	Ilford FP4
Developer	Promicrol

Art Historian Sir Nicholas Pevsner. Our opening selection by Paul Joyce comes from his exhibition 'Elders', one of a number of successful photographic exhibitions staged at the National Portrait Gallery London with the encouragement of Curator of Photography Colin Ford.

Der Kunsthistoriker Sir Nicholas Pevsner. Unsere anfänglichen Fotografien stammen aus der Ausstellung 'Die alten Herren' von Paul Joyce, einer von mehreren erfolgreichen Fotoausstellungen, die mit Förderung durch Colin Ford, den Kurator für Fotografie, in der National Portrait Gallery in London veranstaltet wurden.

Kunsthistoricus Sir Nicholas Pevsner. Onze eerste selectie foto's begint met een serie van Paul Joyce uit zijn tentoonstelling 'Ouderen', één van een reeks succesvolle tentoonstellingen in de National Portrait Gallery in Londen onder de bezielende leiding van de conservator voor de afdeling fotografie, Colin Ford.

He aquí al conocido investigador de la Historia del Arte Sir Nicholas Pevsner. La selección de fotografías de Paul Joyce con la que hemos dado comienzo al libro procede del conjunto de su exposición 'Nuestros mayores', una de las varias celebradas en el National Portrait Gallery de Londres, gracias a los buenos oficios del Director del Departamento de Fotografía, Colin Ford.

L'historien d'art Sir Nicholas Pevsner. Notre sélection d'ouverture par Paul Joyce provient de son exposition 'Elders' (Les anciens), exposition de photographies réputée parmi d'autres, qu'il a tenue à la National Portrait Gallery de Londres avec les encouragements de Colin Ford, conservateur de la photographie de cette institution.

3

Photographer	Paul Joyce
Camera	Gandolfi 5 × 4
Lens	150 mm Symar
Film	Ilford
Developer	Microphen

Master Photographer Bill Brandt. Paul Joyce directed films and documentaries before becoming seriously involved in still photography. He has now held a number of exhibitions of his work, a portfolio of which has been acquired by the Victoria and Albert Museum in London.

Der Meisterfotograf Bill Brandt. Paul Joyce war Regisseur von Unterhaltungs- und Dokumentarfilmen, bevor er sich ernstlich für normale Fotografie zu interessieren begann. Nun hat er mehrere Ausstellungen veranstaltet und eine Sammlung seiner Aufnahmen wurde von dem Victoria and Albert Museum in London erworben.

Topfotograaf Bil Brandt. Paul Joyce regisseerde films en documentaires voordat hij zich serieus met fotografie ging bezighouden. Er zijn thans een aantal exposities van zijn werk gehouden, terwijl het Victoria and Albert Museum in Londen een collectie foto's van hem heeft gekocht.

Bill Brandt, el extraordinario fotógrafo. Paul Joyce dirigió varias películas y documentales antes de dedicarse en serio a la fotografía 'estática'. Parte de las obras presentadas en varias de sus exposiciones han sido adquiridas por el Victoria and Albert Museum de Londres.

Le maître photographe Bill Brandt. Paul Joyce a été réalisateur de films et de documentaires avant de s'intéresser sérieusement à la photographie. Il a déjà tenu un certain nombre d'expositions de ses propres travaux, dont une série a été acquise par le Victoria and Albert Museum de Londres.

4

Photographer	Paul Joyce
Camera	Gandolfi 5 × 4
Lens	150 mm Symar
Film	Ilford FP4
Developer	Promicrol

Master camera maker Fred Gandolfi in his workshop – photographed with one of his own creations.

Fred Gandolfi, ein Meister der Kunst des Kamerabaus, in seiner Werkstatt. Hier wurde er mit einer seiner eigenen Kameras fotografiert.

Fred Gandolfi, de bekende cameramaker, in zijn werkplaats – samen met een van z'n scheppingen.

El famoso fabricante de cámaras Fred Gandolfi fotografiado en su taller con una de sus propias creaciones.

Fred Gandolfi, un maître fabricant d'appareils photographiques, dans son atelier – photographié par l'une de ses propres créations.

5

Photographer	Sam Tata
Camera	Leica M4
Lens	35 mm Summicron
Film	Kodak Tri-X
Shutter Speed	1/100
Aperture	f/4
Developer	D76
Paper	Ilfobrom

Veteran French photographer Jacques-Henri Lartigue, portrayed in Paris by Canadian photographer Sam Tata.

Jacques-Henri Lartigue, ein Veteran der französischen Fotografie, wie er von dem kanadischen Fotografen Sam Tata in Paris aufgenommen wurde.

De Franse veteraan onder de fotografen Jacques-Henri Lartigue; in Parijs geportretteerd door de Canadese fotograaf Sam Tata.

Retrato del veterano fotógrafo francés Jacques-Henri Lartigue, obtenido en París por el fotógrafo canadiense Sam Tata.

Vétéran parmi les photographes français, Jacques-Henri Lartigue, photographié à Paris par le photographe canadien Sam Tata.

6

Photographer	Sam Tata
Camera	Leica M4
Lens	35 mm Summicron
Film	Kodak Tri-X
Shutter Speed	1/125
Aperture	f/2.8
Developer	D76
Paper	Ilfobrom

Photographer Robert Frank in Montreal.

Der Fotograf Robert Frank in Montreal.

De fotograaf Robert Frank in Montreal.

He aquí al fotógrafo Robert Frank en Montreal.

Le photographe Robert Frank à Montréal.

7

Photographer	Sam Tata
Camera	Leica
Lens	35 mm Elmar
Film	Kodak Tri-X
Shutter Speed	1/100
Aperture	f/4.5
Developer	D76
Paper	Ilfobrom

Photographer Andre Kertesz in New York.

Der Fotograf Andre Kertesz in New York.

De fotograaf Andre Kertesz in New York.

He aquí al fotógrafo Andre Kertesz en Nueva York.

Le photographe Andre Kertesz à New York.

8

Photographer	Jayne Fincher
Camera	Nikon
Lens	85/250 Nikkor Zoom
Film	Kodak Tri-X
Shutter Speed	1/125
Aperture	f/8
Developer	D76

It took Prince Charles and the Battle of Arnhem for 20 year old Jayne Fincher to make her debut in *Photography Year Book*, but some advice from famous photographer father, Terry Fincher, helped too. Jayne works in his company, Photographers International, at Chilworth, Surrey, where he pushed her in at the deep end three years ago in the darkroom. Jayne caught Prince Charles relaxing during a break from polo, boldly sporting a tee-shirt for the film "A Bridge Too Far".

Die zwanzigjährige Jayne Fincher, die zum ersten Mal durch eine Aufnahme im *Photography Year Book* vertreten ist, setzte Prinz Charles zu der Schlacht von Arnheim in Beziehung. Dabei wurde sie auch von ihrem Vater, dem bekannten Fotografen Terry Fincher, beraten. Jayne arbeitet in seiner Firma, Photographers International, Chilworth, Surrey, wo sie vor drei Jahren in der Dunkelkammer ihre Lehre antrat.
Jayne knipste Prinz Charles, als er sich gerade in der Pause eines Polokampfes ausruhte. Das T-Shirt, das er so kühn trägt, wurde ursprünglich für den Film "A Bridge Too Far" gestaltet.

Twintigjarige Jayne Fincher had prins Charles en de Slag om Arnhem nodig, samen met het nodige advies van haar vader, de bekende fotograaf Terry Fincher, om haar debuut te maken in het *Fotojaarboek 1979*. Jayne werkt in haar vaders bedrijf, Photographers International te Chilworth in Surrey, waar hij haar drie jaar geleden gelijk voor de leeuwen gooide door haar in de doka te stationeren. Jayne maakte deze foto van prins Charles tijdens een pauze in een polowedstrijd. De Engelse kroonprins droeg hierbij een reclame T-shirt voor de film *Een brug te ver*.

Fue gracias al prícipe Carlos y a la batalla de Arnheim que Jayne Fischer, fotógrafo de veinte años, llevó a cabo su debut en el *Photography Year Book*, También hay que tener en cuenta, sin embargo, los estímulos recibidos de su padre, el famoso fotógrafo Terry Fincher, en cuya Compañía, Photographers International, de Chilworth, Surrey, trabaja Jayne desde hace tres años, cuando aquél la empujó por primera vez al interior del cuartó de revelado.
Jayne sorprendió al príncipe Carlos descansando durante una pausa de un partido de polo, atrevidamente ataviado con una camiseta de propaganda de la película 'Un puente lejano'.

Ce sont le Prince Charles et la Bataille d'Arnhem qui ont amené Jayne Fincher, âgée de vingt ans, à faire ses débuts dans le *Photography Year Book*. Mais elle a aussi bénéficié de l'aide de son père, le célèbre photographe Terry Fincher. Jayne travaille en effet dans sa société, la Photographers International, de Chilworth, Surrey, où il l'a introduite, il y a trois ans, dans la chambre noire. Jayne a saisi le Prince Charles alors que, arborant un élégant maillot créé à l'occasion du film 'A Bridge Too Far' (Un pont trop loin), il prend quelques instants de repos au cours d'un match de polo.

9

Photographer	David Graeme-Baker
Camera	Nikon
Lens	85mm
Film	Kodak Plus-X
Shutter Speed	1/60
Aperture	f/4
Developer	D76

On a London assignment for Photographers International, David Graeme-Baker visited the location for the re-make of John Buchan's classic adventure story "The Thirty-nine Steps". Someone whispered that it was the 70th birthday of John Mills, so David marked the anniversary with this striking portrait of the famous British actor.

Als sich David Graeme-Baker in London befand, um im Auftrag der Photographers International eine Bilderreihe anzufertigen, besuchte er den Ort, an dem ein neuer Film von John Buchans klassischer Abenteuergeschichte "The Thirty-nine Steps" gedreht werden soll.
Irgendwo hörte er, es sei dies der 70. Geburtstag des berühmten britischen Schauspielers John Mills, und David Graeme-Baker feierte ihn, indem er dieses interessante Porträt aufnahm.

In opdracht van Photographers International bezocht David Graeme-Baker de plaats waar John Buchans beroemde avonturenverhaal 'The Thirty-nine Steps' zou worden heropgevoerd. Er werd gefluisterd dat het de zeventigste verjaardag van de acteur John Mills was, voor David reden genoeg om dit pakkende portret van deze beroemde Britse toneelspeler te maken.

Enviado por la agencia Photographers International para realizar un reportaje sobre la filmación de la ya clásica novela de aventuras de John Buchan 'Los treinta y nueve escalones', Graema-Baker visitó los estudios londinenses de la firma productora el mismo día en que el actor, John Mills, celebraba su 70 aniversario. Puesta en conocimiento del fotógrafo esta circunstancia, le obsequió con este extraordinario retrato.

En service à Londres pour le compte de Photographers International, David Graeme-Baker s'est rendu au lieu choisi pour le nouveau tournage de l'aventure classique de John Buchan 'The Thirty-nine Steps' (Les trente-neuf marches). Quelqu'un a chuchoté que c'était le 70e anniversaire de l'acteur John Mills, et David a marqué l'événement en réalisant ce saisissant portrait du célèbre acteur britannique.

10

Photographer	Joan Wakelin
Camera	Mamiyaflex
Film	Ilford FP4
Shutter Speed	1/125
Aperture	f/5.6
Developer	Promicrol

'Family. Sri Lanka'. Joan Wakelin is a prominent member of the Royal Photographic Society of Great Britain and regularly participates in the Society's Annual International Exhibitions.

'Familie. Sri Lanka'. Joan Wakelin ist ein prominentes Mitglied der Royal Photographic Society of Great Britain und nimmt regelmässig an den jährlichen internationalen Ausstellungen dieses Verbandes teil.

'Gezin op Sri Lanka'. Joan Wakelin is een vooraanstaand lid van de Royal Photographic Society of Great Britain en neemt regelmatig deel aan de jaarlijkse internationale exposities van de Society.

'Familia de Sri Lanka'. Joan Wakelin es una de los miembros más destacados de la Royal Photographic Society of Great Britain y sus fotografías suelen ser incluídas en las Exposiciones anuales organizadas por esta Sociedad.

IF YOU WANT A MINUTE OF PHILIPS TIME, YOU WON'T GET 59.9 SECONDS.

Dial 10 seconds with Philips darkroom equipment and you'll get 10 seconds.

There's no fraction of a second here or there.

That's because Philips darkroom equipment is precision made.

Which doesn't mean it costs a bomb. Neither does it mean it's so complicated only top professionals can use it.

Take the basic exposure timer, the Philips PDC 011.

It guarantees you accuracy right down to a 10th of a second.

But with just a twiddle of a dial you can entrust it to switch the enlarger on and off, automatically.

And because like a computer, it's got a data store, you can leave it to repeat the process again and again: without wasting precious photo paper.

The Philips PDT 024 is that bit more sophisticated. This machine combines an exposure timer with an exposure meter.

It's a simple way of determining the exposure time needed for your black and white or colour negatives and then getting the actual timing exactly right.

The PDT 024 also includes a factor control. So you can adjust results to the paper sensitivity and, of course, your own personal requirements.

The Philips Colour Analyser has all the appearance and features of a rather formidable piece of equipment.

But it isn't. Although we must admit, it is a precision instrument.

And the component parts selected and design features such as the motor controlled primary

filters within the measuring probe, do give it a rather professional character.

However, look at the price and how simple it is to use and you'll become far more relaxed.

Especially when you've noticed the two year plus warranty we've backed this product with—like all our photo-equipment products.

Philips darkroom equipment will add new precision to your photo performance. Without blinding you with science, in the process.

All Philips photo equipment is available only from selected dealers.

For full details and the address of your nearest stockist write to:
Philips Lighting, FREEPOST, City House, 420-430 London Road, Croydon CR9 9ET.

Photomakers

PHILIPS

Simply years ahead

'Famille au Sri Lanka'. Joan Wakelin, membre éminent de la Royal Photographic Society of Great Britain, participe régulièrement aux expositions internationales annuelles de cette institution.

11

Photographer	Joan Wakelin
Camera	Asahi Pentax
Film	Ilford FP4
Shutter Speed	1/250
Aperture	f/8
Develop	Acutol

'Beggar Woman'. From a photo essay made during Joan Wakelin's three month visit to Sri Lanka. 'I tried to photograph them in a compassionate way', she writes, 'and not just for a documentary record.'

'Bettlerin'. Aus einem Bildbericht, den Joan Wakelin während ihres dreimonatigen Besuches von Sri Lanka anfertigte. 'Ich versuchte sie mit Mitgefühl zu fotografieren', so schreibt sie, 'und nicht nur als dokumentarische Beweise.'

'Bedelares'. Een van de opnamen uit een foto-essay, gemaakt tijdens een bezoek van drie maanden aan Sri Lanka. 'Ik heb geprobeerd het medelijden dat ze bij me opwekten te fotograferen', schrijft ze, 'en niet alleen maar vanwege de documentaire.'

'Mendiga'. Esta foto forma parte del conjunto realizado por Joan Wakelin en el curso de una estancia de tres meses en Ceilán. La autora ha escrito: 'Traté de tomar mis instantáneas con piedad, evitando convertirlas en simples documentos testimoniales'.

'Mendiante'. A partir d'un essai photographique réalisé durant un séjour de trois mois de Joan Wakelin au Sri Lanka. 'Je me suis efforcée de les photographier avec compassion, écrit-elle, et pas seulement pour rapporter des images documentaires.'

12

Photographer	Joan Wakelin
Camera	Mamiyaflex
Lens	65 mm
Film	Ilford FP4
Developer	Promicrol

A Sri-Lankan smile. 'The Senghalese were so keen to be photographed that I was usually surrounded by masses of people. I had an exhibition of my work in Colombo and gave many lectures'.

Ein Lächeln in Sri Lanka. 'Die Einwohner waren so eifrig fotografiert zu werden, dass ich in der Regel von ganzen Menschenmassen umgeben war. Ich stellte meine Arbeiten in Colombo aus und hielt zahlreiche Vorträge.'

Een glimlach in Sri Lanka. 'De Singalezen wilden zo graag worden gefotografeerd dat ik gewoonlijk door hele horden mensen werd omsingeld. Er is een tentoonstelling van mijn werk in Colombo gehouden en ik gaf er ook nogal enkele lezingen'.

Sonrisa cingalesa. 'Los cingaleses evidenciaron un interés tan grande en dejarse tomar fotografías que me encontraba asediada de continuo por grandes masas de gente. En Colombo se celebró una exposición de mis fotografías y di muchas charlas.

Sourire du Sri Lanka. 'Les Cingalais tenaient tant à se faire photographier que j'étais généralement entourée de masses de gens. J'ai tenu une exposition de mes travaux à Colombo et j'ai fait de nombreuses conférences.'

13

Photographer	Steve Hartley
Camera	Nikon F2
Lens	50 mm Kikkor
Film	Kodak Tri-X
Shutter Speed	1/60
Aperture	f/5.6
Lighting	Vivitar 292 Direct Flash
Developer	ID11
Paper	Kenthene

'A fistful' from the 'Sports Photographer of the Year' contest sponsored by the Sports Council and the Royal Photographic Society of Great Britain. Steve Hartley of the Reading *Evening Post* stopped a punch by Charles Cooper right on the nose of Trevor Francis, who looks pained but came back to win the bout.

'Eine Faustvoll' Bilder von dem 'Sports Photographer of the Year' – Wettbewerb, der von dem Sports Council und der Royal Photographic Society of Great Britain gefördert wurde. Steve Hartley von der Reading *Evening Post* knipste einen unmittelbar auf die Nase von Trevor Francis gezielten Faustschlag von Charles Cooper, der darunter zu leiden schien, aber sich dann revanchierte und den Kampf gewann.

'Uit het vuistje', geschoten door Steve Hartley van de *Evening Post* uit Reading. Hij legde een stoot van Charles Cooper recht op de neus van Trevor Francis vast. Francis, die er nogal pijnlijk getroffen uitziet, kwam echter terug en won het gevecht. Dit is een opname uit de 'Sports Photographer of the Year'-wedstrijd onder auspiciën van de Sports Council en de Royal Photographic Society of Great Britain.

'Un buen golpe'. Fotografía participante en el concurso de elección del mejor fotógrafo deportivo inglés del año pasado, convocado por el Sports Council y la Royal Photographic Society of Great Britain. El fotógrafo Steve Hartley, del *Evening Post*, captó perfectamente un certero golpe de Charles Cooper directamente a la nariz de Trevor Francis, quien, a pesar del gesto de dolor, fue capaz de recuperarse y ganar la pelea.

'Un fameux coup de poing', photographie présentée au concours du 'Sports Photographer of the Year', patronné par le Sports Council et par la Royal Photographic Society of Great Britain. Steve Hartley, du journal *Evening Post* de Reading, a saisi le coup de poing de Charles Cooper juste sur le nez de Trevor Francis, qui semble avoir mal, mais qui est revenu pour gagner la reprise.

14

Photographer	William E. Sampson
Camera	Canon AE-1
Lens	135 mm Tamron Adaptall
Film	Kodak Tri-X
Shutter Speed	1/1000
Aperture	f/22
Developer	D76
Paper	Ilfospeed

'Whoops'. A slalom canoeist shooting Richmond Falls on the River Swale. Sampson's shot also featured in the 'Sports Photographer of the Year' awards.

'Hoppla'. Ein Teilnehmer an einem Kanu-Slalom an den Richmond Falls des River Swale. Sampsons Aufnahme wurde auch in dem 'Sports Photographer of the Year' – Wettbewerb ausgezeichnet.

'Whoops'. Een slalom-kanovaarder neemt de Richmond Falls in de River Swale. Sampsons opname viel ook in de prijzen bij de verkiezing van de 'Sports Photographer of the Year'.

!Yuju!. Participante en un slalom de canoas salvando la cascada de Richmond en el río Swale. Esta fotografía recibió también una mención especial en el certamen de elección del mejor fotógrafo deportivo del año.

'Houp'. Un canoéiste spécialiste du slalom franchissant les chutes Richmond sur la rivière Swale. Cette photographie de Sampson a également été récompensée au concours du 'Sports Photographer of the Year'.

15

Photographer	Denis Thorpe
Camera	Nikonos III
Lens	35 mm
Film	Ilford FP4
Shutter Speed	Open
Aperture	f/8
Developer	Microphen
Paper	Ilfospeed

It was natural that *Guardian* photographer Thorpe (see also 195/196 plates) should enter a potholing picture from his native Yorkshire for the 'Sports Photographer of the Year' Contest, and not surprising that his dramatic composition – taken by multiple flash – should have received acclaim.

Es war verständlich, dass der für die Zeitung *Guardian* tätige Fotograf Thorpe (siehe auch Tafeln) eine Aufnahme aus den Höhlen seiner Heimat Yorkshire in dem 'Sports Photographer of the Year' – Wettbewerb einreichte. Es war auch keineswegs erstaunlich, dass diese bei mehrfachem Blitzlicht aufgenommene dramatische Komposition allgemein gelobt wurde.

Het was vanzelfsprekend dat de fotograaf van de *Guardian*, Thorpe, met een turbulente foto uit zijn eigen Yorkshire aan de 'Sports Photographer of the Year'-wedstrijd zou meedoen. Het is nauwelijks verrassend dat deze dramatische compositie – genomen door middel van multiple flash – een heleboel bijval oogstte.

No nos sorprendió an absoluto que el fotógrafo del *Guardian*, Thorpe participara en el certamen de elección del mejor fotógrafo deportivo del año con una fotografía sobre espeleología realizada – con flash múltiple – en su nativa región de Yorkshire. Tampoco nos sorprendieron por otra parte los elogios dedicados a la misma.

Il était naturel que Thorpe, photographe du *Guardian* (voir aussi les clichés) présentât une photographie de spéléologie provenant de son Yorkshire natal au concours du 'Sports Photographer of the Year', et il n'est pas surprenant que cette saisissante composition – prise au flash multiple – ait été très appréciée.

16

Photographer	Ronald G. Bell
Camera	Nikon
Lens	50 mm Nikkor
Film	Ilford FP4
Shutter Speed	1/1000
Aperture	f/8
Developer	HC 110

'Flying High', this attractive study of 'spinnaker flying' at Cowes Yacht week by the Press Association photographer, successfully featured in both the RPS/Sports Council contest and the Ilford £1,000 Print Awards.

'Hochflug'. Diese ansprechende Studie des 'Spinnakerflugs' wurde während der Jachtwoche in Cowes von diesem Fotografen der Presse Association aufgenommen. Das Bild schnitt sowohl in dem RPS/Sports Council-Wettbewerb als auch bei den Ilford £1000 Print Awards gut ab.

'Flying High', deze attractieve studie van het zeilen met de spinnaker tijdens de Yacht-week in Cowes, gemaakt door een fotograaf van de Press Association, deed met succes mee in zowel de RPS/Sports Council prijsvraag als de Ilford £1.000 Print Awards.

'Volando a gran altura'. Este atractivo estudio realizado por el fotógrafo de la Press Association en la semana náutica de Cowes fue galardonado tanto en el certamen de la RPS/Sports Council como en los premios de 1.000 libras de Illford.

'A la conquête de l'espace'; cette intéressante étude d'un 'vol au spinnaker', prise lors de la Semaine du yacht de Cowes par le photographe de Press Association, a remporté un franc succès au concours RPS/Sports Council et aux Ilford £1000 Print Awards.

17

Photographer	Phil Sheldon
Camera	Nikon
Lens	600 mm
Film	Kodak Tri-X
Aperture	f/5.6
Developer	HC 110
Paper	Kodak Veribrom

'Shot in the dark'. A 'smashing' picture of John Lloyd in the final of the Benson and Hedges championship at Wembley. Phil Sheldon obtained a diploma in illustrative Photography at Harrow, joined a Sport Photo Agency and is now a freelance sports specialist.

'Schuss ins Dunkle'. Dieses dynamische Bild von John Llyod wurde während des Finales der Benson and Hedges-Meisterschaft in Wembley aufgenommen. Phil Sheldon erhielt ein Diplom für illustrative Fotografie in Harrow, wurde Mitarbeiter einer Sportfotoagentur und ist nun als freiberuflicher Sportspezialist tätig.

'Een schot in het duister'. Een 'knallende' opname van John Lloyd tijdens de finale van het Benson and Hedgeskampioenschap op Wembley. Phil Sheldon behaalde een graad uit van een sportfotobureau en is nu free-lance sportfotograaf.

'Golpe en la oscuridad'. Una instantánea 'devastadora' tomada a John Lloyd en la final del torneo Benson y Hedges celebrado en Wembley. Phil Seldon obtuvo en Harrow su diploma en Fotografía Ilustrativa, luego trabajó en una Agencia de Fotografía deportiva y en la actualidad se dedica exclusivamente (como fotógrafo 'free-lance') a esta especialidad.

'Déclic dans la nuit'. Une remarquable photographie de John Lloyd à la finale du championnat Benson and Hedges à Wembley. Après avoir obtenu un diplôme de photographie d'illustration à Harrow, Phil Sheldon s'est engagé dans une agence spécialisée dans la photographie sportive, et il travaille aujourd'hui comme photographe de sport indépendant.

18

Photographer	Keith Randall
Camera	Asahi Pentax SL
Lens	200 mm Meyer
Film	Kodak Tri-X
Shutter Speed	1/500
Aperture	f/8
Developer	D76
	Acufix
Paper	Kodak Veribrom

Two motor racing pictures from the Sports Council/RPS sports photography contest. This flip over is by an Essex motor sport specialist.

Zwei Aufnahem aus der Welt des Autorennsports, die in dem RPS/Sports Council-Wettbewerb für Sportfotografie eingereicht wurden. Der Fotograf stammt aus Essex und ist auf den Autorennsport spezialisiert.

Twee racefoto's uit de Sports Council/RPS-wedstrijd. Deze opname is gemaakt door een motorsportspecialist uit Essex.

Dos instantáneas de carreras motociclísticas seleccionadas en el certamen del Sports Council/RPS. Su autor es un fotógrafo especializado en temas deportivos, natural de Essex.

Deux photographies d'une course automobile, prises lors du concours de photographie sportive du Sports Council/RPS. Ce renversement est l'oeuvre d'un spécialiste des courses automobiles, originaire du comté d'Essex.

19

Photographer	Charles B.-Knight
Camera	Nikon F2
Lens	200 mm
Film	Kodak Tri-X
Shutter Speed	1/500
Aperture	f/5.6
Developer	D76
Paper	Veribrom

'Andretti breakfasts early in the wheat'. An incongruous background for a Grand Prix car after a spin off.

'Andretti desayuna temprano entre el trigo'. He aquí a un bólido de carreras situado en un marco incongruente después de un despiste.

'Vroeg ontbijt van Andretti in het tarweveld'. Een nauwelijks passende achtergrond voor een Grand Prix-wagen na een slip.

'Andretti bei frühem Frühstück im Weizen'. Ein ungewöhnlicher Hintergrund für einen Grand-Prix-Wagen, der 'seinen Weg verloren hat'.

'Petit déjeuner matinal d'Andretti dans le blé.' Arrière-plan incongru pour une voiture gagnante du Grand Prix après un carambolage.

20

Photographer	Leo Mason
Camera	Nikon F2
Lens	55 mm Nikkor Macro
Film	Kodak EPD 64
Aperture	f/8
Lighting	Bowens Quad 200 Flash

London freelance Leo Mason entered an exceptionally fine portfolio for the 1977 'Sports Photographer of the Year' Awards. This one records the 'Madison Style' hand changeover in a six day cycling event.

Leo Mason, ein freiberuflicher Londoner Fotograf, reichte im Zusammenhang mit dem 1977 'Sports Photographer of the Year' – Wettbewerb eine besonders schöne Sammlung ein. Dieses Bild zeigt die Handübergabe im 'Madison-Stil' in einem Sechstagesrennen.

De Londense free-lance fotograaf Leo Mason zond een buitengewoon fijne collectie foto's voor de 1977 'Sports Photographer of the Year'-wedstrijd in. Deze laat het 'handovernemen' in een wielerzesdaagse zien.

El fotógrafo 'free-lance' londinense Leo Mason participó con una extraordinaria selección de fotografías en el certamen de elección del mejor fotógrafo deportivo del año 1977. En esta instantánea recogió un cambio manual al estilo 'Madison' en una prueba ciclista de seis días.

Leo Mason, photographe indépendant londonien, a constitué une extraordinaire série pour le concours du 'Sports Photographer of the Year' 1977. Ce cliché montre l'échange de témoin style 'Madison' au cours d'une manifestation cycliste de six jours.

21

Photographer	Leo Mason
Camera	Nikon F2 Motordrive with 250 exposure back and waterproof housing.
Lens	20 mm Nikkor
Film	Kodak EPD 200
Shutter Speed	1/500
Aperture	f/5.6

Off Sandgate beach with the Deal wind surfing club. To get this shot, the twenty nine year old freelance was strapped into a special harness on the wind surfer. In the three and a half years since he first picked up a camera, Leo Mason has gained awards in the RPS and Adidas European sports photo contests and worked for the *Observer* newspaper, *Stern* magazine and *Sports Illustrated*. His portfolio gained him the runner-up commendation in the last 'Sports Photographer of the Year' contest.

PRAK

PRAKTICA

EE 2

PENTACON electric 1,8/50 Multi Coating

FULLY AUTOMATIC
Full Aperture With Pentacon's unique EDC system lenses, full aperture metering is possible under all conditions – and EDC lenses are available from 20mm to 300mm!
Stop Down All universal screw thread lenses, whether automatic or pre-set diaphragm, can be utilised on the EE2 retaining fully automatic operation!

AUTOMATIC CLOSE-UPS...
. . . with internal viewfinder cover. The Praktica EE2 system operates fully automatically (with full aperture using the special EDC accessories!) for ultra close ups. A special viewfinder baffle eliminates stray light when using lamps.

FULLY ELECTRONIC SHUTTER...
. . . with Optional Manual Control The Praktica EE2 operates on the aperture priority system – just set the aperture and the shutter will adjust itself automatically within the range of 1 sec to 1/1000th sec. Alternatively, the EE2 can be operated manually from 1/30th sec to 1/1000th sec and B, whilst still retaining electronic control of the shutter for absolute accuracy.

UNIVERSAL SCREW THREAD...
. . . gives unlimited versatility. The use of the universal screw thread means that literally thousands of lenses and accessories from a vast choice of manufacturers (although we would, of course, recommend Pentacon accessories!) can be utilised – a unique choice!

MANUAL AUTO CORRECTION...
. . . plus or minus 2 stops! You may have a back-lit subject, or one where the shade area has an undue influence on the picture. The EE2 has a plus/minus switch which allows you to correct by one or two stops, whilst still retaining fully automatic operation.

TWO SUPERB LENSES...
. . . Fully multi coated. The Praktica EE2 has the choice of either 50mm f1.8 Pentacon or Zeiss Pancolar lenses; both are multi-coated for maximum flare reduction and have Electric Diaphragm Control for full aperture metering operation. The Praktica EE2 also comes complete with a special De-luxe ER case.

KTICA

The Camera with fully Automatic Operation

At last – the camera that everybody has been waiting for ; a fully automatic camera from the World's oldest single lens reflex manufacturers – the Praktica EE2.
And this is no ordinary automatic SLR ! – the Praktica EE2 is a fully electronic, full aperture TTL metering SLR with universal screw thread and all the features demanded by the most advanced of photographers.
Technically the Praktica EE2 is one of the most advanced SLR cameras on the market today.

Truly outstanding specification –

• Fully automatic, aperture-priority, TTL metering camera • Manual operation if required (1/30-1/1000th) • Fully electronic shutter giving auto operation from 1 sec. to 1/1000 sec. – infinitely variable • Pointer in V/F indicates s/speed in use • Full aperture viewing and metering utilising EDC lenses • Other lenses utilised, with auto-metering, on stop-down principle • Full automatic operation with D/A • Full automatic operation with bellows, tubes etc. • Manual correction of exposure within +/– 2 stops • Internal V/F cover can be switched in for repro-work • Built-in battery check visible in V/F • Accepts all lenses and accessories with standard Praktica 42mm screw thread

The Praktica EE2 is now at your local Pentacon Dealer, who will be happy to demonstrate it to you. If you would like further information, please send for fully illustrated literature to :

C.Z. Scientific Instruments Ltd.
P.O. Box 43, 2 Elstree Way,
Borehamwood, Herts.
Tel: 01-953 1688 (Sales)

Tel: 01-207 3757 (Service)

PENTACON

QUALITY PRODUCTS FROM THE GDR

computer

Mit dem Deal Wind Surfing Club bei Sandgate. Für diese Aufnahme musste sich der 29-jährige freiberufliche Fotograf mit einem besonderen Gurtwerk festschnallen lassen. In den 3¹/₂ Jahren, seit er zum ersten Mal zur Kamera griff, hat Leo Mason in den europäischen Sportfotowettbewerben der RPS und von Adidas Auszeichnungen gewonnen. WAR IM Dienste der Zeitung *Observer*, der Zeitschrift *Stern* und der *Sports Illustrated* tätig. In dem letzten 'Sports Photographer of the Year' – Wettbewerb wurde er aufgrund seiner Sammlung für den zweiten Preis empfohlen.

De windsurfclub van Deal ter hoogte van het strand bij Sandgate. Om deze opname te kunnen maken moest de negenentwintigjarige free-lance fotograaf in een speciaal harnas op de windsurfer worden gebonden. In de drieëneenhalf jaar dat hij fotografeert heeft Leo Mason prijzen gewonnen in de RPS en Adidas sportfotowedstrijden. Tevens werkte hij voor de *Observer, Stern* en *Sports Illustrated*. Zijn oeuvre was goed voor een tweede plaats in de laatste 'Sports Photographer of the Year'-wedstrijd.

Frente a la playa de Sandgate con algunos miembros del club de surf. Para obtener esta fotografía, Leo Mason, fotógrafo 'free-lance' de 29 años de edad, se ató a la embarcación con unas correas especiales. En los tres años y medio que lleva dedicándose a la fotografía, este artista ha obtenido diversos premios en los certámenes de la RPS y en los organizados por la casa Adidas, habiendo trabajado asimismo para el periódico *'The Observer'* y las revistas *Stern* y *Sports Illustrated*. Las obras presentadas le valieron la segunda posición en el último certamen de elección del mejor fotógrafo deportivo del año.

Au large de la côte de Sandgate avec le Deal wind surfing club. Pour réaliser cette photographie, son auteur, un photographe indépendant de vingt-neuf ans, a dû s'attacher à un harnais spécial sur le 'wind surfer'. Depuis trois ans et demi qu'il se consacre à la photographie, Leo Mason a remporté différents prix aux concours européens de photographie sportive RPS et Adidas, et a travaillé pour le journal l'*Observer*, le magazine *Stern* et *Sports Illustrated*. Sa série lui a valu la deuxième place au concours du 'Sports Photographer of the Year'.

22

Photographer	Leo Mason
Camera	Nikon F2
Lens	16 mm Nikkor Fisheye
Film	Kodachrome 64
Shutter Speed	1/125
Aperture	f/5.6

Castle Howard, Yorkshire. Dawn on the fourth day of the world Balloon championship.

Castle Howard in Yorkshire. Im Morgengrauen des vierten Tages der Luftballon-Weltmeisterschaft.

Castle Howard, Yorkshire. Ochtendgloren op de vierde dag van het wereldkampioenschap ballonvaren.

Castillo de Howard, Yorkshire. Amanecer del cuarto día del campeonato mundial de globos.

Castle Howard, Yorkshire. L'aube au quatrième jour du championnat mondial de montgolfière.

23

Photographer	Leo Mason
Camera	Nikon F2
Lens	400 mm Nikkor
Film	Kodak EPD
Shutter Speed	1/500
Aperture	f/4.5

Sand yacht racing on Bream beach. Mason used a polarizing filter for this action sports composition.

Sandjachtrennen auf dem Strande von Bream. Mason machte für diese Komposition von einem polarisierenden Filter Gebrauch.

Surfrace op het strand bij Bream. Mason gebruikte een polarisatiefilter bij het maken van deze sportcompositie.

Carrera de balandros en la playa de Bream. Mason utilizó un filtro polarizado para obtener esta instantánea llena de acción.

Course de chars à voile sur la plage de Bream. Pour cette composition de sport d'action, Mason a utilisé un filtre polarisant.

24

Photographer	Leo Mason
Camera	Nikon F2
Lens	20 mm Nikkor
Film	Kodachrome 64
Shutter Speed	1/1000
Aperture	f/4

The year of the skateboard. The essence of this new youthful enthusiasm was taken by Mason at Weymouth's skatepark for the *Telegraph* Colour Magazine.

Das Jahr des Skateboard. Mason kam mit dieser im Skatepark von Weymouth aufgenommenen Studie dem Wesen dieses neuen Sports, der von der Jugend mit solcher Begeisterung aufgegriffen wurde, nahe. Er machte die Aufnahme für die Farbeinlage der Zeitung *Telegraph*.

We leven in het jaar van het skateboard. De essentie van dit nieuwe jeugdige spel werd vastgelegd door Mason op het speciale skateterrein in Weymouth voor het *Telegraph Colour Magazine*.

Este fue el año del patinaje sobre tablas. He aquí una imagen reveladora del entusiasmo juvenil por este nuevo deporte tomada por Mason en las pistas de Weymouth por encargo del *Telegraph Colour Magazine*.

L'année de la planche à roulettes. L'essence de ce nouvel enthousiasme juvénile a été saisie par Mason sur la piste de Weymouth pour le magazine en couleurs du *Telegraph*.

25

Photographer	Leo Mason
Camera	Nikon F2 Motordrive
Lens	16 mm Nikkor Fisheye
Film	Kodak EPD
Shutter Speed	1/250
Aperture	f/5.6

To get what is probably the best hang gliding shot we have yet seen, Mason mounted his Nikon on the wing of the craft and activated the shutter release by means of an infra-red device.

Um die wohl beste Aufnahme eines Hängegleiters zu erzielen, die wir bisher gesehen haben, brachte Mason seine Nikon am Flügel des Geräts an und betätigte den Verschluss mit Hilfe einer Infrarot-Vorrichtung.

Om te komen tot de beste opname die ooit bij het hangweven is gemaakt, bevestigde Mason zijn Nikon aan het frame van het zweeftuig en ontspande de sluiter door middel van een infrarood afstandbediening.

Para obtener esta instantánea, probablemente la mejor que hemos visto de las dedicadas al vuelo sin motor, Mason montó su Nikon en el ala del planeador y activó el disparador por medio de un dispositivo de rayos infrarrojos.

Pour réaliser ce qui est probablement le meilleur cliché de deltaplane, Mason a monté son Nikon sur l'aile de l'appareil et actionné le déclic au moyen d'un dispositif à rayons infrarouges.

26

Photographer	Tony Duffy
Camera	Nikon F2
Lens	600 mm Nikkor
Film	Kodachrome
Shutter Speed	1/500
Aperture	f/6.3

British swimmer Duncan Goodhew by Tony Duffy of the All-Sport Photo Agency. In addition to his success in the 'Sports Photographer of the Year' contest, Tony Duffy recently won first prize in the International Sports Photo Contest for the second time in three years.

Der britische Schwimmer Duncan Goodhew. Der Fotograf war Tony Duffy, ein Mitarbeiter der All-Sport Photo Agency. Duffy schnitt nicht nur in dem 'Sports Photographer of the Year' – Wettbewerb erfolgreich ab, sondern gewann auch zum zweiten Mal in drei Jahren den ersten Preis in dem International Sports Photo Contest.

Een opname van de Engelse zwemmer Duncan Goodhew, gemaakt door Tony Duffy van het All-Sport Photo Agency. Behalve zijn succes in de 'Sports Photographer of the Year'-wedstrijd, won Tony Duffy recentelijk, voor de tweede keer in drie jaar, de eerste prijs in de internationale sportfotowedstrijd.

He aquí al nadador inglés Duncan Goodhew fotografiado por Tony Duffy, de la Agencia Fotográfica All-Sport. Las obras de este artista le valieron grandes elogios en el certamen para la elección del mejor fotógrafo deportivo del año, haciéndose además recientemente, y por segunda vez en tres años, con el primer premio del Certamen Internacional de Fotografía Deportiva.

Le nageur britannique Duncan Goodhew photographié par Tony Duffy de la All-Sport Photo Agency. Outre le succès qu'il a remporté au concours du 'Sports Photographer of the Year', Tony Duffy s'est récemment adjugé, pour la deuxième fois en trois ans, le premier prix au Concours international de la photographie sportive.

'Un grand champion'. Autre étude d'action saisissante extraite de la série du 'Sports Photographer of the Year' de Tony Duffy. Il s'agissait là d'une récompense britannique, mais, dans le cadre du concours international patronné par Adidas, il s'est également adjugé les deuxième et cinquième places en sus de son premier prix.

Joueurs de pelote basque à Guernica. Un des jeux le plus rapides au monde. La pelote basque se répand aujourd'hui hors d'Espagne, et pour fixer l'action de ses deux joueurs pour le magazine du *Telegraph*, Skelly, photographe indépendant de vingt-cinq ans, a utilisé un ingénieux dispositif d'éclairage comprenant dix petits flashes commandés par ordinateur Sunpak et dix microcontacts conçus pour des portes de réfrigérateur. Objectif ouvert, Skelly a réalisé ce cliché simplement en laissant courir son doigt sur les microcontacts pendant le jeu. Après avoir terminé un des premiers cours permettant d'obtenir une licence en photographie au Polytechnic de Londres Central, Shaun Skelly s'est lancé avec succès dans une carrière de photographe de presse.

27

Photographer Steve Powell

Also a member of the successful All-Sport Photo Agency, Steve Powell shot a winner with 'Slalom Superstar', a fine study of world champion Mike Hazelwood.

Steve Powell, ebenfalls ein Mitglied der erfolgreichen All-Sport Photo Agency, erzielte mit 'Slalom Superstar', einer interessanten Studie des Weltmeisters Mike Hazelwood, einen Volltreffer.

Eveneens een lid van het succesvolle All-Sport Photo Agency. Steve Powell schoot midden in de roos met 'Slalom Superstar', een prachtige studie van wereldkampioen Mike Hazelwood.

Miembro también de la famosa Agencia Fotográfica All-Sport, Steve Powell consiguió una instantánea de primera categoría con su obra titulada 'Campeón de Slalom', un perfecto estudio del campeón del mundo Mike Hazelwood.

Membre, lui aussi, de la All-Sport Photo Agency couronnée de succès, Steve Powell a pris une photographie gagnante avec 'Slalom Superstar', belle étude du champion du monde Mike Hazelwood.

28

Photographer Tony Duffy

'Blockbuster'. Another dramatic action study from Tony Duffy's 'Sports Photographer of the Year' portfolio. This was a British award but in the International contest sponsored by Adidas he also gained second and fifth place in addition to his first prize.

'Startbereit'. Eine weitere dramatische Aktionsstudie aus Tony Duffys Sammlung für den 'Sports Photographer of the Year' – Wettbewerb. Dies war ein britischer Wettbewerb, doch gewann er in dem von Adidas geförderten internationalen Wettbewerb den ersten Preis und schnitt ausserdem an zweiter und fünter Stelle ab.

'In de startblokken'. Nog een dramatische actiefoto uit de collectie die Tony Duffy maakte voor de Sports Photographer of the Year-wedstrijd. Deze opname was goed voor een prijs in Engeland, maar in de internationale wedstrijd, gesponsord door Adidas, behaalde Duffy behalve de eerste prijs ook nog eens de tweede en de vijfde plaats.

Esta instantánea dramática y llena de acción le valió a Tony Duffy una de las menciones en el certamen de elección del mejor fotógrafo deportivo del año en su fase inglesa. Además, este artista se hizo con el primero, el segundo y el quinto premios en la fase internacional de este concurso, patrocinada por Adidas.

29

Photographer	Shaun Skelly
Camera	Nikon F2
Lens	55 mm Micro Nikkor
Film	Ektachrome 64 (Rated 125 ASA)
Shutter Speed	Open
Aperture	f/8

Pelota players in Guernica. One of the fastest games in the world, Pelota is now becoming popular outside Spain and to record the action of his two players for the *Telegraph* Magazine, twenty five year old freelance Skelly employed an ingenious lighting arrangement consisting of ten small Sunpak computer flashes and ten micro switches designed for refrigerator doors. With his camera shutter open, Skelly made his exposure simply by running his finger over the micro switches during the game. After completing one of the first degree courses in photography at the Polytechnic of Central London, Shaun Skelly is now making a successful career in editorial photography.

Pelota-Spieler in Guernica. Pelota, eines der schnellsten Spiele der Welt, wird allmählich auch ausserhalb Spaniens beliebt. Der 25-jährige freiberufliche Fotograf Skelly machte von einer originellen Beleuchtungsanlage Gebrauch, die zehn kleine Sunpak-Computer-Blitzlichter und zehn für Kühlschranktüren gestaltete Mikroschalter umfasste, um den Kampf der beiden Spieler im Auftrag der Zeitschrift *Telegraph* zu veranschaulichen. Skelly liess die Blende der Kamera offen und beleuchtete einfach, indem er während des Spiels mit dem Finger über die Mikroschalter fuhr. Er absolvierte einen der ersten akademischen Fotografiekurse der Polytechnic of Central London und ist nun mit Erfolg als redaktioneller Fotograf tätig.

Pelotaspelers in Guernica. Pelota, een van de snelste sporten ter wereld, wordt nu ook populair buiten Spanje en om de actie van deze twee spelers vast te leggen voor het *Telegraph Magazine*, gebruikte de vijfentwintigjarige freelance fotograaf Skelly een ingenieuze verlichtingsopstelling, die bestond uit tien kleine Sunpak computerflitsers en tien microschakelingen zoals die voor koelkastdeuren worden gebruikt. Met zijn sluiter open maakte Skelly deze opname heel eenvoudig door tijdens het spel met zijn vinger over de microschakelaartjes te gaan. Na het voltooien van zijn opleiding aan de Polytechnische school in Centraal-Londen is Shaun Skelly nu bezig met het maken van een succesvolle carrière in redactionele fotografie.

Jugadores de pelota en Guernica. Este juego, uno de los que exigen a los participantes una mayor rapidez de movimientos, está empezando a popularizarse fuera de España. Para tomar esta instantánea, cuyo encargo le había sido formulado por la revista *Telegraph*, S. Skelly, fotógrafo 'free-lance' de 25 años, utilizó un ingenioso dispositivo de iluminación integrado por diez pequeños flashes Sunpak conectados a otros tantos microconmutadores de los que se colocan en las puertas de los refrigeradores. Manteniendo el obturador de su cámara abierto, Skelly obtuvo la exposición adecuada desplazando su dedo sobre los conmutadores durante el juego. Después de completar su formación fotográfica básica en el Central London Polytechnic, Shaun Skelly está realizando una carrera relámpago en el mundo de la fotografía editorial.

30/31

Photographer	M Germann
Camera	Hasselblad
Film	Vericolor
Shutter Speed	1/25
Lighting	Broncolor Studio Flash

Two superb fashion and glamour studies by M Germann, one of Holland's leading professional photographers and a master of colour print technique.

Mode und Charme – zwei bewundernswerte Studien von M. Germann, einem der führenden Berufsfotografen in Holland und eineih Meister der Farbdrucktechnik.

Twee uitnemende mode- en glamourstudies, gemaakt door M. Germann, een van de beste professionele fotografen van Nederland en onbetwiste meester in het maken van kleurafdrukken.

Dos atractivas fotografías de modas, obtenidas por M. Germann, uno de los profesionales holandeses más representativos, verdadero maestro de la técnica de impresión a color.

Deux remarquables études de mode de M. Germann, un des plus grands photographes professionnels des Pays-Bas, et un maître de la technique d'impression en couleur.

32

Photographer	Salvador Garcia de la Torre
Camera	Nikon FT
Lens	50 mm Nikkor
Film	Ektachrome EH
Shutter Speed	1/125
Aperture	f/8

Beauty and the beast. The conflicting expressions of model Patricia and her dog provided the Spanish photographer with an original glamour treatment on a classic theme.

Kontrast. Die kontrastierenden Ausdrücke auf den Gesichtern des Modells Patricia und ihres Hundes dienten dem spanischen Fotografen zum Anlass für eine originelle Studie zu einem klassischen Thema.

'Hondsmooi'. De tegenstrijdige uitdrukkingen van Patricia en haar hond werden door de Spaanse fotograaf op de welhaast klassieke 'glamour'-wijze vastgelegd.

on the Mamiya RB67

The shot on the left was taken on a Mamiya RB67 Pro-S fitted with a 180mm lens, using 2500 joules at f.32 on Ektachrome Professional film. As you can see, the RB67 takes a very impressive picture.

The 6×7cm format gives you studio quality, while features like the revolving interchangeable backs, bellows focusing and a focus lock enable the RB67 Pro-S to handle still-lifes like a sheet film camera. Of course, there's the added bonus of roll film convenience and economy.

But the really remarkable thing about the RB67 Pro-S is its versatility. Richard Winslade, who took the photograph on the left, also uses his RB67 for hand held air-to-air photography, where ease of handling and quick operation are vital, and the large negative size produces beautifully sharp action shots.

With 5 viewfinders, 3 backs (including Polaroid, naturally) and a range of 8 lenses, the RB67 Pro-S is just as at home on location as it is in the studio. You really don't need any other system.

There's a lot more to the RB67 Pro-S, and if you'd like to know the details write to the address below.

In the meantime, the most effective advertisement for the camera is printed here.

Mamiya.
The Japanese professional camera.

 Rank Photographic, P.O. Box 70, Great West Rd, Brentford, Middlesex, TW8 9HR.

La bella y la bestia. Las expresiones contrastantes de la modelo Patricia y su perro proporcionaron al fotógrafo español la posibilidad de dar un tratamiento original a este tema clásico.

La belle et la bête. Les expressions contradictoires de Patricia et de son chien ont permis au photographe espagnol de traiter de manière originale un thème classique.

33

Photographer Ferdinando Quaranta

We first encountered the work of Italian photographer Quaranta at a Festival of underwater photography and presented one of his sub aqua nudes in the last edition. 'Ritratto di Giovanna' proves that he is equally adept with his camera above water.

Wir lernten die Werke des italienischen Fotografen Quaranta ursprünglich auf einem Festival der Unterwasserfotografie kennen. Eine seiner Aktstudien unter Wasser veröffentlichten wir in der letzten Ausgabe. 'Ritratto di Giovanna' beweist, dass er auch über Wasser mit seiner Kamera umzugehen versteht.

We zagen voor het eerst werk van deze Italiaanse fotograaf op een tentoonstelling van onderwaterfotografie en lieten één van zijn onderwaternaakten in de vorige editie zien. 'Ritratto di Giovanna' bewijst dat hij bóven water even bedreven is met zijn camera.

Tuvimos oportunidad de ver por primera vez un trabajo del fotógrafo italiano Quaranta en un festival dedicado a la fotografía submarina y presentamos uno de sus desnudos subacuáticos en la última edición de este libro. El 'Ritrato di Giovanna' constituye una prueba de que su talento no se halla restringido al medio acuático.

Nous avions découvert les travaux du photographe italien Quaranta à un festival de photographie sous-marine, et un de ses nus subaquatiques figurait dans notre dernière édition. 'Ritratto di giovanna' (Portrait de jeune fille) prouve qu'il est tout aussi à l'aise avec son appareil hors de l'eau.

34/38

Photographer Sally Soames
Camera Nikon F
Lens 300 mm Nikkor
Film Kodak Tri-X
Shutter Speed 1/125
Aperture f/4
Developer D76

Although the British Press Photography Awards are still largely male dominated, the work of women is increasingly represented in this important annual exhibition. One of the most significant female talents to emerge in recent years must surely be Sally Soames of the *Sunday Times* and her opening set of pictures, taken at the Conservative Party Conference, has captured the revealing expressions of some of the leading participants with a sense of gleeful mischief of which, we suspect, only a woman would be capable. From top left to right: a nail nibbling William Whitelaw, a sardonically smiling Edward Heath, a head clasped Norman St. John Stevas, a deeply thoughtful Sir Keith Joseph and an elated Iron Lady – party leader Mrs Margaret Thatcher.

Obgleich die British Press Photography Awards auch heute noch zum grössten Teil von Männern gewonnen werden, sind die Werke von Frauen in dieser wichtigen Jahresausstellung in immer höherem Masse vertreten. Eine der interessantesten Fotografinnen, die in den letzten Jahren in den Vordergrund gerückt ist, ist ohne Zweifel Sally Soames, die im Dienste der *Sunday Times* tätig ist. Ihre erste Serie von Bildern, die auf der Konferenz der konservativen Partei aufgenommen wurde, gibt die Ausdrücke auf den Gesichtern einiger führender Persönlichkeiten mit einer Schadenfreude wider, deren unserer Ansicht nach nur eine Frau fähig ist. Oben sieht man von links nach rechts William Whitelaw, der seine Nägel beisst, den sardonisch lächelnden Edward Heath, Norman St. John Stevas mit dem Kopf in den Händen, Sir Keith Joseph mit sehr nachdenklicher Miene und Mrs. Margaret Thatcher, die Führerin der Partei, in gehobener Stimmung.

Alhoewel de British Press Photography Awards nog steeds voor een groot deel een mannenaangelegenheid zijn, komen er steeds meer inzendingen van vrouwen voor deze belangrijke jaarlijkse tentoonstelling. Een van de meest opmerkelijke fotografes die de laatste tijd opvallend werk maken is Sally Soames van de *Sunday Times* en de eerste serie foto's, genomen op een vergadering van de Conservatieve partij, laat de onthullende uitdrukkingen van een aantal belangrijke partijgangers zien – en wel met een gevoel van vrolijke ondeugendheid waartoe alleen een vrouw in staat is. Van links boven naar rechts: een nagelbijtende William Whitelaw, een sardonisch glimlachende Edward Heath, een aandachtige Norman St. John Stevas, een in gedachten verzonken Sir Keith Joseph en een opgetogen partijleidster, Margaret Thatcher.

Aunque la mayor parte de los premios otorgados por la asociación de la prensa británica tienen aún como destinatarios a fotógrafos de sexo masculino, los trabajos realizados por mujeres van entrando de manera progresiva en las exposiciones anuales organizadas por dicha asociación. Uno de los talentos femeninos más importantes entre los surgidos en los últimos años es Sally Soames, del *Sunday Times*, que en este conjunto de fotografías tomadas durante una convención del partido conservador británico logró captar con una deliciosa picardía, que sospechamos sólo una mujer es capaz de exhibir, las expresiones más reveladoras de algunos de los más conocidos participantes. Desde la parte superior izquierda a la derecha: William Whitelaw mordiéndose las uñas, Edward Heath exhibiendo una sonrisa sardónica, Norman St. John Stevas abrazándose la cabeza, Sir Keith Joseph sumergido en sus pensamientos y la 'líder' del partido, Margaret Thatcher confirmando con su alegría su fama de 'mujer de hierro'.

Bien que les prix de la photographie de presse britannique soient toujours nettement dominés par des lauréats masculins, les oeuvres des femmes sont de plus en plus représentées à cette importante exposition annuelle. L'un des talents féminins le plus remarquable qui se soit dégagé ces dernières années est certainement celui de Sally Soames, du *Sunday Times*, dont la série d'ouverture de photographies prises à une conférence du parti conservateur a capté les expressions révélatrices de certains des principaux participants avec une souriante malice dont, pensons-nous, seule une femme est capable. De gauche à droite, en partant du haut, un William Whitelaw se rongeant les ongles, un Edward Heath au sourire sardonique, un Norman St. John Stevas la tête entre les mains, un Sir Keith Joseph perdu dans ses pensées et une exultante Madame Poigne-de-Fer – Mme Margaret Thatcher, leader du parti.

39/40

Photographer Sally Soames
Camera Nikon F
Lens 28 mm Nikkor
Film Kodak Tri-X
Shutter Speed 1/125
Aperture f/4
Developer D76

Switching from politics to the arts, Sally Soames took these pictures at the Dance Centre, Covent Garden.

Sally Soames machte diese völlig unpolitischen Aufnahmen im Dance Centre von Coven Garden.

Van politiek naar de schone kunsten: Sally Soames maakte deze foto's in het Dance Centre, Covent Garden.

Saltando de la política al arte, Sally Soames tomó estas fotografías en el Covent Garden, el centro de la danza por excelencia.

Passant de la politique aux arts, Sally Soames a pris ces images au Dance Centre, Covent Garden.

41

Photographer Sally Soames
Camera Nikon F
Lens 35 mm Nikkor
Film Kodak Tri-X
Shutter Speed 1/125
Aperture f/5.6
Developer D76

A lively impression of composer Lional Bart.

Ein lebhaftes Bild des Komponisten Lionel Bart.

Een treffende impressie van componist Lional Bart.

Una vívida instantánea del compositor Lional Bart.

Impression vivante du compositeur Lionel Bart.

42

Photographer Mayotte Magnus
Camera Asahi Pentax 6 × 7
Lens 75 mm
Film Kodak Tri-X
Shutter Speed 1/60
Aperture f/5.6

Two Deaconesses, Una Kroll and Linda-Mary Evans, both champions of woman priesthood, from another well attended photographic exhibition at the National Portrait Gallery. This time the photographer was Mayotte Magnus, the talented Frenchborn photographer of people who, in consultation with Colin Ford, selected as her subjects other talented women who have made a significant contribution to Society.

Zwei Diakoninnen, Una Kroll und Linda-Mary Evans, die beide für das Recht von Frauen zur Aufnahme in den geistlichen Stand einstehen. Dieses Bild wurde auf einer fotografischen Ausstellung in der National Portrait Gallery gezeigt, die ebenfalls sehr viele Besucher anzieht. Die Fotografin war Mayotte Magnus, die talentierte Französin, die von Colin Ford beraten andere talentierte Frauen, die wesentliche Beiträge zum Leben der Gesellschaft geleistet haben, aufnahm.

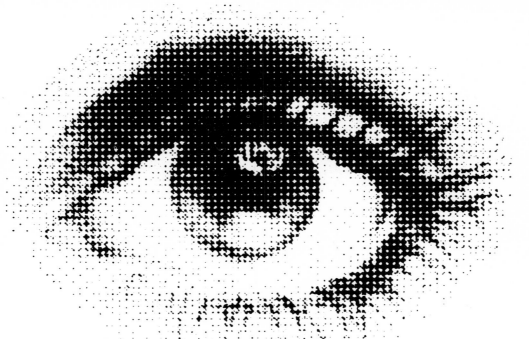

There's more to ILFORD than meets the eye.

You'll know us for our range of films and papers, HP5, FP4 and ILFOSPEED to name but a few.

Yes, but that's only part of the picture.

Did you know we make Microfilm products for recording computer output and for image retrieval systems in banking and industry — even the security recording of the millions of football coupons returned each week.

Pick up any newspaper or magazine and not only are ILFORD films and papers likely to have been used for the illustrations, but ILFORD Graphic Arts materials probably played a part in printing them on the page.

Photographic products as diverse as Surveillance film used in banks and high-risk security areas, Nuclear Emulsions, Cibachrome Colour Printing materials for professionals and amateurs — all come from the international complex that is ILFORD.

And we believe in after sales and technical service to support the full range.

That's why we say there's more to ILFORD than meets the eye.

ILFORD

ILFORD Limited, Basildon, Essex

Twee diaconessen, Una Kroll en Linda-Mary Evans; beiden zijn bekende vrouwelijke geestelijken. Een opname uit de goedbezochte fototentoonstelling in de National Portrait Gallery. Deze keer was de getalenteerde Franse fotografe Mayotte Magnus de maakster. Samen met Colin Ford ging ze op zoek naar markante vrouwen. Een prachtige collectie foto's van vrouwen die een belangrijke bijdrage aan de maatschappij hebben geleverd was het resultaat.

Dos diaconisas, Una Kroll y Linda-Mary Evans, luchadoras impenitentes por la igualdad de derechos eclesiásticos con los hombres, constituyen el tema de esta fotografía que formó parte de una exposición celebrada con gran éxito por Mayotte Magnus en la National Portrait Gallery. Esta conocida artista, francesa de nacimiento, seleccionó para captarlas en sus fotografías, con la ayuda de Colin Ford, a una serie de mujeres de talento que han contribuído poderosamente al desarrollo de la sociedad moderna.

Deux diaconesses, Una Kroll et Linda-Mary Evans, l'une et l'autre championnes du clergé féminin, reprises d'une exposition très courue de photographies à la National Portrait Gallery. Cette fois, le photographe était Mayotte Magnus, la talentueuse portraitiste française, qui, en consultation avec Colin Ford, a choisi pour sujets d'autres femmes de talent qui ont apporté une contribution importante à la société.

43

Photographer	Mayotte Magnus
Camera	Asahi Pentax 6 × 7
Lens	75 mm
Film	Kodak Tri-X
Shutter Speed	1/60
Aperture	f/5.6

The actress Glenda Jackson, photographed in her stage dressing room between performances. Magnus was a student in ballet, classical guitar and painting before she decided to become a professional photographer.

Die Schauspielerin Glenda Jackson in ihrem Umkleidersum im Theater zwischen Auftritten. Mayotte Magnus studierte Ballett, klassische Gitarre und Malerei, bevor sie sich entschloss Berufsfotografin zu werden.

Actrice Glenda Jackson in haar kleedkamer tussen twee voorstellingen door. Mayotte Magnus studeerde, voordat ze besloot fotografe te worden, ballet en klassiek gitaar, terwijl ze daarnaast ook nog schilderde.

La actriz Glenda Jackson fotografiada en su camerino entre dos actos de una obra teatral. Magnus estudió ballet, guitarra clásica y pintura antes de convertirse en fotógrafo profesional.

L'actrice Glenda Jackson, photographiée dans sa loge entre deux apparitions sur scène. Magnus a étudié le ballet, la guitare classique et la peinture avant d'opter pour la carrière de photographe professionnelle.

44

Photographer	Mayotte Magnus
Camera	Asahi Pentax 6 × 7
Lens	75 mm
Film	Kodak Tri-X
Shutter Speed	1/125
Aperture	f/8

Fashion designer Mary Quant, the caravan being, according to her photographer, 'a symbol of her adaptability and simplicity'.

Die Modeschöpferin Mary Quant. Der Zigeunerwagon ist, wie die Fotografin erklärt, 'ein Symbol ihrer Anpassungsfähigkeit und Einfachheit'.

Modeontwerpster Mary Quant. De caravan is, volgens de fotografe, een symbool voor zowel haar aanpassingsvermogen als haar eenvoud.

He aquí a la diseñadora Mary Quant. El remolque constituye para Magnus un símbolo de 'su adaptabilidad y sencillez'.

La dessinatrice de mode Mary Quant. Selon son photographe, la caravane est 'un symbole de son adaptabilité et de sa simplicité'.

45

Photographer	Mayotte Magnus
Camera	Asahi Pentax 6 × 7
Lens	55 mm
Film	Kodak Tri-X
Shutter Speed	1/60
Aperture	f/8

Margaret Busby, 'a young publisher from Ghana, who never sends a manuscript back without careful reading and a friendly letter. She has discovered quite a few good writers among those rejected by other publishers.'

Margaret Busby, 'eine junge Verlegerin aus Ghana, die kein Manuskrip zurücksendet, ohne es sorgfältig gelesen zu haben ohne einen freundlichen Begleitbrief zu schreiben. Sie hat mehrere gute Schriftsteller entdeckt, die von anderen Verlegern abgewiesen wurden.'

Margaret Busby, 'een jonge uitgeefster uit Ghana, die nooit een manuscript terugstuurt zonder het goed te hebben gelezen en in zo'n geval altijd een vriendelijke brief erbij doet. Onder de schrijvers die door andere uitgevers werden afgewezen heeft ze in de loop van de tijd al een aantal veelbelovende auteurs ontdekt'.

Margaret Busby, 'una joven editora, natural de Ghana, que nunca devuelve un manuscrito sin haberlo leído cuidadosamente y la compañía de una carta amistosa. Ha descubierto a una serie de escritores de calidad cuyas obras habían sido rechazadas previamente por otros editores'.

Margaret Busby, 'jeune éditrice du Ghana, qui ne renvoie jamais un manuscrit sans l'avoir lu soigneusement et sans l'accompagner d'une lettre amicale. Elle a découvert maints bons écrivains parmi ceux rejetés par d'autres éditeurs'.

46

Photographer	Mayotte Magnus
Camera	Asahi Pentax 6 × 7
Lens	75 mm
Film	Kodak Tri-X
Shutter Speed	1/60
Aperture	f/5.6

Penny Slinger, described by Mayotte Magnus as an 'Artist and sensualist of great inventiveness, deeply influenced by Indian religious thinkings'. Magnus herself regularly works for the magazines Radio Times, Harpers and Vogue and does not concentrate exclusively on women subjects. It is interesting, however, that the subject of this plate is also the contributor of those immediately following.

Mayotte Magnus beschreibt Penny Singer als eine 'Künstlerin und Sensualistin von grosser Originalität, auf die die indische Religionsphilosophie einen tiefen Einfluss ausgeübt hat.' Mayotte Magnus arbeitet regelmässig für die Zeitschriften Radio Times, Harpers und Vogue, wobei sie sich keineswegs auf ausschliesslich mit weiblichen Themen befasst. Es ist jedoch interessant, dass nicht nur sie sondern auch ihr Modell durch Beiträge in diesem Jahrbuch vertreten ist.

Penny Slinger wordt door Mayotte Magnus beschreven als een 'kunstenares en sensualiste met een groot scheppingsvermogen, die bijzonder is beïnvloed door het Indiase religieuze denken'. Mayotte Magnus werkt regelmatig voor bladen als de Radio Times, Harpers en Vogue en maakt niet alleen foto's van vrouwen. Het is echter interessant dat de vrouw op deze foto de maakster van de direct hierop volgende opnamen is.

Penny Slinger, descrita por Mayotte Magnus como una 'Artista de extraordinaria inventiva y poderosa sensualidad, profundamente influenciada por el pensamiento religioso hindú'. Magnus trabaja regularmente para las revistas Radio times, Harpers y Vogue, tratando muy diversos temas, aparte de los feministas. Cabe destacar que la mujer retratada en esta fotografía es precisamente la autora de las que figuran a continuación.

Penny Slinger, décrite par Mayotte Magnus comme 'une artiste et une sensualiste à l'esprit remarquablement inventif, profondément influencée par la pensée de la religion indienne'. Magnus elle-même travaille régulièrement pour les magazines Radio Times, Harpers et Vogue, mais ne se consacre pas exclusivement aux sujets féminins. Il est toutefois intéressant de noter que le sujet de cette composition est le même que celui des photos suivantes.

47

Photographer	Penny Slinger
Camera	Asahi Pentax
Film	Kodak Tri-X
Developer	D76
Paper	Kodak Bromide

The following images are from Penny Slinger's latest book of photo-collages, An Exorcism, published in a limited edition by Neville Spearman Ltd., for Empty-Eye Ltd. 'The scene is set in a large deserted mansion house. The photographs were taken with natural light and each image incorporates collage or montage techniques. This was a three-year project, a 'Photo-Romance', a Surrealist autobiography of a woman's inner world, and the house is here presented as an image to the Self. The head of the woman and the house share the same space. The Inner Eye (symbolised by the jewel) opens the door for exploration while the headless phantom body haunts the mansion with unfulfilled desires . . .'
Penny Slinger was born in 1947 in England. She studied Fine Art at the Farnham and Chelsea Colleges, completing her thesis on the collage-work of Max Ernst. She has exhibited at the Institute of Contemporary Arts in London, at the Angela Flowers Gallery and other locations. She is known as a painter, sculptress, photographer and collagist, and has travelled widely.

Pre loaded inserts for rapid film change.

Interchangeable hoods and focusing screens.

Power supply. Sinter Ni cad pack. 800 exposures per charge.

Shutter speeds ½ sec to 1/500 or 1 sec to 30 sec.

Rolleiflex SLX

Light metering system. Silicon blue cells.

Electronically controlled exposure.

Remote control plug for radio signals, light signals or infrared.

Linear motors in lens for shutter and aperture.

Built in motor drive.

Range of Zeiss lens 40-350mm.

Single shot or continuous high speed exposures.

Shutter release, left or right hand.

Introducing the most professional photographer on earth.

That's quite a claim.
But just a glance at the SLX's features will tell you that this is a totally revolutionary 6 x 6cm camera system.

Rollei designed it for the professional photographer. A tough customer who doesn't want temperamental equipment.

A broken camera can cost him more than just money.

So for the SLX we used solid state electronics for utter reliability.

We created a 'through the lens' metering system, so sophisticated that it'll read and adjust the aperture before every shot. Even when the built-in motor drive is racing along at one frame every 0.7 seconds.

The SLX is the first real

breakthrough in camera design for 30 years. Virtually every feature is innovative.

Call us at Wellingborough 76431 and we'll arrange for you to test drive the SLX.

Rollei
The living legend.

Rollei (UK) Ltd., Dennington Estate, Wellingborough, Northants NN8 2RG.

Die folgenden Bilder stammen aus Penny Slingers neuester Sammlung von Foto-Collagen, die von Neville Spearman Ltd. für Empty-Eye Ltd. in einer begrenzten Ausgabe unter dem Titel "An Exorcism" veröffentlicht wurde. "Den Hintergrund bildet ein grosses verlassenes Herrenhaus. Die Aufnahmen wurden bei natürlichem Licht gemacht, und jedes Bild ist das Ergebnis von Collage- oder Montagetechniken. Es handelte sich hier um ein dreijähriges Projekt, eine 'Foto-Romanze', eine surrealistische Autobiographie der Innenwelt einer Frau, und das Haus hält hier dem Selbst den Spiegel. Der Kopf der Frau und das Haus teilen hier den gleichen Raum. Das innere Auge (versinnbildlicht durch den Edelstein) öffnet die Tür zur Erkundung, während der kopflose geisterhafte Körper das Haus mit unerfüllten Wünschen heimsucht . . .'. Penny Slinger wurde 1947 in England geboren. Sie studierte die schönen Künste an den Colleges von Farnham und Chelsea und verfasste eine These über die Collagen von Max Ernst. Sie hat ihre Werke am Institute of Contemporary Arts in London, in der Angela Flowers Gallery und in anderen Ausstellungszentren zur Schau gestellt. Sie ist für ihre Gemälde, Skulpturen, Fotografien und Collagen bekannt und hat viele Länder besucht.

De volgende opnamen komen uit Penny Slingers laatste boek met fotocollages, *An exorcism*, in een beperkte oplaag uitgegeven door Neville Spearman Ltd. voor Empty-Eye Ltd. 'De opnamen werden gemaakt in een groot, verlaten landhuis. De foto's zijn bij bestaand licht gemaakt en iedere opname omvat diverse collage- of montagetechnieken. Dit was een project van drie jaar en kan een 'fotoromance' genoemd worden; een surrealistische autobiografie van de belevingswereld van een vrouw, waarbij het hier gefotografeerde huis een indruk van 'het ik' voorstelt. Het hoofd van de vrouw en het huis delen dezelfde ruimte. Het 'oog naar binnen' (met als symbool het juweel) opent de jeur naar het zoeken terwijl het hoofdloze spooklichaam in het luis rondwaart vol onvervulde verlangens . . .' Penny Slinger werd in 1947 in Engeland geboren. Ze was leerlinge van de kunstacademies in Farnham en Chelsea, waar zij haar studie besloot met een scriptie over Max Ernst. Ze heeft tentoonstellingen gehad in het Institute of Contemporary Arts in Londen, in de Angela Flowers Gallery en op andere plaatsen. Tevens is zij bekend als schilderes, beeldhouwster en maakster van collages. Voorts maakte zij vele reizen.

Esta y las fotografías que siguen han sido extraídas del último libro de fotocollages de Penny Slinger, titulado, *Un exorcismo* y publicado por Neville Spearman Ltd. para Empty-Eye Ltd. en edición reducida. 'Como escenario utilicé una gran mansión abandonada. Tomé las fotografías con luz natural, incorporando a cada una ellas técnicas de collage o de fotomontaje. Este proyecto me tomó tres años de trabajo, convirtiémdose en realidad en una historia en imágenes, en la autobiografía surrealista del mundo interior de una mujer, en la que la casa constituye una representación de su yo verdadero. La cabeza de la mujer y la casa comparten el mismo espacio. El Ojo Interior (simbolizado por la joya) abre la puerta a la exploración de la mansión mientras que el cuerpo fantasmal y sin cabeza se pasea por la misma espoleado por sus deseos insatisfechos . . .' Penny Slinger nació en Inglaterra en 1947. Estudió Bellas Artes en las Escuelas Superiores de Farnham y Chelsea, realizando su tesis de fin de carrera sobre los collages de Max Ernst. Ha presentado exposiciones en el Institute of Contemporary Arts de Londres, en la Angela Flowers Gallery y en otros centros. Ha adquirido un gran renombre como pintora, escultora, fotógrafo y 'collagista' y ha realizado numerosos viajes.

Les images qui suivent sont extraites du dernier album de photo-collages du Penny Slinger, *Un exorcisme*, publié dans une édition limitée par Neville Spearman Ltd. pour Empty-Eye Ltd. 'La scène se situe dans un grand château désert. Les photographies ont été prises sous un éclairage naturel, et chaque cliché est le résultat de techniques de collage ou de montage. Il s'agissait d'une opération portant sur trois ans: un 'Photo-Roman' et une autobiographie surréaliste du monde intérieur d'une femme, le château étant ici présenté comme une image du Moi. La tête de la femme et le château se partagent le même espace. L'oeil intérieur (symbolisé par le bijou) ouvre la porte pour une exploration, tandis que le corps du fantôme sans tête hante le château de désirs

insatisfaits . . .' Penny Slinger est née en Angleterre en 1947. Elle a étudié les beaux arts au Farnham College et au Chelsea College, où elle a achevé sa thèse sur les collages de Max Ernst. Elle a tenu des expositions à l'Institute of Contemporary Arts de Londres, à la Angela Flowers Gallery et ailleurs. Elle est connue comme peintre, sculpteur, photographe et collagiste; et elle a beaucoup voyagé.

48

Photographer	Penny Slinger
Camera	Asahi Pentax
Film	Kodak Tri-X
Developer	D76
Paper	Kodak Bromide

'Talking to myself'. 'This image uses the addition of simple collage elements to imply the 4th Dimension. Three separate photographs are involved: the background image of landscape and railings, the foreground image of the woman's back, and the little girl (from a family album). The woman confronts herself as a child.'

'Selbstgespräch'. 'In diesem Bild habe ich von einfachen Collage-Elementen Gebrauch gemacht, um die verte Dimension anzudeuten. Es setzt sich aus drei verschiedenen Fotografien zusammen. Den Hintergrund bildet die Aufnahme einer Landschaft mit Geländer, während man im Vordergrund den Rücken einer Frau und ein kleines Mädchen (aus einem Familienalbum) sieht. Die Frau sieht sich hier als Kind.'

'In mijzelf praten'. 'Dit beeld wekt door middel van de toevoeging van eenvoudige collage-elementen de indruk van een vierdimensionale foto. Het betreft hier eigenlijk drie afzonderlijke foto's: de achtergrond met z'n landschap en het hek, de voorgrond met de vrouwenrug, en het meisje (afkomstig uit een familiealbum). De vrouw wordt geconfronteerd met zichzelf als kind.'

'Hablando conmigo misma'. 'En esta instantánea el empleo de las técnicas del collage está orientado hacia la sugerencia de la cuarta dimensión. Se han superpuesto tres fotografías distintas: la imagen de fondo con el paisaje y la reja, la imagen de la espalda de la mujer, situada en primer plano, y el retrato de la niña (tomado de un álbum familiar). La mujer se enfrenta con su propia imagen infantil'.

'Entretien avec moi-même'. 'Ce cliché utilise l'addition de simples éléments de collage pour suggérer la quatrième dimension. Il s'agit d'un montage de trois photographies: le cliché d'arrière-plan pour le paysage et la grille, le cliché d'avant-plan pour le dos de la femme, et la petite fille (extraite d'un album de famille). La femme se revoit sous les traits d'une enfant.'

49

Photographer	Penny Slinger
Camera	Asahi Pentax
Film	Kodak Tri-X
Developer	D76
Paper	Kodak Bromide

'Letting go'. 'This collage is a combination of three different photographs. The shot of the building was taken looking down from the fire-escape of the house, the Bridge was taken in Wales and the nude in an Iranian desert. The intention was to create the feeling of vertigo in the viewer, as if falling in a dream.'

'Gehenlassen'. 'Diese Collage verbindet drei verschiedene Fotografien. Als ich das Gebäude aufnahm, befand ich mich oben auf der Notleiter und blickte nach unten. Die Brücke wurde in Wales aufgenommen, und die Aktstudie in einer iranischen Wüste. Ich hatte die Absicht in dem Betrachter ein Schwindelgefühl zu erwecken, als versinke er in einem Traum.

'Laten gaan'. 'Deze collage is een combinatie van drie verschillende foto's. De opname van het huis werd genomen vanaf de brandladder, de brug is gemaakt in Wales terwijl het naakt opgenomen is in een woestijn in Iran. De bedoeling was om bij de kijker een duizelig gevoel teweeg te brengen, alsof men tijdens een droom in een oneindig gat valt.'

'Dejándose ir'. 'Este collage está constituído por la combinación de tres fotografías diferentes. La imagen del edificio fue tomada desde la salida de incendios, la del puente la tomé en Gales y el desnudo en un desierto persa. Mi intención fue sumir al espectador en la vertiginosa sensación de caer en un sueño sin fondo'.

'Laisser-aller'. 'Ce collage est une combinaison de trois photographies différentes. Le cliché représentant le bâtiment a été pris de haut en bas à partir de la sortie de secours de la maison, le pont a été pris au Pays de Galles et le nu dans un désert iranien. L'idée était de créer la sensation de vertige de l'observateur, comme s'il tombait dans un rêve.'

50

Photographer	Penny Slinger
Camera	Asahi Pentax
Film	Kodak Tri-X
Developer	D76
Paper	Kodak Bromide

'The Chymical Wedding'. 'This black and white collage contains ten different photographic elements. Many of the combined images are 'found objects' while painted stars have been added to complete the overall effect. Outside and inside have ceased to be separate as the elements of space enter the room.' Original in the collection of Sir Roland Penrose.'

'Die chymische Hochzeit'. 'Diese schwarz-weisse Collage enthält zehn verschiedene fotografische Elemente. Viele der Bilder sind 'Fundobjekte', und die gemalten Sterne vervollkommnen die Gesamtwirkung. Aussen und innen sind nicht mehr getrennt, da die Elemente des Raums in das Zimmer eindringen.' Das Original befindet sich in der Sammlung von Sir Roland Penrose.

'Bruiloft der hersenschimmen'. 'Deze zwartwitcollage bevat tien verschillende fotografische elementen. Een groot aantal van de gecombineerde beelden zijn "gevonden objecten", terwijl geschilderde sterren zijn toegevoegd om het totale effect te completeren. Buiten en binnen zijn niet langer gescheiden als de ruimtelijke elementen de kamer "binnenkomen".' Het origineel is in het bezit van Sir Roland Penrose.

'La boda química'. 'En este collage realizado en blanco y negro se han combinado diez imágenes fotográficas distintas. Varias de ellas están constituídas por 'objetos hallados', habiéndose pintado una serie de estrellas adicionales para completar el efecto general. El interior y el exterior han dejado de estar separados, a causa de la entrada en la habitación de los elementos espaciales'. El original se halla en la colección de Sir Roland Penrose.

'Le mariage chimique'. Ce collage en noir et blanc contient dix éléments photographiques différents. Nombre des clichés sont des 'objets trouvés' tandis que les étoiles peintes ont été ajoutées pour compléter l'effet d'ensemble. L'extérieur et l'intérieur ont cessé d'être séparés avec l'introduction des éléments spatiaux dans la salle.' Original extrait de la collection de Sir Roland Penrose.

51

Photographer	Penny Slinger
Camera	Asahi Pentax
Film	Kodak Tri-X
Developer	D76
Paper	Kodak Bromide

'The woman, dressed in a nun's habit, was photographed in a variety of poses. These were then enlarged to varying sizes, cut out and the selected images collaged into the empty room. The silver beam of light was then sprayed on. The progression and duplication of the figure is here used to suggest the transport of mystical vision.'

Die als Nonne gekleidete Frau wurde in verschiedenen Posen fotografiert. Diese wurden dann auf verschiedene Formate vergrössert, ausgeschnitten und in dem leeren Raum zusammengesetzt. Dann wurde der silberne Lichtstrahl aufgesprüht. Der Gang und die Wiederholung der Figur deuten die durch eine mystische Vision bedingte Verzückung an.'

'Deze vrouw in habijt werd in verschillende poses gefotografeerd. Deze opnamen werden vervolgens op verschillende formaten vergroot, uitgesneden en tot een collage in de lege kamer gemaakt. Vervolgens werd de zilveren lichtstraal op de collage gespoten. De progressie en het dubbel afbeelden van de figuur is hier gebruikt om het doorgeven van een mystieke visie te suggereren.'

'Empecé por fotografiar a la mujer, vestida con un hábito de monja, en varias poses distintas. Luego amplié las fotografías obtenidas, propocionándoles tamaños diferentes, seleccioné varias partes y las recorte, combinándolas, utilizando la técnica del collage, sobre el fondo de la habitación vacía. A continuación introducí el rayo de luz plateada. Con la progresión y duplicación de la figura traté de sugerir la transformación producida por la visión mística'.

'La femme, vêtue d'une robe de nonne, a été photographiée dans différentes poses. Celles-ci ont ensuite été agrandies à différentes tailles et découpées, après quoi les clichés retenus ont été collés dans la pièce vide. Le rayon argenté de lumière a ensuite été rapporté au vaporisateur. La projection et la duplication de la silhouette sont utilisées ici pour suggérer le transport d'une vision mystique.'

52

Photographer	Jean Berner
Camera	Nikkormat FT
Lens	105 mm
Film	Kodak Tri-X
Developer	D76
Paper	Agfa

'Saint-Malo sur la dignette allant a la tombe de Chateaubriand', is the title of this excellent contre jour composition from France.

'Saint-Malo sur la dignette allant a la tombe de Chateaubriand' ist der Titel dieser ausgezeichneten Contre-Jour-Komposition aus Frankreich.

'Saint-Malo sur la dignette allant à la tombe de Chateaubriand' es el título de esta excelente composición a 'contre jour' recibida de Francia.

'Saint-Malo sur la dignette allant à la tombe de Chateaubriand', is de titel van deze buitengewone tegenlichtopname uit Frankrijk.

'Saint-Malo: sur la diguette allant à la tombe de Chateaubriand'. Tel est le titre de cette excellente composition en contre-jour d'un photographe français.

53

Photographer	Jean Berner
Camera	Nikkormat FT
Lens	20 mm Nikkor
Film	Kodak Tri-X
Developer	D76
Paper	Agfa

Good landscapes form an all too small proportion of our submitted material so we are glad to include this one, 'Baie des Trespasses, Bretagne' by the Paris photographer.

Viel zu wenige der eingereichten Aufnahmen sind gute Landschaftsbilder. Wir freuen uns dahrer, diese Aufnahme, 'Baie des Trespasses, Bretagne' des Pariser Fotografen veröffentlichen zu können.

Goede landschapsfoto's vormen nog steeds een erg klein gedeelte van de opnamen die wij krijgen toegezonden, zodat wij erg blij zijn deze te kunnen laten zien: 'Baie des Trespasses in Bretagne', gemaakt door de Parijse fotograaf Jean Berner.

Hemos recibido muy pocas fotografías de paisajes, por lo que nos complace extraordinariamente el poder incluir esta excelente imagen de la 'Baie des Trespasses, Bretagne', obra de este buen fotógrafo parisino.

Les beaux paysages forment une part beaucoup trop réduite des photographies qui nous ont été adressées; c'est pourquoi nous nous félicitons de pouvoir présenter cette 'Baie des Trépassés, Bretagne', due à un photographe parisien.

54

Photographer	Wang Yul Lung
Camera	Canon Fl
Lens	100 mm
Film	Kodak Tri-X
Shutter Speed	1/125
Aperture	f/5.6
Developer	Microdol-X
Paper	Agfa

This year we received a large and excellent series of submissions from Taiwan. 'Hard to win' is the title of this fine action study but, other than technical, no descriptive caption was supplied.

Dieses Jahr erhielten wir viele ausgezeichnete Bilder aus Taiwan. 'Schwer zu gewinnen' ist der Titel dieser erstklassigen Aktionsstudie, doch abgesehen von technischen Einzelheiten wurde uns nichts näheres mitgeteilt.

Dit jaar ontvingen wij een grote en technisch uitstekende collectie foto's uit T'ai-wan. 'Moeilijk te winnen' is de titel van deze prachtige actiefoto. Behalve de technische gegevens werden er verder geen bijzonderheden bij deze foto gegeven.

Este año hemos recibido una abundante y excelente serie de fotografías de Taiwan. 'Difícil victoria' es el título de este brillante estudio, que venía acompañado únicamente por los datos técnicos.

Cette année, nous avons reçu une excellente série de photographies de Taïwan. 'Difficile à gagner', tel est le titre de cette fine étude d'action, mais, en dehors des caractéristiques techniques, aucune légende descriptive n'a été fournie.

55/58

Photographer	Brian Duff

Little old Lady. The inimitable Gracie Fields, North of England entertainer extraordinary, has lived on the island of Capri for many years and Duff's pictures show her with husband Boris in the garden of their home; being greeted by Scarola, the Capri TV Singer; demonstrating a typical Chaplin walk and performing an impromptu song and dance on her terrace high above the town. At 49 Duff has been with the *Daily Express* in the North for 21 years, eleven of them as chief photographer. In recent years, working principally in the features department, he has been able to devote more time to the quality of his work, rather than suffer the speed and rush that often leads to sacrifices on the altar of news. He now prefers to concentrate on people and most of his work is with politicians, theatre and film personalities. He has shown in a number of exhibitions, including one in rather unusual surroundings – aboard the liner QE2, sailing between Southampton and New York.

Alte Dame. Die einmalige Gracie Fields, eine Nordengländerin, die in der Unterhaltungswelt eine ganz besondere Stellung einnimmt, wohnt bereits seit vielen Jahren in Capri. Brian Duffs Fotografien zeigen sie mit Boris, ihrem Mann, im Garten ihres Hauses. Man sieht, wie sie von Scarola, dem Sänger des Fernsehdienstes von Capri, begrüsst wird, wie sie sie in der Art von Chaplin dahergeht und während sie auf ihrer Terrasse hoch über der Stadt aus dem Stegreif singt und tanzt. Duff, der 49 Jahre alt ist, steht seit 21 Jahren im Dienste des *Daily Express*. In den letzten Jahren war er vor allem für die redaktionelle Abteilung tätig und konnte der Qualität seiner Aufnahmen daher mehr Zeit widmen als in der Regel auf dem Nachrichtensektor zur Verfügung steht. Heute fotografiert er am liebsten Menschen und die meisten seiner Aufnahmen zeigen Politiker und Persönlichkeiten der Bühnen- und Filmwelt. Er hat seine Aufnahmen in mehreren Ausstellungen gezeigt, u.a. in einer etwas ungewöhnlichen Umgebung an Bord des Passagierschiffes QE2, das zwischen Southampton und New York verkehrt.

De onnavolgbare Gracie Fields, de meest bekende entertainer uit Noord-Engeland, heeft jaren op Capri gewoond en de foto's van Duff laten haar samen met haar man Boris in de tuin van hun huis zien. Hier wordt ze begroet door Scarola, op Capri bekend door haar vele TV-optredens. Gracie geeft haar versie van Chaplins manier van lopen terwijl ze verder nog even een geïmproviseerde voorstelling, compleet met zang en dans, weggeeft. De nu negenentwintig jaar oud zijnde Duf zit al eenentwintig jaar voor de *Daily Express* in het noorden van Engeland, waarvan elf jaar als chef-fotograaf. De afgelopen jaren was hij voor het grootste

gedeelte werkzaam bij de afdeling cultuur zodat hij wat meer in staat was aan de kwaliteit van zijn werk te sleutelen in plaats van constant haast te moeten maken, wat altijd weer leidde tot offers op het altaar van het nieuws. Nu geeft hij er de voorkeur aan mensen te fotograferen: politici en mensen uit de theater- en filmwereld. Hij heeft al een groot aantal tentoonstellingen gehad, waarvan één varende: aan boord van de Queen Elizabeth II, tussen Southampton en New York.

La diminuta señora mayor. Gracie Fields, la inimitable comediante nacida en el Norte de Inglaterra, vive en Capri desde hace ya muchos años. En las fotografías de Duff la vemos junto con su marido Boris en el jardín de su casa, recibiendo el saludo de Scarola, cantante popularizado por la TV de Capri, imitando la forma de andar de Charlot e improvisando una actuación en la terraza de su casa, situada a considerable altura sobre la ciudad. A sus 49 años, Duff lleva 21 trabajando para el *Daily Express* en la redacción del Norte de Inglaterra dos de ellos como repórter-jefe. En los últimos años ha podido abandonar la prisa y el aturdimiento consustanciales con la captación de las noticias y se ha dedicado preferentemente a pulir la calidad de sus obras. En la actualidad prefiere concentrarse en las imágenes personales y la mayor parte de sus obras recientes son retratos de políticos o estrellas del cine y del teatro. Ha celebrado numerosas exposiciones, entre las que se incluye una presentada en un originalísimo emplazamiento – el trasatlántico QE2 que cubre la línea Southampton-Nueva York.

Petite vieille femme. Gracie Fields, l'inimitable et extraordinaire animatrice du nord de l'Angleterre, a vécu pendant de nombreuses années sur l'île de Capri, et les clichés de Duff nous la montrent avec son mari Boris dans le jardin de leur villa; salués par Scarola, le chanteur de la télévision de Capri; imitant la démarche si particulière de Chaplin; et exécutant une chanson et un pas de danse impromptu sur sa terrasse perchée tout au-dessus de la ville. A 49 ans, Duff travaille dans le Nord pour le *Daily Express* depuis vingt et un ans, dont onze en qualité de photographe en chef. Ces dernières années, travaillant principalement au service des articles de magazine, il a pu consacrer davantage de temps à la qualité de son travail, au lieu de souffrir de la vitesse et de la précipitation qui aboutissent souvent à des sacrifices sur l'autel de l'information. Il préfère aujourd'hui concentrer son attention sur les gens, et la plupart de ses photographies ont pour sujet des hommes politiques ou des personnalités du théâtre ou du cinéma. Il a tenu différentes expositions, dont une dans un environnement assez insolite – à bord du paquebot *Queen Elizabeth II*, entre Southampton et New York.

Der deutsche Fotograf Georg Fischer betätigte sich in vielen Ländern der dritten Welt freiberuflich. Vor kurzem schloss er sich der bekannten Fotoagentur Visum in Essen an, wo er einst unter Otto Steinert in der berühmten Folkwangschule Fotografie studierte. Diese dramatischen Aufnahmen, die er in der westlichen Sahara, machte, gehören einem Bildbericht über die *Fronte Polisario* an.

De Duitse fotograaf Georg Fischer heeft in veel landen van de derde wereld als free-lance fotograaf gewerkt en trad recentelijk toe tot het bekende foto-agentschap Visum in Essen, waar hij op de bekende Folkwangschule onder leiding van Otto Steinert fotografie studeerde. Deze dramatische opnamen uit de westelijke Sahara zijn afkomstig uit een fotoreportage over het *Fronte Polisario*.

El fotógrafo alemán Georg Fischer ha viajado a menudo por el Tercer Mundo realizando reportajes por encargo de varias agencias. Ultimamente ha 'fichado' por la conocida agencia Visum de Essen – en cuya Folwangschule realizó sus estudios bajo la dirección de Otto Steinert. Estas dramáticas instantáneas tomadas en el Sáhara Occidental forman parte de una serie dedicada al *Frente Polisario*.

Le photographe allemand Georg Fischer a exercé son art comme photographe indépendant dans de nombreux pays du Tiers Monde et a été récemment engagé par une agence de photographie connue, Visum à Essen – où il a étudié la photographie sous la direction d'Otto Steinert à la célèbre Folkwangschule. Ces saisissantes photographies, qu'il a prises dans l'ouest du Sahara occidental, sont accompagnées d'une légende qui les classe comme reportage photographique sur le *Fronte Polisario*.

Dos retratos de calidad casi hipnótica realizados por este conocido fotógrafo sudafricano. El primero es del político de derechas Honorable 'Pik' Botha. Y en su obtención Robertson utilizo una cámara Hasselblad, un flash Braun F 900 y dos parasoles Reflectasol, a uno de los cuales adjudicó la función de reflector de relleno.

Deux portraits hypnotisants d'un maître photographe sudafricain. Le premier est celui d'un homme politique, le Right Honourable 'Pik' Botha, photographié par un appareil Hasselblad équipé d'un flash Braun F900 monté dans une coupole Reflectasol, tandis qu'une seconde coupole était utilisée comme réflecteur d'appoint.

62

Photographer	Struan Robertson
Camera	Hasselblad
Lens	150 mm Sonnar
Film	Ilford FP4
Developer	Aculux
Paper	Ilfospeed

The poet Chris Barnard, portrayed by the softer available light from a window.

Der Dichter Chris Barnard in weichem Fensterlicht.

De dichter Chris Barnard, geportretteerd bij het minder harde licht van een venster.

He aquí el retrato del poeta Chris Barnard, obtenido en la suave luz filtrada por una ventana.

Le poète Chris Barnard, photographié à la lumière diffuse filtrant au travers d'une fenêtre.

59/60

Photographer	Georg Fischer
Camera	Nikon
Lenses	24 and 35 mm
Film	Kodak Tri-X

German photographer Georg Fischer has worked as a free-lance in many countries of the third world and recently joined the well known photo agency Visum in Essen – where he studied photography under Otto Steinert at the famous Folkwangschule. These dramatic pictures that he took in West Sahara are captioned as being from a photo report on the *Fronte Polisario*.

61

Photographer	Struan Robertson
Camera	Hasselblad
Lens	150mm Sonnar
Film	Ilford FP4
Developer	Aculux
Paper	Ilfospeed

Two hypnotically compelling portraits by a master South African photographer. The first is of a politician, the Right Honourable 'Pik' Botha, who confronted Robertson's Hasselblad, one Braun F900 flash in a Reflectasol umbrella and a second Reflectasol used as a fill reflector.

Zwei hypnotisch eindrucksvolle Porträts eines südafrikanischen Meisterfotografen. Das erste zeigt einen Politiker, den Right Honourable 'Pik' Botha. Robertson verwendete eine Hasselblad-Kamera und ein Braun F900-Blitzlicht in einem Reflectasol-Parapluie-Weichstrahler und einen Reflectasol, der als Aufhell-Reflektor diente.

Twee meeslepende portretten van een Zuidafrikaanse topfotograaf. Het eerste is dat van een politicus, de Right Honourable 'Pik' Botha. De opname werd gemaakt met een Hasselblad en een Braun F900 elektronenflitser in een Reflectasol paraplu en een tweede Reflectasol als een invulreflector.

63/64

Photographer	Stephen Shakeshaft
Camera	Nikon
Lens	400 mm
Film	Kodak Tri-X
Shutter Speed	1/60
Aperture	f/4
Developer	D76
Paper	Ilfospeed

British Trade Union notables Len Murray and Jack Jones at the Blackpool Trades Union Congress. They look sleepy but the Liverpool *Daily Post & Echo* photographer was obviously wide awake.

Len Murray und Jack Jones, zwei führende Persönlichkeiten der britischen Gewerkschaftsbewegung, auf dem Gewerkschaftskongress in Blackpool. Sie sehen schläfrig aus, doch der Fotograf der Liverpooler Zeitung *Daily Post & Echo* war offensichtlich völlig wach.

Twee Britse vakbondsleiders, Len Murray en Jack Jones, op het congres van de TUC in Blackpool. Ze zien er slaperig uit maar de fotograaf van de *Daily Post & Echo* uit Liverpool was duidelijk klaarwakker.

Other zoom lenses would let you down halfway across the river.

This scene is probably familiar to you.

It's where many lenses have had a pretty rough crossing in the hands of Amateur Photographer magazine.

So we designed a range of zooms (that's our 70-350mm in action above) that would ensure excellent resolution and contrast at any focal length. And perfect shots in the trickiest situations.

The results we achieved have even impressed Victor Blackman. Writing recently in Amateur Photographer, he named the 70-350mm zoom his Lens of the Year. Finding it gave "outstanding performance over its unusually long zoom range".

And if this lens doesn't suit you, we've got five other zooms to choose from. Which you may find surprising when you consider most lens

makers are hard put to make two.

Admittedly, there is one department where we don't equal other lenses: our zooms cost about a third less than those of most camera makers.

So not only do we offer the best way to cross the river, we also charge a lower fare.

Los dirigentes sindicales británicos Len Murray y Jack Jones fotografiados en el Congreso de Blackpool. Parecen adormecidos pero no cabe duda de que el fotógrafo del periódico de Liverpool *Daily Post & Echo* se hallaba conpletamente despierto.

Len Murray et Jack Jones, figures de proue des syndicats britanniques au Trades Union Congress de Blackpool. Ils semblent avoir sommeil, mais il est évident que le photographe du *Daily Post & Echo* de Liverpool était, lui, bien éveillé.

65

Photographer	Stephen Shakeshaft
Camera	Nikon
Lens	28 mm Nikkor
Film	Kodak Tri-X
Shutter Speed	1/60
Aperture	f/5.6
Developer	D76
Paper	Ilfospeed

'Can you hear me mother?' A lonely phone box at a Liverpool demolition site.

'Hörst Du mich Mutter?' Ein einsamer Telefonkiosk auf einer Abbruchstelle in Liverpool.

'Kunt u mij verstaan, ma?' Een eenzame telefooncel in een sloopwijk in Liverpool.

'¿Puedes oírme, mamá?'. Una cabina telefónica solitaria en un solar en demolición de Liverpool.

'Est-ce que tu m'entends, Maman?' Cabine téléphonique isolée sur un chantier de démolition à Liverpool.

66

Photographer	Nick Rogers
Camera	Nikon F2
Lens	24 mm Nikkor
Film	Ilford HP5
Shutter Speed	1/250
Aperture	f/5.6
Developer	D76
Paper	Kodak

Thirty one year old Rogers has been a press photographer for fourteen years – the last five with the London *Daily Mail*. Here he portrays two men also at the top of their professions beginning with Prime Minister James Callaghan on a skateboard during a break at a Labour Party Conference. A political balancing act?

Nick Rogers isterst 31 Jahre alt, aber bereits seit 14 Jahren Pressefotograf. Seit fünf Jahren ist er im Dienste der Londoner *Daily Mail* tätig. Hier zeigt er zwei Männer, die in ihren Berufen ebenfalls die Spitze erreicht haben. Der eine ist Premierminister James Callaghan, der sich während einer Pause in einer Konferenz der Labour Party auf ein Skateboard gewagt hat. Könnte man dies als politische Akrobatik bezeichnen?

De eenendertigjarige Roberts is nu veertien jaar persfotograaf – de laatste vijf jaar bij de *Daily Mail* in Londen. Hier portretteert hij twee mannen op het hoogtepunt van hun carrière. Wij beginnen met de Engelse premier James Callaghan op een skateboard tijdens een pauze op een partijconferentie. Wellicht een politieke balanceeract?

A sus treinta y un años Nick Rogers lleva 14 trabajando como fotógrafo de prensa – los cinco últimos para el *Daily Mail*. En este caso nos obsequia con los retratos de dos hombres que se hallan también en la cumbre de sus carreras respectivas. En primer lugar vemos al Primer Ministro inglés James Callaghan sobre una tabla de patinar durante una pausa del Congreso del Partido Laborista. ¿Un acto de equilibrio político?.

Agé de trente et un ans, Rogers est photographe de presse depuis quatorze années – dont les cinq dernières au *Daily Mail* de Londres. Il a photographié ici deux hommes également arrivés au faîte de leur profession, à commencer par le Premier ministre James Callaghan, que l'on voit ici sur une planche à roulettes au cours d'une pause, lors d'une conférence du parti travailliste. Un acte d'équilibre politique?

67

Photographer	Nick Rogers
Camera	Nikon F2
Lens	24 mm Nikkor
Film	Ilford HP5
Shutter Speed	1/500
Aperture	f/5.6
Developer	D76

An exhuberant Freddie Laker anticipates the success of his Skytrain service on its first day at Gatwick Airport.

Freddie Laker am ersten Tage des neuen Skytrain-Dienstes im Flughafen Gatwick. Er ist in strahlender Laune, da er felsenfest von dem Erfolg des Vorhabens überzeugt ist.

Een opgetogen Freddie Laker smaakt reeds op de eerste dag het succes van zijn Skytraindienst vanaf Gatwick naar New York.

La exhuberancia de Freddie Laker parece anticiparnos el éxito de su tren elevado en su primer día de funcionamiento en el Aeropuerto de Gatwick.

Un exubérant Freddie Laker suppute le succès de son Skytrain le jour de sa mise en service à l'aéroport de Gatwick.

68

Photographer	Frank Loughlin
Camera	Nikon F
Lens	24 mm Nikkor
Film	Kodak Tri-X
Shutter Speed	1/15
Aperture	f/2.8
Developer	D76
Paper	Ilfospeed

Liverpool press photographer Loughlin demonstrates that a fellow local worker has an equally appreciative eye for an attractive picture.

Wie man in diesem Bilde sieht, ist der Pressefotograf Loughlin keineswegs der einzige in Liverpool, der weiss, was schön ist.

Persfotograaf Loughlin uit Liverpool laat zien dat z'n stadgenoten minstens even veel waardering voor een mooi plaatje hebben.

El fotógrafo de Liverpool Frank Loughlin nos demuestra que este trabajador de su ciudad sabe apreciar perfectamente la calidad de una imagen atractiva.

Loughlin, photographe de presse de Liverpool, démontre qu'il n'est pas le seul à apprécier un tableau agréable.

69

Photographer	Frank Loughlin
Camera	BronicaS2A
Lens	Nikkor
Film	Kodak Tri-X
Shutter Speed	1/15
Aperture	f/4
Developer	D76
Paper	Ilfospeed

An available light portrait by the *Post Echo* photographer which beautifully captures facial expression.

In diesem bei natürlichem Licht aufgenommenen Bild des Fotografen der Zeitung *Post Echo* ist der Gesichtsausdruck besonders schön festgehalten.

Een portret bij bestaand licht van de fotograaf van de *Post Echo*, dat de gelaatsuitdrukking op een prachtige manier laat zien.

En este bien iluminado retrato, el fotógrafo del *Post Echo* ha logrado captar de manera maravillosa los más ocultos deltalles de una expresión facial.

Portrait à la lumière ambiante, par le photographe du *Post Echo*, qui a magnifiquement saisi l'expression du visage.

70

Photographer	Josep Maria Ribas Prous
Camera	Nikon F2
Lens	20 mm Nikkor
Film	Kodak Tri-X
Shutter Speed	1/15
Aperture	f/5.6
Developer	D76
Paper	Negtor

Taken in the last hour of daylight, Prous used his ultra wide lens to emphasize the floor pattern in this dramatically effective model girl portrait.

Prous, der dieses Bild in der Abenddämmerung aufnahm, machte von seinem Ultraweitwinkelobjektiv Gebrauch, um in diesem dramatisch wirksamen Mädchenporträt das Fussbodenmuster hervorzuheben.

Prous maakte in het laatste uur daglicht met zijn ultra-groothoeklens – om het vloerpatroon te benadrukken – dit welhaast dramatisch indrukwekkende meisjesportret.

Trabajando durante la última hora de luz diurna, Prous utilizó su objetivo gran angular para dar mayor énfasis al dibujo del suelo en su dramática visión de la modelo.

Pour cette photographie prise en fin de journée, Prous a utilisé son super-grand angulaire afin d'amplifier la géométrie du sol dans ce portrait extraordinairement parlant d'un modèle de mode.

71

Photographer	Josep Maria Ribas Prous
Camera	Nikon F2
Lens	20 mm Nikkor
Film	Kodak Tri-X (rated 1600 ASA)
Shutter Speed	1/8
Aperture	f/3.5
Developer	D76
Paper	Negtor

'La Lampara'. From an ongoing essay on 'woman' by the well known Spanish photographer.

'La Lampara'. Aus einer Studienreihe über 'das Weibliche', an der der bekannte spanische Fotograf zur Zeit arbeitet.

'La Lampara'. Een opname uit de serie 'vrouwen' van deze bekende Spaanse fotograaf.

'La lámpara'. Esta fotografía forma parte de una serie dedicada a la mujer por parte del conocido fotógrafo español.

'La Lámpara' (La Lampe). Extrait d'un essai sur 'la femme' par le photographe espagnol bien connu.

72/74

Photographer	Pedro Luis Paota
Camera	Hasselblad
Lenses	200, 150 and 80 mm
Films	Kodak Tri-X and Plus-X
Developer	D76

Buenos Aires photographer Raota has won a total of one hundred first prizes in major international photographic exhibitions. A member of Europhot, these striking – and self explanatory – images explain his well deserved successes which include the award for the best Graphic Reporter of the World (The Hague 1969) and Belgian acclaim as one of the ten best photographers in the world. While, technically speaking, an amateur, this master photographer from Argentina is now a guest of honour at photographic gatherings world wide.

Dieser Fotograf, der seine Tätigkeit in Buenos Aires ausübt, hat insgesamt 100 erste Preise in führenden internationalen Fotoausstellungen gewonnen. Er ist ein Mitglied von Europhot, und diese eindrucksvollen Bilder, die übrigens keinerlei Erklärung erfordern, zeigen deutlich, worauf sein wohlverdienter Erfolg beruht. Er hat u.a. den Titel des besten grafischen Berichterstatters der Welt (Den Haag 1969) gewonnen und wurde in Belgien zu einem der zehn besten Fotografen der Welt erklärt. Obgleich er streng gesprochen ein Amateur ist, wird dieser argentinische Meisterfotograf auf fotografischen Kongressen in der ganzen Welt heute als Ehrengast begrüsst.

Deze fotograaf uit Buenos Aires heeft in totaal honderd eerste prijzen op internationale fototentoonstellingen gewonnen, en is lid van Europhot. Deze opvallende – en voor zichzelf sprekende – beelden maken duidelijk waarom hij zoveel successen heeft behaald. Twee hiervan zijn de prijs voor de beste fotografische serie bij het World Press Photo 1969 en een Belgische huldiging als een van de tien beste fotografen ter wereld. Technisch gesproken is deze topfotograaf uit Argentinië misschien nog steeds een amateur maar toch is hij een eregast op vele tentoonstellingen, waar ook ter wereld.

Este fotógrafo de Buenos Aires ha conseguido un total de cien primeros premios en distintas exposiciones internacionales. Miembro de Europhoto, estas impresionantes imágenes – que se comentan por sí solas – justifican plenamente sus merecidos éxitos, entre los que se incluyen su nominación como el mejor repórter mundial (La Haya 1969) y su consideración por parte de los especialistas belgas como uno de los más importantes fotógrafos de todo el mundo. A pesar de continuar utilizando técnicas conocidas por cualquier aficionado, este maestro de fotógrafos argentino se ha convertido en invitado de honor de la mayor parte de convenciones fotográficas internacionales.

Raota, photographe originaire de Buenos Aires, a remporté un total de cent premiers prix à de grandes expositions photographiques internationales. Il est membre d'Europhot, et ces clichés saisissants – qui se comprennent d'eux-mêmes – expliquent ses succès largement mérités, au nombre desquels il faut citer le prix du meilleur journaliste photographe du monde (La Haye, 1969) et le prix de Belgique qui lui a valu d'être classé comme l'un des dix meilleurs photographes du monde. Bien qu'étant, techniquement parlant, un amateur, ce maître photographe argentin est aujourd'hui un invité d'honneur de toutes les grandes manifestations photographiques du monde.

75/86

Photographer	Juliusz Garztecki
Camera	Zenith B
Lens	50 mm Industar
Film	Orwo NP20
Shutter Speed	1/60
Aperture	f/8
Developer	Hydrofen Foton
Paper	Fotonbrom (Polish licensed Ilford)

'Almost the same'. For three years Garztecki has been working on projects involving the same subject in various contexts. Here the surroundings remain the same but the pose of his model changes. All the pictures are printed full frame as he never crops his work. We first saw this set at a one man exhibition at the Polish Cultural Institute in London where we learned that Garztecki, born 1920, is well known in Poland as a photographer, critic and historian; is General Secretary of that country's Federation of Amateur Photographic Societies; Vice President of the History of Photography Committee in Warsaw and the author of many books and hundreds of magazine articles on photography.

'Fast dasselbe'. Drei Jahre lang arbeitete Garztecki an Studien der gleichen Themen in verschiedenen Rahmen. In dieser Aufnahme ist die Umgebung die gleiche, doch ändert sich die Pose seines Modells. Alle Bilder sind ganz wiedergegeben, da er seine Aufnahmen nie zuschneidet. Wir sahen diese Serie ursprünglich in einer Ein-Mann-Ausstellung am Polnischen Kulturinstitut in London, wo wir erfuhren, daβ der 1920 geborene Garztecki in Polen als Fotograf, Kritiker und Historiker gut bekannt ist. Er ist Generalsekretär des Polnischen Bundes der Vereinigungen von Amateurfotografen, stellvertretender Vorsitzender des Ausschusses für Geschichte der Fotografie in Warschau und Verfasser vieler Bücher und hunderter Zeitschriftenartikel über Fotografie.

'Bijna hetzelfde'. Garztecki is nu drie jaar bezig aan een project met steeds dezelfde persoon, maar onder verschillende omstandigheden. Hier blijft de omgeving dezelfde maar de houding van het model is veranderd. Van alle foto's is steeds het hele negatief afgedrukt, hij maakt namelijk nooit uitsneden van zijn werk. Wij zagen zijn werk voor het eerst op een één-manstentoonstelling in het Poolse culturele instituut in Londen, waar we hoorden dat Garztecki, die in 1920 is geboren, in Polen niet alleen als fotograaf bekend is maar tevens als criticus en historicus; en verder nog als schrijver van ettelijke fotoboeken en tijdschriftartikelen. Daarnaast is hij nu algemeen secretaris van de nog Poolse federatie van amateur-fotografenverenigingen en vice-president van het comité voor fotogeschiedenis in Warschau.

'Casi igual'. Durante estos últimos tres años Garztecki ha trabajado en varios proyectos consistentes en situar a un mismo modelo en distintos contextos. En este caso, sin embargo, es el marco de las fotografías el que permanece constante. Garztecki ha construido sus obras con la totalidad de los negativos obtenidos, conservándose fiel a su costumbre de no recortar sus trabajos. Vimos por primera vez esta colección en una exposición organizada en Londres por el Instituto cultural polaco, en la que se nos informó que este artista, nacido en 1920, es muy conocido en Polonia como fotógrafo, crítico e historiador. Ha escrito varios libros e innumerables artículos en revistas y es, además, secretario general de la Federación de Asociaciones fotográficas de su país, así como vicepresidente del Comité de estudios sobre Historia de la Fotografía.

'Presque la même chose'. Pendant trois ans, Garztecki a travaillé à des projets comprenant le même sujet dans des contextes différents. Ici, l'environnement reste le même, mais la pose du modèle varie. Toutes les photographies sont imprimées en plein cadre, étant donné qu'il ne recoupe jamais ses clichés. Nous avons vu cette série pour la première fois lors d'une exposition personnelle à l'Institut culturel polonais de Londres, où nous avons appris que Garztecki, né en 1920, est très connu en Pologne comme photographe, critique et historien; il est secrétaire général de la Fédération des sociétés de photographes amateurs de son pays, vice-président de la Commission d'histoire de la photographie de Varsovie, et auteur de nombreux livres et de centaines d'articles de magazine sur la photographie.

87

Photographer	Markus Jokela
Camera	Nikon F2
Lens	24 mm Nikkor
Film	Kodak Tri-X

The contributions we receive from Finland are generally of a high standard, aesthetic and technical, so we are glad to present more work by Markus Jokela who took this picture on Finland's southern coast as part of an ongoing project. 'My aim', he writes, 'has been to create landscapes of utter simplicity, with only the most necessary elements of the landscape included in the photograph.'

We've made colour printing easier without improving our products.

Some of our best ideas have been aimed at making colour printing easier:

Our special dichroic colour head. Our patented processing drum. Our advanced colour analyser. And our unique colour print processor.

Successful as they've all been, we think our two latest ideas could do as much for your printing as anything we've done to our products.

DURST CARE

Lucky owners of new Durst enlargers will now receive a number of bonuses.

You get a special booklet on your enlarger and on easy printing.

You get our Securicor collection and return service in the unlikely event of a problem.

You get our express technical advice facilities.

You get 2 years free insurance. And free membership to our new club.

THE DURST DARKROOM CLUB

This ensures that you'll enjoy several valuable advantages over other photographers.

Members can pick up tips at regional club meetings, or our weekend courses. Or at the Durst summer school.

And discover trade secrets, because we're arranging lectures with famous photographic names.

You'll also receive a quarterly colour magazine, full of new ideas.

You might even save money thanks to our special club loyalty discount scheme.

Perhaps, as a result of these efforts, we could be the first people to offer improved photographers with every enlarger.

Die Beiträge, die wir aus Finnland erhalten, sind in der Regel in ästhetischer und technischer Hinsicht hochwertig. Es ist uns daher ein Vergnügen weitere Aufnahmen von Markus Jokela zu veröffentlichen, der dieses Bild an der Südküste Finnlands aufnahm. Es gehört einer Bildserie an, an der Jokela zur Zeit arbeitet. 'Mein Ziel', so schreibt er, 'besteht darin Landschaftsbilder zu schaffen, die völlig einfach sind und bei denen nur die nötigsten Elemente der Landschaft in der Aufnahme erscheinen.'

De inzendingen die wij uit Finland ontvangen zijn gewoonlijk van een erg hoog gehalte, zowel esthetisch als technisch, dus vinden wij het erg plezierig u wat meer werk van Markus Jokela te kunnen laten zien. Hij maakte deze foto aan de zuid-kust van Finland in het kader van een al langer bestaand pro-ject. 'Mijn streven', zegt hij, 'is het maken van uiterst een-voudige landschappen met behulp van alleen de meest noodzakelijke elementen van dat landschap verwerkt in mijn foto's'.

Las contribuciones recibidas de Finlandia poseen, en general, una excelente calidad, tanto técnica como estética. Es por ello que nos complace presentarles algunos trabajos de Markus Jokela. Esta fotografía, tomada en la costa sur de su país, forma parte de un ambicioso proyecto en cuya realización se halla enfrascado. 'Mi meta, nos escribe, reside en crear imágenes paisajísticas de gran simplicidad, en las que se incluyan solamente los elementos más esenciales'.

Les contributions que nous recevons de Finlande sont généralement d'une haute qualité, tant esthétique que tech-nique. Nous sommes donc heureux de présenter de nouveaux clichés de Markus Jokela, qui a pris cette photo-graphie sur la côte sud de la Finlande, dans le cadre d'une opération de grande envergure. 'Mon but, écrit-il, a été de créer des paysages de la plus grande simplicité, en ne faisant figurer sur la photographie que les éléments absolument indispensables.'

88

Photographer	Markus Jokela
Camera	Nikkormat Ftn
Lens	24 mm Nikkor
Film	Kodak Tri-X

The Giant's Causeway, a geometric rock formation on the northern coast of Ireland.

De Giant's Causeway, een geometrische granietformatie aan de noordkust van Ierland.

Der Giant's Causeway, eine geometrische Felsenformation an der Nordküste von Irland.

El arrecife del gigante, una formación rocosa geométrica localizada en la costa norte de Irlanda.

La Chaussée des Géants, formation rocheuse géométrique sur la côte nord de l'Irlande.

89

Photographer	Kalervo Ojutkangas
Camera	Linhof Technica 4 × 5
Lens	135 mm Sironar
Film	Kodak Tri-X
Shutter Speed	1/30
Aperture	f/22
Developer	D76
Paper	Kodak Veribrom

An old farming couple at home at Salla Finland. The first of an impressive portfolio about his fellow countrymen and women by another talented Finnish photographer.

Ein Bauer und seine Frau in ihrem Heim in Salla, Finnland. Es ist dies das erste Bild in einer eindrucksvollen Sammlung, in der ein anderer talentierter finnischer Fotograf seine Land-sleute vorstellt.

Een bejaard boerenechtpaar in Salla, Finland. De eerste uit een indrukwekkende collectie foto's over zijn landgenoten, gemaakt door deze talentvolle Finse fotograaf.

Un viejo matrimonio de granjeros de Salla (Finlandia). Esta fotografía forma parte de una impresionante serie dedicada a sus paisanos por este fotógrafo finlandés de extraor-dinario talento.

Vieux couple de fermiers dans sa maison à Salla, Finlande. Première d'une impressionnante série de photographies sur ses concitoyens et concitoyennes par un autre talentueux photographe finlandais.

90

Photographer	Kalervo Ojutkangas
Camera	Linhof Technica 4 × 5
Lens	135 mm Sironar
Film	Kodak Tri-X
Shutter Speed	1/30
Aperture	f/22
Developer	D76
Paper	Kodak Veribrom

Suomussalmi, Finland. An old man at home in the house he built for himself.

Suomussalmi, Finnland. Ein alter Mann in dem von ihm selbt gebauten Hause.

Suomussalmi in Finland. Een oude man in het huis dat hij voor zichzelf bouwde.

Suomussalmi, Finlandia. Un viejo fotografiado en la casa que él mismo construyó.

Suomussalmi, Finlande. Vieil homme chez lui, dans la maison qu'il s'est construite.

91

Photographer	Kalervo Ojutkangas
Camera	Linhof Technica 4 × 5
Lens	90 mm Super Angulon
Film	Agfapan 400
Shutter Speed	1/4
Aperture	f/16
Developer	D76
Paper	Kodak Veribrom

A farm couple comfortably at home at Suomussalmi.

Ein Bauer und seine Frau in ihrem bequemen Heim in Suomussalmi.

Een boerenechtpaar gezellig thuis in Suomussalmi.

Una pareja de granjeros fotografiados en su confortable casa de Suomussalmi.

Couple de fermiers, confortablement installé dans sa maison à Suomussalmi.

92

Photographer	Cleland Rimmer
Camera	Mamiya C330
Lens	250 mm Sekor
Film	Ilford FP4
Shutter Speed	1/250
Aperture	f/8
Developer	Autophen
Paper	Ilfobrom

Denied on-site facilities, the Humberside teacher, photo-grapher (and former London *Evening Standard* picture editor) had to rely on a long lens for this shot of the new Humber bridge. In the event it won first prize and £500 cash in the Industrial category of the 1977 Ilford £1,000 print awards.

Der in Humberside wohnhafte Lehrer, Fotograf (und ehemeliger Bildredakteur des Londoner *Evening Standard*) musste bei dieser Aufnahme der neuen Humberbrücke von einem langbrennweitigen Objektiv Gebrauch machen, da ihm kein Zutritt zu der Brücke gewährt wurde. Schliesslich gewann er den ersten Preis und £500 in dem industriellen Teil des 1977 Ilford £1000 Print Award-Wettbewerb.

Omdat hij niet op het bouwterrein mocht moest deze onder-wijzer uit Humberside (en voormalig illustratieredacteur van de *Evening Standard* uit Londen) wel gebruik maken van een telelens om deze foto van de nieuwe brug over de Humber te kunnen maken. Met deze opname behaalde hij de eerste prijs in de categorie 'industrie', alsmede een geldprijs van £500 bij de in 1977 gehouden Ilford £1.000 Print Award.

Al haberle sido denegado el permiso para trabajar direc-tamente en el nuevo puente de Humber, C. Rimmer, pro-fesor, fotógrafo (y antiguo director de la sección gráfica del *Evening Standard*) tuvo que servirse de un objetivo de larga distancia para obtener esta instantánea, Precisamenta le valió el primer premio (con una compensación económica de 500 libras) en la categoría industrial de los galardones de 1.000 libras de Ilford, en su edición de 1977.

S'étant vu refuser les installations nécessaires sur place, le professeur de Humberside, photographe (et ancien direc-teur de la photographie à l'*Evening Standard* de Londres), a dû s'en remettre à un téléobjectif pour obtenir ce cliché du nouveau pont sur la rivière Humber. Neanmoins, il a remporté le premier prix et £500 comptant dans la catégorie industrielle des Ilford £1000 Print Awards 1977.

HOYA
HMC LENSES

HOYA

NOW AVAILABLE IN THE U.K.

from the World's leading manufacturer of Optical glass and Camera Filters comes HOYA HMC LENSES

A superb new range of Four Compact and Four Zoom and Macro lenses designed exclusively by Hoya for use with today's breed of lightweight and compact SLR cameras.

Incorporating everything that is demanded in a 1978 lens—computer precision glass optics, brilliant HMC Multi-coating, easy-to-handle controls, plus the added versatility of Zoom and Macro photography with four of the lenses—all finished to the highest possible standards known today, standards only acceptable to Hoya.

AVAILABLE IN:

Wide Angle	28mm/F2.8	**Zoom & Macro**	25-42mm/F3.5
	35mm/F2.8		35-105mm/F3.5
Tele-Photo	135mm/F2.8		70-210mm/F3.8
	200mm/F3.5		100-300mm/F5

Pentax 'S', Pentax 'K', Nikon Al, Minolta, Canon AE, and Olympus fittings.

All lenses supplied complete with hard case and covered by Hoya's 5 year guarantee.

HOYA LENSES NOW AVAILABLE FROM LEADING PHOTOGRAPHIC STORES

For brochure giving full specifications please send a large sae to:—

INTROPHOTO

89 PARK STREET, SLOUGH BERKS, SL1 1PX

93

Photographer	Cleland Rimmer
Camera	Canon FT
Lens	135 mm
Film	Ilford FP4
Shutter Speed	1/125
Aperture	f/5.6
Developer	Autophen
Paper	Kodak Bromesko

'Rural Sentinals', noted in the Yorkshire countryside, helped Rimmer demonstrate to his students that interesting pictures can result from small as well as outsize artifacts such as the Humber Bridge.

'Ländliche Wachen'. Rimmer, der diese Aufnahme in der Landschaft von Yorkshire machte, bewies seinen Studenten damit, daß sich sowohl mit kleinen als auch mit sehr grossen Blickfängern wie der Humberbrücke interessante Bilder erzielen lassen.

'Wachters van het platteland', gemaakt ergens in het landbouwgebied van Yorkshire. Deze foto hielp Rimmer bij het aan zijn leerlingen duidelijk maken dat zowel kleine als grote onderwerpen – zoals de brug over de Humber – kunnen resulteren in interessante foto's.

'Centinelas rurales'. Esta instantánea tomada en los campos de Yorkshire le permitió a Rimmer mostrar a sus alumnos que es posible obtener, a partir de pequeños artefactos, fotografías tan interesantes como las que tienen como tema objetos de desmesurado tamaño (el puente de Humber, por ejemplo).

Ces 'Sentinelles rurales', observées dans la campagne du Yorkshire, ont aidé Rimmer à démontrer à ses élèves que des clichés intéressants peuvent résulter de petits artifices aussi bien qui gigantesques, tels que le pont sur la rivière Humber.

94

Photographer	Josh Zander

Equally impressive, as a subject for architectural photography, are these tower blocks admirably recorded by New York professional Zander.

Ebenso eindrucksvoll, als Thema für architektonische Fotografie, sind diese Häuser, die von dem New Yorker Berufsfotografen Zander auf so bewundernswerte Weise aufgenommen wurden.

Even indrukwekkend – uit het oogpunt van architectuurfotografie – zijn deze wolkenkrabbers, op bewonderenswaardige manier vastgelegd door de New-Yorkse fotograaf Zander.

Igualmente impresionantes, como tema para la fotografía arquitectónica, son estos altísimos bloques admirablemente captados por el fotográfo neoyorquino Josh Zander.

Tout aussi impressionnants, en tant que sujet de photographie architecturale, sont ces grattes-ciel, admirablement pris par le photographe professionnel Zander, de New York.

95

Photographer	Martin Wolin
Camera	Minolta SRT 101
Lens	21 mm Rokkor
Film	Kodak Tri-X
Shutter Speed	1/125
Aperture	f/16
Paper	Agfa Brovira

Similarly stark in treatment, and also from the U.S.A., is this picture about which the photographer writes: 'A red filter was used to bring out the clouds and darken the sky. I left in a little of the background to show the environment which, in a way, contradicts other elements in the photograph'.

Ebenso kompromisslos ist dieses in den USA aufgenommene Bild, von dem der Fotograf folgendes schreibt: 'Um die Wolken zu betonen und den Himmel zu verdunkeln machte ich von einem roten Filter Gebrauch. Ich liess ein wenig von dem Hintergrund stehen, um die Umgebung anzudeuten, die in gewissem Masse anderen Elementen in der Aufnahme widerspricht.'

Even strak in behandeling en eveneens afkomstig uit de Verenigde Staten is deze foto, waarover de maker schrijft: 'Er is een roodfilter gebruikt om de wolken op te halen en de hemel wat donkerder te krijgen. Ik heb er een beetje achtergrond ingelaten om de omgeving, die in zekere zin sterk contrasteert met de andere elementen in de foto, te laten zien.'

También esta instantánea (tomada asimismo en los EE.UU.) ha recibido un enérgico tratamiento. A propósito de la misma, escribe el artista: 'Para dar mayor relieve a las nubes y oscurecer el cielo utilicé un filtro de color rojo. Dejé una parte del fondo para mostrar el ambiente general, el cual, en cierta forma, se halla en contradicción con otros elementos de la fotografía'.

Tout aussi rigoureuse du point de vue du traitement, et également en provenance des Etats-Unis, est cette image à propos de laquelle le photographe écrit: 'Un filtre rouge a été utilisé pour faire ressortir les nuages et obscurcir le ciel. J'ai laissé un peu de l'arrière-plan pour montrer l'environnement qui, d'une certaine manière, contredit d'autres éléments de la photographie.'

96

Photographer	Henning Christoph
Camera	Nikon F
Lens	90 mm
Film	Kodak Tri-X
Shutter Speed	1/30
Aperture	f/8
Developer	D76
Paper	Agfa BN 310

'The Macumba priest in a trance'. Spectacular imagery by the Essen photojournalist from a photo story on Macumba rites in Nova Iguacu, Brazil.

'Der Macumba-Priester in einer Trance'. Eine spektakuläre Aufnahme des Essener Foto-Journalisten, die einem Fotobericht über Macumba-Zeremonien in Nova Iguacu, Brasilien, entnommen ist.

'De Macumbapriester in trance'. Spectaculaire beelden van een fotojournalist uit Essen. Een foto uit een serie over de riten bij de Macumba's in Nova Iguacu, Brazilië.

'Un sacerdote Macumba en trance'. He aquí una instantánea de espectacular imaginería, que forma parte de un reportaje fotográfico realizado por este repórter de Essen sobre los ritos de los Macumba de Nova Iguacu (Brasil).

'Le prêtre macumba en transes'. Imagerie spectaculaire par le journaliste photographe d'Essen, reprise d'une histoire en photos sur les rites macumba à Nova Iguaçu, Brésil.

28

97

Photographer	Henning Christoph
Camera	Nikon F
Film	Kodak Tri-X
Shutter Speed	1/30
Aperture	f/1.8
Developer	D76
Paper	Agfa BN 310

A belly dancer in a Turkish 'Gastarbeiter' (Guestworker) bar in Oberhausen, West Germany.

Bauchtänzerin in einer in Oberhausen, BRD, befindlichen Wirtsstube für türkische Gastarbeiter.

Een buikdanseres in een café voor Turkse gastarbeiders in Oberhausen.

Una bailarina ejecutando la danza del vientre en un bar para Gastarbeiter (trabajadores emigrados) turcos de Oberhausen (Alemania Occidental).

Spécialiste de la danse du ventre dans un bar pour 'Gastarbeiter' (travailleurs émigrés) turcs d'Oberhausen, en Allemagne de l'Ouest.

98

Photographer	Stephen Dalton
Camera	Leicaflex SL
Lens	100 mm Macro Elmar
Film	Kodachrome
Aperture	f/16
Shutter speed	1/25,000
Lighting	Custom designed high speed electronic flash

House fly launching itself from a loaf of bread. Stephen Dalton is the author of 'The Miracle of Flight' (Sampson Low) and makes use of special lighting techniques which have enabled him to produce some of the most remarkable pictures of insects in flight ever taken.

Ausfliege beim Abflug von einem Laib Brot. Stephen Dalton ist der Verfasser des von Sampson Low veröffentlichten Buches 'The Miracle of Flight'. Er macht von speziellen Beleuchtungstechniken Gebrauch, um Aufnahmen fliegender Insekten zu erzielen, die zu den interessantesten ihrer Art zählen.

Een gewone huisvlieg opvliegend vanaf een brood. Stephen Dalton is de schrijver van 'The Miracle of Flight' (Sampson Low) en maakt gebruik van zeer speciale verlichtingstechnieken die hem in staat stellen de meest bijzondere opnamen van vliegende insekten te maken.

Mosca doméstica proyectándose en el aire desde una hogaza de pan. Stephen Alton es el autor de 'El milagro de volar' (Sampson Low), en cuya composición utilizó unas técnicas de iluminación especiales que le permitieron obtener algunas de las fotografías más impresionantes tomadas nunca a insectos en pleno vuelo.

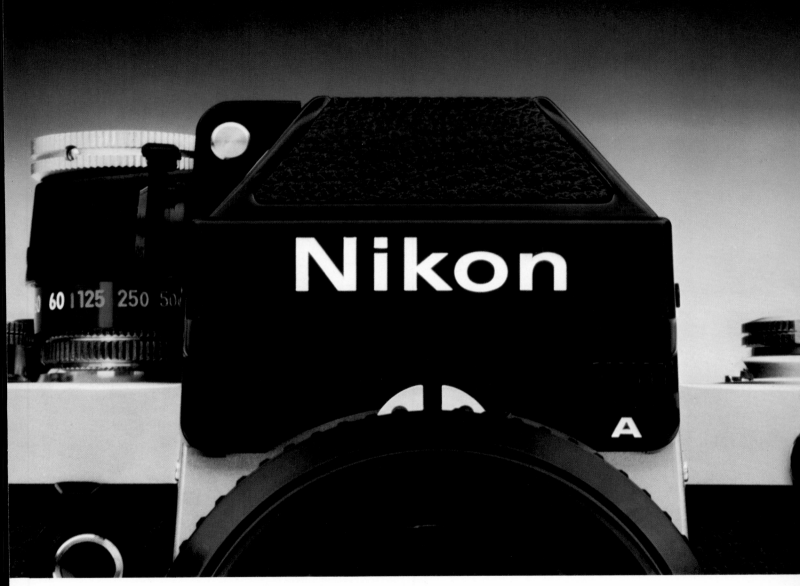

One word that's worth a thousand pictures.

More professionals use Nikon than any other camera.
Not because of what we say, but because of what they
say to each other.
Well, you know how the word gets around.

 Nikon Division, Dept Y Rank Audio Visual Ltd, PO Box 70 Great West Road, Brentford, Middlesex TW8 9HR. **Nikon**

Mouche commune s'élançant d'une miche de pain. Stephen Dalton, qui est l'auteur de 'The Miracle of Flight' (Le miracle du vol) (Sampson Low), utilise des techniques spéciales d'éclairage qui lui ont permis de réaliser quelques-unes des plus remarquables photographies d'insectes en vol qui aient jamais été prises.

99

Photographer	Stephen Dalton
Camera	Leicaflex SL
Lens	100 mm Macro Elmar
Film	Kodachrome
Aperture	f/16
Shutter Speed	1/25,000
Lighting	Custom designed high speed electronic flash

Portrait of a paper wasp. A Fellow and medal winner of the Royal Photographic Society and the recipient of awards from both Nikon and Kodak, Stephen Dalton is an enthusiastic spare time pilot and hang glider when he is not photographing the flight of insects and birds.

Porträt einer Wespe. Stephen Dalton ist Vollmitglied der Royal Photographic Society und wurde von dieser Organisation sowie von Nikon und Kodak für seine Leistungen ausgezeichnet. In seiner Freizeit, wenn er nicht gerade den Flug von Insekten und Vögeln fotografiert, betätigt er sich auch mit Begeisterung als Pilot oder fliegt mit dem Hängegleiter.

Close-up van een wesp. Dalton is lid en medaillewinnaar van de Royal Photographic Society en heeft ook Nikon- en Kodak-prijzen gewonnen. Als hij geen vliegende insekten en vogels fotografeert, vliegt hij zelf. Zowel sportvliegtuigen als hangzwevers zijn in dat geval zijn domein.

Retrato de una avispa. Miembro de la Royal Photographic Society, que le ha concedido varias medallas, Stephen Dalton, que ha recibido también varios premios de Nikon y Kodak, es un entusiasta piloto aficionado y se dedica asimismo a la conducción de planeadores cuando no se halla fotografiando el vuelo de los insectos.

Portrait d'une guêpe cartonnière. Membre et titulaire d'une médaille de la Royal Photographic Society, en même temps que lauréat de différents prix Nikon et Kodak, Stephen Dalton est un pilote amateur enthousiaste et un adepte convaincu du deltaplane, lorsqu'il ne photographie pas le vol d'insectes ou d'oiseaux.

100

Photographer	Lin Sulu
Camera	Asahi Pentax SP
Lens	300 mm SMC Takumar
Film	Ektachrome/Kodacolor 11
Shutter Speed	1/125
Aperture	f/5.6
Developer	E4
Paper	Sakura

'Maternal Love', a delightful study of Formosan Rock Macaques, was taken by a regular contributor from Taiwan who also specializes in Nature photography.

'Mutterliebe', eine entzückende Studie von Fels-Makaken, wurde von einem regelmässig Beitragenden aus Taiwan beigesteuert, der sich ebenfalls auf Naturfotografie spezialisiert.

'Moederliefde', een verrukkelijke opname van rotsaapjes op T'ai-wan. Deze foto werd gemaakt door een natuurfotograaf uit van wie we in het verleden wel meer werk hebben laten zien.

'Amor materno'. Este delicado estudio de los macacos de Formosa nos ha sido enviado por uno de nuestros contribuidores habituales residente en Taiwan, que se ha especializado también en la captación de temas naturales.

'Amour maternel', délicieuse étude de Formosan rock macaques, a été prise par un de nos fidèles collaborateurs de Taïwan, qui se spécialise également dans la photographie de la nature.

101

Photographer	Lin Sulu
Camera	Asahi Pentax SP
Lens	85 mm SMC Takumar plus extension tube
Film	Sakuracolor 400
Shutter Speed	1/60
Aperture	f/11
Developer	C41
Paper	Fujicolor

'Fighting'. Three electronic flash heads were used to expose this unusual fish close up.

'Gefecht'. Drei elektronische Blitzgeräte dienten bei dieser ungewöhnlichen Nahaufnahme von Fischen zur Belichtung.

'In gevecht'. Er moesten drie elektronenflitskoppen worden gebruikt om tot deze aparte close-up van vissen te kunnen komen.

'Pelea'. Para obtener este primer plano de los peces el fotógrafo se sirvió de tres flashes electrónicos distintos.

'Combat'. Trois flashes électroniques ont été utilisés pour éclairer cet insolite gros plan sur des poissons.

102

Photographer	Lin Sulu
Camera	Asahi Pentax SP
Film	Sakuracolor 11
Lens	300 mm SMC Takumar
Shutter Speed	1/60
Aperture	f/5.6
Developer	C41
Paper	Fujicolor

'Night Singer' Lin Sulu used two flash heads for this nocturnal nature study.

'Nachtsänger'. Lin Sulu verwendete für diese nächtliche Naturstudie zwei Blitzgeräte.

'Night Singer'. Lin Sulu gebruikte twee flitskoppen voor deze nachtelijke natuurstudie.

'Cantante nocturno'. Lin Sulu utilizó dos flashes para obtener este estudio de la naturaleza.

'Chanteur de nuit'. Lin Sulu a utilisé deux flashes électroniques pour cette étude nocturne de la nature.

103/106

Photographer	Richard Haughton
Camera	Nikkormat
Lens	18, 28 and 50 mm
Film	Fujichrome R-100 and Kodachrome 25

The author of these fine Irish Landscapes, twenty year old Richard Haughton, supplied the following information about himself and his work. 'I was born in Cork and have been taking photos for about six years, full time for two, working in several fields – theatres, architectural, industrial, though my main preoccupation is with landscapes, particularly the Irish landscape. I've had work published in the *Architectural Review, Vogue, Harpers, Country Life*, and in one or two photographic publications, but I've yet to put a major exhibition together.
'All the landscapes were taken in Kerrythree in Cloghane, on the Dingle peninsula, and one (the mountains shortly after sunset) in Killarney. All were taken in very unstable lighting conditions – the particular light lasting, in some cases, for only a couple of seconds, illustrating how vital speed of working is in landscape work, especially in Ireland, where the light is constantly changing.'

Der Fotograf dieser schönen irischen Landschaftsbilder, der 20-jährige Richard Haughton, lieferte die folgenden Informationen über sich und seine Tätigkeit. 'Ich wurde in Cork geboren und fotografiere seit etwa sechs Jahren. Seit zwei Jahren bin ich vollzeitig als Fotograf tätig, und zwar auf verschiedenen Sektoren wie Theater, Architektur und Industrie. Mein Hauptinteresse gilt jedoch Landschaftsaufnahmen, besonders der irischen Landschaft. Meine Bilder wurden in *Architectural Review, Vogue, Harpers, Country Life* und ein paar fotografischen Sammlungen veröffentlicht, doch habe ich bisher noch keine grössere Ausstellung veranstaltet.
'Alle Landschaftsbilder wurden in Kerrythree in Cloghane auf der Halbinsel Dingle aufgenommen und eines (die Berge kurz nach Sonnenuntergang) in Killarney. Die Lichtbedingungen waren in allen Fällen sehr unstabil – und in gewissen Fällen dauerten sie nur wenige Sekunden. Dies erweist, wie wichtig Geschwindigkeit in der Landschaftsfotografie ist, besonders in Irland, wo das Licht in ständigem Wechsel begriffen ist.'

De maker van deze prachtige Ierse landschappen, de twintigjarige Richard Haughton, leverde de volgende informatie over zichzelf en zijn werk: 'Ik ben geboren in Cork en fotografeer nu zo'n zes jaar. Het is mijn beroep en ik heb gelukkig erg veel werk. Ik ben op zeer verschillende gebieden werkzaam, Zoals theater–, architectuur–, en industriële fotografie, maar ik prefereer toch de landschapsfotografie, en dan vooral het fotograferen van het Ierse landschap. Mijn werk staat afgedrukt in *Architectural Review, Vogue, Harpers, Country Life* en in nog een stuk of twee fotobladen, maar m'n eerste echte, grote tentoonstelling moet nog komen.'
'Alle landschappen werden genomen in Kerrythree in Cloghane op het schiereiland van Dingle, en één (de heuvels direct na zonsondergang) in Killarney. Ze zijn allemaal gemaakt onder uiterst ongunstige lichtomstandigheden – het juiste licht duurde in bepaalde gevallen maar een paar seconden. Een en ander laat zien hoe belangrijk snel werken bij het maken van landschapsfoto's is, vooral in Ierland, waar het licht voortdurend verandert.'

El autor de estas hermosas reproducciones de paisajes irlandeses, Richard Haughton, de veinte años, nos ha enviado la siguiente información acerca de sí mismo y de su trabajo: 'Nací en Cork y empecé a dedicarme a la fotografía hace seis años, aunque sólo me he consagrado plenamente a ella en los últimos dos años. He trabajado en diversos campos – en el teatral, el arquitectónico y el industrial sobre todo – pero me interesan especialmente los paisajes, y, en particular, los de Irlanda. He publicado algunas obras en la *Architectural Review, Vogue, Harpers, Country Life*, y en una o dos revistas especializadas, pero aún no he presentado una exposición realmente representativa.
'Estos paisajes corresponden a la región de Kerrythree, en Cloghane, en la península de Dingle, excepto uno (las mon-

The LEICA Experience

A LEICA is the best made 35 mm camera in the world. It's
designed for many years of dependable service, no matter
how tough the going, or how extreme the conditions. And it's
backed by a vast range of lenses and accessories of legendary
quality to cope with any assignment.
The LEICA gave the world 35 mm photography. It has seen
more action than any other 35 mm camera.
It has been called the ultimate experience in 35 mm
photography.
Or, more simply – ''The Leica Experience''.

 Leitz means precision- worldwide.

E. Leitz (Instruments) Ltd., 48 Park Street, Luton, LU1 3HB.

tañas bajo la luz del atardecer) que pertenece a Killarney. En todos los casos trabajé en condiciones luminosas muy inestables, de forma que a menudo la luz buscada se conservava sólo durante unos segundos. Ello constituye una prueba de la importancia vital que posee la rapidez de acción en la toma de paisajes, sobre todo en Irlanda, donde la luz sufre modificaciones constantes.'

L'auteur de ces beaux paysages irlandais, Richard Haughton, âgé de vingt ans, a accompagné son envoi des commentaires suivants au sujet de lui-même et de ses travaux: 'Je suis né à Cork et je prends des photographies depuis environ six ans, dont deux à plein temps, et je travaille dans différents domaines: théâtre, architecture, industrie, mais je m'intéresse principalement aux paysages, et plus particulièrement aux paysages irlandais. Certains de mes travaux ont été publiés dans Architectural Review, Vogue, Harpers, Country Life et dans une ou deux publications spécialisées en photographie, mais il me reste encore à organiser une grande exposition.
Tous les paysages ont été pris à Kerrythree in Cloghane, sur la péninsule de Dingle, et l'un d'eux (les montagnes peu après le coucher du soleil) à Killarney. Toutes les photographies ont été prises sous un éclairage très instable – la lumière ne durant, dans certains cas, que quelques secondes, ce qui montre combien est importante la vitesse de travail dans la photographie des paysages, en particulier en Irlande, où la lumière change constamment.'

107

Photographer	Rolf Harris
Camera	Asahi Pentax Spotmatic F
Lens	400 mm
Film	Kodachrome 64

The uniquely talented Rolf Harris is probably our best known contributor this year, for his regular television appearances have won him a wide following among audiences of all ages. His lightening sketch routines are merely one facet of his great skill as a serious painter and that he is equally accomplished with a camera has been demonstrated by popular exhibitions of his colour photography. This subtle animal study was taken in the Wankie game reserve, Rhodesia. 'Sadly', he comments, 'I can't remember the name of this particularly delicate breed of beast.'

Der ausserordentlich talentierte Rolf Harris dürfte dieses Jahr unser bekanntester Beitragender sein, denn seine regelmässigen Fernsehauftritte haben ihm viele Freunde aller Altersstufen gewonnen. Er ist ein hervorragender Maler, was bereits durch seine blitzschnell ausgeführten Skizzen erwiesen wird. Dass er ebenso gut mit der Kamera umzugehen versteht – dafür sprechen die beliebten Ausstellungen seiner Farbaufnahmen. Diese subtile Tierstudie wurde in dem Wildschutzbereich Wankie von Rhodesien aufgenommen. 'Leider', so schreibt er, 'kann ich mich an den Namen dieser besonders zarten Tierart nicht erinnern.'

De uitzonderlijk talentvolle Rolf Harris is wellicht de meest bekende fotograaf die in dit fotojaarboek te zien is. Zijn regelmatige televisie-uitzendingen worden in Engeland door talloze amateurfotografen van alle mogelijke leeftijden gevolgd. Zijn lichtvoetige, maar erg duidelijke informatie betreffende de fotografie is slechts één facet van deze kunstschilder die heeft getoond dat hij met de camera tot topprestaties kan komen, zoals zijn populaire kleurenfototentoonstellingen bewijzen. Deze subtiele dierenstudie is gemaakt in het Wankie natuurreservaat in Rhodesië. 'Jammer genoeg', zegt hij, 'weet ik de naam van dit erg aparte dier niet meer'.

El extraordinario fotógrafo Rolf Harris es probablemente el contribuidor más conocido de la edición de este año, ya que sus apariciones regulares en la televisión inglesa le han proporcionado una gran popularidad entre los públicos de todas las edades. Su gran dominio de las técnicas de iluminación constituye simplemente una de las múltiples facetas de su habilidad pictórica, mientras que la calidad de sus imágenes fotográficas ha quedado perfectamente establecida en las múltiples exposiciones que ha presentado. Este sutil estudio de una figura animal fue tomado en la reserva de caza de Wankie (Rodesia). 'Desgraciadamente, nos dice su autor, me es imposible recorder el nombre de este delicado animal'.

Rolf Harris, au talent si particulier, est probablement le plus connu de nos participants cette année, ses apparitions régulières à la télévision lui ayant valu une large audience chez des gens de tous âges. Ses croquis au pied levé ne sont qu'une facette de son grand art comme peintre sérieux, mais son expérience de photographe est également attestée par des expositions très suivies de sa photographie en couleur. Cette subtile étude animale a été prise dans la réserve de gibier de Wankie en Rhodésie. 'Malheureusement, explique-t-il, je ne me rappelle pas le nom de cette espèce particulièrement délicate d'animal.'

108

Photographer	Rolf Harris
Camera	Asahi Pentax Spotmatic F
Lens	90-250 mm Komuranon
Film	Ektachrome

Old man with baskets. The much travelled entertainer photographer took this shot in Korea.

Alter Mann mit Körben. Der vielgereiste Künstler machte diese Aufnahme in Korea.

Oude man met manden. De bereisde Harris maakte deze foto in Korea.

Viejo con cestos. Rolf Harris tomó esta fotografía en uno de sus múltiples viajes (a Corea en este caso).

Vieil homme portant des paniers. Grand voyageur, le photographe-animateur a pris ce cliché en Corée.

109

Photographer	Heinz Stücke
Camera	Nikkormat
Lens	50 mm Nikkor
Film	Agfacolor CT18
Shutter Speed	1/10
Aperture	f/2

Amarnath Cave in Kashmir is, according to Hindu mythology, the birth place of Shiva. At an altitude of 13,700 feet an Ice-Lingam (symbol of Shiva's recreative powers) waxes and wanes according to the phases of the moon. During the full moon in August a pilgrimage, called Yathra, is performed by many Hindus. Sadhus (holymen) who have renounced worldly living strip naked and enter the cave, to be 'one' with Shiva.

Die Amarnath-Höhle in Kaschmir ist gemäss der Hindu-Mythologie der Geburstsort des Gottes Shiva. In einer Höhle von 4 200 m nimmt ein Eis-Lingam (ein Symbol von Shivas Wiedererschaffungskräften) im Einklang mit den Phasen des Monds ab und zu. Bei Vollmond im August gehen viele Hindus auf eine als Yathra bezeichnete Pilgerfahrt. Sadhus (heilige Männer), die dem weltlichen Leben den Rücken gekehrt haben, ziehen sich nackt aus und treten in die Höhle ein, um sich mit Shiva 'zu vereinen'.

De Amarnath grot in Kashmir is volgens de Hindoe-mythologie de geboorteplaats van Shiva. Op een hoogte van 4100 meter neemt de linga (het symbool van de herscheppende krachten van Shiva) toe en af, al naar gelang de bewegingen van de maan. Tijdens een volle maan in augustus vindt er een pelgrimstocht, Yathra genaamd, plaats. Veel Hindoes nemen hieraan deel. Sadhu's (heilige mannen) die het wereldse leven hebben afgezworen gaan naakt de grot in teneinde één te zijn met Shiva.

La cueva de Amarnath en Cachemira es, según la mitología hindú, el lugar donde nació Shiva. A una altura de 13.700 pies existe un Lingam helado (el símbolo de los poderes de renovación poseídos por Shiva) que aparece y desaparece, de acuerdo con la oscilación de las fases lunares. Durante la luna llena de Agosto una gran cantidad de hindúes participan en una peregrinación denominada Yathra. Los Sadhus, 'iluminados' que han renunciado a los placeres mundanos, se desnudan completamente y entran en la cueva para alcanzar la total unión con el dios.

La grotte d'Amarnath au Cachemire est, selon la mythologie hindoue, le lieu de naissance de Shiva. A une altitude de quelque 3200 mètres, un lingam de glace (symbole de la fécondité de Shiva) croît et décroît selon les phases de la lune. Au cours de la pleine lune d'août, un pélerinage, dénommé Yathra, est suivi par de nombreux hindous. Les Sadhus (saints), qui ont renoncé à la vie dans le monde, se déshabillent et pénètrent dans la grotte pour ne faire qu'un avec Shiva.

110

Photographer	Heinz Stücke
Camera	Nikkormat
Lens	80–200 Nikkor Zoom
Film	Kodachrome 64
Shutter Speed	1/125
Aperture	f/8

'Every morning, milkmen in the Punjab cycle to the market in Amritzar carrying their produce in brass containers' writes Stücke. 'Being a world traveller rather than a photographer I came to use Photography as a way to record places and people in the quickest and most accurate manner. Sometimes I was pleased with the result, sometimes disappointed, but always excited to know the outcome. As my journey progressed my photos got better. My only limitation – little money to buy plenty of film for more experimentation. So I often waited long for the right subject to come along, at the right moment, in the right light. Most of my many slides remain unpublished and are stocked in my home in Germany because the excitement of non-stop travelling encouraged me to take new shots all the time. However, I had some photos published in magazines and sold some through a photo-agency in Japan'.

'Jeden Morgen fahren Milchmänner im Punjab auf Fahrrädern nach dem Markt in Amritzar, wobei sie die Milch in Messinggefässen tragen' schreibt Stucke. 'Da ich eher ein Weltreisender als Fotograf war, benutzte ich die Fotografie, um Orte und Menschen auf die schnellste und genaueste Weise festzuhalten. Manchmal war ich mit dem Ergebnis zufrieden, gelegentlich war ich auch enttäuscht, aber stets wartete ich mit grösster Spannung auf das Ergebnis. Indem ich meine Reisen fortsetzte, wurden meine Aufnahmen besser. Mein einziges Problem bestand darin, dass ich zu wenig Geld hatte, um genügend Film für weitere Versuche zu kaufen. Ich wartete daher oft lange, bis alle Umstände – das Modell, der Augenblick und das Licht – genau stimmten. Die meisten meiner vielen Dias sind unveröffentlicht in meinem Heim in Deutschland, da mich die Spannung des ununterbrochenen Reisens zu immer neuen Aufnahmen anregte. Einige meiner Aufnahmen wurden jedoch in Zeitschriften veröffentlicht bzw. durch eine Fotoagentur in Japan verkauft.'

Print your colour slides

Some of your best work is in that slide magazine; why keep it hidden?

You can now make your own brilliant colour enlargements using the new 'Photochrome R' chemicals (and Kodak 'Ektachrome' 14RC paper).

'Photochrome R' chemicals are easy to use; no powders to prepare; just concentrates requiring dilution. Colour filtration is simple—the three basic steps take about 12 minutes before your print is ready to dry. 'Photochrome R' chemicals are very economical; up to 60 8 x 10 prints can be processed in one 2-litre kit.

Equipment? Provided your enlarger will accept colour filters you need only your basic black and white equipment. . .

Photochrome® R

Another innovation from

Photo Technology Limited

Potters Bar, Hertfordshire, England.

'Melkmannen in de Punjab fietsen iedere ochtend met hun produkten naar de markt in Amritzar,' schrijft Stücke. 'Omdat ik meer wereldreiziger ben dan fotograaf, ben ik ertoe overgegaan fotografie te gebruiken als een middel om plaatsen en mensen op de meest accurate en vlugge manier vast te leggen. Soms was ik tevreden met het resultaat, soms teleurgesteld, maar altijd was ik opgewonden als ik zag wat het was geworden. Hoe langer ik op reis was, hoe beter mijn foto's werden. Mijn enige beperking waren mijn beperkte financiële middelen zodat ik niet genoeg film – nodig voor verdere experimenten – kon aanschaffen. Een en ander had tot gevolg dat ik vaak erg lang moest wachten tot het juiste onderwerp zich aandiende op de juiste tijd onder de juiste lichtomstandigheden. De meeste van mijn dia's zijn nog nooit gepubliceerd en komen mijn huis in Duitsland niet uit omdat er door het constant op reis zijn steeds meer dia's bijkomen. Er zijn echter een paar van mijn foto's in tijdschriften opgenomen en er zijn er een aantal via een foto-agentschap in Japan verkocht.'

'Cada mañana los granjeros del Punjab se dirigen en bicicleta al mercado de Amritzar llevando la leche en recipientes de latón', nos dice Stucke. 'Siendo por encima de todo un caminante que recorre el mundo, la fotografía representó para mí al principio una simple forma de poseer rápidamente un recuerdo imborrable de la gente y los lugares que iba conociendo. A veces me complacían los resultados obtenidos, en otras, me decepcionaban completamente, pero siempre estaba impaciente por conocerlos lo antes posible. A medida que progresaba en mi viaje, mis fotos fueron adquiriendo una mejor calidad. Mi única limitación era de tipo económico (tenía que ahorrar al máximo la película). Por ello a veces tuve que esperar durante mucho tiempo a que se presentara un tema interesante en el momento oportuno y bajo la luz adecuada. Muchas de las diapositivas obtenidas no han llegado nunca a publicarse y permanecen guardadas en mi casa, en Alemania, Ello es debido a que la excitación del viaje me llevó a tomar fotografías casi sin descanso. Algunas han aparecido en diversas revistas y he vendido otras a través de una agencia japonesa'.

'Chaque matin, ces laitiers du Punjab se rendent à bicyclette au marché d'Amritzar en transportant leurs produits dans des récipients en laiton', écrit Stucke. 'Etant globe-trotter plutôt que photographe, j'en suis venu à utiliser la photographie pour fixer les lieux et les gens de la manière la plus rapide et la plus exacte possible. J'ai généralement été satisfait du résultat, parfois déçu, mais toujours impatient de connaître l'issue. Au fil de mon voyage, mes photographies se sont améliorées. Ma seule limite – le manque d'argent pour acheter une grande quantité de pellicule et pouvoir faire davantage d'essais. Aussi ai-je souvent dû attendre longtemps pour avoir le sujet voulu au moment voulu et sous

l'éclairage voulu. La plupart de mes diapositives n'ont toujours pas été publiées et sont stockées dans ma maison en Allemagne, car l'exaltation qu'engendre toujours en moi un voyage ininterrompu m'a encouragé à prendre de nouvelles photographies sans discontinuer. Toutefois, certains de mes clichés ont été publiés dans des magazines et vendus par l'intermédiaire d'une agence de photographie au Japon.'

111

Photographer	Nick Wheeler
Camera	Nikon

Space Shuttle. 'The objective of the first inert flight of the 747/Orbiter was to validate the mated combination of rocket and plane and to test the airworthiness of the shuttle as an Oribiter transport vehicle. In the first taxi ground tests, the space shuttle, mounted on a jumbo jet, travelled at 158 mph on the ground. Then it was carried aloft by the same jumbo jet. Test pilots Fitzhugh L. Fulton and Thomas C. McMurty were greeted by their ecstatic wives as they left the ship after its successful first flight.'
British photographer Wheeler works for the famous French agency Sipa Press but is based in the United States.

Space Shuttle. 'Durch den ersten inerten Flug des 747/Orbiter sollte die Kombination von Rakete und Flugzeug und die Lufttüchtigkeit des Shuttle als Orbiter-Transportfahrzeug erprobt werden. In den ersten Bodenversuchen wurde das Space Shuttle von einem Grossraum-Strahlflugzeug mit einer Geschwindigkeit von 158 Meilen pro Stunde transportiert. Dann flog das gleiche Flugzeug damit los. Als die Testpiloten Fitzhugh L. Fulton und Thomas C. McMurty das Fahrzeug nach ihrem erfolgreichen ersten Flug verliessen, wurden sie von ihren begeisterten Frauen begrüsst.'
Der britische Fotograf Wheeler arbeitet für die berühmte französische Agentur Sipa Press, wohnt aber in den Vereinigten Staaten von Amerika.

De Space Shuttle. 'Het doel van de eerste vlucht van de 747/Orbiter-combinatie was het checken van de eerder gemaakte berekeningen betreffende deze combinatie raket/vliegtuig en het testen van de luchtwaardigheid van de Shuttle als een ruimtetransportmiddel. Tijdens de eerste taxiproeven bereikte de Space Shuttle, gemonteerd boven op een Boeing 747, een snelheid van 255 km/u. Vervolgens werd de Shuttle door dezelfde Jumbo jet mee naar boven genomen. De testpiloten Fitzhugh L. Fulton en Thomas C. McMurty werden na de eerste, succesvolle vlucht geestdriftig begroet door hun vrouwen.'
De Britse fotograaf Wheeler werkt voor het bekende Franse agentschap Sipa Press maar zijn werkterrein is de Verenigde Staten.

Módulo espacial. 'El objetivo del primer 'vuelo' inerte del 747/Orbiter residía en comprobar la validez de la combinación cohete-avión y poner a prueba el módulo transportador del Orbiter. En las primeras pruebas, el módulo, montado en un Jumbo, se desplazó en el suelo a 253 Km/h. A continuación el propio Jumbo se encargó de llevarlo a las alturas. Los pilotos encargados de realizar la prueba, Fitzhugh L. Fulton y Thomas C. McMurty recibieron la felicitación efusiva de sus esposas al abandonar el vehículo tras coronar con éxito su misión'.
El fotógrafo inglés Nick Wheeler trabaja para la famosa agencia francesa Sipa Press, aunque reside en los EE.UU.

Navette spatiale. 'L'objectif du premier vol par inertie du 747/Orbiter était de démontrer l'utilité du mariage de la fusée et de l'aéronef, et d'éprouver les qualités spatiales de la navette en tant que véhicule de transport Orbiter. Lors des premiers essais de roulage au sol, la navette spatiale, montée sur un gros-porteur, a roulé au sol à la vitesse de 262 km/h. Puis elle a été portée dans l'air par le même appareil. Les pilotes d'essai Fitzhugh L. Fulton et Thomas C. McMurty ont été accueillis par leurs femmes ravies à leur descente de l'appareil, au retour de son premier vol réussi.'Le photographe britannique Wheeler travaille pour la célèbre agence française Sipa Press, mais est établi aux Etats-Unis.

112

Photographer	Veikko Vasama
Camera	Linhof Technika
Lens	240 mm Tele-Arton
Film	Agfachrome 50S

Reproduced from a large format transparency by the talented Finnish pictorialist. The actual location was not specified.

Von einem grossen Diapositiv des talentierten finnischen Künstlers reproduziert. Der Aufnahmeort war nicht angegeben.

Gereproduceerd van een groot-formaatdia door een talentvolle Finse kunstfotograaf. De precieze lokatie weten wij niet.

He aquí una reproducción de una diapositiva de gran formato obtenida por este extraordinario fotógrafo finlandés. No se nos ha indicado la situación exacta del lugar.

Reproduction d'une diapositive de grand format par le talentueux pictorialiste finlandais. L'emplacement réel n'a pas été précisé.

113/114

Photographer	Gunnar Larsen
Camera	Asahi Pentax
Film	Agfa

Born in 1936, Danish photographer Gunnar Larsen has worked in Paris for ten years. After five years with *Mode International* he now has his own magazine *Mode Avantgarde* and has established an international reputation as a fashion photographer.

Der 1936 geborene dänische Fotograf Gunnar Larsen ist seit zehn Jahren in Paris tätig. Nachdem er fünf Jahre im Dienste der *Mode International* gestanden ist, besitzt er nun eine eigene Zeitschrift – *Mode Avantgarde* – und geniesst als Modefotograf und Redakteur Weltruf.

De in 1936 geboren Deense fotograaf Gunnar Larsen heeft de laatste tien jaar in Parijs gewerkt. Na vijf jaar voor *Mode International* te hebben gefotografeerd heeft hij nu zijn eigen tijdschrift *Mode Avantgarde*. Hij heeft zich een grote reputatie als modefotograaf en -redacteur verworven.

Nacido en 1936, el fotógrafo danés Gunnar Larsen lleva ya diez años trabajando en París. Después de pasar cinco años con *Mode International* fundó su propia revista, *Mode Avantgarde*, y ha logrado el más amplio reconocimiento internacional por su labor como fotógrafo y editor.

Né en 1936, le photographe danois Gunnar Larsen a travaillé à Paris pendant dix dans. Après cinq années passées au service de *Mode International*, il a maintenant son propre magazine – *Mode Avant-Garde* – et s'est acquis une réputation internationale comme photographe de mode et rédacteur en chef.

115

Photographer	Jorge Lewinski
Camera	Asahi Pentax 6 × 7
Lens	75 mm
Film	Agfachrome 50S

Rydal Water in England's Lake District. Well known, not only as a photographer but also as a teacher, writer and lecturer, Lewinski has recently been engaged in producing a series of 'literary landscapes' for a major book project.

Rydal Water in Englands Lake District. Lewinski, der nicht nur also Fotograf sondern auch als Lehrer, Schriftsteller und Vortragender gut bekannt ist, erhielt vor kurzem den Auftrag zur Anfertigung mehrerer 'literarischer Landschaftsbilder' für ein wichtiges Buch.

Rydal Water in het Engelse merengebied. Bekend, niet alleen als fotograaf maar ook als leraar, schrijver en door zijn lezingen, is Lewinski nu bezig met het maken van een serie 'literaire landschapsfotos' voor een nog uit te geven fotoboek.

Rydal Water en el Lake District inglés. Ampliamente conocido, no sólo como fotógrafo, sino también como profesor, escritor y conferenciante, Lewinski tiene en proyecto en la actualidad la realización de una serie de fotografías paisajísticas relacionadas con famosas obras literarias.

Rydal Water dans le District des lacs anglais. Bien connu, non seulement comme photographe, mais aussi comme professeur, écrivain et conférencier, Lewinski a récemment été engagé pour la réalisation d'une série de 'paysages littéraires' destinés à illustrer un grand ouvrage.

116

Photographer	Jorge Lewinski
Camera	Asahi Pentax 6 × 7
Lens	55 mm
Film	Kodak Tri-X
Shutter Speed	1/15
Aperture	f/16
Developer	Microdol

Godvery lighthouse near St. Ives in Cornwall. The literary connection here is with Virginia Woolf.

Der Leuchtturm Godvery bei St. Ives in Cornwall. Seine literarische Bedeutung verdankt das Gebäude der Schriftstellerin Virginia Woolf.

De vuurtoren van Godvery bij St. Ives in Cornwall. Hier probeert de maker het literaire verband met Virginia Woolf te leggen.

El faro de Godvery, situado cerca de St. Ives, en Cornwall. En este caso la conexión literaria se establece con Virginia Woolf.

Phare de Godvery près de St. Ives en Cornouailles. La référence littéraire est ici Virginia Woolf.

117

Photographer	Jorge Lewinski
Camera	Asahi Pentax 6 × 7
Lens	55 mm
Film	Kodak Tri-X
Developer	Microdol

A monochrome impression of Rydal water under storm clouds. The house of Lakeland poet William Wordsworth can be seen in the distance.

Monochromer Eindruck von Rydal Water unter Gewitterwolken. In der Ferne sieht man das Haus des Dichters William Wordsworth, dessen Heimat sich hier befand.

Een monochrome impressie van Rydal Water onder een lucht die storm voorspelt. Het huis van de bekende dichter uit het merengebied, William Wordsworth, is in de verte te zien.

Vista monocroma de Rydal Water cubierta por nubes de tormenta. A lo lejos es posible divisar la casa del poeta de Lakeland William Wordsworth.

Impression monochrome de Rydal Water sous des nuages d'orage. On aperçoit au loin la maison de William Wordsworth, poète du District des lacs.

118/120

Photographer	Jonathan Player
Camera	Canon
Lens	Standard
Film	Ilford HP5
Aperture	f/5.6
Lighting	Bounced electronic flash
Developer	D76

Rex Features photographer Jonathan Player took this delightful series of pictures of an almost human Orang Utang and a baby chick at Bristol zoo. It is this kind of material that an enterprising picture agency can find very profitable.

Jonathan Player, ein für Rex Features tätiger Fotograf, machte diese entzückende Reihe von Aufnahmen eines nahezu menschlichen Orang Utangs und eines Kückens im Tiergarten von Bristol. Aufnahmen dieser Art können für eine unternehmungslustige Fotoagentur sehr gewinnbringend sein.

Fotograaf Jonathan Player van Rex Features nam deze zalige serie foto's van een bijna menselijke orang-oetan en haar baby in de dierentuin van Bristol. Dit soort fotomateriaal kan voor een ondernemend agentschap erg winstgevend zijn.

El fotógrafo de la agencia Rex Features, Jonathan Player tomó en el Zoo de Bristol esta deliciosa serie de instantáneas en las que vemos a un orangután de comportamiento casi humano y a un diminuto polluelo. Una buena agencia fotográfica suele obtener un fabuloso rendimiento de este tipo de material.

Jonathan Player, photographe de Rex Features, est l'auteur de cette délicieuse série de photographies d'un orang-outang presque humain et d'un poussin du zoo de Bristol. C'est là le type de cliché qui peut se révéler très profitable pour une agence de photographie ambitieuse.

121

Photographer	Ian Sumner
Camera	Nikon
Lens	24 mm Nikor
Film	Kodak Tri-X

Boy on a train, Queensland, Australia, and the first of two successful submissions by a Berkshire photographer.

Junge auf einem Zug in Queensland, Australien. Das erste von zwei in diesem Jahrbuch veröffentlichten Bildern eines Fotografen in Berkshire.

Een jongen in de trein in Queensland, Australië. De eerste van twee succesvolle inzendingen van Ian Sumner uit Berkshire.

Muchacho en un tren. Esta foto tomada en Queensland (Australia) es la primera de las dos extraordinarias contribuciones de este fotógrafo de Berkshire que incluímos en el libro.

Jeune garçon dans un train au Queensland, Australie – première de deux excellentes images dues à un photographe originaire du Berkshire.

122

Photographer	Ian Sumner
Camera	Nikon
Lens	24 mm Nikkor
Film	Kodak Tri-X

Top hatted joviality at Derby Day horse racing on Epsom Downs.

Jovialität im Zylinderhut. Dieses Bild wurde während eines Pferderennens am 'Derby Day' auf den Epsom Downs aufgenommen.

Jovialiteit onder een hoge zijden: paarderaces op Derby Day te Epsom Downs.

Una gran jovialidad reina entre los espectadores de chistera del Derby de Epsom Downs.

Jovialité en haut de forme au concours hippique du Derby Day sur les Epsom Downs.

Der Fussballstar Kevin Keegan kehrt in der Uniform seines neuen Klubs Hamburg zum ersten Mal auf den Fussballplatz von Liverpool zurück.

De bekende voetballer Kevin Keegan komt voor het eerst, nu in de kleuren van zijn nieuwe club Hamburg SV, terug in het stadion van zijn oude vereniging, Liverpool.

El famoso futbolista Kevin Keegan salta al campo del Liverpool por primera vez desde que viste la camiseta de su nuevo equipo, el Hamburgo.

Le champion de football Kevin Keegan revient sur le terrain de Liverpool pour la première fois sous les couleurs de son nouveau club Hamburg.

Ein Arbeiter aus einer anderen Welt. Der italienische Fotograf Lombardi ist immer auf der Ausschau nach für surrealistische Behandlung geeigneten Themen.

Een arbeider uit een andere wereld. De Italiaanse fotograaf Lombardi is altijd bedacht op onderwerpen met surrealistische mogelijkheden.

Trabajador de otro mundo. El fotógrafo italiano Lombardi se halla siempre a la caza de temas susceptibles de recibir un tratamiento surrealista.

Travailleur d'un autre monde. Le photographe italien Lombardi est toujours en quête de sujets offrant des possibilités surréalistes.

123/124

Photographer	Lakic Miroslav
Camera	Topcon and Minolta SRT 101
Lens	50 mm and 35 mm
Film	Kodak Tri-X
Shutter Speed	1/25
Aperture	f/11
Developer	D76
Paper	Ilfospeed

These interesting, but untitled figure studies were sent to us by the photographer from Switzerland. The second example, taken with Miroslav's Minolta, was obtained from a sandwich of two negatives.

Diese interessanten Bildstudien ohne Titel wurden uns von dem Schweizer Fotografen zugesandt. Das zweite Bild, das Miroslav mit einer Minolta aufnahm, ist das Ergebnis einer Überlagerung von zwei Negativen.

Deze twee interessante figuurstudies werden ons door een Zwitserse fotograaf toegezonden. De tweede opname, gemaakt met Miroslavs Minolta, werd verkregen door een sandwich van twee negatieven.

He aquí dos interesantes estudios de figuras, enviados, sin título, por este fotógrafo suizo. El segundo, realizado con una Minolta, constituye un 'sandwich' de dos negativos.

Ces études de silhouettes, intéressantes mais sans titre, nous ont été envoyées par le photographe originaire de Suisse. Le second exemple, réalisé avec le Minolta de Miroslav, a été obtenu par la mise 'en sandwich' de deux négatifs.

126

Photographer	John Davidson
Camera	Nikon F
Lens	28 mm Nikor
Film	Kodak Tri-X
Shutter Speed	1/60
Aperture	f/5.6
Lighting	Bounced electronic flash
Developer	D76
Paper	Ilfospeed

For his second personality portrait, the Cheshire photographer visited George Harrison at Warrington where the former Beatle was relaxing at his father's house with a cup of tea.

Das zweite dieser Porträts prominenter Persönlichkeiten zeigt George Harrison, den der in Cheshire wohnhafte Fotograf in Warrington besuchte. Der frühere Beatle erfrischte sich im Hause seines Vaters mit einer Tasse Tee.

Voor zijn tweede portret van een bekende persoonlijkheid zocht de fotograaf uit Cheshire George Harrison op in Warrington, waar de ex-Beatle in het ouderlijk huis op ontspannen wijze van zijn thee geniet.

Pare obtener este segundo retrato de un personaje famoso, el fotógrafo de Cheshire visitó a George Harrison en Warrington, donde captó al antiguo Beatle tomando una taza de té en la casa de sus padres.

Pour son second portrait d'une personnalité, le photographe originaire du Cheshire a rendu visite à George Harrison à Warrington, où l'ancien Beatle se reposait chez son père devant une tasse de thé.

128

Photographer	Enzo Lombardi
Camera	Plaubel
Lens	Komura
Film	Ilford FP4
Shutter Speed	1/2
Developer	Acutol
Paper	Ilfobrom

'Double faced'. Pure contrivance but an interesting arrangement that makes graphic use of the elements in this somewhat bizarre composition.

'Doppeltgesichtig'. Ein absolut künstliches aber interessantes Arrangement, das die Elemente in dieser etwas merkwürdigen Kompositon grafisch verwertet.

'Dubbelportret'. Puur vernuft maar desondanks toch een interessante opstelling die grafisch gebruik maakt van de elementen in deze enigszins bizarre compositie.

'Doble cara'. Composición puramente artificiosa pero que revela una interensantísima ordenación de los elementos gráficos disponibles.

'Double face'. Pure invention mais un résultat intéressant qui utilise graphiquement les éléments de cette composition quelque peu bizarre.

Page 129

Photographer	Enzo Lombardi
Camera	Nikkormat
Lens	85 mm Nikkor
Film	Ilford FP4
Developer	Acutol
Paper	Ilfobrom

'A new metier'. A title as informative as the subject's purpose. But no matter. It describes a thought provoking picture.

'Ein neuer Beruf'. Weder der Titel noch das Objekt ist sehr informativ. Dafür ist aber das Bild anregend.

'Een nieuw vak'. Een titel die even veelzeggend is als de bedoelingen van de hoofdpersoon. Maar wat geeft het? In ieder geval stemt deze foto tot nadenken.

'Un nuevo oficio'. Un título tan poco revelador como la propia imagen. Pero no importa. Constituye una adecuada descripción para esta sorprendente instantánea.

'Un nouveau métier'. Titre aussi informatif que l'objectif du sujet. Peu importe; il décrit une scène stimulante pour l'esprit.

125

Photographer	John Davidson
Camera	Nikon F
Lens	28 mm Nikkor
Film	Kodak Tri-X
Shutter Speed	1/250
Aperture	f/3.5
Developer	D76
Paper	Ilfospeed

Football star Kevin Keegan returns to Liverpool ground for the first time in the strip of his new club Hamburg.

127

Photographer	Enzo Lombardi
Camera	Nikkormat
Lens	85 mm Nikkor
Film	Ilford FP4
Developer	Acutol
Paper	Ilfobrom

Workman from another world. Italian photographer Lombardi is always alert for subjects with surrealist possibilities.

130

Photographer	Bob Collins
Camera	Minolta SR-1
Lens	21 mm Rokkor
Film	Ilford FP4
Shutter Speed	1/125
Aperture	f/5.6

'Empty Hotel' by a successful Surrey freelance adept at capturing mood and atmosphere.

'Leeres Hotel'. Der erfolgreiche freiberufliche Fotograf, der in Surrey lebt, versteht es Stimmungen und Atmosphären widerzugeben.

'Verlaten hotel', gemaakt door een succesvolle free-lance fotograaf uit Surrey. Zijn voorkeur gaat uit naar het vastleggen van stemmingen en atmosferen.

'Hotel vacío'. Imagen obtenida por un fotógrafo 'free-lance' de Surrey, preocupado especialmente por captar la atmósfera general de sus temas.

'Hôtel vide', par un talentueux photographe indépendant originaire du Surrey, qui a le don de saisir le cadre et l'ambiance.

131

Photographer	Bob Collins
Camera	Minolta SR-1
Lens	35 mm Rokkor
Film	Ilford FP4
Shutter Speed	1/15
Aperture	f/8

'Figure behind door'. A composition of surprising menace derived from a simple idea.

'Gestalt in der Türe'. Eine auf einer einfachen Idee beruhende Komposition, die erstaunlich dreohend wird.

'Figuur achter deur'. Een compositie waar een verrassende dreiging van uitgaat, terwijl er toch slechts een simpel idee aan ten grondslag ligt.

'Figura detrás de una puerta'. Una composición sorprendentemente amenazante, obtenida a partir de una idea sencillísima.

'Silhouette derrière une porte'. Composition d'une surprenante menace, née d'une simple idée.

132

Photographer	Renzo Muratori
Camera	Nikon
Lens	85 mm
Film	Ilford HP4
Shutter Speed	1/250
Aperture	f/8
Developer	D76
Paper	Agfa

A distant figure in a Munich park was framed in trees by Italian photographer Muratori.

Der italienische Fotograf Muratori umrahmte eine ferne Gestalt in einem Münchener Park mit Bäumen.

Een eenzaam persoon in de verte in een park in München, als het ware door bomen 'ingelijst' door de Italiaanse fotograaf Muratori.

El fotógrafo italiano Muratori enmarcó a esta figura distante con el fondo proporcionado por los árboles de un parque muniqués.

Cette silhouette lointaine, prise dans un parc de Munich, a été cadrée dans les arbres par le photographe italien Muratori.

133

Photographer	Renzo Muratori
Camera	Nikon
Lens	35 mm
Film	Ilford HP4
Shutter Speed	1/30
Aperture	f/4
Developer	D76
Paper	Agfa

Always fascinated by possible photographic curiosities, the Italian cameraman seized the opportunity presented by this display head in a menswear store.

Der italienische Künstler, den fotografische Merkwürdigkeiten stets faszinieren, machte von diesem Modellkopf in einem Herrengeschäft guten Gebrauch.

Altijd al gebiologeerd door fotografische curiositeiten greep deze Italiaanse fotograaf de gelegenheid die door deze etalagepop in een herenmodezaak werd geboden.

Siempre fascinado por la posibilidad de obtener imágenes curiosas, el fotógrafo italiano aprovechó la oportunidad brindada por esta cabeza exhibida en una tienda de ropa masculina.

Toujours fasciné par les curiosités photographiques possibles, le photographe italien a saisi l'occasion qu'offrait cette tête de mannequin dans un magasin de confection pour hommes.

134/135

Photographer	Augusta Lovera
Camera	Nikon FT
Lens	24 and 50 mm Nikkor
Film	Ilford FP4
Developer	Kodak D76

Also from Italy came two interesting picture sets from a photographer new to the Year Book. The first was briefly captioned 'A Man' and the second 'The Scarecrows. Recalling in the fog'.

Ebenfalls aus Italien kamen zwei interessante Bildserien einer Fotografin, deren Werke zum ersten Mal in dem Year Book veröffentlicht werden. Das erste trägt den kurzen Titel 'Ein Mann', während der zweite 'Die Vogelscheuchen. Erinnerung im Nebel' lautet.

Uit Italië kwamen twee foto's van een fotograaf die nog niet eerder in het fotojaarboek verscheen. De eerste foto heet kort en krachtig 'Een man' en de tweede 'Vogelverschrikkers. Herinneringen in de mist'.

También de Italia hemos recibido estas dos interesantes fotografías realizadas por una artista que aparece en nuestro libro por primera vez. El título de la primera es 'Un hombre' mientras que la segunda lleva el de 'Espantapájaros en la niebla'.

Nous viennent également d'Italie ces deux intéressantes séries d'images dues à un photographe nouveau dans le Year Book. La première a été laconiquement intitulée 'Un homme' et la seconde 'Le rappel des épouvantails dans le brouillard'.

136

Photographer	Vlado Baca
Camera	Pentacon Super
Lens	20 mm Flektogon
Film	Orwo NP27
Shutter Speed	1/60
Aperture	f/4

In the park. The first of two studies of elderly isolation by the Czech photographer.

Im Park. Die erste von zwei Studien des tschechischen Fotografen, deren Thema die Einsamkeit älterer Menschen bildet.

In het park. De eerste van twee studies van de Tsjechische fotograaf Baca die de eenzaamheid onder bejaarden tot onderwerp hebben.

En el parque. El primero de dos estudios realizados por este fotógrafo checo sobre el tema de la soledad de los viejos.

Dans le parc. Première de deux études sur la solitude de l'âge, par le photographe tchèque.

137

Photographer	Vlado Baca
Camera	Pentacon Super
Lens	20 mm Flektogon
Film	Orwo NP27
Shutter Speed	1/60
Aperture	f/4

The other seats are now empty as an old man surveys the park.

Ein alter Mann blickt in den Park, in dem die anderen Sitze nun leer sind.

Alleen op een bank gezeten overziet deze oude man het park.

El viejo contempla los lugares que ahora han quedado vacíos.

Les autres sièges sont maintenant vides, tandis qu'un vieil homme contemple le parc.

138

Photographer	Yves Rouillard
Camera	Canon
Lens	35 mm
Film	Kodak Tri-X
Shutter Speed	1/30
Aperture	f/2
Developer	Acufine
Paper	Ilfospeed

Scenes from French provincial life. Yves Rouillard took this informal vignette at a wedding reception in Brittany.

Szenen aus dem ländlichen Leben Frankreichs. Yves Rouillard machte diese zwanglose Aufnahme auf einem Hochzeitsfest in der Bretagne.

Beelden uit het Franse plattelandsleven. Yves Rouillard maakte dit informele vervloeiende beeld tijdens een trouwreceptie in Bretagne.

Escenas de la vida provinciana francesa. Yves Rouillard captó esta instantánea informal en una fiesta celebrada en Bretaña como colofón de una boda.

Scènes de la vie provinciale française. Yves Rouillard a pris cette photographie tres naturelle en dégradé lors d'un mariage en Bretagne.

139

Photographer	Yves Rouillard
Camera	Leica M4
Lens	35 mm Summicron
Film	Kodak Tri-X
Shutter Speed	1/30
Aperture	f/2.8
Developer	D76
Paper	Ilfospeed

Also in Brittany were these vetern musicians playing at a club for the elderly.

Ebenfalls in der Bretagne fand er diese Veteranen der Musik, die in einem Klub für ältere Menschen spielen.

Ook deze foto is gemaakt in Bretagne: niet meer zó jonge musici spelend in een bejaardentehuis.

También en Bretaña, vemos a una orquesta de músicos veteranos tocando en un club para personas que se hallan en la 'tercera edad'.

Toujours en Bretagne, vieux musiciens jouant dans un club pour personnes âgées.

140

Photographer	Yves Rouillard
Camera	Canon
Lens	35 mm
Film	Kodak Tri-X
Shutter Speed	1/250
Aperture	f/11
Developer	D76
Paper	Ilfospeed

Rouillard took this onlooker in traditional costume at a folk lore fete in Brittany.

Rouillard maakte deze foto van een toeschouwer in traditioneel kostuum tijdens een folklorefestijn in Bretagne.

Este espectador vestido con un traje tradicional fue captado por Ruillard en una fiesta folklórica celebrada en Bretaña.

Rouillard fotografierte diesen Zuschauer in traditioneller Tracht auf einem Volksfest in der Bretagne.

Rouillard a saisi ce spectateur en costume traditionnel lors d'une fête folklorique en Bretagne.

141/144

Photographer	Yoram Lehmann
Camera	View camera with pinhole

The pictures on the next four pages are unique among all others in this book in that none were taken through a camera lens. Instead, Jerusalem photographer Lehmann employed a much earlier technique for producing an image – a simple pinhole. This was used on a view camera so our reproductions are from contact prints. When a pin-hole replaces the lens on a camera only a few rays of light from each point on the subject are permitted to strike the film but, although longer exposures are required, sharp images result with great depth of field if the pin hole produces small enough 'circles of confusion'. Lehmann's pictures, 'A broom', 'An Egg Beater', 'Daniel in North Carolina' and 'Steps, Jerusalem', prove again that effective photography depends on a creative imagination and not necessarily on the possession of elaborate equipment.

Die Bilder auf den nächsten vier Seiten unterscheiden sich von den anderen in diesem Buch dadurch, daβ keines davon mit Hilfe eines Kameraobjektivs aufgenommen wurde. Anstattdessen machte der in Jerusalem wohnhafte Fotograf Lehmann von einem viel älteren Verfahren – einem einfachen Nadelloch – Gebrauch. Dabei bediente er sich einer Reisekamera, so dass unsere Reproduktionen auf Kontaktkopien beruhen. Wenn anstelle einer Kamera mit Objektiv eine Lochkamera verwendet wird, erreichen nur wenig Lichtstrahlen von jedem Punkt des Objekts den Film. Obgleich längere Belichtungen erforderlich sind, werden scharfe Bilder mit grosser Tiefenschärfe erzielt, vorausgesetzt dass das Loch genügend kleine 'Diffusionskreise' bewirkt. Lehmanns Bilder – 'Ein Besen', 'Ein Schneebesen', 'Daniel in North Carolina' und 'Stufen, Jerusalem' – beweisen, dass gute Fotografie von schöpferischer Fantasie und nicht unbedingt dem Besitz komplizierter Geräte abhängt.

De afbeeldingen op de volgende vier pagina's zijn uniek ten opzichte van alle andere foto's in dit boek in die zin dat ze niet met een camera met een normaal objectief werden gemaakt. In plaats daarvan gebruikte de Jeruzalemse fotograaf Lehmann een zeer vroege techniek om beelden te reproduceren – een eenvoudig gaatje. Deze techniek is hier met een boxcamera toegepast, dus onze reprodukties zijn afkomstig van contactafdrukken. Als een gaatje het objectief op een camera vervangt, dan komen er vanaf ieder punt van het onderwerp slechts een paar stralen licht op de film, waardoor, ondanks de noodzakelijke langere belichtingstijden, een haarscherp beeld met een uitzonderlijke scherptediepte ontstaat, tenminste als het gaatje klein genoeg is. Lehmanns foto's, 'Een bezem', 'Een eierklopper', 'Daniël in North Carolina' en 'Treden in Jeruzalem', bewijzen opnieuw dat effectieve fotografie afhankelijk is van een creatief voorstellingsvermogen en niet noodzakelijkerwijs van zeer geavanceerde apparatuur.

Las fotografías que ocupan las cuatro páginas siguientes son únicas en este libro en el sentido de que se tomaron con una cámara desprovista de objetivo. El fotógrafo de Jerusalem Yoram Lehmann, se sirvió en este caso de un simple orificio de alfiler. La cámara utilizada estaba, sin embargo, dotada de visor, lo que nos ha permitido obtener nuestras reproducciones a través de una impresión por contacto. Cuando se reemplaza el objetivo de una cámara por medio de un agujero de alfiler, sólo unos pocos rayos de luz procedentes de cada uno de los puntos del objeto captado pueden llegar a impresionar la película, pero, aunque es necesario trabajar con exposiciones muy largas, se obtienen imágenes perfectamente contrastadas, con gran profundidad de campo, si el agujero de alfiler produce 'círculos de confusión' lo suficientemente pequeños. Las fotografías de Lehmann, tituladas, 'Una escoba', 'Un batidor de huevos', 'Daniel en Carolina del Norte' y 'Escaloves, Jerusalén', constituyen una nueva prueba de que la obtención de imágenes artísticas es producto de la imagación creativa personal y no depende necesariamente de la posesión de un equipo sofisticado.

Les images des quatre pages suivantes sont uniques parmi toutes les autres photographies contenues dans le présent album, en ce sens qu'aucune n'a été prise par l'objectif d'un appareil photographique. Lehmann, photographe originaire de Jérusalem, a utilisé une technique beaucoup plus ancienne pour obtenir une image – un simple sténopé. Celui-ci a été utilisé sur un appareil à visée, de sorte que nos reproductions ont été tirées à partir de clichés imprimés par contact. Lorsque, sur un appareil photographique, le sténopé remplace l'objectif, seuls quelques rayons de lumière émanant du sujet impressionnent la pellicule, mais, bien qu'il faille de longs temps d'exposition, on obtient des images très contrastées avec une grande profondeur de champ si le sténopé engendre des 'cercles de confusion' suffisamment petits. Les photographies de Lehmann: 'Un balai', 'Un batteur à oeufs', 'Daniel en Caroline du Nord' et 'Marches à Jérusalem' démontrent une fois de plus qu'une bonne photographie dépend d'une imagination créatrice féconde et pas nécessairement de la possession d'un matériel sophistiqué.

145/148

Photographer	Chris Capstick
Camera	Nikon F2
Lenses	35, 55 and 85 mm
Film	Ilford HP5
Developer	D76

'How old you have to be before you can learn to play the violin? These children are being trained on miniature violins by Mrs Helen Brunner (using a system devised in Japan by Dr. Suzuki) and the results are claimed to be astonishing.' Chris Capstick of the Rex Features agency found their absorbed interest equally productive photographically.

'Wie alt sollte man sein, bevor man mit dem Geigespielen beginnen kann? Diese Kinder werden von Mrs. Helen Brunner (nach einem in Japan von Dr. Suzuki entwickelten System) auf Miniaturviolinen unterrichtet, und wie es heisst sind die Ergebnisse erstaunlich.' Chris Capstick, ein Mitarbeiter der Rex Features Agentur, fand, dass ihre Konzentration in fotografischer Hinsicht ebenfalls sehr interessant ist.

'Hoe oud moet je zijn om viool te kunnen gaan spelen? Deze kinderen zijn aan het oefenen op miniatuur violen, en wel onder leiding van Helen Brunner (zij gebruikt een systeem dat door dr. Suzuki in Japan werd ontwikkeld), die verbazingwekkend goede resultaten boekt'. Chris Capstick van Rex Features maakte van deze geheel in beslag genomen kinderen een even boeiende opname.

'¿A qué edad se puede empezar a aprender a tocar el violín? Los resultados obtenidos por la Sra. Helen Brunner enseñando a los niños a tocar estos diminutos violines (mediante un sistema elaborado en Japón por el Dr. Suzuki) parecen ser formidables.' Estas expresiones infantiles de profunda y sostenida concentración brindaron una imagen de gran interés fotográfico al repórter Chris Capstick, de la Rex Features.

'Quel âge faut-il avoir avant de pouvoir apprendre à jouer du violon? Ces enfants sont entraînés sur des violons miniature par Mme Helen Brunner (qui utilise un système conçu au Japon par le Dr Suzuki) et dont les résultats seraient étonnants.' Chris Capstick, de l'agence Rex Features, a trouvé que l'air absorbé qui est ici le leur pouvait également donner d'excellents résultats du point de vue de la photographie.

149

Photographer	Michael Joseph
Camera	Hasselblad
Lens	50 mm
Film	Kodak Plus-X
Developer	Microdol-X
Paper	Kodalith

PHOTOGRAPH BY HOWARD GREY

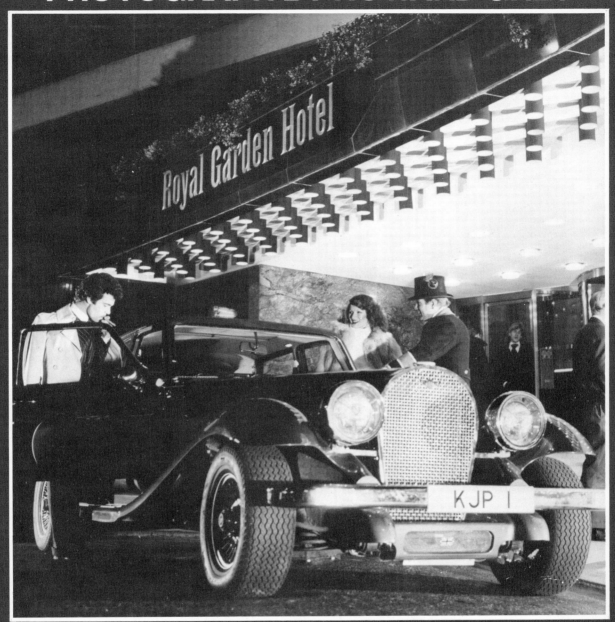

EQUIPMENT BY KEITH JOHNSON

KEITH JOHNSON PHOTOGRAPHIC

Ramillies House 1/2 Ramillies Street London W1V 1DF. 01-439 8811.
Telex 24447.

When *Photography Year Book* first appeared in the early nineteen thirties, it was largely devoted to advertising photography, much of which now seems very banal. While the basic purpose of the advertising photographer is still the same – to help sell goods and services – great advances have been made in the creative application of improved equipment and materials, of which the work of London based photographer Michael Joseph provides many excellent examples. This picture of comedy actor Derek Nimmo was, however, taken during an editorial cover assignment for the magazine *Radio Times*.

Als das *Photography Year Book* zu Beginn der 30er Jahre zum ersten Mal erschien, enthielt es hauptsächlich Werbeaufnahmen, die heute im allgemeinen recht banal wirken. Der Werbefotograf hat zwar auch heute noch die Aufgabe den Verkauf von Waren und Dienstleistungen zu fördern, doch wurden seither, was die schöpferische Anwendung verbesserte Geräte und Materialien anbelangt, grosse Fortschritte erzielt. Dies bestätigen viele ausgezeichnete Aufnahmen des Londoner Fotografen Michael Joseph. Dieses Bild des Komikers Derek Nimmo wurde jedoch für das Titelblatt der Zeitschrift *Radio Times* aufgenommen.

Toen het *Photography Year Book* voor het eerst in het begin van de jaren dertig verscheen was het grotendeels gewijd aan advertentiefoto's, die heden ten dage erg banaal lijken. Terwijl de strekking van de taak van de reclamefotograaf in feite nog steeds dezelfde is, namelijk het helpen verkopen van goederen of diensten, is er erg veel vooruitgang geboekt in de creatieve toepassing van sterk verbeterde apparatuur en materialen, waarvan de Londense fotograaf Michael Joseph een aantal uitstekende voorbeelden laat zien. Deze foto van de Engelse komediespeler Derek Nimmo verscheen als voorplaat op de *Radio Times*.

En las primeras apariciones, allá por los años treinta, del *Photography Year Book*, éste estaba consagrado en su mayor parte a la fotografía publicitaria, un género que hoy en día nos parece generalmente banal. Sin embargo, aunque la razón principal de obtención de las fotografías publicitarias continúa siendo la misma, promocionar la venta de mercancias o serviciosse han llevado a cabo extraordinarios avances en lo que corresponde a la aplicación creativa de los nuevos materiales y aparatos utilizados. Los trabajos del fotógrafo londinense Michael Joseph constituyen una perfecta corroboración de lo que acabamos de decir. La instantánea del comediante Derek Nimmo que aquí reproducimos le fue encargada por la revista *Radio Times*, apareciendo en la cubierta de uno de sus números.

Lorsque le *Photography Year Book* parut pour la première fois, au début des années 1930, il était principalement consacré à la photographie publicitaire, qui semble aujourd'hui bien banale. Si le but fondamental du photographe publicitaire reste le même – à savoir, faciliter la vente de produits et de services – des progrès considérables ont été faits dans l'application créatrice d'équipements et de matériels améliorés, dont les travaux de Michael Joseph, photographe établi à Londres, fournissent tant de bons exemples. Toutefois, cette photographie du comédien Derek Nimmo a été prise dans le cadre d'un contrat pour le compte du magazine *Radio Times*.

150

Photographer	Michael Joseph
Camera	Hasselblad
Lens	120 mm
Film	Kodak Plus-X
Developer	Microdol-X
Paper	Kodalith

Model girl Tracy, from one of a series of portraits taken to check out the work of a make-up artist.

Das Mannequin Tracy. Dies ist eines von mehreren Porträts, die einen Einblick in die Kunst des Schminkens bieten.

Tracy, uit een serie portretten, gemaakt om het werk van een grimeur te kunnen beoordelen.

He aquí un retrato de la modelo Tracy que forma parte de una serie en que se recogen diversos trabajos de maquillaje de un conocido artista.

Tracy, qui exerce la profession de modèle, est ici extraite d'une série de portraits retenus pour démontrer le travail d'une maquilleuse.

151

Photographer	Michael Joseph
Camera	Hasselblad
Lens	50 mm
Film	Kodak Plus-X
Developer	Microdol-X
Paper	Kodalith

Instant nostalgia. Michael Joseph cleverly recreated the atmosphere of a Victorian photograph in this shot which was one of a series commissioned by a German carpet manufacturer. Kodalith paper gave a more graphic quality to the end result which was sepia toned to heighten the effect.

Wehmut ab sofort. In dieser Aufnahme, die einer von einem deutschen Teppichhersteller bestellten Reiche angehört, rief Michael Joseph geschickt die Atmosphäre einer viktorianischen Fotografie ins Leben. Kodalith-Papier verlieh dem Endergebnis eine mehr grafische Wirkung, und die Sepiatönung trägt ebenfalls zu dem Effekt bei.

Instant nostalgie. Michael Joseph herschiep op bekwame wijze de atmosfeer van een Victoriaanse fotografie. Dit is één opname uit een serie die hij maakte voor een Duitse fabrikant van vloerbedekking. Het Kodalith papier zorgde voor een meer grafische kwaliteit, terwijl het effect nog werd verhoogd door het geheel sepia om te kleuren.

Una instantánea nostálgica. Michael Joseph supo recrear perfectamente la atmósfera de las fotografías victorianas en este trabajo, que forma parte de una serie realizada por encargo de un fabricante de alfombras alemán. La calidad gráfica de la obra se ve enriquecida por la utilización de papel Kodalith, cuyo tono sepia confiere un mayor relieve al efecto buscado.

Nostalgie d'un instant. Michael Joseph a astucieusement recréé l'atmosphère d'une photographie victorienne sur ce cliché qui faisait partie d'une série commandée par un fabricant allemand de tapis. Le papier Kodalith a permis d'améliorer la qualité graphique de l'image finale, teintée de sépia pour renforcer l'effet.

152

Photographer	Michael Joseph
Camera	Hasselblad
Lens	40 mm
Developer	Microdol-X
Paper	Kodalith

Another advertising shot this time for a cigar company, based on the copy theme that, in the good old days, a little went a long way. 'Unfortunately', comments Joseph, 'the client didn't appreciate our interpretation so the picture never appeared.' Although there may have been marketing reasons for this, we are glad to rectify the omission.

Eine weitere Werbeaufnahme, die jedoch im Auftrage eines Zigarrenherstellers gemacht wurde. Sie unterstreicht den Text, demzufolge die Menschen in den guten alten Zeiten mit sehr wenig auskamen. 'Leider', so berichtet Joseph, 'stimmte der Kunde mit unserer Auffassung nicht überein und die Aufnahme wurde daher niemals veröffentlicht.' Obwohl es dafür gute Marketing-Gründe gegeben haben mag, berichtigen wir diese Unterlassung gern.

Nog een advertentiefoto en wel voor een sigarenfabrikant. Het thema van de campagne was 'dat men vroeger weinig nodig had om te kunnen genieten'. 'Helaas', vertelt Joseph, 'waardeerde de cliënt onze benadering niet met het gevolg dat de foto nooit is gebruikt.' Alhoewel er misschien tal van reclametechnische redenen zijn die het niet gebruiken van deze foto rechtvaardigen, zijn wij toch erg blij dit verzuim te kunnen herstellen.

Otra fotografía publicitaria, encargada en este caso por una compañía de tabaco, en la que su autor intentó poner de manifiesto la idea de que, en los viejos tiempos, la satisfacción se conseguía con poco. 'Desgraciadamente, ha dicho Joseph, al cliente no le gustó nuestra interpretación y la fotografía no llegó a utilizarse'. Respetando las razones comerciales que pudieran empujar al fabricante a tomar esta decisión, nos complace rectificar ahora la omisión.

Autre photographie publicitaire, cette fois pour une société fabriquant des cigares, basée sur l'idée que, au bon vieux temps, un peu durait longtemps. 'Malheureusement, ajoute Joseph, le client n'a pas apprécié notre interprétation, de sorte que la photographie n'a jamais vu le jour.' Bien que des raisons de commercialisation aient pu militer en faveur de cette décision, nous sommes heureux de pouvoir rectifier cette omission.

153

Photographer	Dirk Reinartz
Camera	Nikon
Lens	24 mm
Film	Kodak Tri-X

Dirk Reinartz, also an ex student of the Essen Folkwangschule, worked as a staff photographer for *Stern* Magazine for six years before joining the Visum agency. While on assignment for *Stern* he shot this in America's Monument Valley as the opening photo for a story about Red Indian medicine men.

Dirk Reinartz, ebenfalls ein ehemaliger Student der Folkwangschule in Essen, war sechs Jahre lang als Stabfotograf der Zeitschrift *Stern* tätig, bevor er in die Agentur Visum eintrat. Im Auftrage des *Sterns* nahm er dieses Bild im Monument Valley in Amerika auf. Es bildete die erste Aufnahme in einem Bericht über indianische Medizinmänner.

Dirk Reinartz, die eveneens aan de Folkwangschule in Essen heeft gestudeerd, is zes jaar als staffotograaf bij *Stern* werkzaam geweest, voordat hij bij het agentschap Visum ging werken. Een van zijn opdrachten in zijn *Stern*tijd was het maken van een reportage over medicijnmannen bij de Amerikaanse Indianen. Deze foto, gemaakt in Monument Valley, was de eerste uit deze reportage.

Dirk Reinartz, antiguo alumno también de la Folkwangschule de Essen, trabajó durante seis años como fotógrafo de plantilla de la revista *Stern*, uniéndose después a la agencia Visum. Formando parte de uno de sus reportajes para Stern (sobre los hechiceros indios en este caso) tomó esta instantánea en el Monument Valley americano.

Dirk Reinartz, lui aussi ancien étudiant de la Folkwangschule d'Essen, a travaillé comme photographe attitré pour le magazine *Stern* pendant six ans avant de s'engager à l'agence Visum. Dans le cadre d'un contrat pour *Stern*, il a pris cette photographie dans la Monument Valley aux Etats-Unis en vue de l'utiliser comme prologue à une histoire sur les sorciers indiens.

THE VARIABLE BALCAR

Balcar flashes have continuous variation of flash power. This permits you to 'dial in' the output to an exact f/stop (many 35mm cameras do not have fractional f/stops). There are two types of Balcar flashes: 'A' style - these have greater variability and control. 'Rapid' style - lighter in weight, faster recycle.

Both accept the 102u fan cooled head, or the 102xu convection cooled head.

All Balcar units have built-in sensitive photo cells, optional radio control units, and low current draw switching.

Two flash tubes are available:

104U The normal tube provided for all "A" flashes rated to 2600 w/s.

104S Short flash duration tube, to half the flash duration and permit fast recycle. Provided with Rapid flashes, and when shorter flash duration is required with A flashes.

- Flash power varies continuously 3 f/stops
- Ratio switch with three ratios
- Model lamp variator on each flash with three f/stop range, plus off position
- Bi-voltage operation 120 or 220 volts, 50 or 60 cycle operation
- Low draw switch for motor generator use
- Built-in photo cell
- 2.9 seconds at 1200 w/s
 22 lbs. weight
- 6 seconds at 2400 w/s
 25 lbs. weight

Light weight, fast recycle. Ideal for location or motor drives.
- On/off switch each light head
- Ratio switch, two ratios
- Model light ratio, full/off/half
- Continuous flash variation
 R600 - 2/3 f/stop
 R1200 - 1/f stop
 (using ratio switch you have a total of 1 and 2/3 f/stops on Rapid 600 and 2 f/stops with R1200)
- 1.2 seconds at 1200 w/s
 12 lbs. weight
- 1 second at 600 w/s
 9 lbs. weight

All Balcar units accept splitter boxes to further divide power and accept one extra flash head.

103b Bi-tube flash head permits **two** power packs into one head. Thus, two Rapid 1200 units may be used for a total of 2400 w/s every 1.2 seconds

*recycle times are nominal and depend on power supply available

154

Photographer Dirk Reinartz
Camera Nikon
Lens 180 mm
Film Kodak Tri-X

Another American face, this time observed by Reinartz in Times Square, New York. It formed part of a huge advertising sign.

Ebenfalls ein amerikanisches Gesicht, das Reinartz dieses Mal auf dem Times Square in New York einfing. Es bildete einem Teil einer riesigen Werbung.

Nog een gezicht van Amerika, dit keer door Reinartz ontdekt op Times Square in New York. Het maakte deel uit van een gigantische reclame.

Otra cara de América, captada en este caso por Reinartz en Times Square (Nueva York). Se trataba de una parte de un enorme cartel publicitario.

Autre visage américain, observé cette fois par Reinartz à Times Square, New York. Cette photographie faisait partie d'un immense panonceau publicitaire.

155

Photographer Kip Rano
Camera Nikon
Film Kodak Tri-X

Peter Ustinov in Cannes. The first of a series taken at the International Film Festival.

Peter Ustinov in Cannes. Das erste einer Reihe von Bildern, die auf dem Internationalen Film Festival aufgenommen wurden.

Peter Ustinov in Cannes. De eerste van een serie die op het internationale filmfestival aldaar werd gemaakt.

Peter Ustinov en Cannes. La primera imagen de una serie tomada en el Festival Internacional del Cine.

Peter Ustinov à Cannes. Première d'une série de photographies prises au Festival international du cinéma.

156

Photographer Kip Rano
Camera Nikon
Film Kodak Tri-X

Pele turns singer. The world famous Brazilian football star was singing the sound track of a film about his life when Kip Rano photographed him in a French Riviera recording studio.

Pele als Sänger. Der weltberühmte brasilianische Fussballer wurde von Kip Rano in einem Tonaufnahmestudie auf der französischen Riviera fotografiert, während er gerade ein Lied sang. Die Tonaufnahme wurde für einen Film über sein Leben benötigt.

Pele als zanger. De wereldberoemde Braziliaanse voetballer werd door Kip Rano gefotografeerd terwijl hij in een geluidsstudio aan de Franse Rivièra bezig was opnamen te maken voor een film over zijn leven.

Pelé se convierte en cantante. Kip Rano fotografió al famosísimo futbolista brasileño mientras grababa en un estudio de la Riviera francesa una canción incluída en la banda sonora de una película sobre su vida.

Pele devient chanteur. Le célèbre champion du monde brésilien de football chantait dans un film tourné sur sa vie lorsque Kip Rano l'a photographié dans un studio d'enregistrement de la Riviera française.

157

Photographer Kip Rano
Camera Nikon
Film Kodak Tri-X

Freelance photographer Rano noted and made good use of the symbolic backdrop when he pictured film producer Carlo Ponti at a Cannes press conference.

Der freiberufliche Fotograf Rano machte von dem symbolischen Hintergrund guten Gebrauch, als er den Filmregisseur Carlo Ponti auf einer Pressekonferenz in Cannes aufnahm.

De free-lance fotograaf Rano maakte prachtig gebruik van de symbolische achtergrond toen hij een plaat schoot van de filmproducent Carlo Ponti tijdens een persconferentie in Cannes.

Al tomar esta fotografía, en la que vemos al productor cinematográfico Carlo Ponti en el curso de una conferencia de prensa celebrada en Cannes, Reno se sirvió con gran inteligencia del simbólico telón que aparece en la misma.

Rano, photographe indépendant, a noté et fait bon usage de cette toile de fond symbolique lorsqu'il a photographié le producteur de cinéma Carlo Ponti au cours d'une conférence de presse à Cannes.

158

Photographer David Redfern
Camera Olympus OM-2
Lens 135 mm Zuiko
Film Ilford HP5 (rated 1000 ASA)
Shutter Speed 1/250
Aperture f/2.8
Developer Microphen
Paper Ilfospeed

An emotional moment for singer Shirley Bassey at the close of the first concert of what she announced as her last tour. David Redfern was at the Brighton Conference Centre to record the scene and comments that Shirley is one of the two best selling artistes in his comprehensive picture library of popular musicians. The other one is, incidentally, the late Louis Armstrong.

Die Sängerin Shirly Bassey erlebt am Ende des ersten Konzertes ihrer angeblich letzten Tournee einen gefühlvollen Augenblick. David Redfern, der die Szene im Brighton Conference Centre aufnahm, berichtet, daß Shirley einer der beiden beliebtesten Musiker in seiner umfassenden Sammlung sei. Der andere ist übrigens der verstorbene Louis Armstrong.

Een emotioneel ogenblik voor zangeres Shirley Bassey aan het einde van het eerste concert van een serie die, zo zei ze, haar laatste zou zijn. David Redfern was in het Brighton Conference Centre om het een en ander vast te leggen. Shirley Bassey en Louis Armstrong zijn, waar het betreft de foto's in zijn uitgebreide archief, de twee populairste musici.

Un momento de gran emoción para Shirley Bassey fue la culminación de su primera actuación en la que anunció sería la última de sus giras. David Redfern se encontraba en el Brighton Conference Centre y tuvo oportunidad de captar fielmente la escena, y nos ha comentado que Shirley es una de los dos cantantes más populares entre los que ha ido incluyendo en su colección de fotografías de artistas actuales. El otro es Louis Armstrong.

Moment d'émotion pour la chanteuse Shirley Bassey à l'issue du premier concert de ce qu'elle a annoncé comme devant être son dernier tour de chant. David Redfern était au Conference Centre de Brighton pour fixer cette scène; il précise que, parmi les personnages dont la photographie figure dans son extraordinaire photothèque de musiciens populaires, Shirley est l'une des deux artistes dont les photos se vendent le mieux. L'autre, par parenthèse, est le regretté Louis Armstrong.

159

Photographer David Redfern
Camera Hasselblad 500 CM
Lens 150 mm Sonnar
Film Ilford FP4
Shutter Speed 1/125
Aperture f/4
Developer Microphen
Paper Ilfospeed

Jazz maestro Oscar Petersen relaxing in David Redfern's London studio. Redfern tries to persuade every visiting popular music notable to pose for a picture to add to his library and his old acquaintance Petersen was happy to oblige – with this pleasantly informal result.

Jazz-Maestro Oscar Petersen entspannt sich hier in David Redferns Londoner Studio. Redfern überredet jeden beliebten Musiker von Ruf dazu, sich von ihm für seine Sammlung aufnehmen zu lassen. Sein alter Freund Petersen leistete ihm gern diesen Gefallen – und hier sehen Sie das ansprechend zwanglose Ergebnis.

De bekende jazzpianist Oscar Peterson ontspannen in David Redferns Londense studio. Redfern probeert iedere bekende populaire musicus over te halen voor hem te poseren, teneinde zijn archief up to date te houden. Zijn oude vriend Peterson was maar al te graag bereid aan dit verzoek te voldoen, hetgeen resulteerde in deze plezierige, informele foto.

El gran maestro del jazz Oscar Petersen descansando en el estudio londinense de David Redfern. Este fotógrafo trata siempre de convencer a los artistas que le visitan de que posen para él y su viejo amigo Petersen no podía lógicamente negarse. El resultado fue esta escena agradablemente distendida.

Le maître du jazz Oscar Petersen au repos dans le studio de David Redfern à Londres. Redfern s'efforce de persuader tous les grands représentants de la musique populaire qui lui rendent visite de poser pour une photographie afin d'enrichir sa collection, et son vieil ami Petersen s'est fait un plaisir de l'obliger – avec ce résultat d'un naturel exquis.

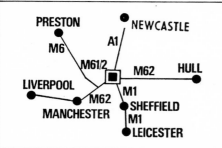
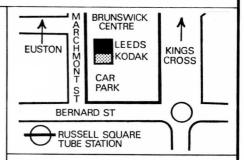

160/163

Photographer	Raymond De Berquelle
Camera	Asahi Pentax Spotmatic
Lens	28 mm Takumar
Film	Ilford FP4
Shutter Speed	1/125
Aperture	f/8
Developer	Microphen
Paper	Ilfobrom

Conversation in a Mykonos lane. The Greek islands are a mecca for pictorialists but in this sequence the Australian based photographer proves that the inhabitants provide equally good subjects.

Unterhaltung in einer Gasse in Mykonos. Die griechischen Inseln sind ein Mekka der Anhänger bildmässiger Fotografie, doch in dieser Reihe erweist der australische Fotograf, dass die Einwohner ebenso gute Aufnahmen ergeben.

Gesprek op straat op Mykonos. De Griekse eilanden vormen een mekka voor de liefhebbers van mooie plaatjes, maar in deze serie toont de gewoonlijk in Australië werkende fotograaf dat de eilandbewoners minstens net zo fotogeniek zijn.

Conversación en un callejón de Mikonos. Las islas griegas constituyen una meca para los fotógrafos interesados en obtener imágenes de gran belleza artística. En esta secuencia, sin embargo, nuestro artista, que reside actualmente en Australia, nos proporciona una prueba de que sus habitantes se pueden erigir también en modelos perfectos.

Conversation dans une avenue de Mykonos. Les îles grecques sont une Mecque pour les pictorialistes, mais, dans cette séquence, le photographe, originaire d'Australie, démontre que les habitants peuvent constituer des sujets non moins intéressants.

164

Photographer	Hartmut Rekort
Camera	Asahi Pentax
Lens	85 mm SMC Takumar
Film	Kodak Plus-X Pan
Shutter Speed	1/250
Aperture	f/11
Developer	Microdol-X
Paper	Agfa Brovira

Alma-Ata USSR. Sports action is 'covered' by a warlike young spectator as well as by the German photojournalist.

Alma-Ata Sowjetunion. Das sportliche Ereignis wird nicht nur von dem deutschen Foto-Journalisten sondern auch von einem kriegerischen jungen Zuschauer 'erfasst'.

Alma-Ata in de Sovjet-Unie. Een sportwedstrijd wordt behalve door een nogal militante jonge bezoeker ook door de Duitse persfotograaf verslagen.

Alma-Ata, URRS. El espectáculo deportivo es seguido con gran apasionamiento por el joven y belicoso espectador y el fotógrafo de prensa alemán.

Alma-Ata, URSS. Cette action sportive est 'saisie' tant par ce jeune spectateur à l'allure de guerrier que par le journaliste photographe allemand.

165

Photographer	Hartmut Rekort
Camera	Asahi Pentax
Lens	50 mm SMC Takumar
Film	Kodak Plus-X Pan
Shutter Speed	1/125
Aperture	f/4
Developer	Microdol-X
Paper	Agfa Brovira

A bust of Soviet space pioneer Gagarin dominates this picture taken in a Moscow museum during Rekort's Russian assignment.

Eine Büste des sowjetischen Raumfahrtpioniers Gagarin beherrscht dieses Bild, das Rekort für ein russisches Projekt in einem Moskauer Museum aufnahm.

Een borstbeeld van de eerste Russische ruimtevaarder Gagarin domineert deze foto, genomen in een museum in Moskou tijdens Rekorts verblijf in de Sovjet-Unie.

El busto del héroe espacial Gagarin domina esta instantánea, tomada por Rekort durante un viaje profesional por la Unión Soviética.

Un buste de Gagarine, le pionnier soviétique de l'espace, domine cette photographie prise à Moscou, dans un musée, au cours d'une tournée photographique de Rekort en Union soviétique.

166

Photographer	Baron Baron
Camera	Hasselblad 500 CM
Lens	30 mm Fisheye
Film	Ilford FP4
Shutter Speed	1/125
Aperture	f/5.6
Developer	Microphen
Paper	Kentmere

Two interesting examples of humour in photography based on deliberate distortion with an ultra wide angle lens. During a procession in Manchester, 'The Baron' (as the photographer is known in his main occupation as a broadcaster) saw the picture possibilities in the teeth of this horse. But the animal nearly got to the camera first.

Zwei interessante Beispiele für Humor in der Fotografie wurden durch absichtliche Verzerrung mit Hilfe eines Ultraweitwinkelobjektivs erzielt. Während einer Prozession in Manchester erkannte der 'Baron' (wie der Fotograf in seinem Hauptberuf als Rundfunk-Persönlichkeit bekannt ist) das Künstlerische Potential der Zähne dieses Pferdes. Beinahe hätte das Tier aber die Kamera aber zuerst fertiggemacht.

Twee interessante voorbeelden van humor in de fotografie, gebaseerd op een opzettelijke vertekening door middel van een ultragroothoeklens. Tijdens een optocht in Manchester zag de 'Baron' (zoals deze fotograaf bij zijn luisteraars – hij is radiopresentator – bekend staat) in de tanden van dit paard een mogelijkheid om tot een fraaie plaat te komen, maar bijna was het paard hem voor geweest.

Dos interesantes muestras de fotografía humorística basadas en el efecto de distorsión obtenido con un objetivo de gran angular. Durante un desfile celebrado en Manchester, El 'Barón' (es así como se conoce en el mundo radiofónico, al que pertenece profesionalmente, a nuestro fotógrafo) vio claramente las posibilidades artísticas que ofrecía la captación de los dientes del caballo. A punto estuvo sin embargo el animal, de hacerse con la cámara.

Deux exemples intéressants de l'humour en photographie résultant de la distorsion délibérée obtenue au moyen d'un angulaire ultra-grand. Au cours d'un défilé à Manchester, 'The Baron' (pseudonyme sous lequel le photographe est connu dans l'exercice de son activité principale d'animateur de radio) a vu les possibilités d'une belle photographie dans les dents de ce cheval. Mais l'animal a bien failli arriver le premier à l'appareil.

167

Photographer	Baron Baron
Camera	Olympus OM-1
Lens	24 mm Tamron
Film	Ilford FP4
Shutter Speed	1/125
Aperture	f/8
Developer	Microphen
Paper	Kentmere

Another amusing wide angle composition, taken during the Manchester procession. An enthusiastic 'non professional' photographer, Baron began his career as a disc jockey with Radio Luxembourg then moved to the BBC where he has had his own series both on the local BBC Radio Manchester and on the National Radio One wavelength. He is also the 'voice over' on many well known Commercials.

Eine weitere amüsante Weitwinkel-Komposition, die fast wie eine Karikatur wirkt und ebenfalls während der Prozession in Manchester aufgenommen wurde. Als begeisterter 'nichtberuflicher' Fotograf begann Baron seine Laufbahn als Disk-Jockey bei Radio Luxemburg und trat dann in den Dienst der BBC, in der er eine eigene Serie hatte. Diese wurde sowohl von dem örtlichen BBC-Sender Radio Manchester und über das Landesnetz ausgestrahlt. In vielen bekannten Rundfunkwerbungen ist er auch der 'Off-Sprecher'.

Nog een amusante compositie met behulp van de groothoeklens, grenzend aan de karikatuur, eveneens gemaakt tijdens de optocht in Manchester. De 'Baron' is een enthousiast amateurfotograaf, die zijn carrière als disc-jockey bij Radio Luxemburg begon en later naar de BBC verhuisde (BBC Radio Manchester en BBC One). Tevens is hij de 'stem' in vele reclamespots in Engeland.

Otra instantánea humorística tomada también durante el desfile de Manchester con un objetivo de gran angular. Entusiásticamente aficionado a la fotografía, Baron empezó su carrera como disc-jockey en Radio Luxemburgo, pasando más adelante a la BBC, donde ha realizado sus propios programas, tanto en la emisora de Manchester como en la cadena principal (Radio One). Ha prestado también su voz en numerosos anuncios comerciales.

Autre composition amusante, à la limite de la caricature, également prise, avec un grand angulaire, au cours du défilé de Manchester. Photographe 'non professionnel' enthousiaste, 'The Baron' a commencé sa carrière comme animateur de programmes de disques à Radio Luxembourg, puis il est passé à la BBC où il avait sa propre série tant sur les antennes locales de Radio Manchester qu'à la national Radio One. Il est également le commentateur de nombreuses émissions publicitaires à la télévision.

168/169

Photographer	Jose Torregrosa

Two examples of straight reportage by Pamplona photographer Torregrosa, who combines great visual awareness with complete mastery of technique.

Zwei Beispiele unmittelbarer Reportage von dem in Pamplona wohnhaften Fotografen Torregossa, der grosses visuelles Einfühlungsvermögen mit vollkommener Beherrschung fotografischer Verfahren verbindet.

Twee voorbeelden van pure reportagefotografie van deze fotograaf uit Pamplona, die een groot visueel bewustzijn koppelt aan een volledige beheersing van de techniek.

Dos ejemplos de fotografía de reportaje, obtenidos por José Torregrosa, un artista que combina su perfecto sentido visual con un completo dominio técnico.

Deux exemples de reportage sur le vif par Torregrosa, le photographe originaire de Pampelune, qui allie un remarquable coup d'oeil à une maîtrise totale de la technique.

170

Photographer	S. Paul
Camera	Nikon F.
Lens	80-200 mm Zoom
Film	Orwo NP-7
Shutter Speed	1/125
Aperture	f/5.6
Developer	D76
Paper	Indian made Agfa

Leading Indian photographer S. Paul calls this picture 'White bucks at their fullest speed' and panned his camera with the action.

Der führende indische Fotograf S. Paul, der dieses Bild 'White bucks at their fullest speed' benannte, verfolgte die Aktion mit seiner Kamera.

De vooraanstaande Indische fotograaf S. Paul noemt deze foto 'Witte reebokken op topsnelheid' en trok zijn camera met de dieren mee.

El conocido fotógrafo hindú S. Paul tituló esta instantánea 'Gamos blancos corriendo a gran velocidad'. En su captación utilizó la técnica panorámica.

S. Paul, l'un des grands photographes indiens, intitule cette photographie 'Daims blancs en plein effort', et fit un panorama de l'action.

171

Photographer	S. Paul
Camera	Nikkormat El
Lens	35 mm Nikkor
Film	Kodachrome 64
Shutter Speed	1/15
Aperture	f/8

'During a downpour which lasted for two days I followed this group at the Kumbh fair at Allahabad', writes the much published Delhi Photojournalist. A slow shutter speed helped make this delightful result.

'Bei zweitägigem intensivem Regen folgte ich dieser Gruppe auf der Kumbh Fair in Allahabad', schreibt der in Delhi tätige Foto-Journalist, von dem viele Fotografien veröffentlicht wurden. Die neidrige Verschlussgeschwindigkeit trug zu diesem entzückenden Ergebnis bei.

'Tijdens een twee dagen durende regenbui volgde ik deze groep op de Kumbh-jaarmarkt in Allahabad', is de informatie die deze bekende fotograaf uit New Delhi ons geeft. Een lange sluitertijd zorgde mede voor dit verrukkelijke beeld.

'Seguí a este grupo por la feria Kumbh de Allahabad bajo un fuerte chaparrón que duró dos días', escribe el conocido repórter de Delhi. Para obtener este delicioso resultado se sirvió de una velocidad de obturación muy baja.

'Durant une pluie torrentielle, qui dura deux jours, j'ai suivi ce groupe à la foire de Kumbh à Allahabad', écrit le journaliste photographe, très connu, de Delhi. Une faible vitesse d'obturation a permis d'obtenir ce charmant résultat.

172/175

Photographer	Jose Torregrosa

People and road vehicles, from a series of sepia impressions by the Spanish photographer whose work has been exhibited and published in Spain with notable success.

Leute und Fahrzeuge. Dieses Bild gehört einer Reihe von in Sepia ausgeführten Studien des spanischen Fotografen an, dessen Bilder in seiner Heimat mit erheblichem Erfolg ausgestellt und verlegt werden.

Mensen en vervoermiddelen, uit een serie van sepia-impressies gemaakt door de Spaanse fotograaf, wiens werk in Spanje met bijzonder veel succes wordt tentoongesteld en gepubliceerd.

He aquí una serie de impresiones en papel sepia en las que vemos a un amasijo de gente y vehículos, realizadas por el conocido fotógrafo español cuyas exposiciones han sido siempre recibidas con gran éxito en su país.

Des gens et des véhicules routiers, pris à partir d'une série d'impressions sur sépia par le photographe espagnol dont les travaux ont été exposés et publiés en Espagne avec un succès notable.

176

Photographer	Tony Boxall
Camera	Mamiya C330
Lens	65 mm
Film	Agfacolor CT18
Shutter Speed	1/125
Aperture	f/5.6

Tony Boxall is an amateur photographer with a list of publication successes that would be the envy of most professionals. Winner of many contests organised by the UK Photo Press he always carries a camera and is ever alert to any picture possibility. He found this one amid the arches of the Ouse Viaduct, Balcombe.

So viele Aufnahmen des Amateurfotografen Tony Boxall wurden veröffentlicht, dass die meisten Berufsfotografen Grund hätten ihn darum zu beneiden. Der Sieger in vielen von der UK Photo Press veranstalteten Wettbewerben trägt er stets eine Kamera und lässt sich die Gelegenheit zu einer guten Aufnahme nicht ohne weiteres entgehen. Dieses Bild nahm er unter den Bögen des Ouse Viaduct in Balcombe auf.

Tony Boxall is een amateurfotograaf met een lijst van gepubliceerd werk waar de meeste vakfotografen jaloers op zouden worden. Hij heeft veel wedstrijden, georganiseerd door de Britse fotopers, gewonnen, heeft altijd een camera bij zich en is altijd bedacht op mogelijkheden die zich kunnen voordoen. Deze vond hij te midden van de bogen van het Ouseviaduct bij Balcombe.

Tony Boxall es un fotógrafo aficionado cuyas producciones, aparecidas en numerosas publicaciones, no tienen nada que envidiar a las de muchos artistas profesionales. Ganador de varios de los certámenes organizados por la Asociación de la Prensa Gráfica inglesa, acostumbra a llevar siempre una cámara con él y permanece totalmente alerta a la posibilidad de sacar una buena foto. En este caso, aquélla se la presentó entre las arcadas del viaducto Ouse en Balcombe.

Tony Boxall est un photographe amateur dont les succès remportés dans diverses publications constituent un ensemble qui ferait l'envie de la plupart des professionnels. Lauréat de nombreux concours organisés par UK Photo Press, il ne se sépare jamais de son appareil, et est toujours en quête d'un sujet à photographier. Il a découvert celui-ci entre les arches du viaduc de l'Ouse, à Balcombe.

177

Photographer	Tony Boxall
Camera	Mamiya C330
Lens	135 mm
Film	Agfacolor CT18
Shutter Speed	1/125
Aperture	f/8

'The Unhappy Choir'. A local Jubilee fete provided Boxall with an eminently saleable picture. Most of his work is of a cheerful or humorous nature but supported by meticulous technique and a very efficient filing system. A Fellow of the Royal Photographic Society he is a popular lecturer and also associated with the London based Bureau of Freelance Photographers.

'Der unglückliche Chor'. Boxall erzielte diese für den Verkauf besonders geeignete Aufnahme während einer örtlichen Jubiläumsfeier. Die meisten seiner Bilder, die in einer sehr zuverlässigen Datei registriert sind, sind lustig oder humorvoll und in technischer Hinsicht hervorragend. Ein Vollmitglied der Royal Photographic Society ist er ein beliebter Vortragender. Gelegentlich arbeitet er auch für das Londoner Bureau of Freeland Photographers.

'Het ongelukkige zangkoor'. Dit Royal Jubilee feest maakte dat Boxall dit uitstekend verkoopbare plaatje kon maken. Zijn werk ademt meestal een opgewekte of grappige sfeer maar wordt altijd ondersteund door een nauwgezette techniek en een erg efficiënt opbergsysteem. Hij is lid van de Royal Photographic Society en zijn lezingen worden altijd goed bezocht. Tevens is hij verbonden aan het Londense bureau voor free-lance fotografen.

'El coro infeliz'. Esta fiesta de aniversario proporcionó a Boxall la oportunidad de obtener una foto extraordinariamente comercial. La mayor parte de las obras de este fotógrafo reflejan una envidiable alegría y buen humor, así como una meticulosa utilización de sus recursos técnicos. Es miembro de la Royal Photographic Society y su nombre se ha popularizado a través de sus numerosas conferencias. Forma parte también de la rama londinense de la Asociación de fotógrafos autónomos.

'Le choeur malheureux'. Une fête locale pendant l'année du Jubilé 1977 a fourni à Boxall l'occasion de cette photographie à succès. La plupart de ses travaux sont empreints de gaieté et d'humour, mais soutenus par une technique méticuleuse et par un système d'archivage très efficace. Fellow de la Royal Photographic Society, c'est en outre un conférencier connu, qui travaille en association avec le Bureau of Freelance Photographers (Bureau des photographes indépendants), établi à Londres.

178

Photographer	Timothy Harvey
Camera	Nikon F
Lens	85 mm
Film	Kodachrome 64
Shutter Speed	1/60
Aperture	f/8

'House in Landscape'. London photographer Harvey is fascinated by unusual architecture so these painted walls he found in Paris were immediately added to his collection of architectural colour slides.

'Haus in Landschaft'. Der Londoner Fotograf Harvey findet ungewöhnliche Bauwerke faszinierend. Er reihte dieses Bild bemalter Mauern, die er in Paris entdeckte, daher unverzüglich in seine Sammlung architektonischer Farbdias ein.

'Huis in landschap'. De Londense fotograaf Harvey wordt gefascineerd door ongebruikelijke architectuur, dus deze beschilderde muren in Parijs werden direct toegevoegd aan zijn reeds uitgebreide collectie kleurendia's.

'Casa en un paisaje'. El fotógrafo londinense T. Harvey experimenta una especial fascinación por las construcciones arquitectónicas poco usuales, por lo que añadió rápidamente a su colección de diapositivas a color – estos muros pintados con los que se encontró en París.

'Maison dans un paysage'. Le photographe londonien Harvey est un fanatique de l'architecture insolite; c'est pourquoi ces murs peints, qu'il a découverts à Paris, ont été immédiatement ajoutés à sa collection de diapositives en couleur sur l'architecture.

179

Photographer	Geri Della Rocca De Candal

Milan photographer Candal found his painted wall at Lafayette Street and Astor Plaza in New York.

Der Mailänder Fotograf Candal fand diese bemalte Mauer in New York an der Kreuzung zwischen Lafayette Street und Astor Plaza.

De Milanese fotograaf Candal vond deze muurschilderingen op Lafayette Street en Astor Plaza in New York.

El fotógrafo milanés Candal captó esta pared en la esquina entre Lafayette Street y Astor Plaza, en Nueva York.

Le photographe milanais Candal a découvert son mur peint dans Lafayette Street et à Astor Plaza, à New York.

180

Photographer	James Elliott

Unlike the authors of the preceding plates, James Elliott creates his own designs with the actual photography the final stage in a process which may have taken him hundreds of working hours before the release of his camera shutter. 'The Blue Bars' has attracted much praise and was included in an important exhibition of his art held at the Asahi Pentax Gallery in London.

Zum Unterschied von den auf den vorhergehenden Seiten vertretenen Künstlern schafft James Elliott durch die Fotografie selbst eigene Effekte. Oft gehen dem eigentlichen Druck auf den Knopf der Kamera hunderte Arbeitsstunden der Vorbereitung voraus. 'The Blue Bars' wurde sehr gelobt und war eines der Bilder in einer in der Asahi Pentax Gallery in London abgehaltenen wichtigen Ausstellung seiner Werke.

In tegenstelling met de vorige fotografen creëert James Elliott zelf zijn eigen onderwerpen. Het fotograferen vormt dan slechts het laatste onderdeel van het proces, waar dan vaak al vele honderden uren werk in zijn gaan zitten voordat de sluiter in werking wordt gesteld. Deze foto, 'Blauwe strepen', heeft veel lof geoogst en was te zien op een belangrijke fototentoonstelling in de Asahi Pentax Gallery in Londen.

A diferencia de los artistas cuyas obras acabamos de ver, el fotógrafo James Elliott no procede a disparar su cámara hasta después de haber llevado a cabo un minucioso proceso de preparación que abarca a menudo cientos de agotadoras horas de trabajo. Esta obra titulada 'Las Barras azules', incluída en una importante exposición de sus producciones presentada en la Asahi Pentax Gallery de Londres, le valió numerosos elogios.

Contrairement aux auteurs des images précédentes, James Elliott crée ses propres modèles avec la photographie ellemême, le stade final d'un processus qui lui a peut-être pris des centaines d'heures de travail avant de déclencher l'obturateur de son appareil. 'Les barres bleues' est une photographie qui a recueilli de nombreux compliments et qui a figuré dans une importante exposition de son art, tenue à la Asahi Pentax Gallery de Londres.

181

Photographer	John Chard
Camera	Nikon F2
Lens	Tamron Nestar with 2X converter and red filter
Film	Kodachrome 64
Shutter Speed	1/250
Aperture	f/16

Sunset rider. John Chard teaches photography at the Somerset Collage of Arts and Technology and produces as much freelance work as his teaching time allows. This beautiful composition is a good example of his coverage of rural life in England and has already been sold for a poster and for a calendar in Japan. He is currently completing a book of photographs about South West Cornwall.

Reiter im Abendsonnenschein. John Chard unterrichtet Fotografie am Somerset College of Arts and Technology und ist, wenn er die Zeit dazu findet, auch noch freiberuflich tätig. Diese schöne Komposition ist ein gutes Beispiel für seine Behandlung des ländlichen Lebens in England. Sie wurde bereits zur Anfertigung eines Plakats und eines Kalenders in Japan verkauft. Zur Zeit vollendet er ein Buch mit Fotografien aus dem Südwesten von Cornwall.

Ruiter tijdens zonsondergang. John Chard doceert fotografie aan het Sommerset College of Arts and Technology en maakt zoveel free-lance werk zijn vrije tijd toelaat. Deze prachtige compositie geeft een goed voorbeeld van zijn wijze van verslaan van het Engelse landleven en wordt in Japan reeds gebruikt voor een affiche en een kalender. Op het ogenblik is Chard bezig met een fotoboek over Zuidwest-Cornwall.

Jinete en el crepúsculo. John Chard es profesor de fotografía en el Somerset College of Arts and Technology, realizando sus obras creativas en las horas que le deja libre su trabajo educativo. Esta hermosa composición constituye un perfecto ejemplo de su extraordinaria habilidad para captar la vida rural inglesa, habiendo sido adquirida para ser convertida en un poster y figurar en un calendario japonés. En la actualidad Chard está a punto de completar un libro de fotografías sobre South West Cornwall.

Cavalier au coucher du soleil. John Chard enseigne la photographie au College of Arts and Technology du Somerset et travaille en indépendant dans toute la mesure où ses loisirs le lui permettent. Cette remarquable composition, qui est un bon exemple de ses photographies de la vie rurale en Angleterre, a déjà été vendue pour une affiche et pour un calendrier au Japon. Il achève actuellement un album de photographies sur le sud-ouest de la province de Cornouailles.

182/183

Photographer	Jacques Bourboulon

At the time of going to press no details were available about these agency girl studies by French photographer Bourboulon. But we decided to include them as highly professional examples of a popular – but difficult – genre.

Zur Zeit der Drucklegung standen hinsichtlich dieser für eine Agentur gefertigten Mädchenstudien des französischen Fotografen Bourboulon keinerlei Einzelheiten zur Verfügung. Wir beschlossen jedoch, sie als beruflich hochwertige Beispiele eines beliebten aber schwierigen Genres aufzunehmen.

Bij het drukken van dit boek waren wij niet in het bezit van de technische gegevens betreffende deze opnamen dié ons door een Frans agentschap werden toegezonden. Maar wij hebben toch besloten deze op te nemen omdat het een zeer professioneel voorbeeld is in dit populaire – maar moeilijke – genre.

En el momento de imprimir este libro no conocíamos ningún detalle acerca de los estudios femeninos realizados por el fotógrafo francés Bourboulon. Decidimos, sin embargo, incluirlos en nuestro libro como muestras de un género popular pero difícil.

Au moment où nous mettons sous presse, nous ne disposons d'aucun détail sur ces études de modèles dues au photographe français Bourboulon. Nous avons néanmoins décidé de les inclure, en tant qu'elles constituent des exemples hautement professionnels d'un genre populaire mais difficile.

184

Photographer	Tsang Chi-Yen
Camera	Minolta SRT 101
Lens	100 mm Rokkor
Film	Kodak
Shutter Speed	1/125
Aperture	f/8
Paper	Kodak

'Happy Song'. Another offering from Taiwan in which people, colour and movement come together in attractive harmony.

'Glücklicher Gesang'. Ein weiteres Bild aus Taiwan, in dem Menschen, Farben und Bewegungen eine ansprechende Harmonie bilden.

'Blij gezang'. Nog een opname uit T'ai-wan waarin mensen, kleur en beweging samen een aantrekkelijk harmonisch beeld vormen.

'Canción de felicidad'. Otra instantánea procedente de Taiwán, en la que se hallan combinados perfectamente el colorido, la gente y la acción.

'Heureuse chanson'. Autre contribution originaire de Taïwan, dans laquelle les gens, la couleur et le mouvement sont réunis en une séduisante harmonie.

185/186

Photographer	Tsang Chi-Yen
Camera	Minolta SRT 101
Lens	16 mm Rokkor
Film	Kodak
Shutter Speed	1/125
Aperture	f/11

'Dragon Dance'. More traditional pageantry on Taiwan skillfully recorded by Tsang Chi-Yen. The facing monochrome plate is from a series, 'Chorus', taken in a Taiwan School by the same photographer.

'Trachtentanz'. Weitere traditionelle Riten aus Taiwan, die von Tsang Chi-Yen mit viel Geschick erfasst wurden. Das monochrome Bild gehört der Reihe 'Chorus' an, die dieser Fotograf in einer Schule in Taiwan aufgenommen hat.

'Drakendans'. Een traditioneel volksfeest op T'ai-wan vakkundig vastgelegd door Tsang Chi-Yen. De monochrome opname hiernaast komt uit een serie 'Koor', gemaakt door dezelfde fotograaf in een school op T'ai-wan.

'La danza del dragón'. Otra muestra del boato de las celebraciones tradicionales de Taiwán, captado magistralmente por Tsang Chi-Yen. La instantánea monocroma opuesta forma parte de una serie, 'Coro', realizada en una escuela de su país por este misma fotógrafo.

'Danse du dragon'. Autre manifestation traditionnelle originaire de Taïwan, enregistrée d'une main habile par Tsang Chi-Yen. Cette photographie monochrome est extraite d'une série intitulée 'Chorus', réalisée dans une école de Taïwan par le même photographe.

187/189

Photographer	Tony Boxall
Camera	Mamiya C330
Lenses	135 and 80 mm
Film	Kodak Tri-X

A further selection of pictures, this time in monochrome, by award winning amateur photographer Tony Boxall (see plates 176/177). 'Ma's Landing'. taken in a local sandpit, has sold very successfully as a piece of offbeat photographic comedy while 'Woman of Volendam' and 'Members of the Radha Krishna temple sect in Paris' are good examples of Boxall's eye for a picture while in foreign locations.

Eine weitere Auswahl von Bildern, diesmal in Schwarz und Weiss, von dem preisgekrönten Amateurfotografen Tony Boxall (siehe Tafeln 176/177). 'Die Landung', das in einer örtlichen Sandgrube aufgenommen wurde, war als ein Beispiel ungewöhnlicher Fotokomik sehr erfolgreich, während 'Frau aus Volendam' und 'Mitglieder der Radha Krishna Tempelsekte in Paris' beweisen, welch markante Bilder Boxall in fremden Ländern erzielt.

Nog een selectie foto's, dit keer in zwartwit, van de bekende amateurfotograaf Tony Boxall (zie tevens afbeeldingen 176/177). 'Moeders landing', gemaakt in een plaatselijke zandafgraving, is erg goed verkocht omdat het weer een totaal andere dimensie aan fotografische humor geeft, terwijl 'Volendamse vrouw' en 'Leden van de Radha Krishna tempel sekte in Parijs' duidelijk laten zien dat Boxall ook in het buitenland een gelegenheid tot het maken van de juiste foto weet te benutten.

Una nueva selección de fotografías, en este caso monocromas, del conocido fotógrafo aficionado Tony Boxall (ver también las 176/177). 'El aterrizaje de la mamá', tomada en un arenal inglés, se ha vendido muy bien a causa de su complicidad poco habitual, mientras que 'La mujer de Volendam' y 'Miembros parisinos de la secta Radha Krishna' constituyen dos buenas muestras de la habilidad de Boxall para captar las posibilidades de una imagen en el curso de sus viajes.

Autre sélection de photographies, cette fois en monochrome, par Tony Boxall, photographe amateur lauréat de divers prix (voir les clichés 176/177). 'Atterrissage de Grand-mère', pris dans une sablière locale, s'est remarquablement bien vendu en tant qu'exemple de comédie photographique non orthodoxe, tandis que 'Femme de Volendam' et 'Membres de la secte du temple de Radha Krishna à Paris' constituent de bons exemples de l'art qu'a Boxall de découvrir des sujets de photographie à l'étranger.

190/192

Photographer	Valdis Brauns

We are always pleasantly surprised by the compositional impact of pictures sent to us from the Baltic states and this year present a set from Latvia U.S.S.R. The name of the photographer is new to us and he has only supplied titles, not captions or technical data. In order of appearance these are: 'Memories', 'Rain of Happiness', and, on the final spread, 'Sailor's Bride'.

Wir sind von der durch die Komposition bedingten Wirkung von Bildern aus den Baltischen Staaten stets angenehm überrascht und bringen dieses Jahr eine Serie aus Lettland, Sowjetunion. Der Name des Fotografen ist uns neu, und er hat uns nur Titel aber keine Bildunterschriften oder technischen Daten übermittelt. Der Reihe nach lauten die Titel 'Erinnerungen', 'Regen des Glücks' and 'Matrosenbraut'.

Wij zijn altijd blij verrast als ons goede foto's uit de Baltische staten bereiken. Dit jaar ontvingen wij een aantal indrukwekkende composities uit de Sovjetrepubliek Letland. De naam van de fotograaf is nieuw voor ons en hij leverde geen technische bijzonderheden bij zijn foto's, alleen maar titels. Deze zijn respectievelijk: 'Herinneringen', 'Gelukzalige regen' en op de dubbele bladzijden 'Zeemansbruid'.

Siempre constituye para nosotros una sorpresa agradable el impacto composicional que suelen poseer las fotografías que se nos envía desde los estados bálticos. Este año incluímos en nuestro libro una selección recibida de Letonia. El nombre del fotógrafo resulta completamente nuevo para nosotros y éste sólo nos ha proporcionado los títulos de las instantáneas, sin comentarios ni detalles técnicos, Por ordeu de aparición las fotografías se titulan: 'Recuerdos', 'Lluvia de felicidad' y 'La novia del marino'.

Nous sommes toujours agréablement surpris par la puissance de la composition des clichés qui nous parviennent des Etats baltes, et, cette année, nous présentons une série de photographies prises en Latvie, URSS. Le photographe, dont le nom est nouveau pour nous, n'a fourni que des titres, mais ni légendes ni caractéristiques techniques. Dans l'ordre d'apparition, il s'agit de: 'Souvenirs', 'Pluie de bonheur' et, sur la dernière double page, 'Fiancée de marin'.

193

Photographer	Denis Thorpe
Camera	Leica M2
Lens	35 mm
Film	Ilford FP4
Shutter Speed	1/60
Aperture	f/2
Developer	Microphen
Paper	Ilfospeed

Superb coverage from India by award winning Guardian photojournalist Thorpe. From his Calcutta portfolio are these macabre portraits of unclaimed dead on display at Sealdah Station.

Ein hervorragender Beitrag aus Indien von dem preisgekrönten Foto-Journalisten Thorpe, der für die Zeitung *Guardian* tätig ist. Diese makabren Porträts unbekannter Toter, die auf dem Bahnhof Sealdah zu sehen sind, gehören seiner Kalkutta-Sammlung an.

Een grootse reportagefoto uit India van de prijzen winnende fotojournalist van de *Guardian* Denis Thorpe. Deze macabere portretten van doden die niet door familieleden worden weggehaald werden door Thorpe in Calcutta bij het Sealdahstation gemaakt.

He aquí algunas fotografías seleccionadas de un reportaje sobre la India efectuado por el conocido fotógrafo de '*The Guardian*', Denis Thorpe. En primer lugar vemos los cadáveres no reclamados de varias personas, expuestos de forma macabra en la Sealdah Station de Calcuta.

Remarquable contribution en provenance de l'Inde par Thorpe, le journaliste photographe du *Guardian*, lauréat de divers prix. Ces portraits macabres de morts non réclamés exposés à la gare de Sealdah sont extraits d'une série de photographies prises à Calcutta.

194

Photographer	Denis Thorpe
Camera	Leica M2
Lens	35 mm
Film	Ilford FP4
Shutter Speed	1/60
Aperture	f/2.8
Developer	Microphen
Paper	Ilfospeed

Sleeping Indian families in the booking hall of Sealdah Station.

Schlafende indische Familien in der Bahnhofshalle von Sealdah.

Slapende Indiase gezinnen in de hal van het Sealdahstation.

Familias hindúes durmiendo en el vestíbulo de la estación de Sealdah.

Familles indiennes endormies dans le hall des réservations de la gare de Sealdah.

195

Photographer	Denis Thorpe
Camera	Nikon F
Lens	200 mm Nikkor
Film	Ilford FP4
Shutter Speed	1/60
Aperture	f/4
Developer	Microphen
Paper	Ilfospeed

Film Director Satjajit Ray talked about film and photography when Thorpe called on him in Calcutta.

Als Thorpe den Filmregisseur Satjajit Ray in Kalkutta besuchte, unterhielten sie sich über Filme und Fotografie.

Filmregisseur Satjajit Ray sprekend over film en fotografie, vastgelegd door Thorpe in Calcutta.

El director cinematográfico hindú Satjajit Ray conversó con Thorpe sobre cine y fotografía cuando éste lo visitó en Calcuta.

Le réalisateur de films Satjajit Ray parlait de cinéma et de photographie lorsque Thorpe lui a rendu visite à Calcutta.

196

Photographer	Denis Thorpe
Camera	Nikon F
Lens	85 mm Nikkor
Film	Ilford FP4
Shutter Speed	1/60
Aperture	f/2.8
Developer	Microphen
Paper	Ilfospeed

Calcutta. An old man crawls toward a milk distribution centre in monsoon rain.

Kalkutta. Ein alter Mann kriecht im Regen des Monsuns zu einer Milchausgabestelle.

Calcutta. Een oude man kruipt tijdens een hevige regenbui naar een melkdistributiecentrum.

Calcuta. Un anciano se arrastra bajo la lluvia monzónica hacia un centro de distribución de leche.

Calcutta. Un vieil homme rampe, sous la mousson, vers un centre de distribution de lait.

197

Photographer	Werner Stuhler
Camera	Mamiya C220
Lens	80 mm Rokkor
Film	Orwo NP20
Shutter Speed	1/125
Aperture	f/11

The powerful imagery of German pictorialist Werner Stuhler always makes a fabourable impression. Here he portrays a street artist.

Die kräftigen Bilder des deutschen Fotografen Werner Stuhler machen stets einen tiefen Eindruck. Hier zeigt er einen Strassenkünstler.

De krachtige beelden van de Duitse kunstfotograaf Werner Stuhler maken altijd een grote indruk. Hier portretteert hij een straatartiest.

La poderosa imaginería del fotógrafo alemán Werner Stuhler causa siempre una impresión favorable. En este caso nos ofrece el retrato de un artista callejero.

La puissante imagerie du pictoraliste allemand Werner Stuhler fait toujours une impression favorable. Ici, il a fixé sur la pellicule un artiste des rues.

198

Photographer	Werner Stuhler
Camera	Hasselblad
Lens	250 mm Sonnar
Film	Orwo NP20
Shutter Speed	1/250
Aperture	f/8

An Italian Priest. All the pictures in Stuhler's latest collection are reproduced from copy prints made from high contrast copy film.

Ein italienischer Priester. Alle Bilder in Stuhlers letzter Sammlung sind Wiedergaben von Kopien, die mit Hilfe von kontrastreichem Kopierfilm angefertigt wurden.

Een Italiaanse priester. Alle foto's uit Stuhlers nieuwste collectie zijn gereproduceerd vanaf kopie-afdrukken, gemaakt met contrastrijke kopieerfilm.

Sacerdote italiano. Todas las fotografías de Stuhler incluidas aquí se han reproducido a partir de las impresiones obtenidas utilizando una película de elevado contraste.

Prêtre italien. Toutes les photographies de la dernière collection de Stuhler sont reproduites à partir d'impressions réalisées avec des pellicules à copier à fort contraste.

199/200

Photographer	Werner Stuhler
Camera	Mamiya C220
Lens	180 and 55 mm Rokkor
Film	Orwo NP20
Shutter Speed	1/125
Aperture	f/8 and f/11

Stuhler's high contrast technique works equally well with non portrait subjects. In these two compositions the complex patterns of nature are reduced to more graphic simplicity.

Stuhlers Technik scharfer Kontraste eignet sich nicht nur für Porträts. In diesen beiden Kompositionen sind die komplizierten Formen der Natur zu grafischerer Einfachheit reduziert.

Stuhlers hoog-contrasttechniek werkt even goed voor andere dan portretstudies. In deze twee composities worden de ingewikkelde patronen van de natuur gereduceerd tot een meer grafische eenvoud.

La technique du fort contraste de Stuhler est tout aussi excellente dans le cas de sujets autres que des portraits. Dans ces deux compositions, les structures complexes de la nature sont réduites à une simplicité plus graphique.

Las técnicas contrastantes utilizadas por Stuhler permiten obtener también buenos resultados con otros géneros, aparte del retrato. En estas dos composiciones las formas complejas presentadas por la naturaleza han quedado reducidas a una extrema simplicidad gráfica.

201

Photographer	Peter J. Hoare
Camera	Nikon F
Lens	35 mm Nikkor
Film	Kodak Tri-X
Shutter Speed	1/60
Aperture	f/8
Developer	D76

'This unemployed school leaver found work in a circus as an 'apprentice everything' writes provincial newspaper photographer Hoare. One of the subjects' first jobs was to feed a lion cub.

'Dieser arbeitslose Schulabsolvent fand in einem Zirkus als ''allgemeiner Lehrling'' Arbeit', schreibt der für eine Provinzzeitung tätige Fotograf Hoare. Eine der ersten Aufgaben des Jungen bestand im Füttern eines Löwenjungen.

'Deze werkloze schoolverlater vond werk in een circus als manusje van alles', schrijft de persfotograaf van een provinciaal dagblad, Peter J. Hoare. Een van zijn eerste taken was het voeden van dit leeuwejong.

El fotógrafo Hoare, que trabaja regularmente para un periódico de provincias, nos indica que 'este joven encontró grandes dificultades en conseguir trabajo tras finalizar sus estudios, por lo que se enroló en un circo como aprendiz de lo que quisieran enseñarle. Así, una de sus primeras ocupaciones consistió en alimentar a un cachorro de león'.

Cet étudiant de dernière année en chômage a trouvé du travail dans un cirque comme 'apprenti en tout', écrit Hoare, photographe d'un journal de province. L'un des premiers travaux du sujet a été de donner à manger à un lionceau.

202

Photographer	Peter J. Hoare
Camera	Nikon F
Lens	50 mm Nikkor
Film	Ilford HP5
Shutter Speed	1/125
Aperture	f/5.6
Developer	D76

A boy and his pet Kestrel. The striking photography of Peter Hoare has found a place in previous editions of this annual and also achieved success in the British Press Awards and other leading photo contests.

Ein Knabe und sein Turmfalke. Die eindrucksvollen Aufnahmen von Peter Hoare wurden auch in früheren Ausgaben dieses Jahrbuchs veröffentlicht und haben in den British Press Awards und anderen führenden Fotowettbewerben Anerkennung gefunden.

Een jongen met zijn torenvalk. De opvallende fotografie van Peter J. Hoare was al eerder in ons fotojaarboek te zien en tevens boekte hij verschillende successen bij de British Press Awards en andere belangrijke fotowedstrijden.

Un muchacho con su animal favorito, Kestrel. Las obras de Peter Hoare, caracterizadas por un sorprendente estilo directo, han figurado ya en ediciones anteriores de nuestro libro, habiéndole proporcionado también diversos premios en los certámenes organizados por la prensa inglesa y en otros importantes concursos.

Un jeune garçon et son animal favori Kestrel. La remarquable photographie de Peter Hoare a trouvé une place dans les éditions précédentes du présent annuaire, et a remporté un grand succès dans les concours organisés par la presse britannique et dans d'autres concours de photographie réputés.

203

Photographer	Paul Harris
Camera	Olympus OM-1
Lens	85 mm
Film	Kodak Tri-X
Shutter Speed	1/60
Aperture	f/2

The Punk craze may have been born on the streets of London's Chelsea but it took the streets of Los Angeles to produce the cult's most bizarre picture. It was taken by Devon born Paul Harris, now based in California, for Photographers International.

Die 'Punk'-Mode mag in den Strassen des Londoner Viertels Chelsea entstanden sein, doch wurde das merkwürdigste Bild des Kults im Auftrage der Photographers International von Paul Harris auf einer Strasse in Los Angeles aufgenommen. Der in Devon gebürtige Künstler hat sich nun in Kalifornien niedergelassen.

De punkmanie mag dan misschien zijn ontstaan in de straten van het Londense Chelsea, de straten van Los Angeles waren nodig om de meest bizarre plaat van deze cultus te kunnen maken. Deze werd gemaakt door Paul Harris – geboren in Devon, nu werkzaam in Californië – van Photographers International.

Aunque la locura punk nació originalmente en las calles del barrio londinense de Chelsea, fue en las de Los Angeles donde se obtuvo la más original instantánea sobre este fenómeno. Su autor fue el fotógrafo Paul Harris, natural de Devon pero residente en California, donde trabaja para Photographers International.

Le culte 'Punk' est peut-être né dans les rues du quartier de Chelsea à Londres, mais il a fallu les rues de Los Angeles pour obtenir l'image la plus bizarre de ce culte. Le cliché est dû à Paul Harris, originaire du Devon, mais aujourd'hui établi en Californie, pour Photographers International.

204

Photographer	Terry Fincher
Camera	Olympus OM-1
Lens	134 mm
Film	Kodak Tri-X
Shutter Speed	1/60
Aperture	f/11

Terry Fincher has photographed Gregory Peck many times before, but never like this. The actor has always been the good guy in the countless films he has made but in 'The Boys From Brazil' which was on location in Vienna, Peck played the villain for the first time as the Auschwitz 'Angel of Death' Nazi, Dr. Josef Mengele who, in the film, is savaged to death by a pack of bare-fanged Dobermans.

Terry Fincher hat Gregory Peck schon oft fotografiert, aber nie so. Der Schauspieler war in seinen zahllosen Filmen stets der gute Kerl, doch in 'The Boys From Brazil', einem in Wien gedrehten Film, spielte er zum ersten Mal den Auschwitzer 'Todesengel' Dr. Josef Mengele, der in em Film von einem Rudel reißender Doberman-Hunde zerfleischt wird.

Terry Fincher heeft al erg vaak foto's van Gregory Peck gemaakt, maar nog nooit zó. In de talloze films die hij in de loop van de tijd heeft gemaakt speelde hij altijd de strijder tegen het onrecht, de held. Maar in 'The Boys From Brazil', die onder andere in Wenen werd opgenomen, speelde hij voor de eerste keer 'de boef', en wel de nazi-kamparts van Auschwitz, dr. Josef Mengele, die in de film door een meute Dobermanns aan stukken wordt gescheurd.

Terry Fincher había fotografiado varias veces a Gregory Peck, pero nunca de esta forma. Este actor solía encarnar siempre al 'bueno' de la película en sus interpretaciones en el celuloide pero en el film 'Los muchachos del Brasil' (que se estaba filmando en Viena en el momento en que fue tomada esta instantánea) Peck encarnaba al villano (el 'verdugo' de Auschwitz) Josef Mengele, apodado el 'Angel de la Muerte' que será devorado al final por un grupo de perros Doberman.

Terry Fincher a photographié Gregory Peck de nombreuses fois auparavant, mais jamais de cette façon. Cet acteur a toujours tenu des rôles de gentil garçon dans les innombrables films qu'il a tournés, mais dans 'The boys from Brazil' (Les gars du Brésil), en tournage à Vienne, Peck interprétait pour la première fois le rôle d'un scélérat sous les traits d'un tortionnaire nazi d'Auschwitz baptisé 'L'ange de la Mort', en l'occurrence le Dr Josef Mengele qui, dans le film, est mordu à mort par une meute de Dobermans aux crocs à nu.

205

Photographer	Terry Fincher
Camera	Olympus OM-1
Lens	85 mm
Film	Kodak Tri-X
Shutter Speed	1/500
Aperture	f/8

As a famous British war photographer Terry Fincher of Photographers International has witnessed a scene like this many times before – from Vietnam to the Middle East. But this time no-one got hurt. Terry was at Tshipise, South Africa, where he caught this dramatic moment during the filming of 'The Wild Geese'.

Terry Fincher, ein Mitarbeiter von Photographers International, war ein berühmter britischer Kriegsfotograf und hat daher Szenen dieser Art schon oft in den verschiedensten Teilen der Welt – von Vietnam bis zum Nahen Osten – miterlebt. Dieses Mal wurde aber niemand verletzt. Terry befand sich nämlich in Tshipise, Südafrika, wo er beim Drehen des Filmes 'The Wild Geese' diesen dramatischen Moment erfasste.

Als beroemd Brits oorlogsfotograaf heeft Terry Fincher van Photographers International dit soort taferelen al vele malen eerder gefotografeerd – van Vietnam tot aan het Midden-Oosten. Maar deze keer raakte niemand gewond. Terry maakte deze dramatische opname in Tshipise in Zuid-Afrika, tijdens het maken van de film 'The Wild Geese'.

El conocido fotógrafo británico Terry Fincher, especializado en reportajes bélicos, ha contemplado a menudo una escena como ésta – en Vietnam, Oriente Medio etc, Sin embargo, esta vez no resultó nadie herido. Terry captó esta dramática imagen en Tshipise (Sudáfrica) durante la filmación de 'Los Gansos Salvajes'.

En tant que photographe britannique réputé de la guerre, Terry Fincher, de Photographers International, a été maintes fois le témoin d'une scène comme celle-ci – du Vietnam au Moyen-Orient. Mais cette fois personne ne fut blessé. Terry était à Tshipise, en Afrique du Sud, où il a fixé sur la pellicule cet instant dramatique durant le tournage du film 'The Wild Geese' (Les oies sauvages).

Some of our b
from working in

Our famous developing tank is no exception.

Its features are a direct result of practical experience coupled with a desire to prove that developing a strip of film should be as easy as exposing it.

Breathtakingly simple.

The auto-load reel was a Paterson idea. It takes all the fear out of transferring your film from camera to tank in the dark.

The film can be drawn onto the reel with consummate ease.

The reels are also adjustable and take 35mm, 126, 127, 120 and 220 sizes.

Made from an acetal resin, they are completely resistant to all known photographic chemicals and their stainless steel ball bearings will not corrode and seize up.

The tank itself boasts a number of ideas and features many of which are unique.

A cunning light-trap system permits the rapid entry and exit of chemicals.

The Universal model takes just $3\frac{1}{2}$ seconds to fill and $3\frac{1}{2}$ seconds to empty.

The chemicals enter the tank down the centre column and rise up from the bottom to cover the film, avoiding uneven development and streaking.

Inversion agitation is also no problem. It's the most

Empty in seconds.

est ideas come the dark.

The Tank. Multi-unit tanks are available and can cope with a variety of film sizes for simultaneous processing.

The Auto-load Reel. Simply load the film into the grooves. Oscillate the two halves. This action will draw the film automatically into the reel.

Stainless steel ball bearings allow a smooth action and are resistant to corrosion.

All System 4 parts are interchangeable and can be bought separately.

effective way of stopping uneven development and our special seal prevents leakage when the tank is inverted.

Another unique, but not insignificant feature is the design of the base. This prevents the tank aquaplaning onto the floor from a wet surface.

It's the little things that count.

Washing, incidentally, can be made simple by using our force film washer. It circulates water up from the bottom under pressure to ensure efficient washing.

It has always been our maxim that the best darkroom equipment is created in the darkroom.

We think you'll find that our System 4 Developing Tanks live up to it.

PATERSON

A little touch of genius.
A lot of common sense.

Inside the famous Paterson Tank.

206

Photographer	Howard Walker
Camera	Nikon F2
Lens	85 mm Nikkor
Film	Kodak Tri-X
Shutter Speed	1/125
Aperture	f/8
Developer	D76
Paper	Ilford

Episodes in the busy life of a successful newspaper photographer. 'Village Green Cricket' captures the idyllic atmosphere of Sunday cricket at Cheadle near Manchester.

Episoden in dem geschäftigen Leben eines erfolgreichen Pressefotografen. 'Cricket am Dorfrasen' gibt die idyllische Atmosphäre des Cricketspiels am Sonntag in Cheadle bei Manchester wider.

Episoden uit het drukke bestaan van een succesrijke persfotograaf. 'Cricket op de Village Green' ademt de idyllische atmosfeer van het zondagse cricket in Cheadle bij Manchester.

Diversos episodios de la atareada vida de un fotógrafo de prensa famoso. Esta fotografía, titulada 'Cricket en Village Green' recoge la atmósfera idílica de un partido de cricket celebrado en Cheadle, carca de Manchester.

Episodes de la vie mouvementée d'un heureux photographe de presse. 'Village Green Cricket' (Cricket sur la pelouse communale) capte cette atmosphère idyllique d'un match de cricket un dimanche à Cheadle, près de Manchester.

207

Photographer	Howard Walker
Camera	Nikon F2
Lens	28 mm Nikkor
Film	Ilford FP4
Shutter Speed	1/125
Aperture	f/4
Developer	D76
Paper	Ilford

'Winter Walk'. That a national press professional can still retain the keen amateur's eye for a picture is seen in this composition, taken on the sea front at Morecambe with the aid of a red filter.

'Winterspaziergang'. Dass ein Berufsfotograf der Landespresse das scharfe Auge des Amateurs für ein gutes Bild nicht einbüsst, erkennen wir in dieser Komposition, die mit Hilfe eines roten Filters am Strande von Morecambe geschaffen wurde.

'Winterwandeling'. Dat een nationaal bekende persfotograaf toch nog oog voor de traditioneel 'amateuristische' onderwerpen kan hebben bewijst deze foto, gemaakt met behulp van een roodfilter op het strand bij Morecambe.

'Paseo invernal'. Esta composición, tomada en la costa de Morecombe con la ayuda de un filtro rojo, nos muestra que los más famosos repórters gráficos pueden conservar perfectamente la inmediatez de visión típica de un aficionado.

'Promenade en hiver'. Qu'un photographe professionnel de la presse nationale ait su garder la fraîcheur de son regard d'amateur pour une photographie, c'est ce qui transparaît dans cette composition, prise sur le front de mer, à Morecambe, à l'aide d'un filtre rouge.

208

Photographer	Howard Walker
Camera	Nikon F2 with Motordrive
Lens	28 mm Nikor
Film	Kodak Tri-X
Shutter Speed	1/250
Aperture	f/4
Developer	D76
Paper	Ilford

'Police Protection'. Back to the hard news as a line of police decide not to get involved during an incident at a political march in Manchester.

'Polizeischutz'. Mit diesem Bilde einer Reihe von Polizisten, die beschliesst sich in einen Vorfall während eines politischen Marsches in Manchester nicht einzumischen, sind wir wieder bei der harten Realität unserer Tage.

'Politiebescherming'. Terug naar het harde nieuws: de politie besluit dat ze toch maar niet wil worden betrokken in een incident tijdens een protestmars in Manchester.

'Protección policial'. De vuelta a las imágenes de prensa en esta instantánea, en la que vemos a una hilera de policías que deciden no inmiscuirse en un incidente ocurrido en Manchester durante una manifestación política.

'Protection policière'. Retour aux dures réalités, avec ce cordon de police décidé à ne pas intervenir au cours d'un incident survenu lors d'une marche politique à Manchester.

209/210

Photographer	Ferran Artigas Riera
Camera	Minolta SRT 303b
Lens	28 mm Rokkor
Film	Kodak Tri-x
Paper	Enebrom

Twenty four year old Spanish photographer Riera has been taking pictures for seven years and has participated, he writes, in several collective exhibitions. His eye for pattern is evident from this picture, taken from the window of a motel near Geneva, Switzerland. The facing plate, based on a similar idea, was shot in Holland.

Der 24-jährige Spanier Riera fotografiert seit sieben Jahren und hat, wie er schreibt, an mehreren Kollektivausstellung en teilgenommen. Wie gut er Formen erfasst, geht aus diesem Bild hervor, das von dem Fenster eines in der Nähe von Genf befindlichen Motels aufgenommen wurde. Das gegenüberliegende Bild, dessen Grundgedanke ähnlich ist, wurde in Holland aufgenommen.

De vierentwintigjarige Spaanse fotograaf Riera maakt nu zeven jaar foto's en heeft, zo schrijft hij, deelgenomen aan verschillende collectieve tentoonstellingen. Zijn oog voor bepaalde patronen blijkt duidelijk uit deze foto, die hij nam uit een raam van een motel in de buurt van Genève. De foto hiernaast, gebaseerd op hetzelfde idee, werd genomen ergens in Nederland.

F. Artigas, artista español de 24 años de edad, se dedica a la fotografía desde hace siete, habiendo participado, nos dice, en varias exposiciones colectivas. Su buen gusto en la captación de las formas se pone claramente en evidencia en esta instantánea, tomada desde la ventana de un motel cercano a Ginebra. La fotografía opuesta, obtenida de forma similar, fue tomada en Holanda.

Riera, le photographe espagnol âgé de vingt-quatre ans, s'adonne à la photographie depuis sept ans et a participé, écrit-il, à plusieurs expositions collectives. Son sens des structures ressort à l'évidence de cette composition, prise de la fenêtre d'un motel près de Genève, Suisse. La photographie de la page ci-contre, basée sur une idée semblable, a été prise aux Pays-Bas.

211

Photographer	Don McPhee
Camera	Nikon F2
Lens	35 mm Nikkor
Film	Ilford FP4
Shutter Speed	1/250
Aperture	f/5.6
Developer	Microphen
Paper	Ilfobrom

'Sailing through the storm damaged wheatfields of Cheshire'. McPhee used an orange filter for this canal picture.

'Fahrt durch die vom Gewitter heimgesuchten Weizenfelder von Cheshire'. McPhee verwendete für diese Kanalaufnahme ein orangefarbenes Filter.

'Varend door de door storm beschadigde tarwevelden van Cheshire'. McPhee gebruikte voor dit riviergezicht een oranjefilter.

'Navegando a través de los campos de trigo de Cheshire seriamente dañados por una tormenta'. Para obtener esta instantánea McPhee utilizó un filtro anaranjado.

'En bateau à travers les champs de blé du Cheshire ravagés par l'orage'. McPhee a utilisé un filtre orange pour cette photographie d'un canal.

212

Photographer	Don McPhee
Camera	Nikon F2
Lens	24 mm Nikkor
Film	Ilford FP4
Shutter Speed	1/250
Aperture	f/218
Developer	Microphen
Paper	Ilfobrom

The Guardian newspaper photographer McPhee is a colleague of Denis Thorpe so we were glad to receive a portfolio mainly devoted to transport of various kinds. This one is captioned: 'Driving across the Kansas wheatfields in a hailstorm'.

Der für die Zeitung *Guardian* tätige Fotograf McPhee ist ein Kollege von Denis Thorpe, und wir freuten uns daher sehr, als er uns eine Reihe von Aufnahmen über verschiedene Transportthemen sandte. Dieses trägt den Titel 'Durch die Weizenfelder von Kansas im Hagel'.

MRS DAVID BAILEY AND HER OLYMPUS CAMERA.

Olympus 0M2. The single lens reflex camera you can fit in your pocket.
Olympus Optical Co.(UK) Ltd, 2-8 Honduras Street, London EC1Y 0TX. Telephone: 01-253 2772.

Fotograaf McPhee van *The Guardian* is een collega van Denis Thorpe en wij vinden het erg plezierig dat wij van hem een collectie foto's mochten ontvangen die voornamelijk betrekking hebben op verschillende soorten vervoer. Deze foto is getiteld: 'Dwars door de tarwevelden van Kansas tijdens een hagelbui'.

El repórter del *Guardian* McPhee es un compañero de trabajo de Denis Thorpe. Nos ha alegrado mucho recibir su colección de fotografías, consagradas al tema común de los medios de transporte. Ésta se titula: 'Conduciendo a través de los campos de trigo de Kansas bajo una tormenta de granizo'.

McPhee, photographe de presse du *Guardian*, est un collègue de Denis Thorpe; nous nous sommes donc félicités de recevoir une série principalement consacrée aux transports sous différentes formes. Celle-ci est intitulée 'En voiture à travers les champs de blé du Kansas sous un orage de grêle'.

In der industriellen Revolution Grossbritanniens spielten Kanäle eine wichtige Rolle. In diesem in Rotherham aufgenommenen Bild behandelt McPhee, ein Stabsfotograf des *Guardian*, die Wiederherstellung des Sheffield and South Yorkshire Canal als wirtschaftlich lebensfähige Wasserstrasse. Der Künstler, der seit acht Jahren in Manchester lebt, erfasst mit seinen Aufnahmen, die in allen Teilen der Zeitung veröffentlicht werden, einen Bereich, der sich von Birmingham bis nach Nordschottland und Irland erstreckt.

Kanalen speelden een grote rol tijdens de Industriële Revolutie in Groot-Brittannië. Deze opname van de staffotograaf van *The Guardian* toont de wedergeboorte bij Rotherham van het Sheffield en South Yorkshire kanaal als een commercieel levensvatbare waterweg. McPhee heeft al acht jaar Manchester als standplaats, van waaruit hij een gebied dat loopt van Birmingham tot Noord-Schotland en Ierland voor de rubrieken nieuws en kunst bewerkt.

Los canales jugaron un papel muy importante durante la Revolución industrial inglesa. Aquí, el repórter del *Guardian* nos muestra la conversión en Rotherham del Sheffield and South Yorkshire Canal en una vía comercial navegable. McPhee, que lleva ya ocho años residiendo en Manchester, cubre la zona comprendida entre Birmingham y el Norte de Escocia e Irlanda realizando toda clase de reportajes y registrando gráficamente las exposiciones artísticas.

Les canaux ont joué un rôle important dans la révolution industrielle en Grande-Bretagne, et ici McPhee, photographe du *Guardian*, souligne la renaissance du Sheffield and South Yorkshire Canal, en tant que voie d'eau commercialement viable, à Rotherham. Etabli à Manchester depuis huit ans, McPhee couvre une région s'étendant de Birmingham au nord de l'Ecosse et à l'Irlande pour les nouvelles, les articles de magazine et les pages artistiques du journal.

Una interesante secuencia náutica tomada por R. K. O'Neill, un fotógrafo 'free-lance' de 22 años que trabaja asimismo como Jefe de propaganda en un club de entusiastas de la navegación. O'Neill obtuvo estas fotografías en Salcombe cuando una embarcación zozobró al quedar enredado el timón en una cuerda de amarre.

Intéressante séquence de canotage par O'Neill, photographe indépendant de vingt-deux ans, qui travaille aussi comme chef de la publicité d'un centre de navigation de plaisance. Les photographies ont été prises à Salcombe au moment où un voilier se retournait après avoir croisé une amarre qui s'enroula autour de son gouvernail.

213

Photographer	Don McPhee
Camera	Nikon F2
Lens	200 mm Nikkor
Film	Ilford FP4
Shutter Speed	1/250
Aperture	f/8
Developer	Microphen
Paper	Ilfobrom

'Texas Old Timer'. In which bicycles and automobiles are more in evidence than the traditional Texan's four legged friend.

'Alter Mann in Texas'. In diesem Bilde sind Fahrräder und Automobile viel prominenter als der traditionelle vierbeinige Freund des Texaners.

'Texas Old Timer'. Een opname waarin fietsen en auto's duidelijk meer aandacht trekken dan het traditionele viervoetige transportmiddel van Texas.

'De otra época'. En esta fotografía los automóviles y bicicletas aparecen con mucha mayor profusión que el tradicional amigo de cuatro patas con que contaban normalmente los tejanos.

'Scène du bon vieux temps au Texas', dans laquelle les bicyclettes et les voitures sont plus en évidence que le traditionnel ami à quatre pattes du Texien.

214

Photographer	Don McPhee
Camera	Nikon F2
Lens	35 mm Nikkor
Ilford	FP4
Shutter Speed	1/30
Aperture	f/4
Developer	Microphen
Paper	Ilfobrom

Canals played a large part in Britain's Industrial Revolution and here *Guardian* staff photographer McPhee records the rebirth of the Sheffield and South Yorkshire Canal as a commercially viable waterway at Rotherham. Based in Manchester for eight years, McPhee covers an area stretching from Birmingham to Northern Scotland and Ireland for the newspaper's news, features and arts pages.

215/217

Photographer	Robert K. O'Neill
Camera	Mamiya Sekor 100 DLT
Lens	200 mm Panagor
Film	Kodak Plus-X
Shutter Speed	1/250

An interesting boating sequence from 22 year old freelance O'Neill who also works as the Advertising Manager for a Boat Centre. The pictures were taken at Salcombe when a sailing boat capsized after crossing a mooring line which caught around its rudder.

Eine interessante Reihe von Bootaufnahmen des 22-jährigen freiberuflichen Fotografen O'Neill, der auch Werbeleiter eines Bootszentrums ist. Die Bilder wurden in Salcombe aufgenommen, als ein Segelboot kenterte, nachdem es über eine Vertäuleine gefahren war, die sich in dem Ruder fing.

Een interessante reeks zeilfoto's van de tweeëntwintigjarige free-lance fotograaf O'Neill die tevens werkzaam is als reclamechef bij een jachtwerf. Deze opnamen werden bij Salcombe gemaakt: een zeilboot kapseisde nadat hij een meertouw had overvaren dat in het roer verward raakte.

218

Photographer	Attow T.T. Chen
Camera	Leica M3
Lens	28 mm Canon
Film	Kodak Tri-X
Shutter Speed	1/250
Aperture	f/11
Developer	D76
Paper	Gekko

Our final selection of photographs from Taiwan includes 'The head of a Queen', a study of a strange rock formation in the northern part of the island.

Unsere letzte Auswahl von Fotografien aus Taiwan schliesst 'Kopf einer Königin' ein, eine Studie merkwürdiger Felsen im nördlichen Teil der Insel.

Onze laatste selectie foto's uit T'ai-wan begint met 'Het hoofd van een koningin', een studie van een eigenaardige rotsformatie op het noordelijke deel van het eiland.

En nuestra selección final de fotografías recibidas de Taiwan incluimos este estudio de una extraña formación rocosa situada en el norte de la isla, titulado 'La cabeza de la reina'.

Notre sélection finale de photographies de Taïwan comprend 'The head of a Queen' (La tête d'une reine), étude d'une curieuse formation rocheuse de la partie septentrionale de l'île.

219

Photographer	Attow T.T. Chen
Camera	Leica M3
Lens	135 mm Canon
Film	Kodak Tri-X
Shutter Speed	1/30
Aperture	f/3.5
Developer	D76
Paper	Gekko

'The Alvin Ailey American Dance Theatre photographed by stage lighting during a performance in Taipei.'

'Das Alvin Ailey American Dance Theatre bei Bühnenbeleuchtung während einer Vorstellung in Taipei fotografiert.'

'De Alvin Ailey American Dance Theatre met toneelverlichting gefotografeerd tijdens een voorstelling in T'ai-péi.'

'He aquí a la compañía de danza del americano Alvin Ailey fotografiada durante su actuación en Taipe utilizando únicamente la luz del escenario'.

'Le Alvin Ailey American Dance Theatre', photographié à la lumière des feux de la rampe durant une représentation à Taïpeh.

220

Photographer	Colin Monteith
Camera	Nikkormat
Lens	35 mm
Film	Kodak Tri-X
Developer	Aculux
Paper	Kodak Veribrom

In the Edinburgh museum, examples of Scottish shipbuilding skill are ignored by a lady engaged in her own fabrications.

Im Edinburgher Museum werden Beispiele schottischer Schiffbaukunst von einer Dame, die ihren eigenen Interessen nachgeht, ignoriert.

In dit museum in Edinburgh worden staaltjes van Schotse scheepsbouwkunst volledig genegeerd door een dame die geheel verdiept is in haar eigen maaksels.

En el museo de Edimburgo, esta señora, abstraída en sus propias realizaciones, parece ignorar completamente las distintas muestras de la habilidad de los artesanos escoceses en la construcción de barcos.

Au musée d'Edimbourg, ces exemples de la construction navale écossaise sont ignorés par une dame occupée à ses propres fabrications.

221

Photographer	Colin Monteith
Camera	Nikkormat
Lens	200 mm
Film	Kodak Tri-X
Developer	Acuspeed
Paper	Kodak Veribrom

Long legged students on a charity walk are nicely framed in by parking meters through the long lens of Edinburgh photographer Monteith.

Langbeinige Studenten auf einem Wohltätigkeitsspaziergang elegant zwischen Parkzeituhren eingefangen. Der in Edinburgh wohnhafte Fotograf Monteith machte dabei von einem langbrennweitigen Objektiv Gebrauch.

Langbenige studenten bezig met een wandeling, keurig door parkeermeters ingekaderd, gezien door de telelens van deze fotograaf uit Edinburgh.

Estos estudiantes 'zanquilargos', que llevan a cabo una colecta caritativa, fueron enmarcados graciosamente entre los contadores de aparcamiento por el fotógrafo de Edimburgo C. Monteith. A destacar su utilización de un objetivo de foco largo.

Ces étudiants aux longues jambes, photographiés lors d'une marche de charité, sont remarquablement encadrés par des parcmètres grâce au téléobjectif de Monteith, photographe édimbourgeois.

222/223

Photographer	Erwin Kneidinger
Camera	Nikon F
Film	Kodak Tri-X
Paper	Agfa

Much travelled Austrian photographer Kneidinger submitted several interesting assignment portfolios this year. For his first spread we selected Tunisia, where a cat was well observed amid characteristic architecture at Ksar Haddada, 'Work', the facing plate, is a study of one of the human inhabitants.

Der vielgereiste österreichische Fotograf Kneidinger reichte dieses Jahr mehrere interessante Sammlungen ein. Als erstes Bild wählten wir eine Aufnahme aus Tunesien, wo er mit grossem Verständnis eine Katze unter den charakteristischen Bauwerken von Ksar Haddada aufnahm. 'Arbeit', das gegenüberliegende Bild, ist eine Studie von einem der menschlichen Einwohner.

De Oostenrijkse fotograaf Kneidinger, die over de hele wereld heeft gezworven, zond dit jaar een aantal interessante, in opdracht gemaakte, reportages in. Voor zijn eerste dubbele pagina zochten wij Tunesië uit, waar de fotograaf deze kat te midden van de karakteristieke architectuur van Ksar Haddada waarnam. 'Werk', de daaropvolgende plaat, is een studie van een autochtone bewoner.

El fotógrafo austríaco Kneidinger, enamorado de los viajes, nos ha enviado este año varias series de obras interesantísimas. En primer lugar hemos seleccionado esta instantánea tunecina, en la que vemos a un gato graciosamente encuadrado entre las joyas arquitectónicas de Ksar Haddada. 'Trabajando', la obra opuesta, es un estudio de los pobladores humanos.

Grand voyageur, le photographe autrichien Kneidiger nous a cette année envoyé plusieurs séries de photographies intéressantes. Pour sa première présentation, nous avons choisi la Tunisie, où un chat a été bien observé dans le cadre de l'architecture caractéristique de Ksar Haddada. 'Travail', la photographie de la page ci-contre, est une étude de l'un des habitants humains.

224/225

Photographer	Erwin Kneidinger
Camera	Nikon F
Film	Kodak Tri-X
Lens	24 mm Nikkor
Shutter Speed	1/250
Developer	Neutol
Paper	Agfa

Dahome in West Africa. Two further pictures by award winning photographer Kneidinger.

Dahome in Westafrika. Zwei weitere Aufnahmen des preisgekrönten Fotografen Kneidinger.

Dahomey in West-Afrika. Opnieuw twee foto's van de regelmatig in de prijzen vallende Kneidinger.

Dahomey (Africa occidental). Dos nuevas fotografías del laureado artista Kneidinger.

Dahomey, en Afrique occidentale. Deux autres photographies de Kneidiger, lauréat de divers prix.

226

Photographer	Hansjochen Heinecke
Camera	Konica
Lens	180 mm
Film	Kodak Tri-X
Developer	D76
Paper	Ilfospeed

Pattern pictures are a speciality of German photographer Heinecke. Here he concentrates on the legs of racing cyclists.

Der deutsche Fotograf Heinecke spezialisiert sich auf Aufnahmen, die interessante Muster bilden. Hier konzentriert er sich auf die Beine von Rennfahrern.

Dit soort 'patroonfotografie' is een specialiteit van deze Duitse fotograaf. Hier heeft hij zich geconcentreerd op de benen van wielrenners.

Las instantáneas de gran riqueza formal constituyen la especialidad del fotógrafo alemán Heinecke. En este caso eligió como tema a las piernas de los participantes en una carrera ciclista.

Les photographies géométriques sont une spécialité du photographe allemand Heinecke. Ici, il s'est concentré sur les jambes de coureurs cyclistes.

227

Photographer	Hansjochen Heinecke
Camera	Konica
Lens	180 mm
Film	Ilford HP5
Developer	Microphen
Paper	Ilfospeed

A top hatted chimney sweep animates across this composite roofscape.

Ein Schornsteinfeger mit Zylinderhut bewegt sich hier über diese Komposition von Dächern.

Een van een hoge zijden hoed voorziene schoorsteenveger verlevendigt dit ingewikkelde uitzicht op daken.

El deshollinador, ataviado con un gracioso sombrero de copa, introduce una nota característica en esta estampa de tejados.

Un ramoneur en haut de forme anime cette perspective composite de toits.

228

Photographer	Peeter Tooming
Camera	Leica
Lens	20 mm Russar
Film	Infra Red

'Bullrush, sea and sky'. An infra red landscape by the self taught Russian photographer. Tooming's work has been widely exhibited and published.

'Schilf, Meer und Himmel'. Eine infrarote Landschaftsaufnahme des russischen Fotografen, der seine Kunst als Autodidakt gemeistert hat. Toomings Aufnahmen wurden oft ausgestellt und veröffentlicht.

'Biezen, zee en de hemel'. Een infrarood landschap van de Russische autodidact Tooming. Zijn werk is op veel plaatsen tentoongesteld en gepubliceerd.

'Juncos, mar y cielo'. P. Tooming, fotógrafo ruso autodidacta, tomó esta instantánea con rayos infrarrojos. Las obras de este artista han figurado en numerosas exposiciones y se han publicado en diversas revistas.

'Jonc des marais, mer et ciel'. Paysage photographié aux rayons infrarouges par le photographe autodidacte russe. Les oeuvres de Tooming ont été largement exposées et publiées.

229

Photographer	Peeter Tooming
Camera	Practika L
Lens	Mir 10A
Film	KN-3
Shutter Speed	1/125
Aperture	f/5.6
Developer	D76

Tooming calls this picture 'Leave taking'. In addition to his interest in still photography he has worked as director of photography at a film studio in Tallinn, Estonia.

Tooming nennt dieses Bild 'Abschied'. Er interessiert sich nicht nur für normale Fotografie sondern war auch in einem in Tallinn, Estland, befinlichen Filmstudio Leiter der fotografischen Abteilung.

Tooming noemt deze foto 'vrijaf'. Behalve zijn grote interesse in fotografie heeft hij in Tallin (Estland) als chef-cameraman in een filmstudio gewerkt.

Tooming ha titulado a esta pintura 'La despedida'. Este artista ha combinado durante bastante tiempo su trabajo práctico con la dirección de un estudio en Tallinn, Estonia.

Tooming intitule cette photographie 'Adieux'. Outre son intérêt pour la photographie, il a travaillé comme chef opérateur dans un studio cinématographique de Tallinn, Estonie.

230

Photographer	M. R. Owaisi
Camera	Asahi Pentax 6 × 7
Lens	300 mm SMC Takumar
Film	Kodak Pan-X 220
Shutter Speed	1/125
Aperture	f/8
Developer	Microdol-X

A side lit study of a young girl by a photographer from Pakistan.

Studie eines von der Seite beleuchteten jungen Mädchens. Der Fotograf lebt in Pakistan.

Een studie van een jong meisje – van de zijkant verlicht – van een fotograaf uit Pakistan.

Estudio de una chica, obtenido, con iluminación lateral, por un fotógrafo pakistaní.

Etude d'une fillette sous un éclairage latéral par un photographe pakistanais.

231

Photographer	M. R. Owaisi
Camera	Asahi Pentax 6 × 7
Lens	300 mm SMC Takumar
Film	Kodak Plus-X 220
Shutter Speed	1/250
Aperture	f/16
Developer	Microdol-X

Vulture landing. Owaisi released his shutter at just the right moment to obtain this unusual picture.

Ein Geier landet. Owaisi drückte gerade im richtigen Moment auf den Knopf, als er dieses ungewöhnliche Bild aufnahm.

Landende gier. Owaisi ontspande zijn sluiter precies op het goede ogenblik om deze ongebruikelijke foto te krijgen.

Cuervo tomando tierra. Para obtener esta instantánea poco usual Owaisi accionó el obturador justo en el momento oportuno.

Vautour se posant. Owaisi a déclenché l'obturateur de son appareil exactement au moment voulu pour obtenir cette insolite photographie.

232

Photographer	Semsi Güner
Camera	Nikon F
Lens	28 mm Nikkor
Film	Kodak Tri-X
Shutter Speed	1/250
Aperture	f/8
Developer	D76
Paper	Forte

Outstanding among late entries this year was a fine portfolio from Turkish photographer Semsi Güner of Istanbul, fortunately accompanied by comprehensive technical data and picture captions. Boys from the gypsy quarter of Istanbul enthusiastically collaborated in the making of his first picture.

Unter den letzten Werken, die uns dieses Jahr unterbreitet wurden, war eine schöne Sammlung von Aufnahmen des türkischen Fotografen Semsi Grüner, Istanbul, besonders interessant. Erfreulicherweise lieferte er auch ausführliche technische Daten und Bildunterschriften. Knaben aus dem Zigeunerviertel von Istanbul halfen bei der Aufnahme seines ersten Bildes begeistert mit.

Onder de laatste inzendingen dit jaar bevond zich een uitstekende collectie foto's van de Turkse fotograaf Semsi Güner uit Istanbul, gelukkig voorzien van bijschriften en uitgebreide technische bijzonderheden. Jongetjes uit de zigeunerwijk van Istanbul werken maar al te graag mee aan de totstandkoming van deze eerste foto.

Entre las fotografías incluidas en la edición de este año destaca especialmente la colección enviada por el gran fotógrafo de Estambul Semsi Güner, acompañada, por otra parte, por unas detalladas explicaciones y una completa serie de datos técnicos. Para hacer posible esta primera obra, colaboraron decisivamente los niños del barrio gitano de Estambul.

Parmi les dernières contributions qui nous sont parvenues cette année, il faut citer une remarquable série du photographe turc Semsi Güner, originaire d'Istanbul, heureusement accompagnée de caractéristiques techniques complètes et de légendes. Des garçons du quartier gitan d'Istanbul ont collaboré avec enthousiasme à la réalisation de cette photographie.

233

Photographer	Semsi Güner
Camera	Leica M3
Lens	135 mm Elmar
Film	Kodak Tri-X
Shutter Speed	1/250
Aperture	f/11
Developer	D76
Paper	Forte

Seascape with figures. A view from Kumkapi, Istanbul, which Güner describes as 'a paradise for photographers'.

Ansicht des Meers mit Gestalten. Der Aufnahmeort war Kumkapi, Istanbul, und wurde von Grüner als 'ein Paradies für Fotografen' beschrieben.

Zeegezicht met mensen. Een panorama vanaf Kumkapi bij Istanbul, waarvan Güner zegt dat het een paradijs voor fotografen is.

Paisaje marítimo con figuras. Una vista de Kumkapi, Estambul, descrita por Güner como 'un paraíso para los fotógrafos'.

Paysage marin avec silhouettes. Vue prise de Kumkapi, Istanbul, que Güner décrit comme 'un paradis pour les photographes'.

234

Photographer	Semsi Güner
Camera	Nikon F
Lens	20 mm Nikkor
Film	Kodak Tri-X
Shutter Speed	1/250
Aperture	f/8
Developer	D76
Paper	Forte

'Children at play in front of the Mevlana mausoleum, Konya'. An application of the great depth of field available in compositions made with a good wide angle lens.

'Spielende Kinder vor dem Mevlana Mausoleum in Konya'. Eine Anwendung der grossen Tiefenschärfe, die sich mit einem guten Weitwinkelobjektiv erzielen lässt.

'Spelende kinderen voor het Mevlana mausoleum in Konya'. Een toepassing van de grote dieptescherpte, verkregen door het gebruik van een goede groothoeklens.

'Niños jugando frente al mausoleo de Mevlana en Konya'. He aquí una aplicación de la gran profundidad de campo obtenida en las instantáneas tomadas con un objetivo de gran angular.

'Enfants jouant devant le mausolée de Mevlana, à Konya'. Une application de la grande profondeur de champ que l'on trouve dans les compositions réalisées avec un grand angulaire de bonne qualité.

235

Photographer	Semsi Güner
Camera	Nikon F
Lens	135 mm Nikkor
Film	Ilford HP4
Shutter Speed	1/125
Aperture	f/8
Developer	Microphen
Paper	Ilford

While in Muscat, Oman, the Turkish photographer found this man selling parrots. The subject was so pleased that his photograph was to be taken, notes Güner, that he started talking to one of his birds – with this delightful result.

Der türkische Fotograf entdeckte diesen Papageienverkäufer in Muscat, Oman. Grüner berichtet, der Mann habe sich so darüber gefreut, Gegenstand einer Aufnahme zu sein, dass er auf einen seiner Vögel einzusprechen begann. Das entzückende Ergebnis diesser Aufnahme ist hier wiedergegeben.

Tijdens een verblijf in Maskat en Oman liep de Turkse fotograaf deze papegaaien koopman tegen het lijf. Deze man was volgens Güner zo verguld dat hij werd gefotografeerd dat hij tegen een van z'n vogels begon te praten – met dit genoeglijke resultaat.

El fotógrafo turco se tropezó con este vendedor de periquitos en Muscat, Omán. Para manifestar su alegría ante el hecho de que le iba a tomar una fotografía, nos dice Güner, empezó a hablar a uno de sus pájaros – obteniendo el fotógrafo este delicioso resultado.

Lors d'un séjour à Muscat, Oman, le photographe turc a découvert ce vendeur de perroquets. Le sujet s'est montré si satisfait d'être l'objet d'une photographie, note Güner, qu'il s'est mis à parler à l'un de ses oiseaux – avec ce charmant résultat.

236

Photographer	Mike Hollist
Camera	Nikon
Lens	200 mm Nikkor
Film	Kodak Tri-X
Shutter Speed	1/250
Aperture	f/5.6
Developer	D76
Paper	Ilford

Polar Bear Mosa at Whipsnade Zoo inspects the camera of Daily Mail photographer Mike Hollist as her cub Patu is introduced to the press. Having a camera shoved up your nose always provokes mixed feelings but we suspect that this is one case where the subject really would have had the last word had the photographer not been protected by iron bars.

Mosa, ein Polarbär im Tiergarten Whipsnade, besichtigt die Kamera des Daily-Mail-Fotografen Mike Hollist, während Patu, ihr Junges, der Presse vorgestellt wird. Es ist niemals recht angenehm, wenn einem eine Kamera in die Nase geschoben wird, doch dürfte dies ein Fall sein, in dem das Modell das letzte Wort gehabt hätte, wenn der Fotograf nicht durch Eisenstangen geschützt gewesen wäre.

Ijsbeer Mosa in de dierentuin van Whipsnade inspecteert de camera van Daily Mail fotograaf Mike Hollist gedurende de presentatie aan de pers van haar jong Patu. Een camera onder je neus geschoven krijgen veroorzaakt natuurlijk altijd gemengde gevoelens maar we vermoeden dat wanneer de fotograaf niet door tralies van zijn onderwerp was gescheiden deze beer ongetwijfeld het laatste woord zou hebben gehad.

La osa polar Mosa inspecciona en el Zool de Whipsnade la cámara del fotógrafo del Daily Mail Mike Hollist mientras su cachorro Patu es presentado a la prensa. La situación de una cámara frente a la nariz de uno, provoca siempre una sensación de desconcierto, aunque sospechamos que en este caso hubiera sido el modelo quien hubiera tenido la última palabra si el fotógrafo no hubiera contado con la protección de las barras de hierro.

L'ours polaire Mosa, du zoo de Whipsnade, inspecte l'appareil photographique de Mike Hollist, photographe du Daily Mail, tandis que son petit ourson Patu est présenté à la presse. Se voir présenter un appareil photographique juste sous le nez engendre des sentiments mitigés, et c'est sans doute là un cas où le sujet aurait pu avoir le dernier mot, si le photographe n'avait pas été protégé par des barres de fer.

Dust Jacket

Photographer	Wout Gilhuis
Camera	Canon F1
Lens	85–300 mm
Film	Kodachrome 64

'Happy girl' by a leading member of the Dutch Association of Professional Photographers. This attractive picture is an excellent example of the zoom exposure technique which, in this case, involved the model walking towards the tripod mounted camera while the focal length of the lens was changed during the time that the shutter remained open. The fifty two year old freelance is author of a camera technique book entitled 'Between sharp and unsharp'.

'Glückliches Mädchen' von einem führenden Mitglied des Holländischen Verbandes der Berufsfotografen. Dieses hübsche Bild ist ein hervorragendes Beispiel für die Technik, bei der das Modell wie in diesem Falle auf die auf dem Stativ angebrachte Kamera zugeht und die Brennweite des Objektivs geändert wird, solange die Blende offen ist. Der 52-jährige freiberufliche Fotograf ist Verfasser des Kamera-Lehrbuchs 'Between sharp and unsharp'.

'Gelukkige jonge vrouw' door een vooraanstaand lid van de Nederlandse vereniging van vakfotografen. Deze aantrekkelijke plaat is een uitstekend voorbeeld van de zoom-belichtingstechniek die in dit geval een model betrof dat op de camera (op statief) toeliep, terwijl de brandpuntsafstand van het objectief werd veranderd en de sluiter openbleef. De tweeënvijftigjarige free-lance fotograaf is schrijver van een boek over cameratechniek, getiteld 'Tussen scherp en onscherp'.

'Chica feliz'. W. Gilhuis es uno de los miembros directivos de la Asociación de fotógrafos profesionales holandeses. Esta atractiva instantánea constituye una buena muestra de la utilización de la técnica del zoom. La modelo avanzó hacia la cámara, montada en un trípode, mientras la distancia focal del objetivo se modificaba durante el tiempo en que el obturador permanecía abierto. Este fotógrafo 'frelance' de cincuenta y dos años es el autor de un libro sobre técnica fotográfica titulado 'La nitidez de la imagen'.

'Jeune fille heureuse' par un membre éminent de l'Association néerlandaise des photographes professionnels. Cette séduisante photographie est un excellent exemple de la technique d'exposition au zoom qui, dans le cas présent, s'est fait avec un modèle marchant vers l'appareil monté sur trépied, tandis que la distance focale de l'objectif était modifiée pendant la durée d'ouverture de l'obturateur. Le photographe indépendant de cinquante-deux ans qui a pris cette photographie est l'auteur d'un livre de technique photographique intitulé 'Between sharp and unsharp' (Entre le net et le flou).

Back Endpaper

Photographer	Robert Michel
Camera	Rolleiflex
Lens	Planar
Film	Kodak Tri-X
Shutter Speed	1/60
Aperture	f/16
Developer	Microphen
Paper	Agfa

A block of houses just before demolition. To heighten the rather sinister mood of this picture, the well known Belgian photographer bleached out the sky on the negative so that it would print solid black.

Eine Gruppe von Häusern kurz vor dem Abbruch. Um die etwas düstere Stimmung dieses Bildes zu vertiefen, bleichte der bekannte belgische Fotograf den Himmel im Negativ, so dass er als schwarze Masse gedruckt wurde.

Een rij huizen even voordat ze gesloopt gaan worden. Om de sinistere stemming nog meer te benadrukken heeft deze bekende Belgische fotograaf de lucht op het negatief weggeëtst zodat deze volledig zwart werd bij het afdrukken.

Un bloque de casas poco antes de ser demolidas. Para dar un mayor énfasis a la atmósfera casi siniestra de esta instantánea, R. Michel, el conocido fotógrafo belga, blanqueó el cielo en el negativo para que apareciera de color negro en las copias.

Groupe d'immeubles juste avant sa démolition. Pour rehausser l'atmosphère plutôt sinistre de cette photographie, le photographe belge bien connu a blanchi le ciel sur le négatif, de façon à obtenir une impression en noir.

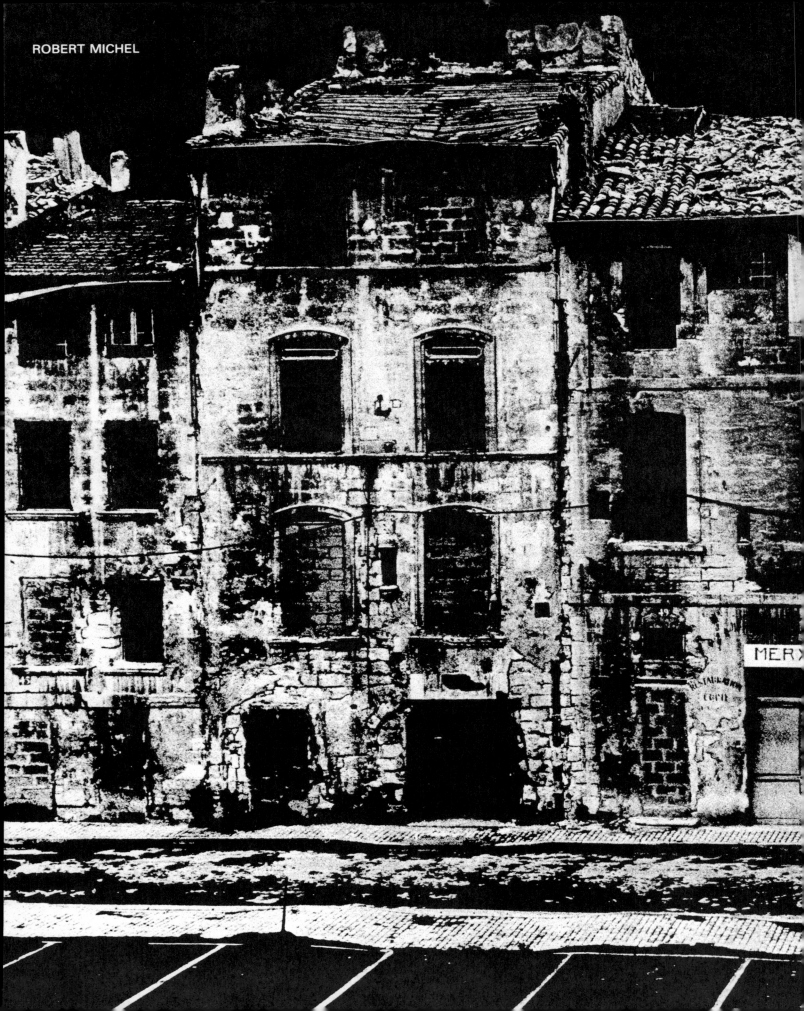
ROBERT MICHEL